THE
LAND
BEYOND
TIME

THE LAND BEYOND TIME

A MODERN EXPLORATION OF AUSTRALIA'S NORTH-WEST FRONTIERS

JOHN OLSEN
with MARY DURACK, GEOFFREY DUTTON,
VINCENT SERVENTY and ALEX BORTIGNON

M

First published in 1984 by
THE MACMILLAN COMPANY OF AUSTRALIA PTY LTD
107 Moray Street, South Melbourne 3205
6 Clarke Street, Crows Nest 2065

Associated companies in
London and Basingstoke, England
Auckland Dallas Delhi Hong Kong
Johannesburg Lagos Manzini Nairobi
New York Singapore Tokyo Washington Zaria

National Library of Australia
cataloguing in publication data
Olsen, John, 1928–.
The land beyond time.

Includes index.
ISBN 0 333 35705 1.

1. Western Australia — Description and
travel — 1976–. 2. Olsen, John, 1928–.
3. Painting, Australian. 4. Western
Australia in art. I. Title.

919.41′30463

Set in Bembo by Savage & Co. Pty Ltd, Brisbane
Printed in Hong Kong
Designed by Judy Hungerford
John Olsen's notebooks photographed
by Robert Walker and Henry Jolles

CONTENTS

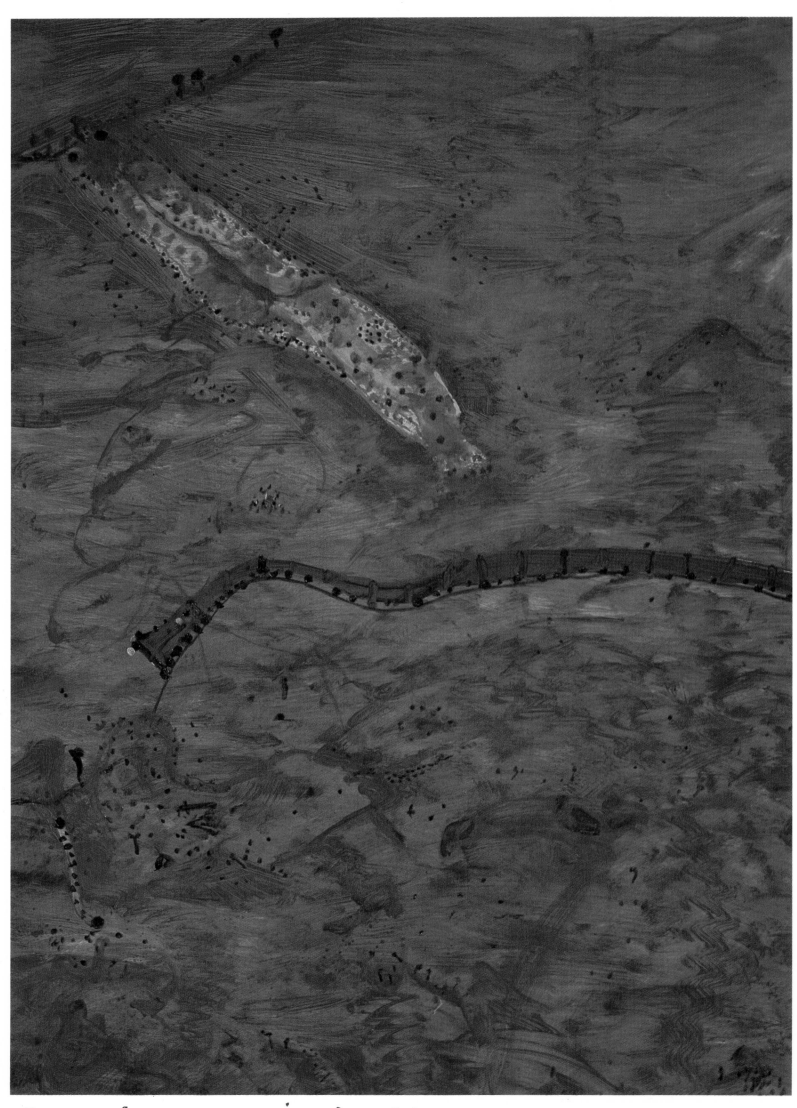

Hamersley Ore Train (Detail)

A NEW WAY INTO AN OLD WORLD

A PREFACE BY JOHN OLSEN

How strange it is that Europeans should ever have thought of Australia as a part of the 'new world'. When the first unwilling settlers arrived here they found themselves on a continent like a wrinkled brown raft, that had drifted away into countless centuries of isolation. The animals, plant life and landforms were so utterly strange to the settlers they could only think of them as 'new', whereas they had evolved since the beginning of time. The complex nomadic people, whose silent feet had trodden the vast landscape for some 35,000 years, had nothing in common with invaders from a much newer civilisation. The settlers felt there should be some point of reconciliation between what they found here and their own experience of the world, but it was as though they were struggling to learn a new language. Their descendants have managed to understand the nouns and verbs, but the subtleties of meaning still escape them. We are a new people on an antique continent, and we must do a lot more thinking and observing before we can piece this language together into the similes and metaphors which bring deeper understanding.

The object of our expedition to the North-West was to decipher a few more of the hieroglyphics in which this ancient language is written, and it was for this reason that the expedition comprised a diversity of talents. Each of us, in his or her own way, tried to solve some of the riddles of a land which is totally strange to the majority of those who live here. Australians lead a saucer-like existence, perched on the edge of their unruly continent, and their lives are like exotic orchids which have no relationship to the wilderness stretching between rim and rim. They wear the profile for the vast unconscious to which some unknown genius gave the marvellously evocative name of the Never Never.

Our expedition was supported by the products of modern technology, from four-wheel-drive vehicles to helicopters, and at places like Mount Newman, Mount Tom Price and Exmouth Gulf we witnessed the operation of some of the most sophisticated technology of space-age man. But the North-West is a territory of such extremes that technology seems little more than a pathetic gesture in the face of an immensity that will never change. Outside the fortresses of the mining towns we saw groups of Aborigines drifting across the ocean of golden spinifex, with their dark heads punctuating the ice-blue sky, following the same tracks of the hunter-gatherer as their Dreamtime ancestors. Falling into their gaze was like tumbling into thousands of years of being an Australian. We met farmers on the Ord River who somehow remained optimistic during their struggle to impose modern agriculture on an environment which has more weapons than technology can ever conquer. We visited missions where the effort to teach a new lifestyle to one of the world's oldest peoples is now fading sadly away. At Fossil Downs, we met the MacDonald family whose pioneer forebears travelled the entire breadth of Australia to create a great cattle station, and marvelled at the elegant homestead built by William MacDonald. Soon after our visit it was ravaged by a great flood. A century of civilised settlement means nothing to the immutable laws of the North-West.

Sometimes the landscape seemed so totally inimical to human invasion that it was like a snarling animal. When we entered the gorges of the Prince Regent River or flew above the massive rockfaces of that country, or stood on the beach of Careening Bay between the sea and the tangled wilderness of rock and scrub, one felt that technology was only a frail shield against disaster. Humans may find ways into such country but it is not really a place for humanity.

It has an impact which makes one strive continuously for familiar points of reference: to compare the complex of channels through the Wyndham salt flats to a gigantic nervous system, or the strange rock formations of the Bungle Bungle to abandoned Buddhist temples. It is as though the observer is forced to seek a key to their messages, but there is really no point in making such comparisons because the North-West remains unique: a territory with a fearful fascination and an unforgettable charisma which have no relationship to any other human experience.

In this book, each of the contributors has attempted to interpret the North-West in his or her own way, in an effort to translate a little more of the silent language of our country. For my part I feel greatly privileged to have participated in this venture, although I believe that the North-West, perhaps more than any other part of Australia, must make us conscious that we are no more than sojourners in this ancient land.

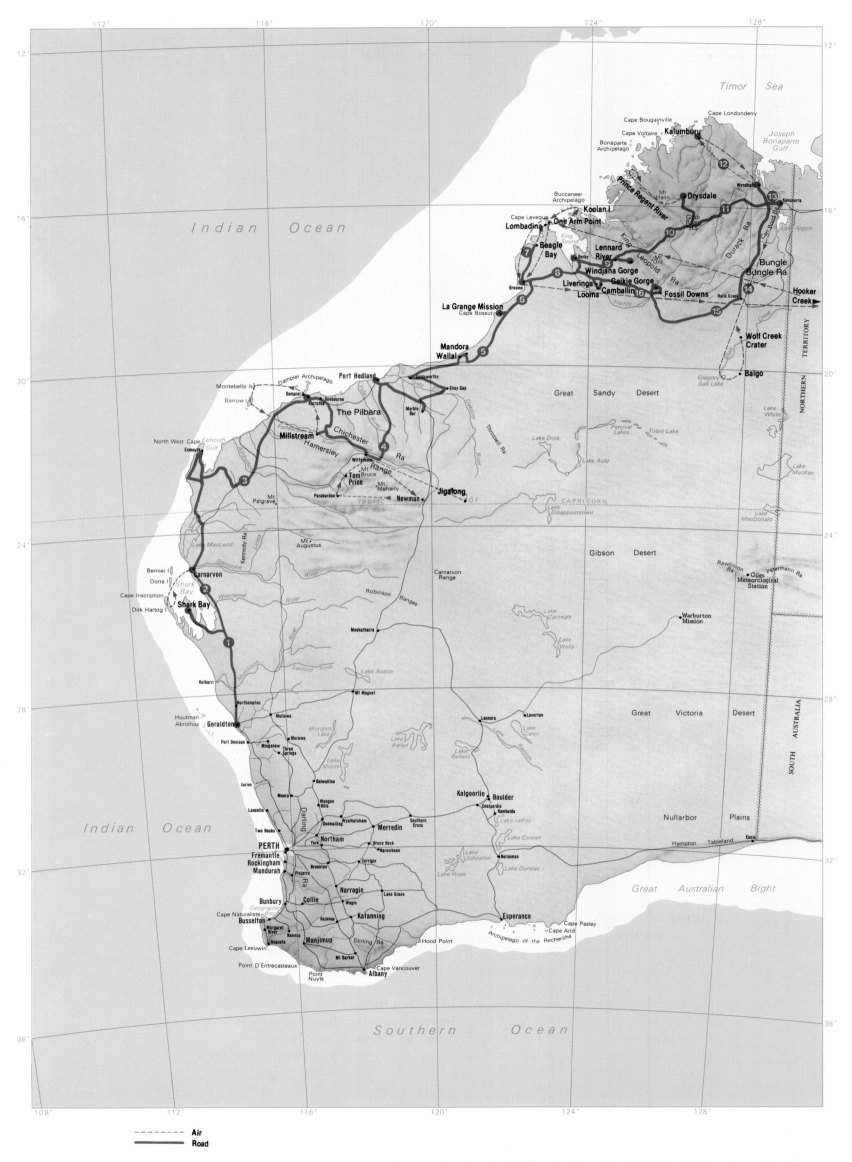

THE ROUTE

1 | THE NORTHBOUND TRACK

GERALDTON TO SHARK BAY

This book is the story of a journey through time and space as seen through five different insights: those of a painter, a photographer, a poet, a naturalist and conservationist, and a historian. It is a faceted view of a region unique in the modern world: the north-west of Western Australia. That territory exists in so many dimensions that it must be seen from a variety of perspectives, and this modern exploration was designed to capture its atmosphere through the hearts and minds of five different creative talents.

The adventure began as a concept by Alex Bortignon, a Western Australian art dealer and collector. He perceived that very few Australian artists, apart from the Aborigines, had had the opportunity to work in some of the remote, almost inaccessible parts of the North-West. Early explorers, and the settlers who followed them, had had to adapt to the harsh environment and they had little inclination to interpret it in any artistic form. Most painters of the region had worked in a representational style without any great depth of perception. Bortignon felt the time was ripe for a deeper interpretation, spiritual as well as physical, of a region still largely unknown. He told a Western Australian newspaper 'European landscapes have been honed and manicured by six centuries of fine poets, painters, and writers, but this hasn't been done in the North-West.

'The area just doesn't have anything to say to city people yet, because TV just slides over the scene.

'But with paintings there is time to dwell on the image: time to reflect on the nature of the land.'

Spurred by the vision that initiated the project, Bortignon began the daunting task of turning it into reality. His first need was that of interesting a sponsor in funding a carefully planned and properly equipped expedition to penetrate the North-West. He took his concept to Allen Christensen, founder of the Christensen Fund, who was fascinated with the project and agreed to support it. His intention is to include the paintings in the Christensen Fund Collection in the Art Gallery of Western Australia.

Bortignon's choice of painter was John Olsen, one of the most notable artists of the modern Australian school. He knew Olsen well, and was not only an admirer of his work but also familiar with such books as *The Artist and the Desert* with which John Olsen had been involved. Olsen had never painted in Western Australia or travelled in the North-West, and so Bortignon believed he would bring a significant immediacy and freshness to the work.

Olsen responded enthusiastically to Bortignon's approach, as did the three writers to whom Bortignon broached the idea. They were the poet and littérateur Geoffrey Dutton, the naturalist-conservationist Vin Serventy, and the historian Mary Durack, who has been acquainted with the North-West since her earliest childhood.

When Alex Bortignon had enlisted his creative team — including himself as the photographer — he had to launch into months of planning and organisation. The aim was for a tightly-scheduled operation which would cover as much ground as possible in a period of nine or ten weeks before the Wet. Mary Durack asked 'Why not travel by horseback or camelback like the pioneers? That's the real way to experience the country,' but in fact the pioneers were rarely able to penetrate the deepest recesses of the North-West. For that purpose the expedition would use helicopters or fixed-wing aircraft, and Bortignon had to organise the pilots and aircraft to be available at the scheduled times.

He had to ask permission for Olsen and the writers to visit Aboriginal communities which normally reject such invasions, and Mary Durack's relation Geraldine Byrne managed to persuade such communities as Jigalong to accept the visitors. For land travel in the outback it was essential to use four-wheel-drive vehicles — or 'bugles' as the Aborigines usually call them — and Bortignon organised the use of Toyota Landcruisers for this purpose. Two-way radio communication between the vehicles enabled the party to split up at various places but still remain in touch. Sophisticated camping equipment, including refrigeration, allowed the

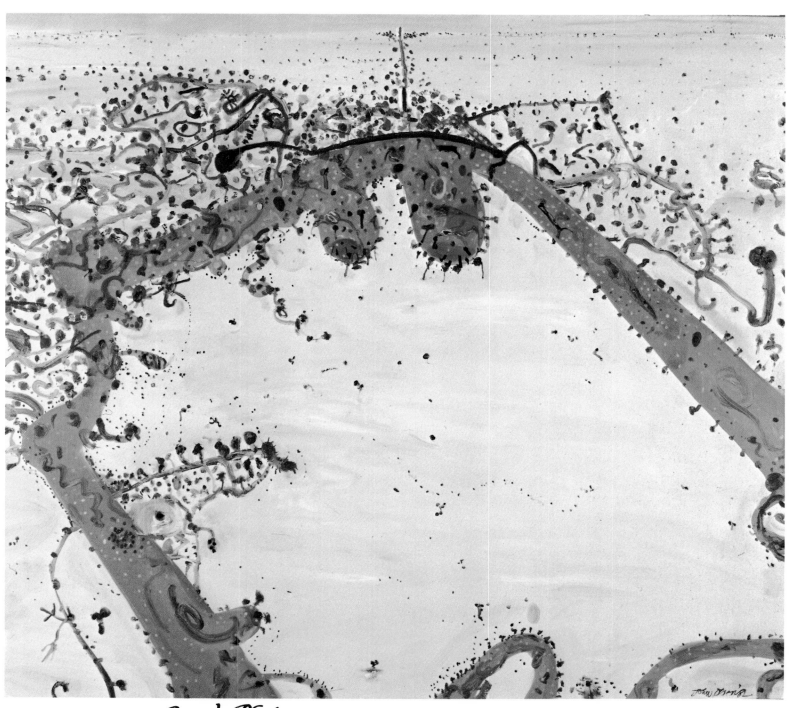

Geraldton Sand Plain

travellers to enjoy a modicum of comfort in the outback. There was no point in rough-and-ready living when the expedition members had to devote their creative utmost to every experience. As Geoffrey Dutton remarks: 'Our most essential equipment was our open minds and eyes. A journey can only be planned to a certain extent. It is transformed into an exploration by one's discoveries en route.'

In organising the expedition, Alex Bortignon had the experienced help of Mr Roy Hamilton, Director of the Department of the North-West, with whom he planned the itinerary, means of travel, and contacts to be made along the way. The project was appropriately launched at the Department's Perth office by Mr Peter Jones, at that time the Acting Minister for the North-West.

Allen Christensen met all the party before it set out, and Geoffrey Dutton recalls that he 'ironically warned of the dangers of lumping several prima donnas together for a couple of months. But, if we were prima donnas, then this also meant that we knew the game, and that the success of the project rested on hard work and not taking anyone's contribution for granted. It is really encouraging, amidst the dismal reports one reads of the selfishness of the human race, to be able to say that in ten weeks of communal living no member of the party ever left any chore for someone else to do. There is an instructive balance to these things which comes from experience as well as from human kindness. The toast got made in the morning and the potatoes got peeled at night but not necessarily by the same person each day.' This spirit of co-operation endured throughout an expedition which covered approximately 18 500 kilometres by land and approximately 11 500 kilometres in helicopters or fixed wing aircraft.

Five members of the expedition assembled in Perth late in the winter of 1982: Alex Bortignon, John Olsen, Geoffrey and Ninette Dutton, and Vin Serventy. Mary Durack writes 'I had heard it was to be a well-planned expedition using all kinds of modern technology, so that we could cover great distances in a reasonable time, but it all seemed too good to be true. I had not reckoned with the organising impetus of Alex Bortignon and the generosity of Allen Christensen, and the project developed so quickly that I could not leave Perth with the rest of the party but had to join them in Broome.' Carol Serventy also joined at that point.

Each member of the cheerful party had his own feelings about the expedition. John Olsen saw it as an opportunity to discover more about unknown Australia, and he wrote in his notebook 'What a fascinating place Australia is! When one thinks of the centuries of civilisation that have passed over China, India, and Europe and here you have a situation — still — in 1982 that most Australians are entirely ignorant of some parts of the continent, be it structure, wildlife, or the heart and soul of this beautiful old bronze raft that severed itself from the rest of the world, and slumbered in a ''dream time'' with its bizarre marsupials and its gentle Aboriginal people who believed that the landscape itself was the creation of their known world; a people whose art to this day is the finest yet done on the continent.'

Vin Serventy, who already knew the North-West very well, saw the adventure as an extension of his dedication to conservation. He writes 'Wherever I travel in this beautiful, fragile, and misused land I look on every building, human landscape, and natural environment with one thought in mind: ''Is this something we should keep forever as part of our heritage?''

'All things change, but nothing of beauty should ever be destroyed for a short-term gain. Some places are so lovely, so mystical, that they must be kept intact for the sake of their value to the human spirit. We are not inheritors and possessors of our land, but only stewards during our lifetimes.'

The journey into the North-West enabled him to compare the present with the past; to see how some things had changed, and others still remain almost secure from human intervention.

Mary Durack says that although she has been associated with the Kimberley region all her life the expedition was still a novel experience for her. It enabled her to cover parts of the country that she knew only from maps or by hearsay. She saw her part in the adventure as that of summarising the historical aspects of the North-West in relation to our changing times.

Geoffrey Dutton had made a previous extensive visit to the Pilbara and Kimberley areas, and 'This extraordinary country made such an impact that I longed to return. I accepted with alacrity the invitation to join the expedition.

'Although I have written many kinds of books I am basically a poet and I accept the strict demands which poetry makes on those who would write it. One of these is to preserve an openness to the correspondence between things and people and landscapes.

'One has to search for new equations to bring the reality of this north-west country together with the spirit of the place and the imagination it stirs in one. The Aborigines instinctively understood this. For them there is no single reality of rock and river, dingo or dancer. So I have tried not only to understand something of this strange country and the black and white people who live there, but to remain vulnerable, to surrender to the demands which the north-west makes on anyone who travels there.'

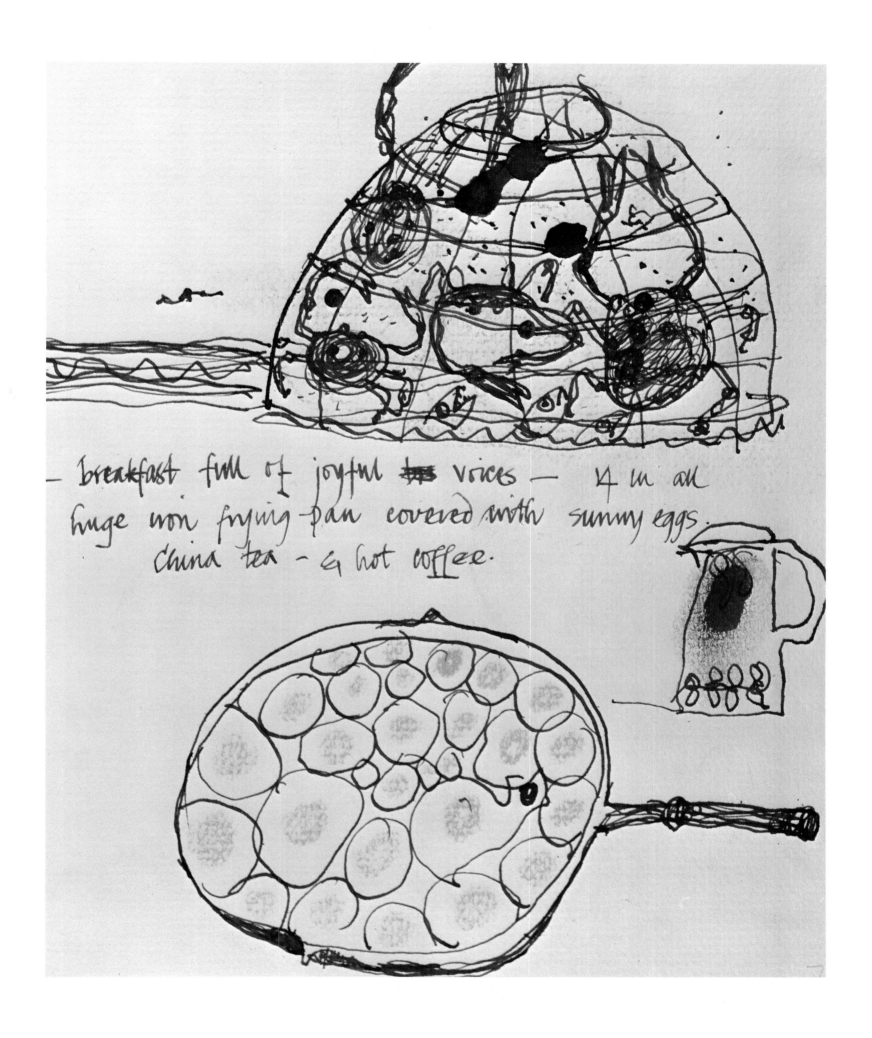

— breakfast full of joyful ~~the~~ voices — 4 in all
huge iron frying-pan covered with sunny eggs.
China tea — & hot coffee.

Apart from their commission to record the physical and spiritual exploration of the North-West, the three writers had another important function. It was to give John Olsen a 'running commentary' on the land and its people in a way which would deepen his own perceptions. On the track by day, and around the campfire by night, each of them drew from his or her knowledge and experience and offered the interpretations to the artist. They were like the guides and translators who help an explorer as he sets out on his venture towards an unknown region.

On 1 August 1982 the expedition drove north, bound for Shark Bay via Geraldton. John Olsen made the first sketches in his journal and wrote accompanying notes:

Fascinated by Vin Serventy's comments on a landscape which is wheat country, spread out in a green haze. Thousands of acres of it. The only original part left was a narrow strip by the side of the road: beautiful banksias, woody pears, blackboys, prickly moses (a spiky acacia). Vin told a story demonstrating how the Australian urge to simplify led to the name 'Spiky Moses'. The first impulse would be to identify it with a religious connotation, but not so. It was originally named 'Prickly Mimosa' and gradually reduced by muffled pronunciation to 'Prickly Moses'.

Our contact with the Aboriginal presence began in Geraldton. I cannot help thinking how they have been misrepresented as a race or a class — a vast generality. Here they are individuals as much as any of us. One of the worst aspects, be it conservatism or Marxism, is to lump humanity into classes.

Of the first two days, Geoffrey Dutton writes:

The roadside margins of Western Australia are among the wonders of the world. You drive through mile after mile of packed garden, with boring old wheat paddocks over the fence. The flowers are particularly magnificent because of the extra water they receive from the run-off from the road. These margins should be preserved for the people at all costs. They should also be preserved for Nature herself, as a kind of peace offering.

On this first day's drive we soon realised we were going to have exceptional travelling companions. In true Australian style, it became obvious that we liked each other because we were soon insulting each other. The poet Craig Powell gave lucid expression to this trait:

> *The men you work with bandy scabrous insults*
> *they are embarrassed by liking each other*

Vin, most informative of travelling companions, would call us on the two-way radio to comment on the trees we were passing, or on a flock of birds, or why the hills were shaped that way. Someone would say 'Thanks, Vin,' but John Olsen would cut in with some outrageous remark about Serventy's habits and prejudices. Thus pomposity went out of the window, and the pseudo-politeness of what John calls the 'boojoi' never dropped its saccharine into our tea.

We stayed the night at a Geraldton hotel, remarkable for a waitress who marched off while we were deciding what wine to order and came back with a couple of bottles, saying 'If you still haven't made up your minds it doesn't matter because we've only got Malbec.'

From John Olsen's notebook:

Arrived at Shark Bay in the evening. A very pleasant drive from Geraldton. Passed through the Murchison Sand Plain where Bob Juniper has done some very fine work. Though [it was] clothed in ghastly wheaty green, I was struck by the deep charcoal greens of the native shrub that Juniper reveals so well in those pictures. Earth pale Naples yellow with a touch of Venetian red. Noticed song larks and spiny-cheeked honeyeater. A jolly lunch with the beautiful chirping of song larks and Geoff Dutton's 60th birthday.

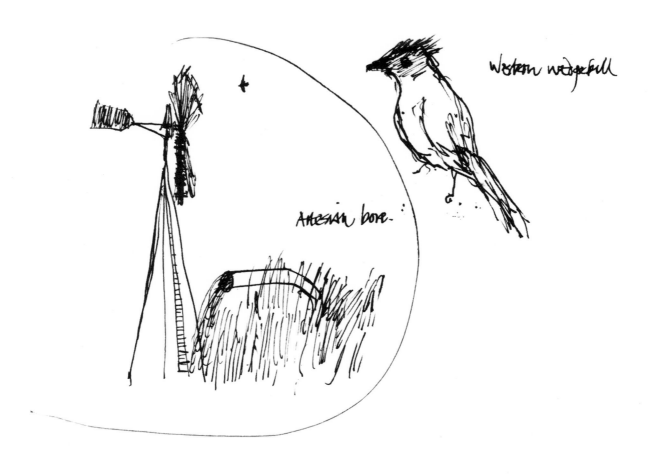

Western wedgebill

Artesian bore.

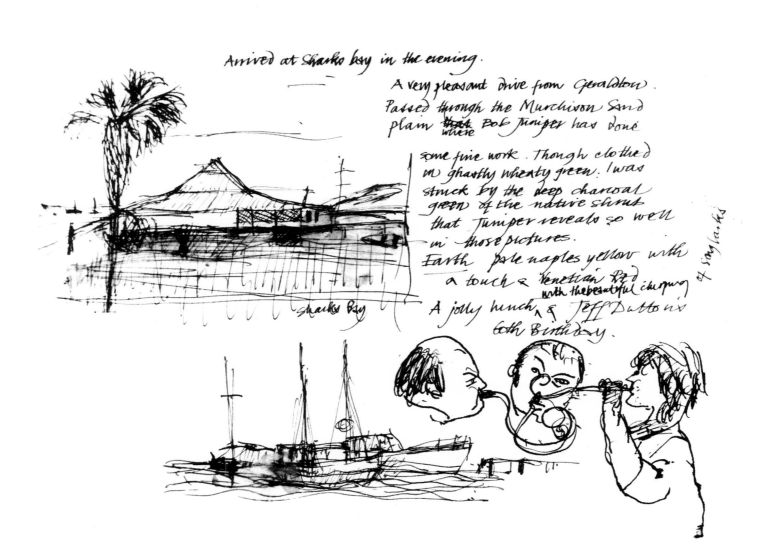

Arrived at Sharks bay in the evening.

A very pleasant drive from Geraldton.
Passed through the Murchison Sand
plain where Bob Juniper has done

some fine work. Though clothed
in ghastly wheaty green. I was
struck by the deep charcoal
green of the native shrub
that Juniper reveals so well
in those pictures.
Earth pale naples yellow with
a touch of Venetian Red
with the beautiful chirping of songlarks
A jolly lunch of Jeff Dutton's
60th Birthday.

Sharks Bay

Geoffrey Dutton recorded:

Despite the pastoral richness around Dongara and Geraldton, the country was giving nothing away except birds and flowers. The great lamps of banksias glowed on their long-leaved bushes, golden or pink grevilleas sank their hooks in air from bare branches, the double blue of leschenaultia had something of both sea and sky.

Past Geraldton and Northampton the road cut straight on through the scrub towards Shark Bay. At last we turned left past Hamelin Pool for Denham, where we planned to stay in the hotel rather than make camp so late. There was a signpost to what must surely be one of the most oddly-named places in Australia: Useless Loop.

The scrub hugged the earth lower and lower as we turned north-west up the treeless prong of Peron Peninsula, with the sea gleaming on both sides. A stupendous sunset flamed across Freycinet Estuary and Zuitdorp Point, with Dirk Hartog Island to the far north-west.

All these French and Dutch names, in English-speaking Australia, remind us of early explorers whose governments lacked the desire or determination to establish colonies on the coast of what Willem de Vlamingh called, in 1697, 'the miserable South Land'. Dirk Hartog was at the entrance to Shark Bay in 1616, the first of numerous Dutch contacts during the seventeenth century, but the French have left more names around here than the Dutch. Captain Nicolas Baudin's expedition, in the ships *Géographe* and *Naturaliste*, surveyed the coast from Cape Leeuwin to Shark Bay in the winter of 1801. Leschenault was the botanist and Péron the naturalist, Emmanuel Hamelin commanded the *Naturaliste*, and other officers included H.Y.P.P. de Bougainville, Henri de Freycinet, and Louis D. de Freycinet. In 1818 Louis de Freycinet commanded the *Uranie* on another expedition to the Shark Bay region, with two remarkable passengers aboard. One was his wife Rose, who smuggled herself into the *Uranie* and wrote a sparkling account of the expedition, and the other was the artist Jacques Arago. Among other drawings he left a sketch of an encounter with Aborigines who danced and waved spears at the Frenchmen, whereupon Arago responded by whipping out a pair of castanets and dancing to their tune.

It is an ever-entertaining game to imagine what Australia's history would have been if the Dutch, French, Portuguese, and British had all established themselves in different parts of the continent, as they did in Africa and India. Think of the variations on Irish stew and plum pudding! Think of the subtleties and excitements of architecture, and of the differing attitudes between the sexes, and, alas, of the inevitable wars, and of an even worse treatment of the Aborigines than that meted out by the British.

The whole Shark Bay area is symbolic of the fragmented and indeterminate impact of European civilisation on early Australia. Nothing remains of it but those French and Dutch names and the Hartog and Vlamingh plates — of which more later.

Apart from the tiny settlements around Shark Bay, and some other imprints of invasion, the coastline must have changed very little since the days of de Vlamingh and Freycinet. The sea will not have changed at all. The same huge tides rip out through Shark Bay as they did in 1772, when they swept away two anchors of François de Allouarn's ship *Gros Ventre* (who but the French could name a ship *Big Belly*?). The same towering surf pounds on the west coast of Dirk Hartog Island, which the men of the *Géographe* named 'The Iron Coast'.

Fortunately for we modern explorers, Shark Bay now offers more hospitality than those seaborne venturers could expect. We found it at the hotel in Denham, a modest little town on the west coast of Peron Peninsula. When we had settled in, Vin and John and I went into the bar to ask about tides. Vin wanted to show us the stromatolites in Hamelin Pool, which can be seen at low tide.

The racial mix along the bar was a reminder that Western Australia has close links with Indonesia and the Philippines, Timor and Malaysia. There was only one 'white man' drinking at the bar: a bearded Australian with whom you would be wise not to argue. The others included a man who looked like a Javanese rajah, a Filipino rake with sunglasses dangling on his chest, and a fat cheerful Aboriginal wearing a blue knitted woollen cap with a bobble. They were served by a beautiful part-Aboriginal girl with a soft smile and a firm lip, who knew them all by name, and a tough young bearded barman.

Vin launched in. 'Do you know when the tide's out?' Silence.

Vin persisted. 'Do you know what stromatolites are?'

He gesticulated to indicate a large dome with a smaller dome on top. The white Australian nodded towards the Aboriginal. 'Yair. Like Joe's head. 'nd all shit underneath.'

Joe led the laughter as the white man continued 'Tide's out at four. Stays out five hours. With this bloody southerly it'll be so low the dust'll be blowing.'

The dust does blow at Shark Bay, though not off the bay. The pub and the few houses are built of a rough stone of compacted shells, so soft it can be sawn into blocks not much heavier than house bricks. When freshly cut it is white, but the red dust blows onto it and hangs onto the rough surface.

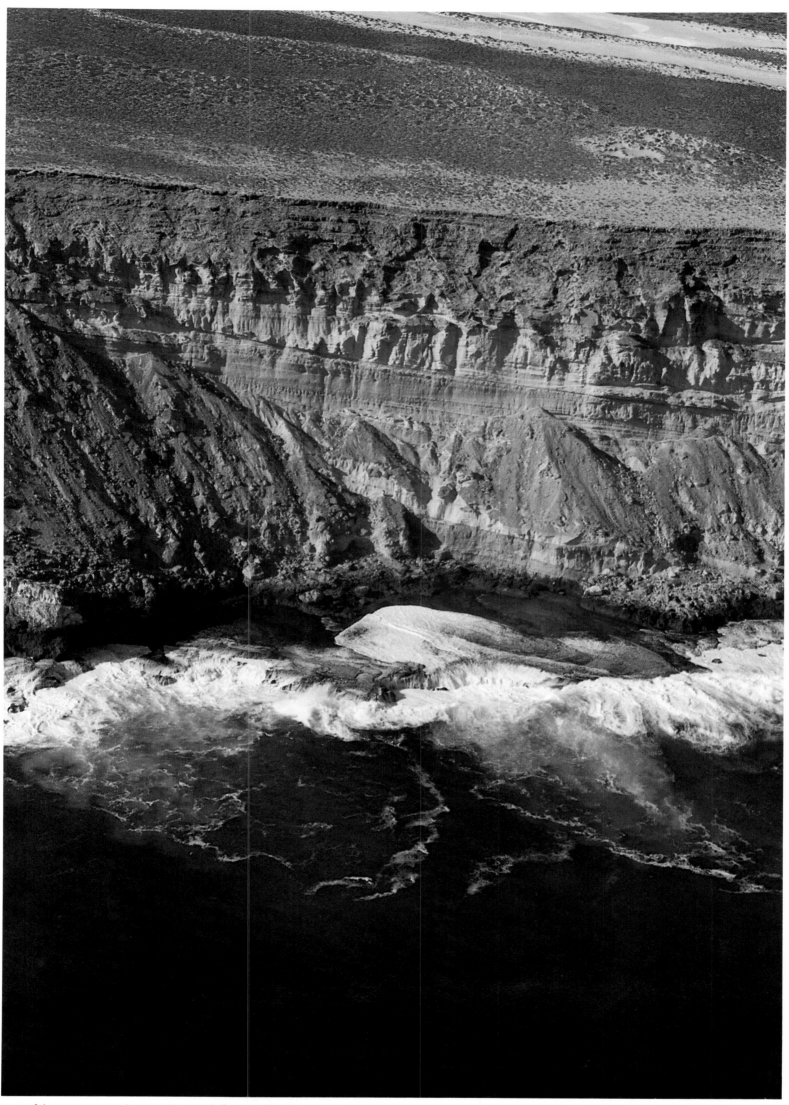

Most of the enormous coastline stretching north from Perth to Broome is low
and sandy. The vertical cliffs of Dirk Hartog Island, pounded by the Indian
Ocean surf, are among the exceptions to this rule

Vin Serventy was no stranger to Shark Bay. He writes:

More than thirty years ago I visited this settlement and stayed at the pub, where we ate by the light of hurricane lamps and a candle guided me to a comfortable bed. A ship's lantern creaked all night, rocked by a steady southerly.

In those days the streets were paved with pearl shell! When this was a pearling port, the local oysters were rotted down in evil-smelling 'pogie pots' so that the tiny pearls could be extracted, and the worthless shell was then used for road surfacing.

The mother-of-pearl road, glistening in the moonlight, was a reminder of a romantic past. Pearling began here in 1850, faded away because of over-harvesting, and then revived again until new dredging methods finally exhausted the oyster beds. A few pearlers struggled until the 1930s depression dealt the last blow to the Shark Bay pearling era.

Before we went to see the stromatolites we drove along the inner shore of Shark Bay to visit Monkey Mia, an old campsite of mine. The name always intrigued me because of its Aboriginal ring, but no one seems to know its origin. 'Mia' means hut or shelter to the Aborigines, but of course the word 'monkey' is meaningless to them.

Wherever I go I ask the locals how their home got its name, but it is surprising how few Australians either know or show any interest. So it was at Monkey Mia. Aborigines accept that every Aboriginal name comes from the Dreamtime and they always know what it means, but Monkey Mia is neither white nor black.

One theory is that pearlers with a pet monkey sometimes camped there, but that explanation seems a bit too trite. Another is that a monkey skeleton was once found there. If so, where did it come from?

I decided to write to that treasury of information, the Battye Library of Western Australia, in search of an answer. Margaret Medcalf, the principal archivist, told me that, in 1834, the ship *Monkey* went in search of a wreck at Shark Bay, supposedly that of the *Mia*. But she remarked cautiously that she could not confirm the name of the *Mia*.

A community of friendly dolphins has made Monkey Mia famous during the last few years. They swim into wading depth and allow visitors to touch, feed, and play with them. Shark Bay businessmen soon realised the tourist value of these ambassadors from the sea, but some permanent residents tend to deplore the flocks of tourists attracted by the dolphins. Their attitude reflects that of the people of Hippo, in North Africa, where a boy and a dolphin became friendly about 2000 years ago. Pliny the Younger recorded that so many people flooded into Hippo to view this phenomenon that they destroyed the peace of the little community, and so the residents slaughtered the friendly dolphin.

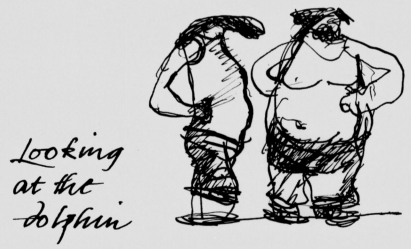

Looking at the dolphin

We found there was a regular feeding time at Monkey Mia, and that a hungry adult dolphin was swimming confidingly among the children and adults standing in the water. Alex Bortignon donned flippers and snorkel and joined in but the dolphin studied him warily, seeming to prefer humans who stay in their own element.

An unpaid official of the Dolphin Welfare Foundation welcomed us to the information caravan and gave us a pamphlet produced by the conservation group Project Jonah. This identified the creatures as Indian Ocean bottlenose dolphins and listed a few simple and sensible rules — including the delightful recommendation 'Introduce yourself to the dolphins and treat them as though they were people.'

Visitors are asked not to touch the blowholes through which the dolphins breathe, or pat the sensitive heads. Grabbing the tail or dorsal fin is apt to annoy a dolphin, and there should be no problem in following the recommendation 'Be gentle with them and they will be gentle with you.' I was especially fascinated by the comment 'If a dolphin gives you a fish, accept it with gratitude and don't give it back.'

Vin tells the story of an African village that had a similar tame Dolphin that became so popular that so many tourists came that they could not feed them. The elders in their wisdom decided to shoot the Dolphin.

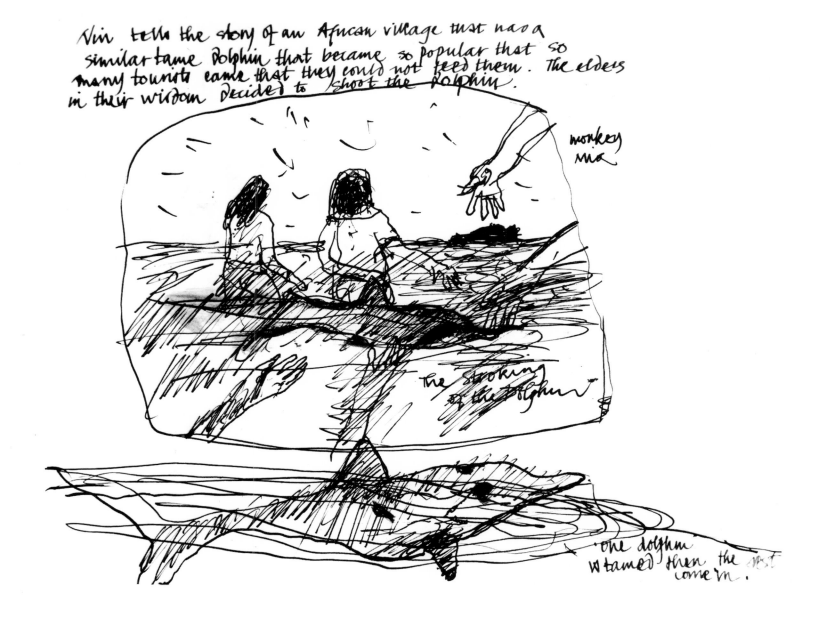

monkey mia

the stroking of the Dolphin

one dolphin is tamed then the rest come in.

It was encouraging to read that the Fisheries and Wildlife authorities have framed regulations to protect both the dolphins and their relatives the dugongs, for which Shark Bay is also a haven. One rule demands that fixed nets, which are killers of airbreathing marine animals, should be inspected at least once an hour. Shark nets have been banned entirely from Shark Bay, thus saving dolphins and dugongs from drowning by being caught in their meshes.

Geoffrey Dutton continues:

There were a lot of visitors to see the tame dolphins. No one has actually tamed them: they just enjoy playing with humans. First there was Big Charlie, who befriended local fisherman, and then Nicky, so-called because she has a jagged fin. Now there is a whole community. They are like a hospitable family welcoming you to their home. If you wade out knee-deep they swim around you and allow you to stroke them. They seem particularly to like children, of whom there were some this day from Tennant Creek with a family slowly making its way south. It was a scene of extraordinary peace.

From John Olsen's notebook:

An image of children and adults wading in the water eager to lay hands on the dolphins — almost biblical — strange and primitive.

From Monkey Mia the travellers drove to Hamelin Pool, which they had chosen as their first campsite so that they might see the stromatolites. Vin Serventy writes:

The sun glittered on the sluggish waters. It was late afternoon. There was no wind and the sea was an oily red. No birds disturbed the primeval silence. The lonely scene had an overwhelming aura of great age, somehow emphasised by the platforms of strangely-shaped black rocks breaking the surface of the water.

More than twenty-five years ago, I stood with Carol on this white beach and said 'If I ever make a film on the story of life on earth I shall begin it here.'

By an extraordinary coincidence, David Attenborough began his TV series *Life on Earth* on this very spot. The black rocks had by then been identified as stromatolites, which are survivors from the earliest lifeforms on our planet. Stromatolite fossils are among the most common fossils remaining from the ancient seas, and they have been found in rocks as old as 3.5 thousand million years, but living examples are rare. These in Hamelin Pool are the finest in the world.

Stromatolites are formed by a layer of one of the most primitive lifeforms, a blue-green algae, establishing itself on a firm base. Sand and shell fragments adhere to this layer, but the algae grows through the non-organic covering to form yet another layer of living organisms. The process repeats itself innumerable times, over hundreds or even thousands of years. The stromatolite layers build up at the rate of about half-a-millimetre a year, and gradually form themselves into a cabbage or club-shaped form.

The earliest stromatolites existed long before the evolution of other plant forms, and survived until the appearance of marine snails and similar complex animals. These fed greedily on the stromatolite pastures and consumed them everywhere except in such places as Hamelin Pool. Here, in an arm of the sea partly cut off by a sand bar, the dehydrating effects of sun and wind create water too salty for the comfort of most of the sea's grazing animals. Free from such predators, the stromatolites began their silent and immobile existence long before the coming of the white man.

Those in Hamelin Pool were identified in 1954. One of my students, Dr Phillip Playford, played an important part in their study and conservation. In 1973 a meeting of scientists recommended their preservation and they are now on the register of the Australian Heritage Commission. We hope they will be placed on the World Heritage register.

Wagons drawn by camels or horses once carried wool or sandalwood to be loaded by lighters in Shark Bay, and their wheeltracks may still be seen on some of the stromatolite fields. Fortunately the damage was slight, and these primeval plant forms survive to remind us of the days long before the dinosaurs.

Geoffrey Dutton saw the stromatolites as:

Little humps of flaking rock with rusty tops . . . the algae working away and to be felt as slippery under the fingers. I thought of the Greek legends, of life as Aphrodite emerging from the sea, and wondered why the Greeks with scientific correctness had picked on the sea as the source of life. John and I tried hard to find Aphrodite's presence in the stromatolites, but failed.

He continues with the story of the first camp:

Vin and Ninette and I went to the station homestead to ask permission to camp on the property. It was a comfortable old low-verandahed place, with a huge windmill working and the water flowing away into a reed-lined pool, the haven of some swans, whiskered terns, and ducks.

Mary Wakes, a young attractive blonde, granted permission for us to camp and hospitably asked us to come up later for a drink. We saw an ideal camping spot near the sea, but a truck and caravan bagged it first. We cursed, headed around the bay through the mulga and prickly acacia, and found a much better spot. John beamed on our enterprise, with the Panglossian

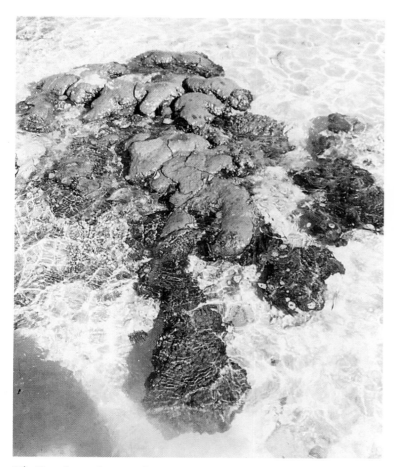

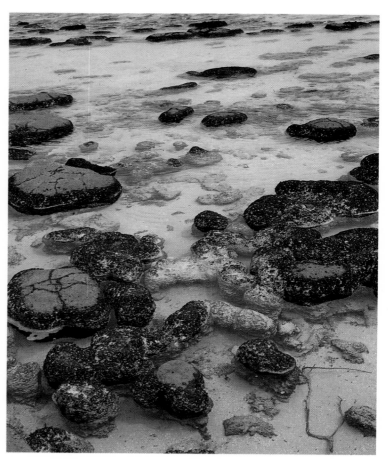

The Hamelin Pool stromatolites are survivors from the age of the earliest life forms on earth. Formed by countless layers of blue-green algae growing through sand and shell fragments, they are the finest examples remaining in the world

First identified in 1954, the extraordinary stromatolites in Hamelin Pool have been placed on the Australian Heritage Commission register. It is hoped the site will soon be included on the World Heritage register — moves that should aid protection of these pre-historic survivors

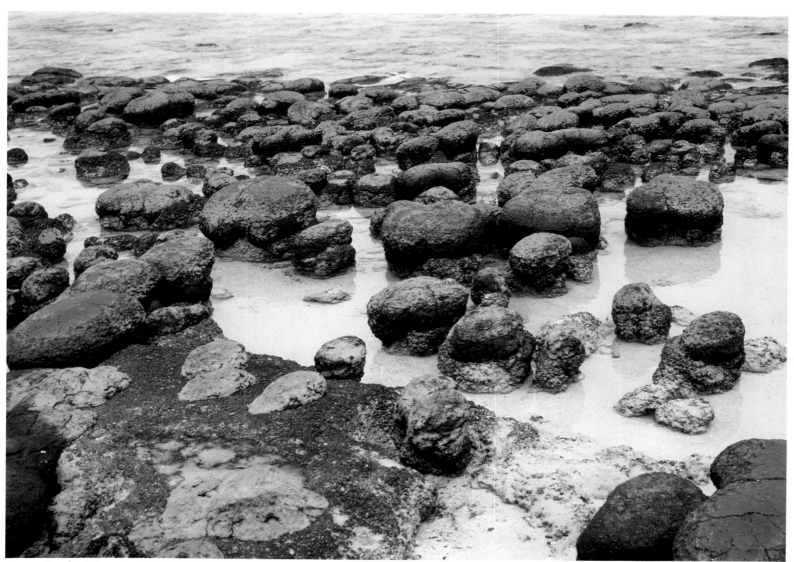

Stromatolite fossils have been found in rocks 3.4 billion years old but living examples are extremely rare. The Hamelin varieties have survived because the backwater pool is too salty to support the marine life which usually grazes on the building block algae. Stromatolites grow half a millimetre each year

comment 'All is for the best in the best of all possible worlds.' As a poet, I was frequently pleased by the passages of prose and poetry which were the gold coinage of conversation with Vin the scientist and John the artist. In many a crisis Vin would sigh 'Ah, the world is too much with us.' Once he confessed that his family had begged him to find another quotation, and I suggested a few but none was to his liking. As for John he is a catholic reader. He had brought a travelling library and he was immersed in Carpenter's biography of Auden.

Teachers and parents who no longer guide children to learn poetry by heart deny them both a pleasure in later life and a constant standard by which to gauge other writing. A poem stored safely in one's mind is like untarnishable gold.

After making camp we went up to the homestead and drank sherry with the Wakes in their enormous kitchen. Mary and Brian Wakes had been schoolteachers before they took the plunge into an entirely different life. They had 2000 square kilometres carrying anything from 6000 to 14 000 sheep, depending on the season. When they took over the station it was infested with feral goats, but these were worth thirteen dollars a head in Singapore and so they used them as their first cash crop. They rounded up 6000 in the first year and 3000, 1500, and 800 in each of the three successive years.

Stromatolites at Hamlin Pool looked to us like any sea shore boulders, but they are the oldest living fossils (some 350 million years), their growth is as little as 1m a year. Warm saline waters with a high evaporative rate is the reason for slaty organisms to flourish. Scarcely the place for the birth of Aphrodite — more akin to 'art brut') which scratched by a finger there was a slight algae feeling

The house was comfortable but Mary regretted that the water was too salty for gardening. They had had to choose between big old tamarisks around the house and a lawn to keep the dust down, and the tamarisks lost.

They came back to camp with us and shared the sumptuous dinner which John had left cooking on the fire. (Recipe: Put slices of groper and unshelled green prawns in a fish kettle with soya sauce, garlic, ginger, crushed Chinese black beans, a dash of whisky and a cup of water. Cook over the campfire and serve with rice.) We ate well in our camps. John had once been a professional chef and Alex's speciality was Chinese. They shared most of the cooking with Ninette although I helped out occasionally — and reached the nadir of my culinary expertise on the Prince Regent River. Vin declared a preference for eating rather than cooking, but he was a superb washer-up.

In the exquisitely delicate dawn there were the calls of the bush bell-bird, and the little wedgebill that carelessly asks 'Did-you-get-drunk? Did-you-get-drunk?' Well, some of us, perhaps, a little, on the night before.

Vin, always clearheaded because he never over-indulged, and a great morning firelighter, had cups of tea ready early. He and John faced the splendid rising sun and in unison recited J. L. Cuthbertson's 'Australian Sunrise', learnt at schools on opposite sides of the continent: John in Newcastle, Vin in Perth:

> The Morning Star paled slowly, the Cross hung low to the sea,
> And down the shadowy reaches the tide came swirling free,
> The lustrous purple blackness of the soft Australian night
> Waned in the grey awakening that heralded the light . . .

It was simple, but it was true; it paid tribute to the fundamental poetic qualities of waning night and awakening day. They ended fortissimo:

> And the bulrushes and reed-beds put off their sallow grey
> And burnt with cloudy crimson at the dawning of the day.

For the first of many times we packed and loaded our camping gear, policed the campsite, and started off again. On the way back to the main road we took on diesel fuel at the Overlander

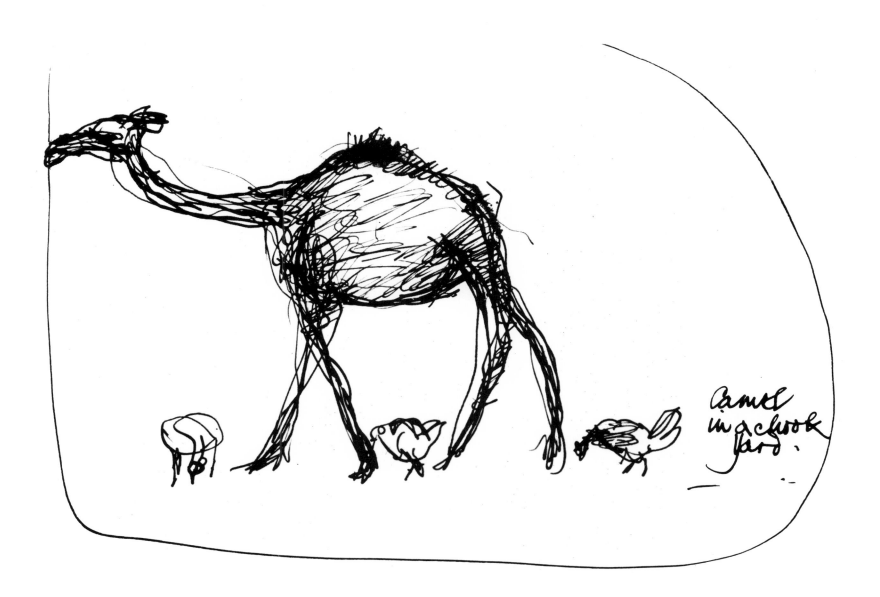

Camels in a chook yard.

Roadhouse. Mobile Australia was there in force, from brown young couples on overloaded motorbikes to an old, old lady who tottered on matchstick legs from a tour bus to the lavatory. Families on the wander in station wagons with laden roofracks, retired couples with caravans behind ancient Holdens, a pair of trendies in a Jaguar coupé which later passed us at around 200 kph — all on the move around Australia, all cheerful and interested in everything along the way.

Tourists can, of course, be as destructive as locusts, but they have also inspired old towns to spruce themselves up and rediscover their histories, national parks to be defined and protected, modern facilities to be established in places which once offered nothing but inhospitable pubs and rundown general stores. Paradoxically, the wanderers are a great stabilising force. As Flaubert wrote in 1858: 'In a few years mankind (thanks to new developments in locomotion) will revert to its nomadic state. People will travel the world from one end to the other, as they used to cross prairies and mountains. This will calm their spirits and inflate their lungs.'

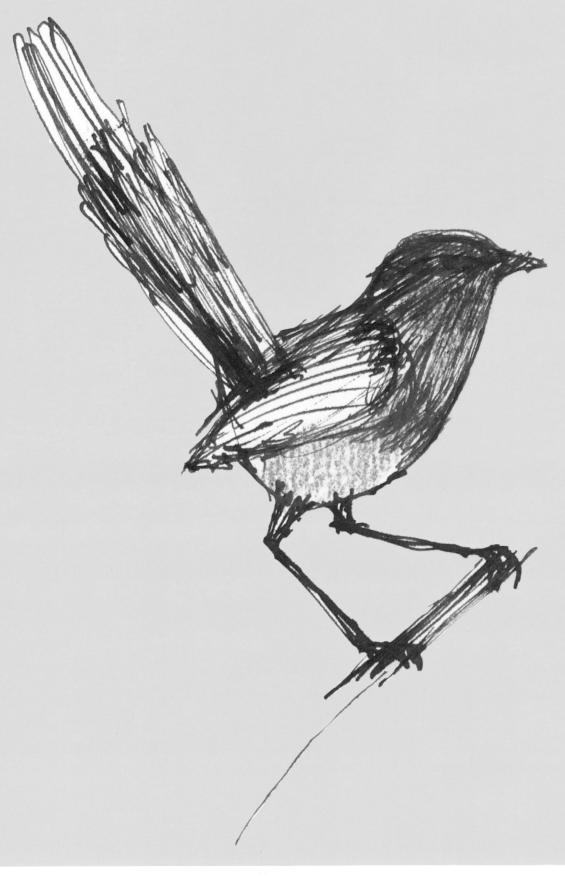

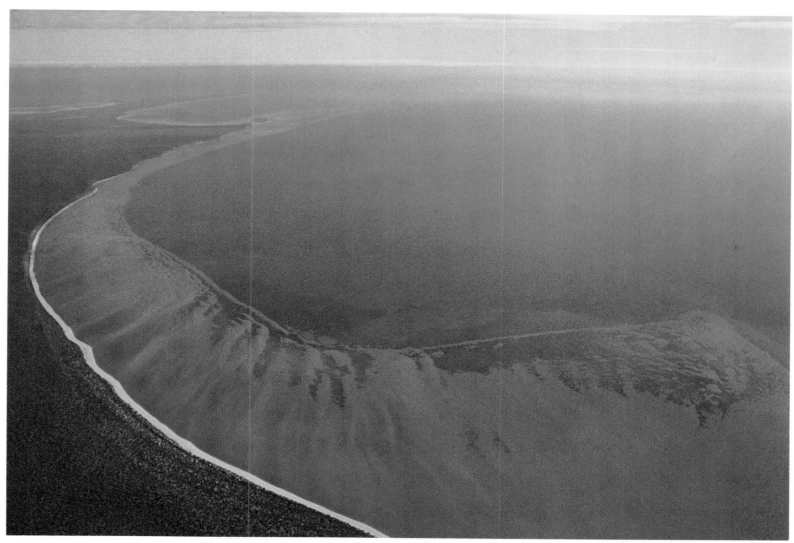

Above: The white sands bordering this stretch of Freycinet Reach form a
sharp rim between the turquoise waters and the harsh, scrubby bushland

Below: The sinuous patterns of coastline, currents and sand bars along the
Peron Peninsula seem to mirror the complexity of some Aboriginal designs

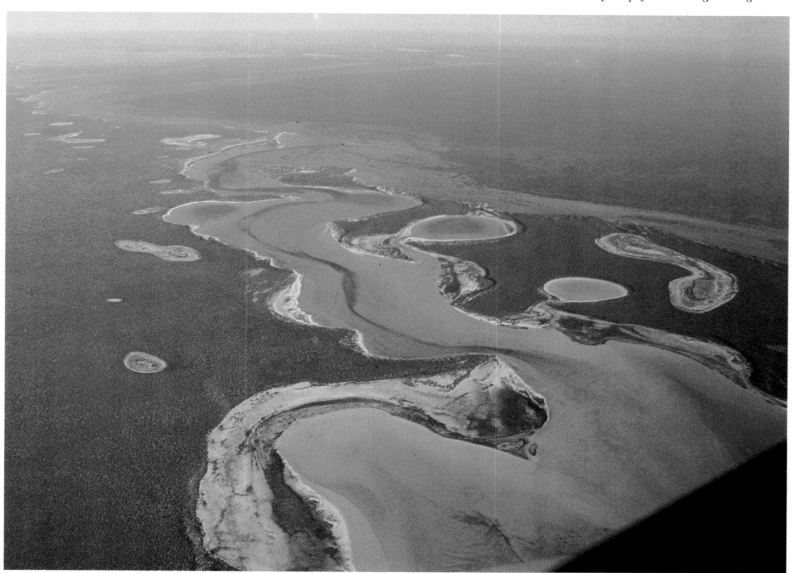

2 | 'IN THE YEAR 1616'

DIRK HARTOG ISLAND

The travellers returned to the main road and drove on to Carnarvon. John Olsen noted: 'An interesting drive through desert — the carnage of kangaroos on the road was quite sickening. Collecting the white bones of one skeleton.' From Carnarvon, the artist and writers flew to Dirk Hartog Island. Geoffrey Dutton writes:

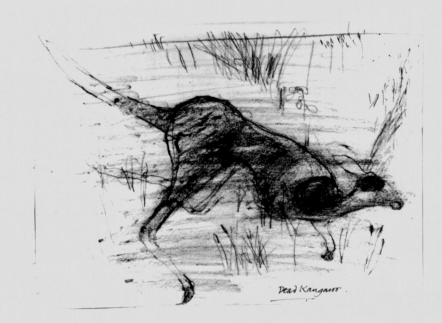

Dead Kangaroo.

To see the mysteries of the North-West, to understand their perspectives, one needs to fly as well as travel on the ground. This was certainly true for John, who was constantly ravished by the patterns revealed from the air. The first impression is of course the untouched immensity, the scale of it all. Then come the subtleties of colour: the speckled dark scrub on the deep red sandy soil of the mainland; the pinks and yellows of Dirk Hartog Island with its crumbling western cliffs and gnawing seas. Between Carnarvon and Dirk Hartog Island lie the elegant slim shapes of Bernier and Dorré Islands, lying back in the easy chair of the sea. From the air this appears to be spread over a strangely-striped bottom, like the pelt of blue and green tigers.

Only wallabies and birds now live on those two islands, but in the early years of this century they housed one of Australia's more disastrous experiments in the treatment of Aborigines. In an attempt to check the spread of venereal disease the authorities rounded up infected Aborigines and took the men to Bernier and the women to Dorré. When they were rounded up in the bush, they were chained together like a coffle of slaves to prevent them from escaping. Many died on the way to the coast and diseases spread among the survivors. In batches of forty at a time they were crammed into the hold of an old lugger and shipped across to the islands, where they arrived chained and stinking.

Daisy Bates visited the islands in 1910 as a government inspector, and she hypocritically reported to the Chief Protector of Aborigines that 'The work was extremely satisfactory.' But in *The Passing of the Aborigines* she wrote 'The horrors of Dorré and Bernier unnerve me yet . . . there was no ray of brightness, no gleam of life. In death itself they could find no sanctuary, for they believed that their souls, when they left their poor broken bodies, would be orphaned on a strange ground.'

Two Cambridge scientists, E. L. Grant Watson and the anthropologist Radcliffe Brown, also visited the islands in 1910. Watson, the author of several underrated books about Western Australia, has left appalling accounts of the Aborigines on these Devil's Islands of the Indian Ocean. Hospitals, sinisterly called 'lock hospitals', were established on each island, with a doctor and a white stockman in charge of each of them.

But Watson admits that life on the islands was idyllic for the two young scientists — although the ants were so ferocious that they even ate the men's toenails when they were sleeping. Sea breezes cooled the beautiful beaches and there was an endless supply of fish and turtles. Watson shed most of his clothes and became, briefly, a kind of hippie.

His memories are still relevant to the hundreds of temporary and permanent dropouts whom one finds around Australia's north, and in Western Australia especially around Broome. 'I felt

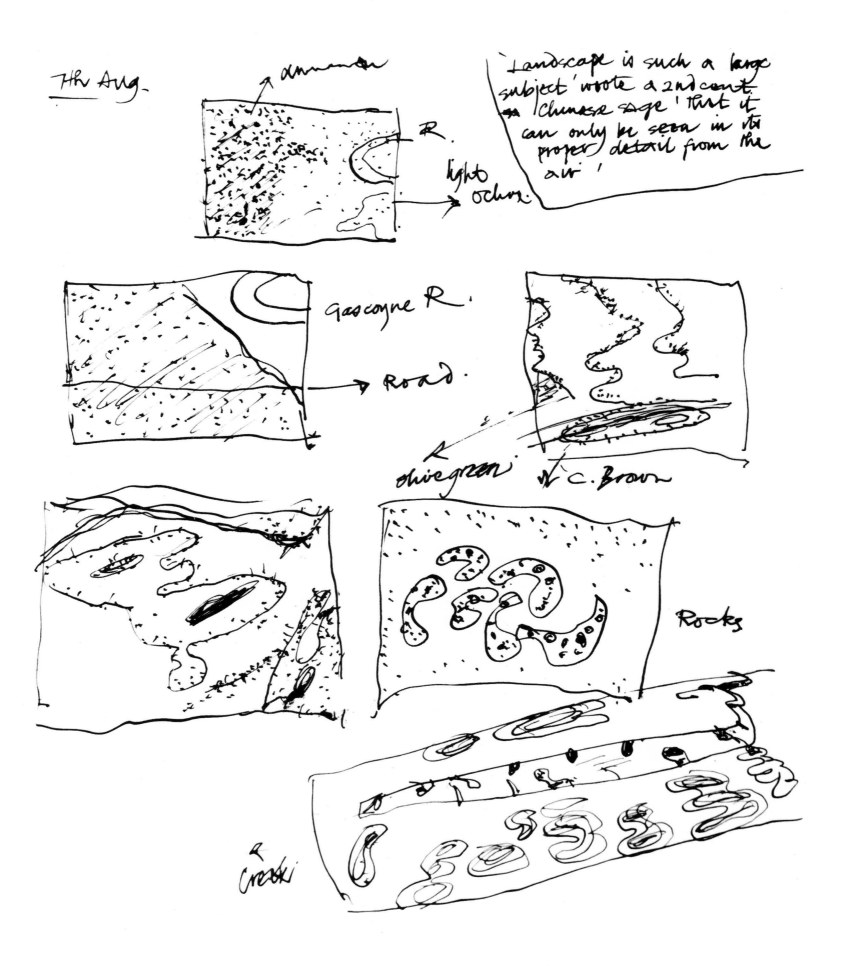

7th Aug.

dammar

R.

light ochre

'Landscape is such a large subject' wrote a 2nd cent. Chinese sage 'that it can only be seen in its proper detail from the air.'

Gascoyne R.

Road.

olive green

C. Brown

Rocks

R. Creek

myself grow closer to nature than I had ever been in England . . . a new sense develops, a rich experience that can only be had by men who live in warm climates. Clothes not only limit our appreciation of the world, they cut off whole ranges of sensation which, when developed, convey an awareness of the pervading serenity of which even civilised men can learn to be a part.'

Sir Thomas Wardle, an ex-Lord Mayor of Perth and famous as the founder of Tom the Cheap supermarkets, now owns Dirk Hartog Island. He was at the airstrip to meet us, with Tommy Drage his handsome part-Aboriginal stockman. Tommy was soft-spoken, and full of the kind of bush humour that is so quiet you have to listen carefully for it. Sir Thomas was genial, despite his battering by the financial world, and immensely hospitable. He had a Toyota Landcruiser which had been rolled on its way north and had only one window left apart from the windscreen. The wireless aerial was a length of fencing wire bent around the windscreen, which it constantly tapped and scratched. Tommy had a short-wheel-base Toyota utility.

We charged off up the bumpy track towards Cape Inscription, about eighty kilometres away. As we drove, Sir Thomas told us he had a barge and a speedboat on the island. In his palmy days he had a jet aircraft, then a Beechcraft Baron. Now he had no aircraft at all. As we bashed along in the Landcruiser, cartons of lunch leaped madly in the back to the crash of crockery. He said 'We'll stop at the next well and fix it' but he did not, and at lunchtime there were broken cups and jars, and everything smeared with chutney from a jar which lost its top.

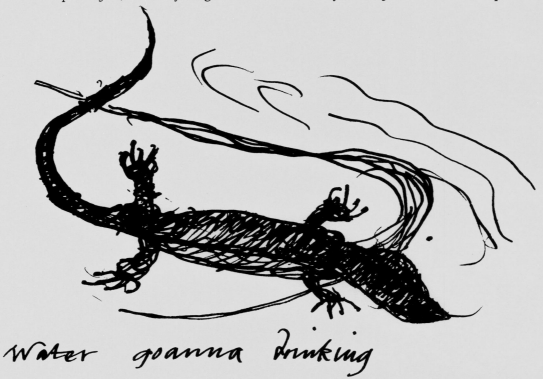

Water goanna drinking

We stopped at the old fort where British soldiers once guarded the guano deposits, then valued as fertiliser. Now, to Vin's excitement, ospreys were nesting there. The male flew obligingly up and down above us, with that heavy flap which sometimes converts to soaring stillness. There were three eggs in the nest, and we felt like privileged spectators when Vin told us that only four or five pairs of ospreys have survived in the United Kingdom. About 60 000 birdwatchers a year take buses to the north of Scotland to watch them through binoculars.

At last we reached Cape Inscription after our drive across the low, dry, hard and prickly island. But there were rusty-red bush roses and tiny lovely native foxgloves and blue dampier flowers to be seen along the dusty track.

The light on Cape Inscription now works automatically and the lightkeepers' cottages are abandoned, but we were more interested in the cleft in the rock which once held the first European artefact in Australia. This was a post set up to carry the inscribed plate left by Dirk Hartog, who sometimes spelled his name Hartoochs or Hatich.

In October 1616, Hartog landed on what is now known as Cape Inscription, set up the post, and nailed onto it a pewter plate inscribed '1616. On 25th October there arrived here the ship Eendraght of Amsterdam. Supercargo [first merchant] Gilles Miehais of Liege; skipper Dirk Hatichs of Amsterdam. On 27th do. she set sail again for Bantam [Indonesia]. Subcargo [second merchant] Jan Stins; upper steersman Pieter Doores of Bil. In the year 1616.'

Eighty-one years later, Willem de Vlamingh arrived off Cape Inscription with his exploration fleet of the *Geelvinck, Nyptangh,* and *Het Weeseltje.* He discovered the plate, replaced it with one recording his own visit, and took the Dirk Hartog plate back to Holland where it was lodged in the Rijksmuseum of Amsterdam.

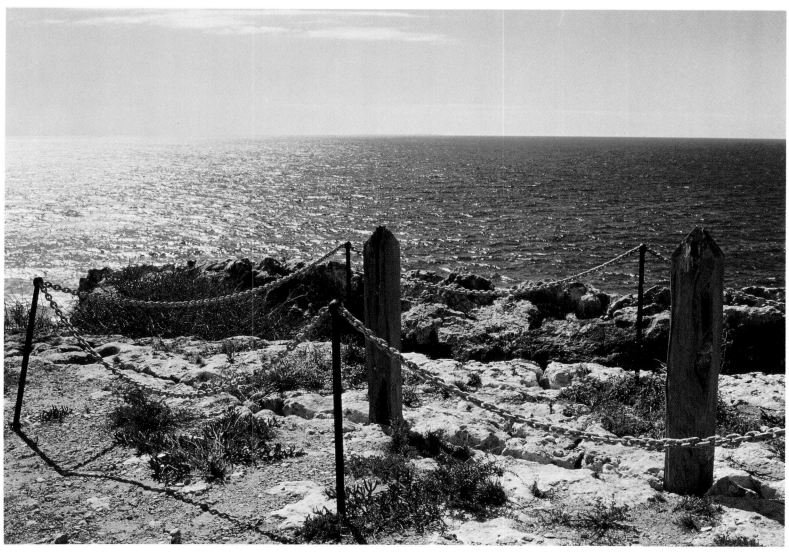

*One of the most significant places in Australian history: Cape
Inscription, Dirk Hartog Island, where the first white men landed*

It is bare and empty on top of the cliffs, looking south to the beautiful Turtle Beach. One can imagine those Dutchmen from their little wet country looking at the sunbleached rocks and the twists of snake-white mulga, and sailing away to continue their search for new territory which would match the opulence of the Dutch East Indies.

The Vlamingh plate faced the deserted sea for another 104 years, until Louis de Freycinet found it in 1801. He took it aboard the *Naturaliste* as a souvenir but Captain Hamelin ordered him to return it and affix it to a new post. When he returned in September 1818, as captain of the *Uranie*, he found that the post he had set up had fallen down. With a nice blend of Gallic practicality and regard for *la gloire* he decided it was 'unwise to leave the plate in an exposed position where it could be damaged or taken by irresponsible people,' and it was lodged in the Royal Academy of Inscriptions and Belles-Lettres in Paris.

After that it was forgotten until 1938, when R. A. Crouch of Victoria began enquiries which eventually discovered the plate in a cupboard of the Museum of Humanity in Paris. In 1947 it was returned to Australia and it is now in the Fremantle Maritime Museum.

The cleft in the rock on Cape Inscription should be a sacred spot for Australians but it is not appealing to the eye. It is enclosed by a rusty cable supported by metal posts eroded by rust, with bottles and cans and other debris lying around.

John Olsen sketched the lighthouse, derelict cottages, and coastline of Cape Inscription, and wrote in his notebook:

A forlorn and lonely place with no trees of any distinction and a wild surf pounding its rocks. Little optimism could be expressed for Australia's future in this place. European policy expressed as discover and forget. Quite impressed when Sir Thomas told us that Manning Clark had come here before he began his history of Australia!

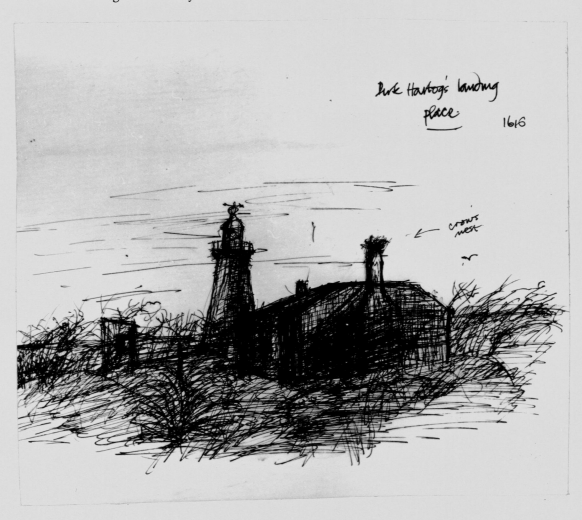

Dirk Hartog's landing place 1616

← crows nest

It was Vin Serventy's first visit to Dirk Hartog Island although he was familiar with its history and he was an old friend of Sir Thomas Wardle. He writes:

The desolate coastline did not deter squatters. In 1868 the sandy shores saw an invasion when the pioneer settler F. von Bibra obtained the first lease, and sheep have been pastured on the island since that day.

Nobody seemed to care that the island, like much of the North-West, is marginal land and only just suitable for sheep. C. E. W. Bean summed up contemporary attitudes when he wrote in 1909 '. . . no one makes a friend of a sheep, any more than he would of a sixpence. They are counted over like so many bank notes. That is all. They are fed because feeding pays. From his lambing until he is killed or dies of starvation, the sheep is just a counter in his owner's wealth . . .'

Dirk Hartog Island has suffered under the onslaught of as many as 20 000 sheep, although Sir Thomas runs only 4000. Sheep on the island, with its huge areas of sand drifts and its low vegetation, must often have had to struggle for survival. At least they did not have to compete with rabbits, which have been held back by the sea. But cats and goats were brought in and have become feral, and house mice slipped in unnoticed. All these competitors soon overwhelmed the native banded hare wallaby and the boodie, which became extinct.

When we landed on the airstrip I was at first surprised that Sir Thomas was not there to meet us, until I realised that he was the youthful-looking man who stepped forward to greet us. He has been rejuvenated by an idyllic life on the island and he is attempting to bring a similar rejuvenation to Dirk Hartog. As we drove to Cape Inscription he pointed out the spot where eleven banded hare wallabies were kept before their release in 1977, as part of a programme to restore the island's original wildlife. I was keenly interested because I had been fighting for this conservation attempt for many years.

It was a moving moment when we stood on Cape Inscription and looked down on the spot where Dirk Hartog and his men landed more than 300 years ago. Later, I wrote to the Director of the Australian Heritage Commission to ensure that the whole island is on the Heritage Register and that damage to the historic well near the lighthouse will be repaired. I was glad to learn that the island is indeed registered and that the well is to be renovated.

For me, the highspot of our visit was the sight of a breeding colony of about 1000 pairs of pied cormorants. The guano odour of seabird colonies is an unforgettable smell for me because so many of my happiest memories are linked with seabird islands. An old sweater impregnated with the smell of shearwaters is enough to engulf me in a wave of nostalgia.

The pied cormorants were a delight. From the clifftop they looked like black and white penguins swimming in the clear blue water. Nearby a nesting osprey watched us with apparent interest and little sign of fear.

Geoffrey Dutton also was impressed by the cormorant rookery:

Vin bounded ahead towards the cliffs, snuffing the acid air, scientist's enthusiasm aflame. Later he told me 'If they made a guano perfume no woman would be safe from me.' It was a marvellous sight when we looked over the edge down to the sea, with thousands of birds and nests and chicks on the cliff face and gulls flying over and round them. There was a perpetual sound in the air like rustling straw. The chicks, fluffy and plump like little penguins, wobbled their beseeching necks. Eggs were exposed in the high nests, above the white rocks plastered with guano and the black rocks of the coast. A few hundred cormorants were dotted on the sea and their squirtings made milky clouds in its pure blue and green.

We had tea with Sir Thomas back at the homestead, a straight row of rooms in an idyllic setting by the sea, and then took off to fly back to Carnarvon along the wild west coast where 200-metre cliffs slope and crumble into the lashing surf. How complex the island's relationship is with the sea. On the eastern side there are strange and lovely sandhills, spreading in soft sensuous curves like a blonde girl's belly and flanks, reaching out to the sea and enclosing it in little lagoons. On the western side the ocean is eating great pieces out of the land.

Turning over Cape Inscription we flew over the sinister hump of Dampier Reef. The pilot said 'Look' and I thought I was gazing down at another reef until I realised that no surf broke upon it. A school of humpback whales lay in the water, with one gigantic fellow showing the full curve of his tail, just snoozing in majestic peace.

Pelican
landing

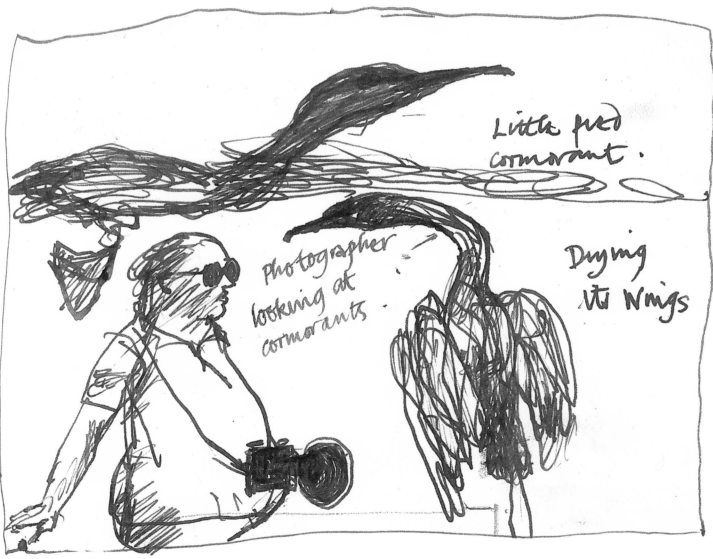

Little pied
cormorant.

Photographer
looking at
cormorants

Drying
its wings

3 | THROUGH THE SPINIFEX

CARNARVON — MANDU MANDU — THE SPINIFEX COUNTRY — KARRATHA

The expedition left Carnarvon behind schedule because of a problem with one of the vehicles. Geoffrey Dutton writes:

While electricians were trying to find the trouble we flew over and around Carnarvon. The Texada salt farms, where industrial salt is produced by dehydration, looked like enormous works of abstract art. Long rectangles shade from chocolate brown to pink; from green to blue and silver. Mondrian and the New York abstract school would have gone berserk over them.

From this rectangular purity we flew back across the thick green fertility of the irrigated fruit and vegetable farms along the Gascoyne River, and over the huge dish of the Satellite Communications reflector.

Because of the vehicle troubles we left very late. The northward road through the semi-desert was lined with dead kangaroos hit by cars or trucks at night. The crows and eagles and foxes deal with them, starting with the eyes and throat, the guts spilling out, sometimes a foreleg lying ten metres away with a little black silky five-fingered hand closed on air.

It was perilously late when we turned down the rough road to Ningaloo Station. Alex Bortignon, who was making a flying visit to Perth, had told us that the Cape Range ranger would meet us at Yardie Creek and show us a good campsite but Yardie Creek was still eighty kilometres away.

There is only one thing worse than making camp after dark and that is making a night camp in treeless spinifex country. An enraged sea of spinifex spikes, with hardly a bush for firewood, rolled on either side of the track as we sped on towards the setting sun. We passed the lighthouse and the old lightkeepers' cottages and pulled up at Ningaloo Station to ask for directions. A fine big woman whom you could have trusted in any bush emergency told us that the track was very slow, and confirmed what one of us had noticed on the map: 'At Yardie Creek normally impassable.' She told us 'It can be treacherous, but you'll get through if you're lucky with that trailer. You could camp in the woolshed but it's full of fishermen from Perth.'

One of the fishermen was shaving outside the woolshed as we drove past. He was burnt to the colour of old jarrah and one wondered how the whiskers ever forced their way through his skin.

We hastened at a maximum speed of thirty kph over the rough track, hoping for a camp. There were kangaroos everywhere, the young ones sitting up with their paws folded and looking so demure. At least the spinifex had thinned out a little as we came down off the plateau.

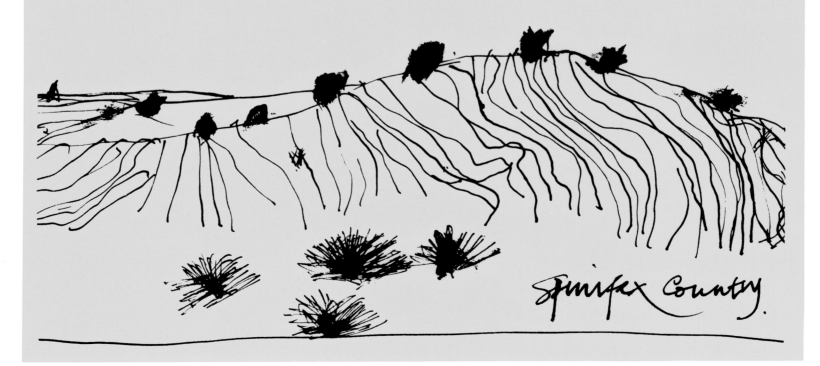

Spinifex Country.

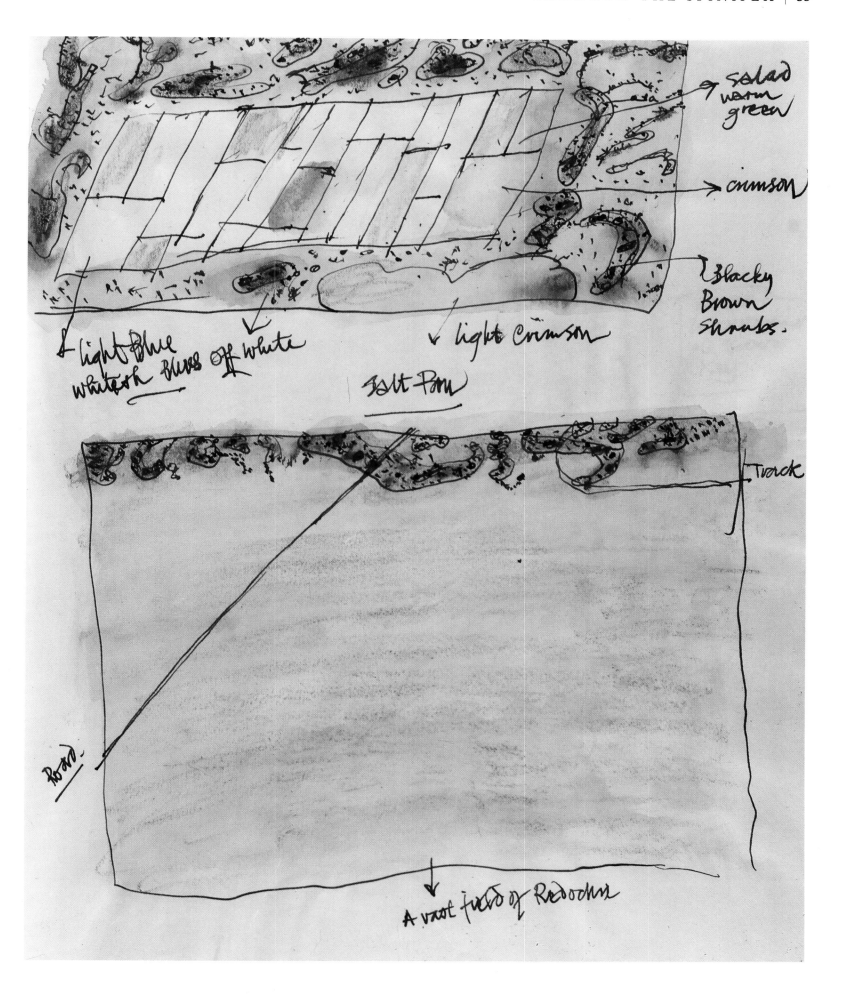

salad warm green

crimson

Blacky Brown Shrubs.

light Blue whiteish Blues Off white

light Crimson

Salt Pan

Track

Road

A vast field of Redochn

DEW IN THE DESERT

In the desert, in the spinifex desert,
There are no cool answers to the questions of fire,
Only needles of doubt that hurt
After piercing, like a memory of desire.

Nature is unkind. Malignant signs
Haunt the anxious traveller through this land,
Like millions of echidnas raising their spines
In fear along the ribs of sand.

No water, not a trace,
No cry nor tongue. The land ends
In a distant dialogue of reef and sea
But where the desert plateau descends

There's a little dry creek, the track
Of a sharp bird, a blunt kangaroo,
The spinifex was held back
By water, and a bent tree grew.

At dusk the spinifex lifts soft ears,
Kangaroos are watching, demure
Front paws folded. It appears
That nature outside man is pure.

In this little nest of miracles the night
Rises like black smoke, where the sun
Dies in the sea, and the next bright
Paradox is the stars that have begun

To heighten the desert, spinifex, ribbed sand.
Ultimate dryness has its confirmation
In the rising moon, filling the hand
With salt. Nature is desolation.

Only man needs a heaven,
The rest of creation is certain of delight.
The evidence is already on fur, even
On spinifex, diamonds threaded by moonlight

Hang over the desert, and the falling
Dew has the blessing of the sea. All over
The drenched ground there is a silent calling
Of hope to life, beloved to lover.

The moonlight was not salt after all, lick it
And it's cold, pure water.
In the spinifex only man is wicked.
If nature is mother, dew is her daughter.

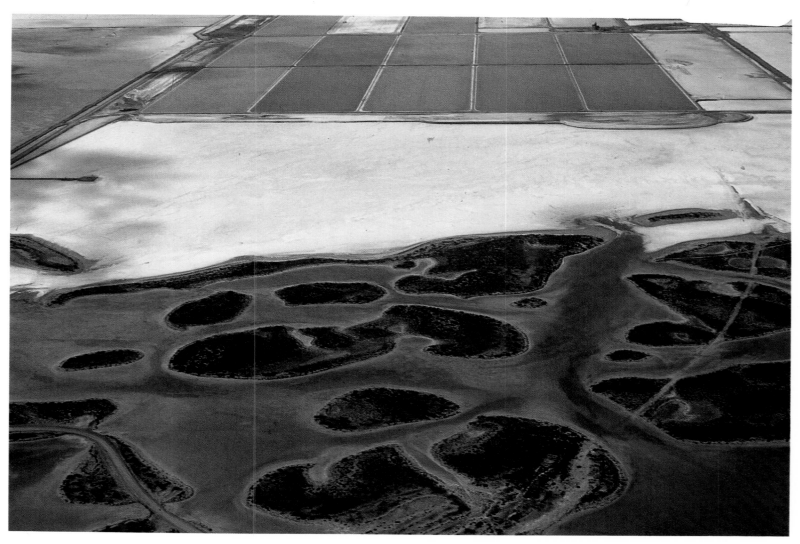

Above: The rectangular shapes of the Texada salt farm at Carnarvon, where industrial salt is produced by dehydration, stand in sharp contrast to the ancient patterns of salt flats and islands among the tidal flats

Below: The travellers thought that the salt farms of Carnarvon, seen from the air, resembled the abstract painting of Piet Mondrian. The colour variations are caused by differing degrees of dehydration, the water's varying chemical content, and the ways in which sunlight is absorbed or reflected by water, salt and earth

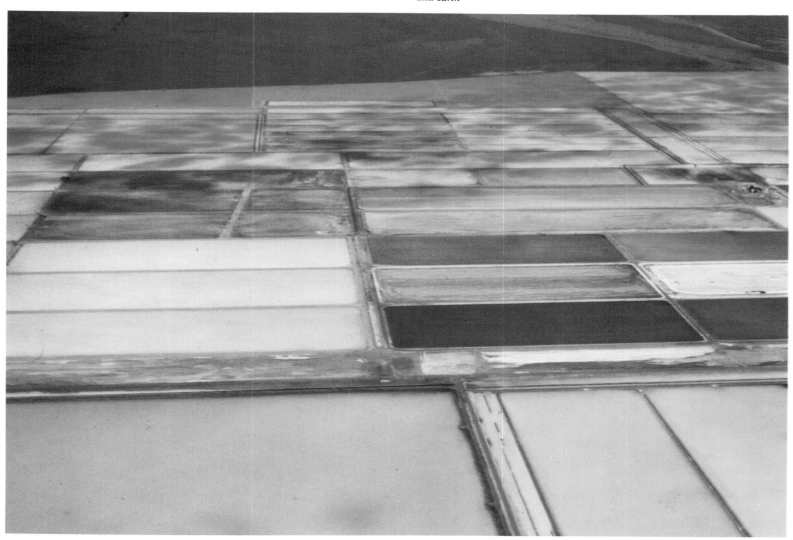

Emus patrolling the cyclone fence NW Cape

Vin Serventy continues the story:

Suddenly I saw a flash of white — a 'blowout' in the sand, that would at least allow us to walk freely among the porcupine-like ramparts of the spinifex.

With the vehicles churning over the rough ground in four-wheel-drive we soon arrived at a delightful dry watercourse fringed with sand dunes. The hollow was covered with a lawn of closecropped grass.

Such 'kangaroo lawns' of the outback show where red kangaroos have nibbled at the green pick which they love. The kangaroo treads softly on the Australian earth and eats delicately, so that both the soil and the plants are conserved for another day. The chisel-like hooves of sheep break up the soil and their tearing teeth sweep like vacuum cleaners over the landscape. In the catchment area of the Gascoyne River more than half the country has been drastically degraded by sheep grazing and fifteen per cent is badly eroded. A third of the country is in reasonable condition but much of the region is dangerously close to the point of no return. The waters of the Gascoyne are essential to the survival of Carnarvon and to the banana growers who tap the underground supply, and so the State government has banned stock from some areas and halved it in others. Such regulations can keep sheep and cattle in check, but they can't control that perennial pest the rabbit. It remains public enemy number one and is steadily increasing the deserts of Australia.

In the old days many of the desirable forage plants were long-lived and often lasted for more than a hundred years. Sheep and rabbits have destroyed most of them but the cuts in stock rates might allow some recovery.

The grasses loosely called 'spinifex' are almost useless for stock although they nourish many native animals, shelter them from the sun, and provide a coward's castle to protect them from hot pursuit. These tough plants, armed with a bristling frieze of needle-like leaves, cover more than a third of our arid areas. There are over thirty different kinds and they belong to two plant groups. They should be called porcupine grass, because spinifex is mainly a grass of the beach dunes, but the name is so well established for the desert grasses that it is unlikely to change. *Porcupine Grass and Sand* would not have the same ring as *Spinifex and Sand*, the title of David Carnegie's classic book of desert exploration.

This grass provided the Aborigines with one of their most important products, spinifex gum. They gathered it by beating the leaves into tiny fragments on a flat rock, then passing a firestick over the particles until they melted and ran together. Another method was to burn spinifex clumps and collect the mixture of ash, sand, and gum globules into the wooden bowl called a yandy. By skilful winnowing the women separated the gum from the ash, in a 'dryblowing' method learned through the need to separate grass seeds, used for food, from chaff or soil. A ball of spinifex gum was a treasured possession, used to fasten the stone heads of weapons to the shafts. When running repairs were needed, a little heating softened the gum for use.

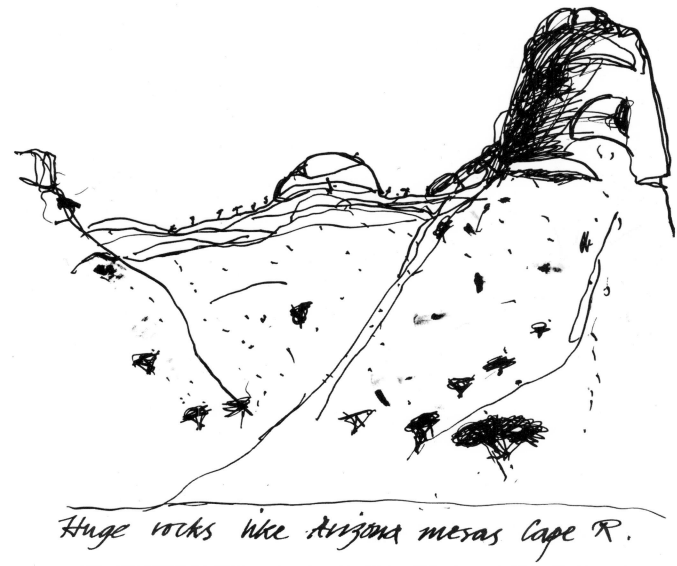

Huge rocks like Arizona mesas Cape R.

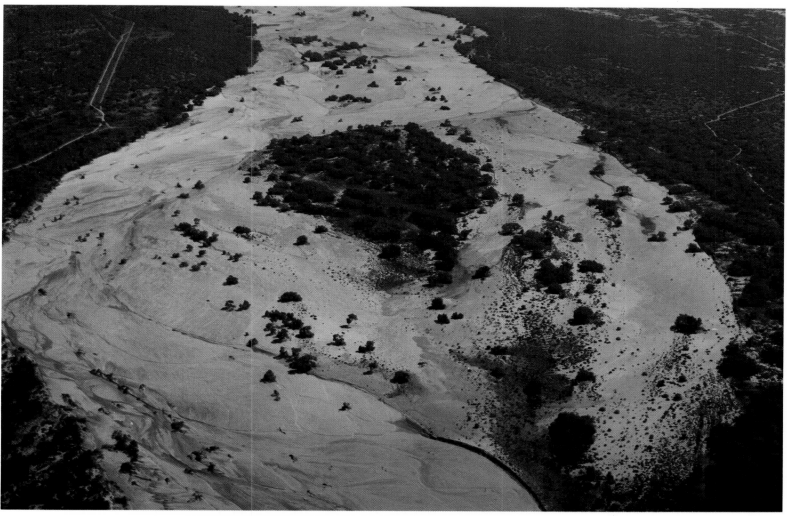

This river of red sand is the Gascoyne River near Carnarvon during the dry season. Subterranean water brought down by this and other waterways irrigates the farms and market gardens in the area. During the Wet, the Gascoyne often floods, spreading relentlessly across the lowlands

Unlovable as spinifex is when one is walking in shorts through the desert country, it surrounded our camp with a shimmering sea of golden grass in the early morning light.

We enjoyed breakfast and billy tea in the dry watercourse but this was still dangerous country. The Aborigines took thousands of years to learn the survival skills demanded by such arid areas but many of these skills are now being lost. I told the story of two Aboriginal boys who died a few years earlier when they tried to walk 150 kilometres from an out-station to a settlement. They had not been taught the desert lesson 'Never walk in the heat of the day.'

The Aborigines are not alone in the degradation of their lifestyle. Indigenous peoples all over the world have suffered from pressures similar to those which destroyed the ancient patterns of Aboriginal society. Nevertheless the process seems even more appalling in Australia because new discoveries are pushing our Aboriginal history even further back in time, into a possible relationship with the earliest forefathers of humanity. In Lake George, near Canberra, excavations have unearthed charcoal deposits which have been carbon-dated as 120 000 years old, and these seem to me to be strong evidence that the Aborigines arrived in Australia at least that long ago. Fires are very rare, anywhere in the world, unless man is present.

Some researchers believe that the Australian plant scenes which we know today became established about 8000 years ago, after a period of extreme aridity which lasted for about 50 000 years. It seems likely that the central regions of the continent may have been too harsh for human occupation until comparatively recent times, and that the desert people may have established themselves much later than the coastal Aborigines. If so then it may explain the similarities between desert tribes over such an enormous region, by contrast with the diversity of Aborigines in more favoured areas.

It may be that the pattern of Aboriginal settlement was a kind of prototype of white settlement in the arid regions, with comparatively small groups pushing further and further inland. The whites, in their eternal greed for land, thrust determinedly into the desert and often thought they had found good country because they saw it first when it was blooming after a good season. After that they had to struggle through years in a region where droughts are the rule rather than the exception, and then retire defeated. The Aborigines, however, adapted themselves to the desert and created a nomadic lifestyle with a flourishing cultural heritage.

I feel that the defeat of white Australians by the desert, which forced them to withdraw towards the coastline, helped to breed a national attitude of laconic irony and pessimism. The Australian experience was a great contrast to that of America, where those who pushed the frontiers westward discovered fertile land, immense herds of wildlife, majestic scenery, and apparently inexhaustible water. Of course there were deserts too but in much of the continent there seemed no end to nature's bounty. It is little wonder that optimism became the keynote of the American character.

From John Olsen's notebook: Spinifex country. A place with scarcely a tree. The euros looked incredulously at us.

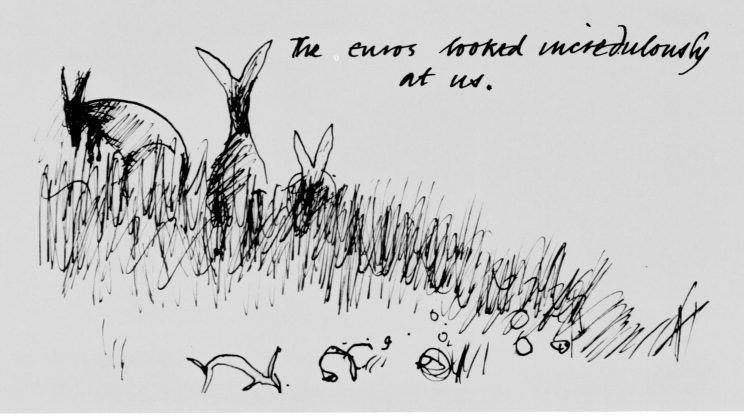

termites nest

mulla
mulla

red violet
tip
blue v.
Light tone

Cape Range

On 7 August the travellers continued their northward course. Geoffrey Dutton writes:

We drove north by garlands of flowers by the sea. I was driving the station wagon, careful of the lurch and drag of the trailer over the bumpy track, stopping to photograph a splendid giant goanna or perentie and an ant-lion's miniature cone and crater, or to look more closely at the flowers.

When we reached Yardie Creek it seemed harmless enough, a sort of sandy crossing that should give no trouble to a four-wheel-drive vehicle. But the trailer dragged the station wagon back, and as we climbed out it just sank in the sand.

Two-and-a-half hours later we were still there. We managed to release the two-tonne trailer from the station wagon, but we could not extricate the trailer from the sand. While we worked, four adults and two children sat on the bonnets of a battered Datsun four-wheel-drive and a Datsun truck and watched us from the other side of the track. Suddenly two men sprang off the bonnets and walked over to us.

We immediately christened one of them 'Gough Whitlam's brother'. He was apparently the perfect bushie: as tall as Gough, sunburnt, in rough clothes, with what may only be described as a vertical smile. It started off in the normal horizontal way and then climbed ecstatically up his long face. He said 'We had a bit of a discussion whether we should help you or not. Nothin' worse than a bastard who offers to help when you can bloody well do it on your own. We began to reckon you was due for help.'

His mate was as short as he was tall, with tattooed arms. His job was not to talk.

I saw they had a number of fishing rods on a roofrack and asked 'What sort of fish do you get along here?'

'I dunno,' with that smile. 'We haven't caught any yet.'

They inspected all our gear and commented on it. We had laid out the tarpaulin in the hope that it would prevent us from sinking in the soft sand. Gough's brother said 'We'll fold that up. Can't go ruining a good tarp.'

A motorcyclist laden with packs appeared on a fancy bike and screamed across the sandhills west of us. 'Huh,' commented Gough's brother. He looked at the winch on our truck. 'That's a real good winch, we'll use that.'

So the cable was connected to the trailer and several of us jumped on the back of it to jerk the towbar up, while Ninette and Gough's brother dug in the sand and I worried about what would happen if the cable broke. At last, pushing and shoving, we got the trailer onto firm ground.

But there was a fresh calamity. We had run out of beer. John said apologetically that we had nothing to offer but thanks. Gough's brother towered over the sturdy Olsen. 'Well, well. You've just got to call the whole trip off if you've run out of beer.'

A few minutes later he was back with an armful of cans. 'Here, have a tinny.' We all drank together, relishing the icy drink.

We had had to deflate the carrier tyres in the sand, and we had trouble blowing them up with our feeble little electric compressor. 'Here, we've got a Bindi,' he said. 'We'll use that.'

A plump boy pulled a hose with fittings out of the back of the Datsun truck, whipped a spark plug out of the engine and inserted the Bindi, which chugged away and blew up our tyres.

I said to Gough's brother 'As if you haven't done enough to help, and given us your beer, now we're using your air.'

'Bugger it!' He put a few kilos of hand on my shoulder, and with the grin rising vertically again said 'We're *enjoying* it!'

I asked him where they came from, expecting it to be some station way out in the desert. 'Fremantle. Just Fremantle.'

So they were specimens of *Homo australianensis suburbanus*. Which just goes to show that you should never give the time of day to anyone who slings off at suburbia.

Camp outside of Exmouth. At dinner I suggest to Geof who is the literary editor for the Bulletin that they should be using artists like the original Bulletin did. Geof agreed & when I suggested that the fee should be what they pay for poetry & the artist keeps. the drawing, he thought that such an idea would be practical

We also discussed a short story Geof is going to do about a bush character who helped us in the sand bog who had a peasant liking to the apparence to Goff Whitlam which might be called 'Goff Whitlam's Brother'

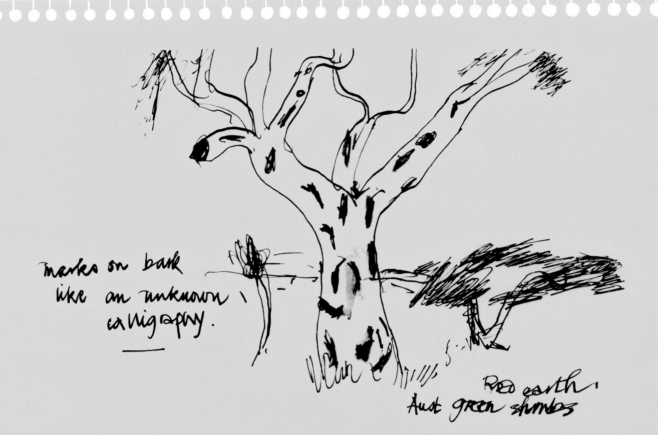

marks on bark
like an unknown
calligraphy.

Red earth,
Aust green shrubs

The party camped at Mandu Mandu Beach, described by Geoffrey Dutton:

There was low scrub with a pebbly beach. In the westerly breeze, waves broke in the distance on Ningaloo Reef. We swam, the water erupting with little fish; when I came out I saw a big swirl and realised it was a shark chasing the fish.

At two a.m. the wind changed with a roar and in the morning the pale green sea had turned dark blue in the offshore wind and the foam was blowing back over the reef.

We drove up the coast to Exmouth, making for the house of the Cape Range ranger, Bob Taylor. Long before we reached Exmouth we could see the U.S. Navy's communication tower: 'The highest manmade structure in the Southern Hemisphere, 387.5 metres.' At the base the Australian and United States flags fly side by side but the whole area is fenced off and signs proclaim 'Prohibited Area'. Whatever the political rights or wrongs of the matter one feels a basic affront to one's spirit of place, one's Australianness, in seeing portions of our continent reserved for outsiders. It was the same when the British were at Woomera.

Yet there is obviously good liaison with the Americans at Exmouth, although there seemed to be a separateness about their squat brick cyclone-proof houses. At the service station I asked a lanky brown-limbed girl how it felt to live in Exmouth and she said 'The kids act better than the grown-ups.'

Bob and Heather Taylor lived in Nimitz Street, named after the USN admiral of the Second World War. Heather gave us tea and told us there were problems in educating youngsters beyond secondary level. They have to be sent to Perth, which is lonely for them and expensive for the parents despite travel allowances. You hear the same story all over the North-West, and indeed in all isolated areas of Australia. Talented Aboriginal adolescents have even more problems. Urban Australia simply does not give enough thought or sympathy to the difficulties of higher education for outback families.

What a pleasure it was to be with people who love their work! Bob and Heather are English, and he said that his task of running the big Cape Range National Park was his ideal job. They are like the old-style British settlers who quickly adapted to an environment totally different from their homeland.

The official pamphlet of the Park warns bushwalkers that *'Cape Range is very rugged and waterless. Temperatures in the bush can be much higher than elsewhere. Many experienced bushwalkers have been overcome because they underestimated the harsh conditions. Ensure you have adequate footwear and clothing, take plenty of water, LET SOMEONE KNOW where you intend to go and keep to that plan.'* Despite such warnings, Bob told us that he had had to rescue a man nearly dead from heatstroke, and that a man had died searching for another lost in the gorges.

The gorges are wonderful, even those you can reach by car. You drive up the valley on the low road into Shothole Canyon, and then take a high road on top of the razorback ridges along the Charles Knife Gorge. There are ghostly white gums in the creeks and pale lemon washaways like lizards' mouths in the red cliffs. The rectangular shapes of individual rocks make it seem that the walls and bastions of the cliffs have been carved by hand.

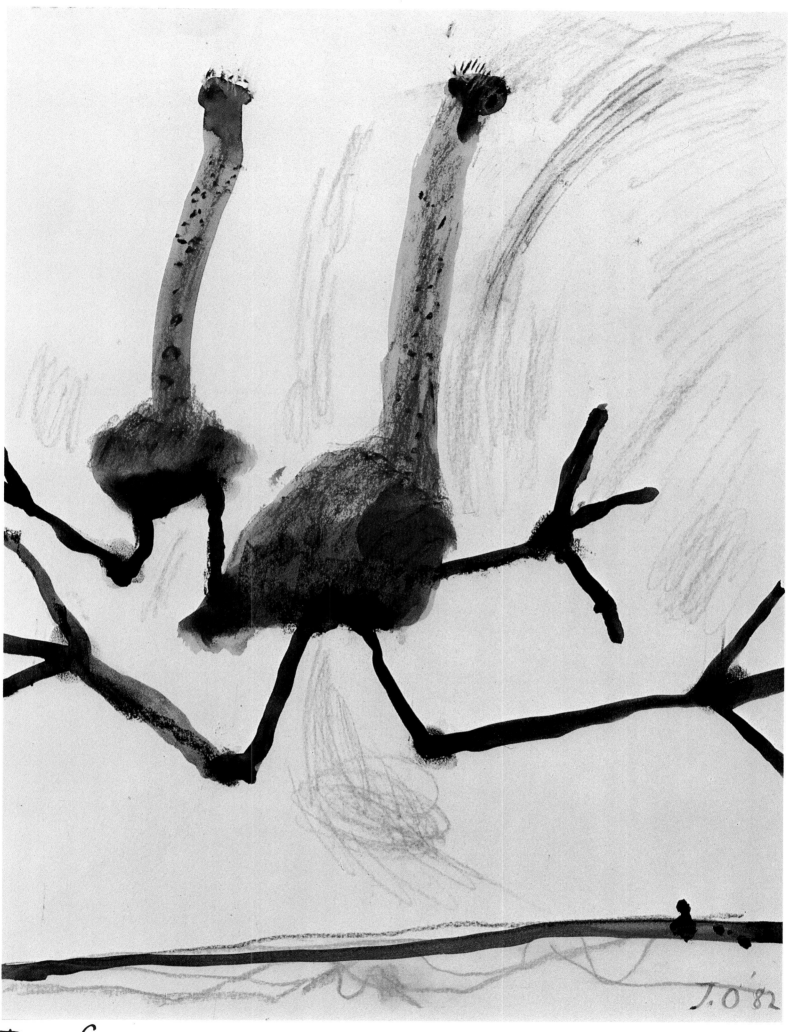

Two Emus

We made a good camp by a creek that night. John cooked a succulent sirloin in the camp oven, and teased Vin about his love for wandering off alone into the bush. He said 'You're more like a bloody koala than a man, Serventy.' Vin nodded in agreement, musing 'Ah yes, the old koala climbs up a tree, looks around, thinks "Thank God there's not another koala in sight."'

At first light in the morning the butcher birds were calling softly and slowly, dreaming their way into the dawn. Surely they have the most beautiful call of all the bush birds. When the light came, the firm pointed leaves of the kurrajong by my bed were a brilliant green, a colour you do not expect to see in the dry season in this landscape of red and gold and black.

From Vin Serventy's diary of the expedition:

We saw few kangaroos and emus in our previous days of travelling but once inside the National Park boundary — invisible to us but well-known to the animals — euros and red kangaroos became common. In such areas they do not suffer from 'visual extinction', a term I coined to explain why casual visitors rarely see kangaroos in the bush. Educated by almost constant persecution, larger kangaroos and wallabies bound for safety at the first sound of a car engine. But a National Park protects them, and fosters a kind of Garden of Eden feeling where man and nature are one.

Shothole Canyon was full of memories for me. Nearly thirty years ago I saw oil-drilling equipment landed on the beach of Exmouth Gulf, saw the exploratory well drilled in Shothole Canyon, and talked to the geologists. The American leader of the venture was cautiously optimistic.

Delirium swept Australia when the first hole at Rough Range struck oil in 1958. Many thought that if the first drill had found oil then the country must be floating on a sea of it. That 'South Sea Bubble' burst when the second hole was proved dry, but the search continues both onshore and offshore.

Bob Taylor was not interested in black gold but in the white gold of the Cape Range limestones, which have so much scenic beauty and wildlife interest. From their heights we could see the blue gold of Ningaloo Reef, which Bob described as a miniature Barrier Reef. It stretches 160 kilometres along the coast. The reef was under threat by a Royal Australian Navy scheme to use the southern end for amphibious exercises, with inevitable damage to the fragile ecosystems, but it is fortunately on the Heritage Register and the Heritage Act can protect such areas from damage by federal agencies.

When we left Cape Range we drove westwards and stopped for lunch under a river red gum in a dry watercourse. We felt at peace with the world until a panel van emblazoned 'Are You Ready for Jesus?' sped past us, and the young people on the front seat threw out some pamphlets in a kind of evangelical littering. Apparently they felt their mission was to traverse Australia in an attempt to educate its people in the beauties and mysteries of the Christian religion.

this missal was thrown at us by a caravan that said 'Are you ready for Jesus'

For some reason the tracts which they scattered in the wake of their vehicle reminded me of a meeting with Father Worms, many years ago in Broome. This gentle leader of his Christian flock had become a distinguished anthropologist, and he showed me some of the artefacts made by the Aborigines of the Kimberley. Being a young agnostic, although a polite one, I used the opportunity to ask 'How many Aborigines do you think you have converted to Christianity?'

He stared at the sky and obviously looked deeply into the valley of the years he had spent in the North-West. I was most impressed by his grave consideration of my brash question, and he answered slowly 'Vincent, I think in all the years I've been here . . . I've converted two. But I'm still not sure about one of them.'

Diogenes went in search of an honest man but I can't remember if he found one. In Father Worms I found one in my youth.

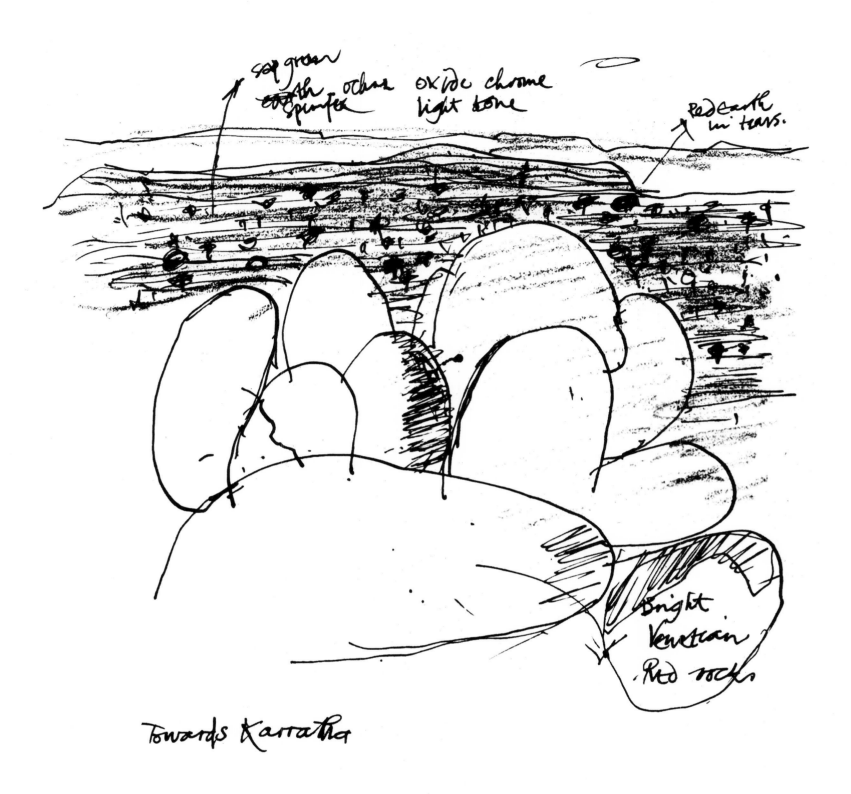

Towards Karratha

4 | 'STILL SO MUCH UNKNOWN'

KARRATHA — MILLSTREAM — WITTENOOM — THE PILBARA

Vin Serventy's record of the journey after Cape Range says 'We drove on through red dunes ablaze with fringe myrtle flowers, past sky-blue lobelias growing in the tumble of red rocks, to reach the towns of Dampier and Karratha, plain evidence of the new world of minerals pushing the old world of pearls and wool into the background.' Geoffrey Dutton comments:

Suddenly we were staying in style at the International Motel. There were three shower taps in each of our bathrooms, marked red, green, and blue. Red is for hot water and the green is supposed to be cold. But the water in the pipeline from Millstream is so hot when it reaches Karratha that you cannot shower under it. The hotel recirculates water condensed from the air conditioning, and that is in the blue tap.

The International is luxurious but expensive. The cost of living for people not employed by the mining or natural gas companies is high in this part of the world. They pay as much as $190 a week for a flat. But employees of the mining companies or of the huge Woodside natural gas project can earn high wages, around $750 a week after tax, and still benefit by subsidised meals and housing. A three-room company flat rents for $50 a week and single men live equally cheaply in the bachelor accommodation. An excellent lunch in the canteen, with vegetables flown in from the south, costs only a dollar.

Company employees work from 6.30 a.m. to 4.30 p.m. six days a week, with five free days every two months. Most stay for one or two years, and if they live sensibly they can return home with a big bankroll. Fortunately, perhaps, there is no casino in Karratha. One man told me of a visit to Darwin on which he watched a bush worker lose $10 000 at roulette — his entire earnings from months of hard and isolated work.

Marilyn Stanmore, the enthusiastic Woodside public relations officer, poured details and statistics into our ears. There are 184 males to every female in the Woodside project, and I wondered whether any enterprising Kings Cross ladies have set up house in Karratha. But this was the kind of question that Marilyn was too discreet to answer. There are more boats per head in Karratha and Dampier than anywhere else in Australia. The delectable beaches of the Dampier Archipelago are not far away, and there is superb fishing a few kilometres from Dampier.

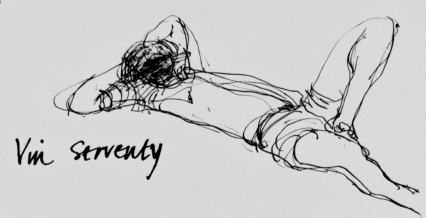

Vin Serventy

Marilyn took us to the construction works by the sea, where Sturt peas grew scarlet in the rubble by the huge rocks of the jetty. Giant Euclid trucks were dashing and rattling off their loads, bulldozed from the landscape that was being levelled to create the jetties and works where the gas pipelines will reach the shore. Marilyn told us that women are favoured as drivers of the trucks and heavy machinery because they are more patient than men. They will relax and read a magazine while their trucks are being loaded, while the men fret impatiently.

In a reversal of the usual course of events, nature herself had left an unsightly mess in this area. Huge heaps of red rocks lie in jagged untidiness like the tailings from a ruthless mining company. Some visiting Japanese have been critical of Woodside's failure to restore the environment and could not believe it was natural, but Woodside in fact has a fulltime environmental officer, Darryl. He took us to lunch in the canteen, full of huge Slavs with hands like hams, Italians, Germans, Japanese, and moustachioed Spaniards. All notices are printed in German, Italian, Spanish and English.

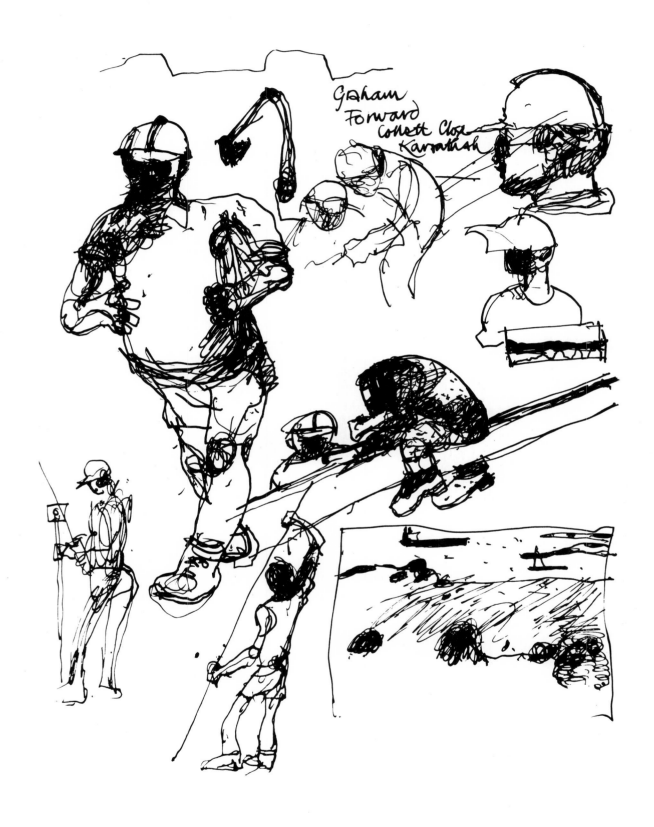

Darryl took us to the Burrup Peninsula, into a valley of hot red rock where there were extraordinarily interesting Aboriginal carvings. They are very early Australian art of a kind not found elsewhere. The strangest were the 'Climbing Men' of which there were several examples in a high cave: bent figures that seem to be climbing a tree. Another creature looked like Sydney Nolan's early painting, 'Moon Boy': a laughing face with eyes staring upwards. Yet another, a dancing figure, had an enormous penis.

It is a hard walk into the valley over a jumble of burning rocks. Darryl has had the track blocked with huge boulders to discourage vandals, but the unstoppable four-wheel-drive vehicles had gone around them. So far there has not been any vandalism but these treasures are perilously unprotected.

How incongruous contemporary life can be in the North-West! That night, in John's room, we watched the final episode of *Brideshead Revisited* on TV.

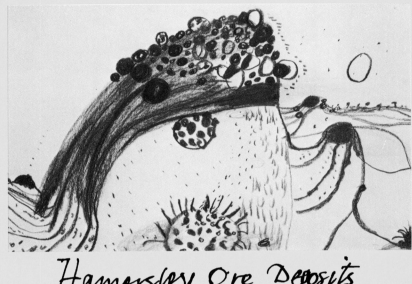

Hamersley Ore Deposits

Next morning we flew in a Cessna 310 out to the North-West Shelf gas rig, 130 kilometres offshore from Dampier. This solitary mass of steel out in the calm blue sea (which is not calm when the cyclones roar in during the Wet) is hard to take in to one's full consciousness. The statistics are overwhelming. We were told that when the platform is completed it will have a greater weight of steel than the Sydney Harbour Bridge, that it will be the height of a fifty-storey building, capable of withstanding winds up to 215 kph and waves up to twenty-three metres high, and so on. When our guide talked about the flow of gas and the tonnes of liquefied gas to be produced he soared into the millions. The whole project is one of man's giant audacious enterprises, barely comprehensible to anyone who is not an engineer.

But it was almost as difficult to comprehend the full meaning of the brown flat shapes and brilliant indented reaches of the Monte Bello Islands, only a few minutes flight from the gas rig. Dampier saw them and believed that the enormous anthills studding the largest island were 'Kaffir huts'; the Dutch also visited the islands, and Baudin named them after the Duke of Montebello. Somewhere upon them stand the remains of the concrete bunkers and the base built in the early 1950s, in preparation for the atomic bomb detonated by British and Australian scientists in October 1952. The thought of the mushroom cloud rising above this superlative region of blue and red and gold seems like an affront to nature.

We flew on across Barrow Island, crisscrossed by oil exploration tracks, penetrated by drills, and emptied by pumps like praying mantises. Then across the ribbed hills of the Pilbara mainland, the red roads cutting through the delicate green of spinifex, and over the lovely pools of Millstream where we were later to camp. Flying home to Karratha in the evening light we looked down on a squared-off landscape scumbled with a blue-grey mist, like a painting by Lawrence Daws. One lone car drew a plume of paprika-coloured dust behind it as it drove along the road following the Hamersley railway. It was poetic, romantic, but incongruously it reminded me of Vin's story of a tough mayor of Port Hedland. When someone complained to him about the dust in town he replied 'Nothing wrong with dust so long as it doesn't get into the cash registers.'

Vin Serventy writes:

The Monte Bello Islands are a classic example of the contempt which Britain had for 'colonial' governments, and which the federal government had for State environmental matters.

These islands had been set aside as nature reserves: fragments of the desert cut off by the sea and holding precious samples of wildlife which were extinct or endangered on the mainland.

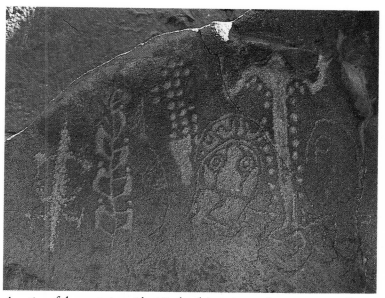

A section of the mysterious Aboriginal rock paintings and carvings in a valley of the Burrup Peninsula, near Karratha. The meaning of these totemic artworks has long been forgotten although some are known as 'The Climbing Men' as they appear to be climbing a tree

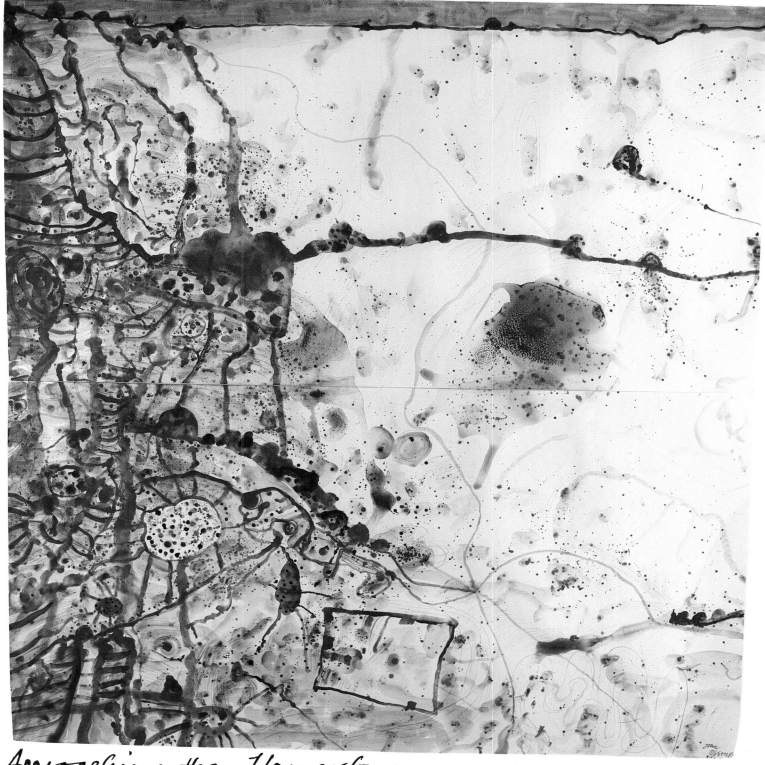

Approaching the Hamersleys

But Winston Churchill dismissed conservationists' protests as absurd and said that British surveys showed 'there was little animal or birdlife of the islands.' We protesters were accused of being communists or communist dupes.

The atomic bomb tests ended in 1956 but the radioactivity lingers and the islands are still a prohibited area.

The lack of environmental concern extended to Barrow Island. This also was a reserve, but the State government handed it over to an oil company without any environmental conditions. Fortunately the company had more sense, or sensitivity, than the government. After discussions with the Department of Fisheries and Fauna, and the Zoology Department of the University of Western Australia, it developed conservation guidelines for the island.

Gorge.

spinifex patterns.

A note from Geoffrey Dutton's diary:

Travelling with Vin we are learning to improve our vocabulary. Not anthills, but termite mounds. In vain to protest that this would ruin one of my poems, written in scientific ignorance twenty years ago. And those lovely little birds around our camps, nodding their heads as they land, must not be called topknot pigeons but crested pigeons. But Vin is rightly incensed at authoritarian decisions by government departments and scientific societies to alter old place names and the names of birds, trees, etc. Cooper's Creek becomes Cooper Creek, regardless of Burke and Wills; forktailed kites become black kites, and so on. It may be scientifically incorrect to call termites white ants, but folk usage is another matter and should be respected.

Vin Serventy continues the story of the journey:

On the twelfth day we left the coastal plain with its old towns like Onslow and Roebourne and its new towns of Karratha and Port Hedland, and turned inland towards the higher ground glowing red on the horizon.

As a student my first love was geology and I knew this landscape to be part of the Western Shield, one of the three great divisions of our continent. The others are the Central Basin and the Eastern Highlands.

This vast shield of ancient rocks covers nine-tenths of Western Australia but it is not a monolithic structure. It is divided into three 'blocks'. The southern Yilgarn Block is a mixture of granites, gneisses, and greenstones which hold the goldfields of Kalgoorlie. The central Pilbara Block comprises the outpourings of ancient volcanoes, overlain by a succession of sedimentary rocks containing the banded iron formations that support the minerals boom, and invading granites and other formations which contain more iron ore. In geological terms, the younger rocks are only 1000 million years old.

The most northerly formation is the Kimberley Block, which we were to explore later.

In the youngest rocks of the Pilbara, near the main road to the inland, a waterfall plunges over a hard ledge into a deep pond which it has scooped out over the centuries. This is Python Pool, named for the giant non-poisonous snakes that shelter here in winter and venture out to feed in the warmer weather.

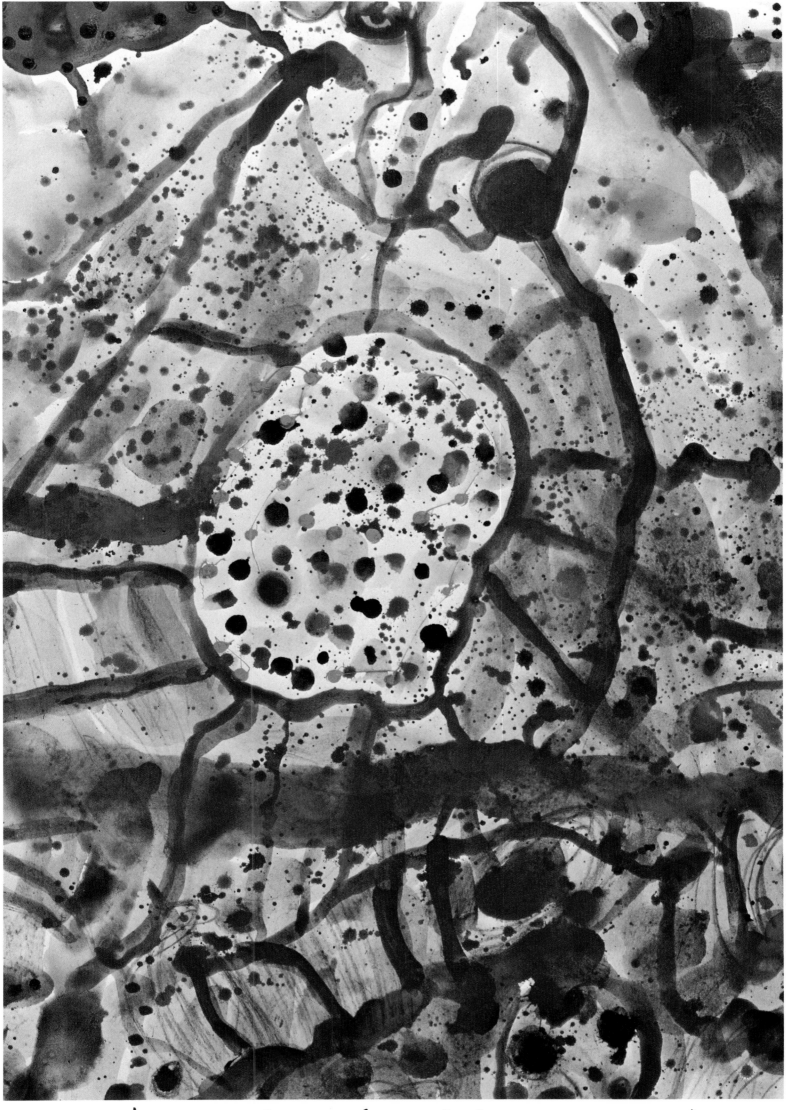

Approaching the Hamersleys — Detail — ore deposits.

THE CAMEL ROAD

Across the grass-plains pale as a kestrel's wing
They came to the harsh escarpment, and a coiled spring

Of water like a python sleeping under the cliff.
The shafts of the unharnessed wagons stood stiff

In the flowing landscape while the camels were cooling their noses
In the deep pool, and the drivers were thinking of roses

And minarets, for water in the desert is contentment,
And to do nothing, inviting dreams, is also excellent.

They were in the presence of hills more ancient than the high Pamirs
Not spiky, but soft in wide, shuffled tiers.

In human beings youth is all roundness
But not in nature, where a distant hill like a mound is

Not a young breast but an ancient tomb.
Yet there was nothing soft in the red escarpment, no room

For dreams with the camels snorting and the wagons still.
So they cut a road out of the side of the hill,

Walled square with red rock, and bridges
Crossed with logs were set into the buttressed edges,

And when it was built no doubt the camels were cursed
For sliding down or slipping back on the worst

Slopes, where even now there are skid-marks of steel
Rims on a rock. But of the drivers not a heel-

Mark remains, only perhaps a rusty metal
Matchbox. A cassia drops a yellow petal

On the road, by an indigo plant whose flowers remain
Between rubbed fingers as a deep stain,

A kind of instant memory. The road is ancient
As the mesas above their red fortresses, and the patient

Camels, a week's water inside them, wait
Invaders of a landscape which is still inviolate.

Dr Tony Start, the Regional Manager of National Parks, had arranged to meet us at Python Pool, and we were soon captivated by his enthusiasm for the old road that the Afghan camel drivers had cut out of the hill. He pointed out the long scar snaking through the spinifex and said that the camel trains used to carry wool down from the stations to the seaports along this road, and return with stores for another lonely year. As we walked up the hill he pointed out the care which the builders had devoted to making the long climb easier for the camels. There was a T-junction where the camels were taken to water at Python Pool and enjoy a good camp before the long haul up to the plateau. The road was so well made that we could easily see its route through the rugged country and the grooves worn by wagon wheels were still visible. Some of the lines of rock were so large and well-laid that we could make out the places where they crossed the modern road. John Olsen exclaimed 'This means more to me than any stories about Roman roads! Why don't they teach Australian children about Australian roads like this one?'

The modern Mount Herbert Road, which parallels the camel road, is perhaps the most beautiful in Australia. It helps to lead the eye up from the symmetry of Pyramid Hill, which is a butte in geological terms, up to the tent hills or mesas of the escarpment. This road is perhaps at its best in afternoon light, but John and I enjoyed a study of the plains, slopes, and tablelands at all times of day. In almost every direction the mesa tops crumble under the onslaught of sun, wind, and rain to create red tumbles of scree slopes. From below the plant tides rise higher and higher, threatening to engulf the hills in a grey-green wave of spinifex. Sturt pea outlines the roadside, with delicate desert bluebells growing amongst it. Mulla mulla grows in profusion. When we reached old Tambrey Station, the red termite mounds arose like pillars out of an ocean of spinifex, Sturt pea, bluebells and mulla mulla.

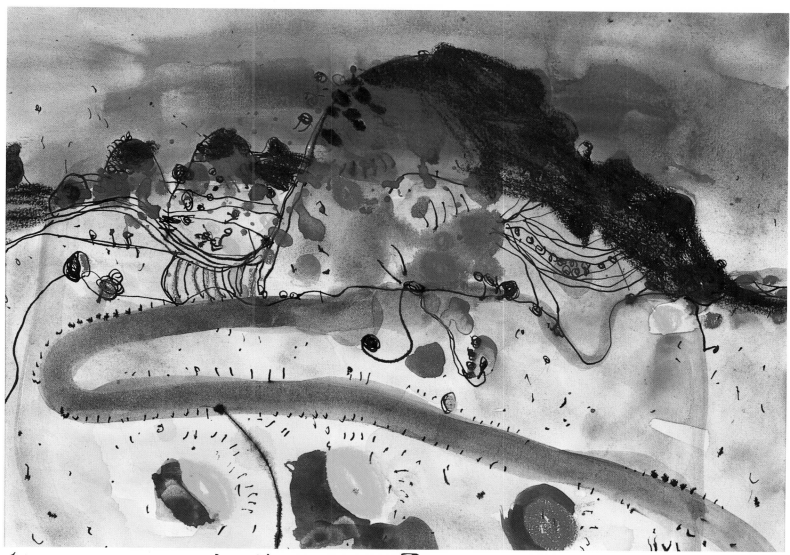

Old Camel Road Hamersley R.

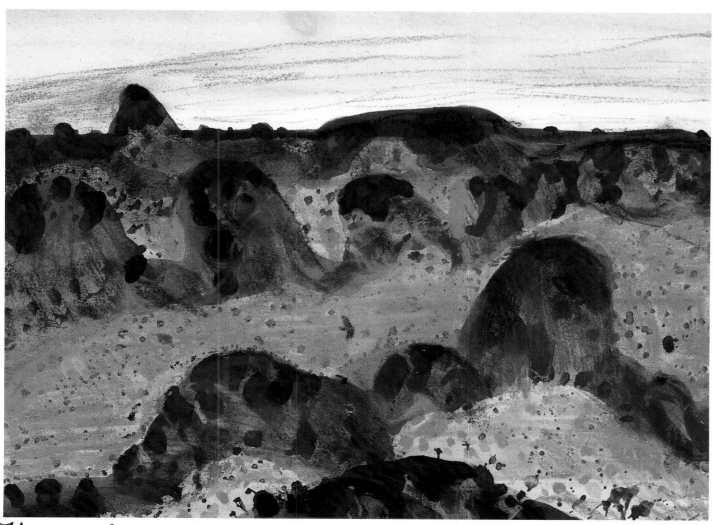

Hamersleys I

John absorbed an avalanche of new impressions along the Mount Herbert Road and told me 'You know, Vin, many painters have thought the Australian landscape is uninteresting and they've tried to enliven it by adding human drama, but the drama is in the landscape itself. I hope our trip will help to form a new landscape in Australian minds. There's still so much unknown.'

He looked over the panorama of spinifex, the rich red slopes of ironstone scree and the sharp outlines of mesas and buttes, cleancut against the desert sky. 'I know the nouns and verbs of this North-West but I still don't know how to put the sentences together . . . what impresses me in my travels is the sobriety of the Australian landscape. European artists are rather shrill.'

We camped on the banks of Deep Reach Pool, one of a chain of pools of which the best-known is Millstream. Francis Gregory found the Millstream pool in June 1861, and wrote '. . . here we first observed very handsome fan-palms, growing in groups, some of them attaining to the height of forty feet and twenty inches in diameter, the leaves measuring eight to ten feet in length. The river had again opened into deep reaches of water, and contained abundance of fish resembling cobblers, weighing four and five pounds apiece . . .'

The fish, a species of catfish, may still be caught and the fan palms still grace the watercourse. They belong to the *Livistona* group which include the cabbage palm, so-called because the growing tip may be eaten. Cabbage-tree hats, made from its woven leaves, were popular with colonial dandies.

Millstream Station, named after the pool, once boasted a magnificent garden kept luxuriant by the inexhaustible supply of water. It had a remarkable bathroom actually built on the water. On a blazing hot day you could wash in the cool water, sheltered from the sun, and watch fish gliding past you.

The Millstream pools are recharged by occasional heavy rains that flow down the Fortescue River, and there is a constant supply from springs that tap the waterholding sands beneath the pools. These aquifers are a godsend to the new mining towns of the region. Dampier, Karratha, Wickham and Point Samson all draw their water supply from the pools but the take has now reached its maximum. A new dam being built on the Harding River will provide for the future needs of these towns, and a special bore has been drilled to provide water for the plants and animals of this area. It has now been declared as a national park.

Hamersleys II

Geoffrey Dutton writes: On the way up to Millstream we stopped at the Roebourne oval, to watch a sports meeting of nine district schools. The white, brown, and black children were mixing freely, with the slim-legged Aboriginal boys and girls winning most of the races, but we noticed that the parents tended to segregate themselves by skin tones. Only a few groups mixed the colours, while others sat or picnicked separately.

Camels

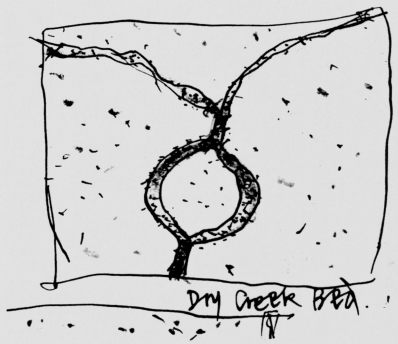

Dry Creek Bed.

The mining towns have no 'colour problem' because they are too new to have a significant Aboriginal component. The people live encapsulated lives in their air-conditioned cyclone-proof buildings, surrounded by a landscape which, as much as any on earth, reminds man of his vulnerability. The situation is different in the older towns and at Roebourne one wondered what will happen to all those kids in their bright yellow, red, or orange shirts, sprinting across the oval or clambering over gymnastic bars or an old railway engine. Probably the little white boy who cheekily threw a small stone, which hit Ninette on the ankle, will have some kind of future. But what about all the Aboriginal and part-Aboriginal children? What can the North-West offer to a population growing up in an era when thousands of Europeans are imported to work in the mining enterprises?

We drove on past Pyramid Hill and the fortress-like hills gently banded by green and gold spinifex to Python Pool. When Ninette and I were last at this lovely deep pool beside the cliffs two naked nymphs were swimming there. There was none on our second visit, but six vandals had taken the trouble to swim across with a spray-can of white paint and desecrate the cliff wall with their names in huge letters: Ray and Gael, Julie and Jerry, Karen and Graeme. May their days be cursed and their nights sleepless! Tony Start said there had been a witness to the desecration and that he had tracked the mindless six to Bega in New South Wales, but it would have cost $5000 to bring the vandals and the witness to court and so the case had lapsed.

It was dark when we found a campsite by Millstream. All through the night we could hear the faint rhythm of the pumping engines which supply water to the coastal towns. Next morning there was the loudest dawn chorus I have ever heard, with reed warblers trilling like nightingales among all the other birds. The mist was rising from Deep Reach as we went for a delicious morning swim.

From John Olsen's notebook:

Pyramid Hill especially, and Chichester Range, have dramatic iron tones with spiky spinifex of such elemental forms . . . molten dripping russet tones sliding down the mountains . . . cobalt cerulean . . . black with ochre gradations . . . warm blue with vermilion, a touch of ochre . . . spinifex coarse texture.

The wonderful Hamersleys! I have not seen anything so exciting since Lake Eyre.

The travellers drove from Millstream to Wittenoom by way of the deserted Tambrey Station homestead. Geoffrey Dutton writes:

If only Australians had enough money and we cared enough about our past, Tambrey ought to be preserved forever with a permanent custodian. At present it is slowly being demolished by cyclones, termites, and vandals. You come to the homestead past huge drifts of Sturt pea to a long galvanised iron roof, sloping down to what a cyclone has left of the verandah outside the red mudbrick and pisé walls. Two brown hawks were nesting by the house. The builder loved curves, and all the doorways are arched and the pine doors cut to match. There is a big curved-top fireplace in the sitting room, and a metal hatbox. The shelves are still in the larder. There is a tennis court and a cemetery near the house, and on one gravestone metal letters carry the memorial 'Thomas Donald Cusack. (1899–1926). After he had served his own generation by the Will of God fell on sleep. Well loved.'

We drove on into Wittenoom, where everything was shut except the pub. The town, named after the Western Australian politician and landowner Sir Edward Wittenoom, was established in 1947 to house workers in the blue asbestos quarries, which operated from 1943 until the cost

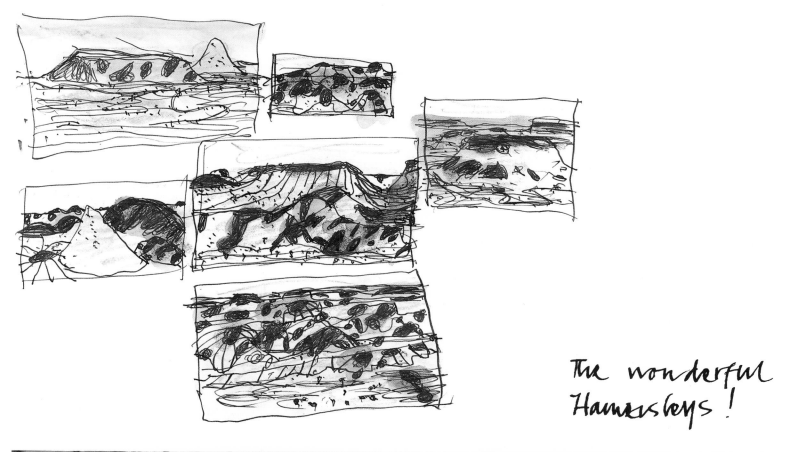

The wonderful
Hamersleys!

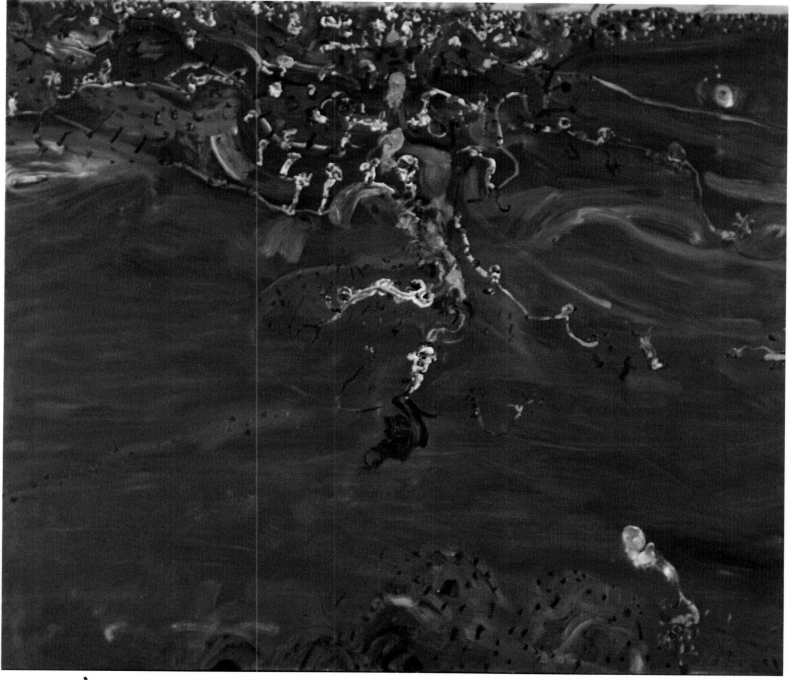

The Pilbara on Fire

of exploitation closed them down in 1967. In the pub we met an oldtimer with thin, carefully-combed hair and washed-out blue eyes, who spoke to John and I in a precise voice and carefully-chosen words. I said that there seemed to be fewer houses left than on my last visit, but he answered 'Ah no, we are by no means destitute of accommodation. For an investment, could you better a house here? Excellent concrete floor, good timber and roof, plus furniture and refrigerator, and all for six thousand dollars. When the blacktop road comes through and the tourists follow it will be worth all of fifty thousand dollars. Lang Hancock's got seven houses here and a camp up the gorge: uses two. He's got a welder, electrician, drilling expert, gardener always on duty. Cars? He's got a white Jag, Range Rover, Christ knows how many Toyotas, always ready. But his offsider's a good bloke, though a bit rough. He's out in the desert somewhere at the moment.' He gave us a courtly smile and wished us well.

Next day we were walking around the town and out into the open, admiring the giant mulla mullas as high as a man, when an oldish man who was trimming his lawn asked us in for a cup of tea. He told us he had a 1200-hectare farm out from New Norcia but he had retired to Wittenoom for health reasons. He had a bad cough, inheritance of wartime years as a prisoner of the Japanese. No, he said, there were no health worries about the asbestos. It was the healthiest climate in Australia. He showed us the prospectus for a huge new tourist complex which may be built at a new town of Wittenoom, several kilometres away. 'Old' Wittenoom is a place in a state of suspended animation amidst some of the world's most magnificent scenery.

Vin Serventy writes:

Lesley Styles, a painter who has made her home in Wittenoom, once wrote to me 'It is a naturalist's paradise with such varied material that the mind boggles.'

She had offered me hospitality in Wittenoom and I seized the chance to visit her Jabiru Art Gallery. She and her friend Val Charlton welcomed me but the meeting was tinged with sadness. Lesley had never been trained as a painter, and over the years she had reflectively sucked at the tips of her brushes while painting out in the ranges. She did not realise that the white paints she was using were lead-based and now she was suffering from lead poisoning.

Yet her enthusiasm was undimmed. I asked about a famous kind of mulla mulla which flourishes in this region and she pointed across the paddock. 'We don't advertise them. They're too lovely to be picked and thrown away.' We walked over with camera and sketchbook to capture these fantastic blossoms with their backdrop of the azure Hamersley Ranges.

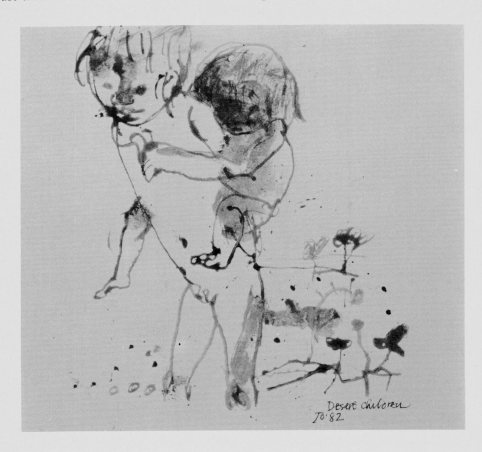

Desert children
JO '82

From John Olsen's notebook:

A flight in the morning on the edge of the Hamersley Ranges to Jigalong, an Aboriginal reserve in the desert . . . The settlement was littered with broken-down abandoned vehicles, apart from official houses the Aborigines were living in humpies. To an urban dweller this looked appalling, galvanised iron with tarpaulins provided the material for housing. Everywhere was strewn with tins and plastic containers.

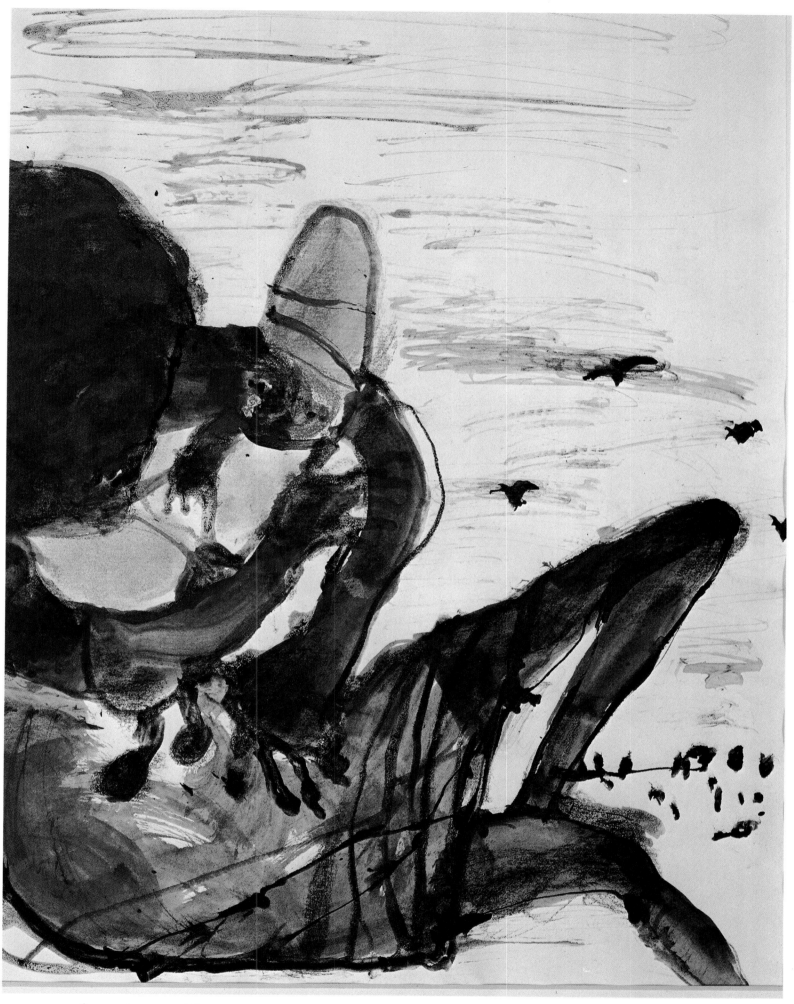

Aboriginal mother – Jigalong

On reflection what else could one expect? They are after all desert nomads whose need for the paraphernalia of twentieth century living would have little meaning. What was extraneous to them would of necessity be immediately discarded. Further they had little education or inclination for the beautifying of any particular locale.

Of housing: the climate has nothing of the chill of winter, while summer is blisteringly hot at temperatures at times of 50°C. As we have found in our limited time of camping during the journey, social standards of housing must be drastically altered. The humpies still looked horrible but in pragmatic terms still suited their purpose admirably. Perhaps a module could be designed by which they could join a shelter together.

The Jigalong people were a cheery lot, thousands of light years away from the ego and consequent aggressiveness of white culture. Quick to laughter, quiet in manner of speech, completely at ease with their harsh but very beautiful landscape.

Around the camp were hundreds of emaciated mangy dispirited dogs, scarcely able to walk. Bob Tonkinson the anthropologist said that the Aborigines have no feeling or care for dogs but used them as blankets (Heaven forbid!) and they served the purpose of keeping evil spirits away by barking at them.

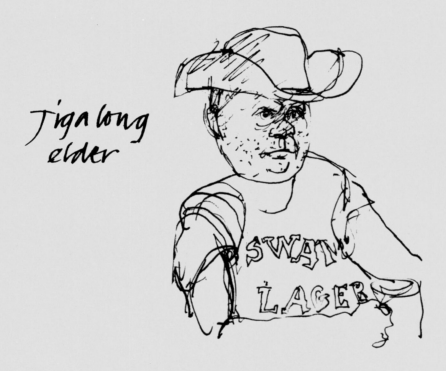

Jigalong elder

Vin Serventy's impressions of Jigalong:

We had been allowed to enter this area only if we promised not to bring in alcohol, not to take photographs without permission, and to allow anything we wrote to be checked by the leaders.

With a sense of excitement we saw Jigalong beneath us, a scatter of houses set in a fearsome desert. On the ground we were met by the white advisers and by some of the Aboriginal Council of twenty men and sixteen women. Lucy Gibbs, the wife of the chairman, is a charming outgoing personality but her husband proved to be a formidable character. He again warned us not to take photographs of the people, and when I asked permission to photograph their 'trademark' on a truck door he pondered the request, no doubt wondering why on earth I wanted to do so. Finally, gravely, he gave consent.

None of we visitors could speak the language and I wondered whether we would be able to gain any insights into this group of between 500 and 600 people, isolated in the desert, without an independent interpreter. But, by happy chance, we found that an old friend had preceded us to Jigalong. He was Bob Tonkinson of the Australian National University, who had done post-graduate work at Jigalong after graduating in anthropology from the University of Western Australia. He had come to Jigalong for a few weeks from the ANU and we could not have asked for a better sponsor. Often an Aboriginal man or woman who hadn't seen Bob for a number of years would embrace him with every sign of deep affection.

Bob explained the background of the present Aboriginal settlements, especially Jigalong and the Strelley Mob, which we were to visit later. For countless centuries the clans or groups of this region lived a nomadic life, roaming over the deserts in which they hunted or gathered enough food for survival. Their need to wander over great distances made them tolerant of their neighbours, because no one ever knew when it would be necessary to enter the territory of another clan in search of food.

The children's hair has been genetically bleached through thousands of years exposure to the desert sun

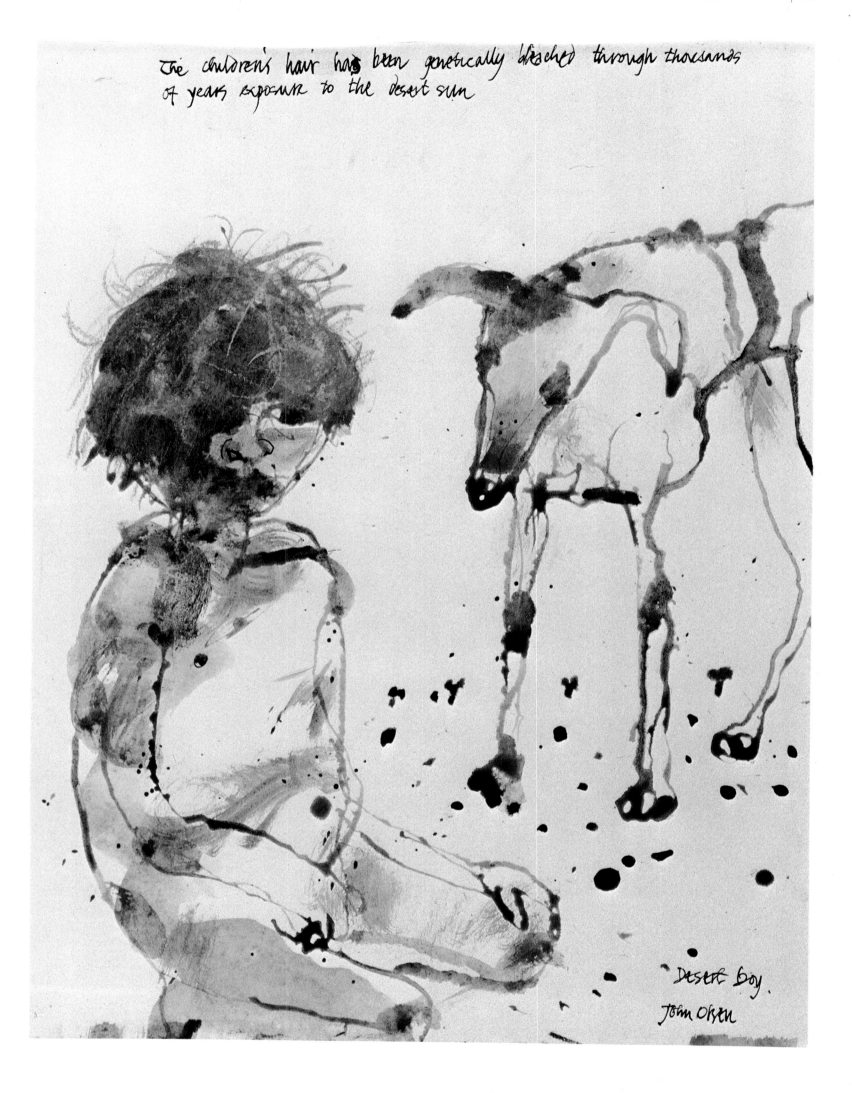

Desert Boy.
John Olsen

They also shared some Dreamtime beliefs, the stories of the first ancestors who created the land and its people, and they developed a rich body of myths and legends. Once or twice a year the wandering groups gathered for the organisation of social life: such matters as the initiation of boys, the arrangement of marriages, the learning of rituals, and the hundred-and-one decisions which any community must make to keep the social order functioning.

When white invaders transgressed on the nomadic territories, in their search for minerals or grazing land, their camps and settlements naturally attracted the Aborigines. Some, who had broken the Law, sought sanctuary with the white men. Others were drawn by curiosity, and they quickly began to covet the white man's food, clothing, tools, tobacco, and alcohol. These luxuries soon became necessities, and they discovered they could trade them for their labour or the sexual services of the women.

Gradually, like raindrops collecting into puddles, the people drifted away from their ancient lifestyle and settled in groups based on the white settlements: the 'black camps' which existed on the fringes of townships or close to the stations. In many places the missionaries of various denominations attempted to create settlements which would bring Aborigines into the fold, or salvage them from the degraded conditions of the fringe camps. Some did excellent work but others were more concerned with converting the Aborigines to Christianity than with their physical well-being.

William, child born on the same day as Prince William

The Jigalong community began in about 1907, as a result of the State government's fruitless endeavour to check the march of the rabbit by erecting a 'rabbit-proof' fence to protect the fertile coastal areas. A fence maintenance depot at Jigalong became the nucleus of a community and eventually a mission was established there. In 1947, Jigalong became a cattle station under mission control, and this survived until it was taken over by the government in 1969.

The Aborigines hereabouts never really accepted the idea of mission control. They could understand the fairly blatant motives of white miners and graziers, but the missionaries were different because they were assaulting their tribal Law. Aborigines countered this with a kind of passive resistance, and in Bob's words they 'played on the deep-seated prejudices of the Christian fundamentalists in order to extract a maximum of material goods and concessions for as little labour and contact as possible. The exploitation was mutual, and the situation persisted because the need of each for the other was self-evident.'

But the Aborigines kept the missionaries out of their religious life and finally they retreated, defeated by their failure to make converts and by the physical difficulties of an isolated desert station.

In 1973 Jigalong became a self-governing Aboriginal community with white advisers. After generations of indifference the white man's government was beginning to show some concern for Aboriginal welfare and it even created an Aboriginal Legal Service, which could protect the Aborigines from their enemies, including the police.

But the Aborigines still had to contend with the subtle effects of white example. Young people demanded 'If it's good enough for whitefellas to marry anyone they like, why can't we?' The numerous differences between white customs and Aboriginal Law created many difficulties, including the problem of alcohol. The upholders of the Law know the dangers of drinking and gambling and they have banned both from the Jigalong settlement, although they tolerate the occasional rampage by an individual who brings liquor in from outside.

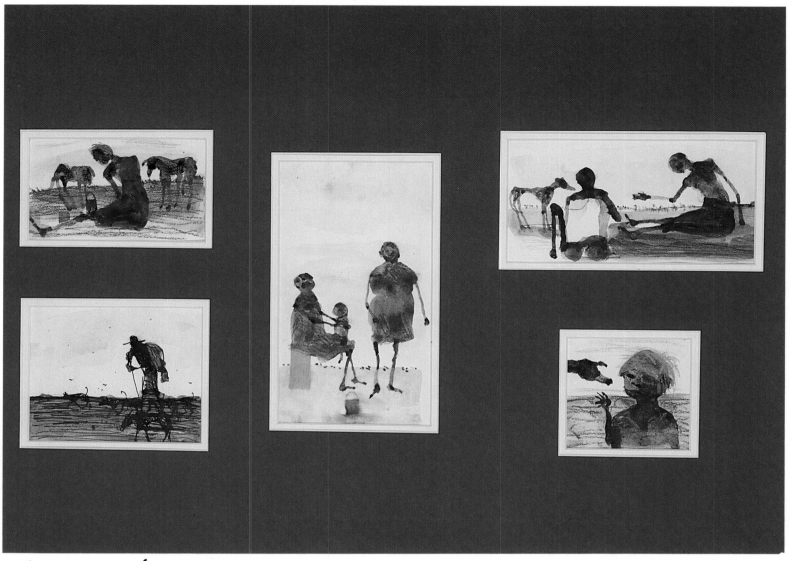

Life at Jigalong

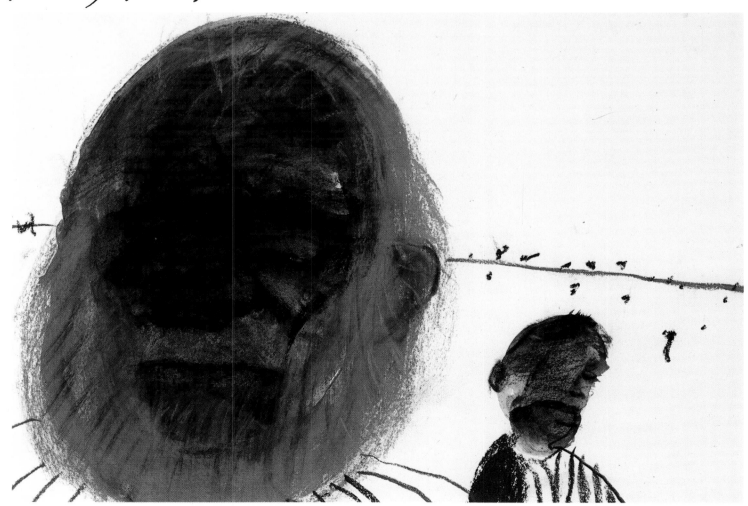

Tribal elder, Jigalong

To our eyes, the litter-smirched landscape and the packs of mangy dogs were discouraging, but one must not judge by outward appearances alone. In the book *Aborigines of the West*, edited by Ron and Catherine Berndt, Bob Tonkinson has written that 'The people of Jigalong remain a proud, determined community with a strong continuing commitment to the major dictates of the Law. It still represents for them the ultimate truths of existence, and it gives uniqueness and a strong sense of self and of identity as upholders of tradition. Their active religious life continues unabated, community spirit is high, and as yet they sense no irrevocable weakening of the Dreamtime heritage that gives them their optimism and conviction.'

The people live primarily on money from the social services, although there are 'cottage industries' which manufacture such items as sleeping bag covers, steel tools for motor vehicles and other metal products, and leather goods. Some 300 to 400 cattle remain from the original station stock and the community hopes to build these up into a herd of about 2000 head.

Bob Tonkinson says the survival of the community depends upon their ability to resist absorption by whites, and on their willingness to tolerate real cultural differences and even promote them in the interests of humanity and of cultural pluralism. The same might apply to every Aboriginal group we visited.

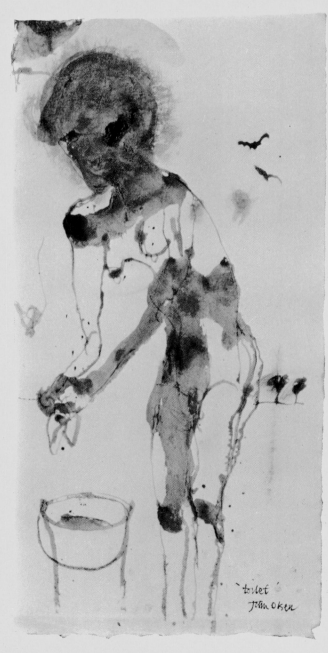

From John Olsen's notebook:

It is impossible to encapsulate a single solution for Aboriginal advancement. Desert people have different needs, such as water and medical care, from urban blacks who have awful difficulties with housing, unemployment, and particularly alcohol. Wherever the Aboriginal comes into contact with urban situations he is in danger.

There are both strong empathies and strong prejudices between the tribes. Certainly great progress has been made towards Aboriginal unity, but as some elders expressed to us 'Charlie Perkins looks after urban problems. We look after our problems!' They are very related to their particular group's advancement.

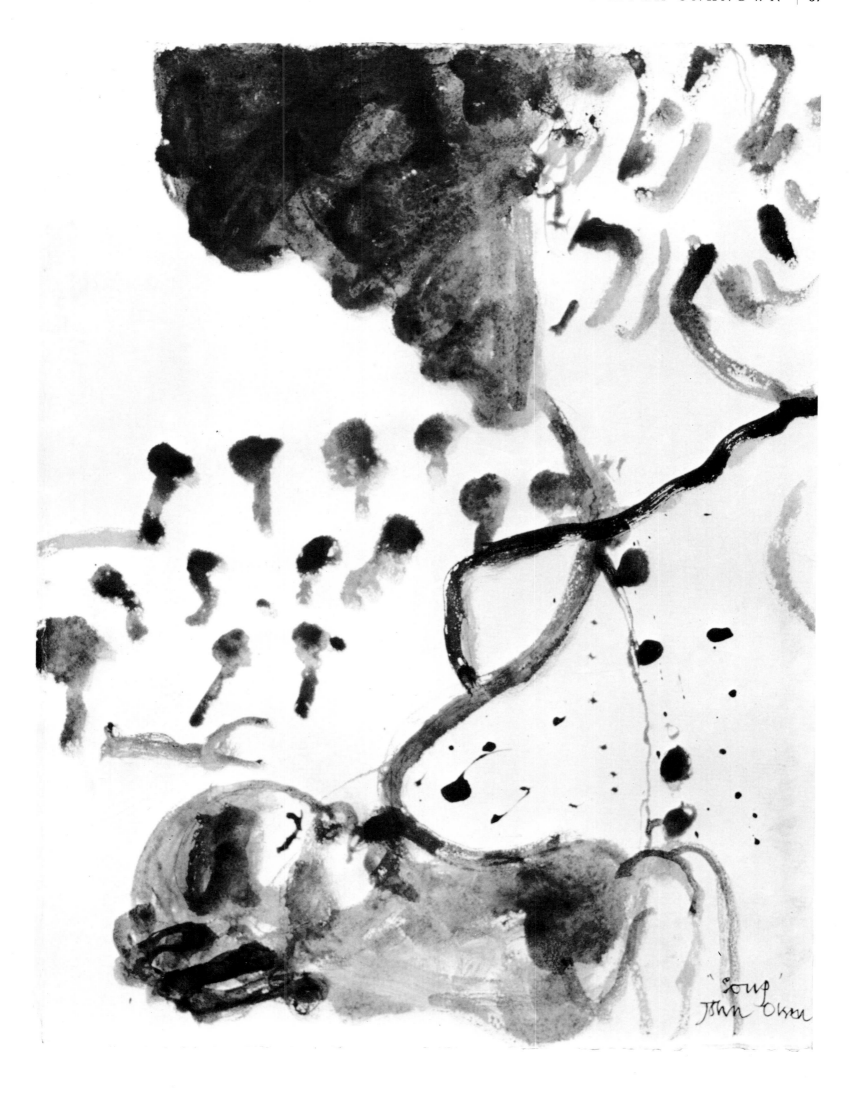

When we said we were going to Strelley from Jigalong we were made aware of a recent kerfuffle that had occurred between the two groups. Apparently Strelley is much more dictatorial with a more systematic programme of progress. They wanted Jigalong to join with them but there was a torrent of protestation and abuse. The Strelley Mob was accused of abusing tribal rituals — 'You Strelley, you bad lot, you let white women circumcise the babies and give the foreskin to the chooks!' (Vin Serventy comments that, to the Jigalong people, the idea of women circumcising boys was 'the ultimate horror'.)

The Jigalong men practised the painful operation of cutting the penis down the urethra, known as 'whistlecock'. It was a sign of courage and manhood. This image is often to be seen in Aboriginal art. The penis would be shown to other men and handled as a symbol of valour.

The Aboriginal notion of swearing, blasphemy, etc. is quite different from that of the white man because it has no moral or emotional connotation. They simply pour out a torrent of 'bad language' but it often makes a good command of English.

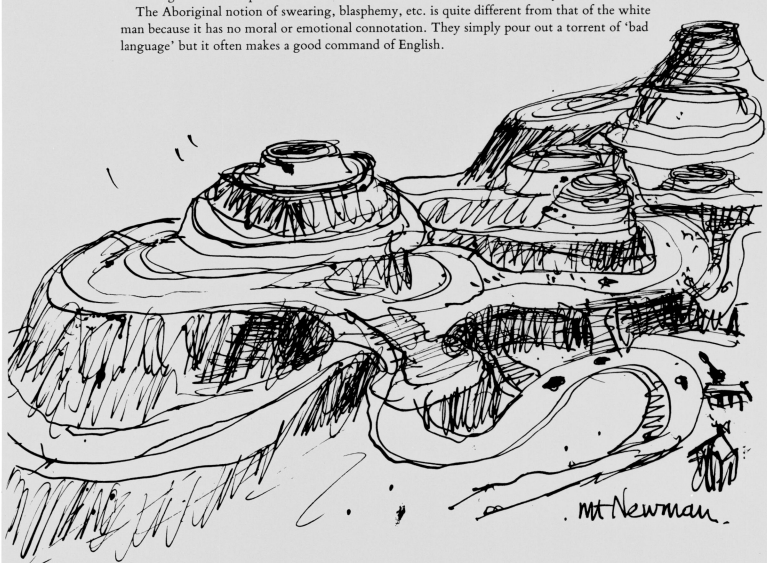

Mt Newman.

Geoffrey Dutton had to interrupt his part in the journey in order to make a visit to Sydney. On 15 August he and the others flew from Wittenoom to Paraburdoo, and he writes:

We flew over the gorges and across to the mining town of Tom Price, where the terraced mine workings look like Sumerian ziggurats. Then on to Paraburdoo in the desert, where the others left me to catch my plane to Sydney. There was not a soul at the vast airfield between the mountains. I had some typing to do and so I settled myself at a metal table and bench under a curved iron roof.

I thought again how strangely separate the mining towns are from the landscape and from the ordinary Australian community. Life in these artificial townships has an element of unreality for both men and women. Annie Holden of Murdoch University has done some research into this and her findings were discussed in an article in the *West Australian* of 22 June 1982. Apparently the men become addicted to a routine of working and drinking together and they don't want to leave the towns. 'Everyday life is predictable and there is no tension or responsibility. Once they become an Iron Man of the North-West it is hard to go back to being just another man in the city.' But for married women, trapped in the company houses, there is no culture outside their families. They feel useless and 'unemployed' when their children leave at thirteen for school in Perth or elsewhere.

One feels that the women, with so much time on their hands and plenty of money, might be able to do something to help themselves and each other. I wonder what relationship, if any, they are able to establish with the austere but infinitely exciting landscape besieging their fortress towns.

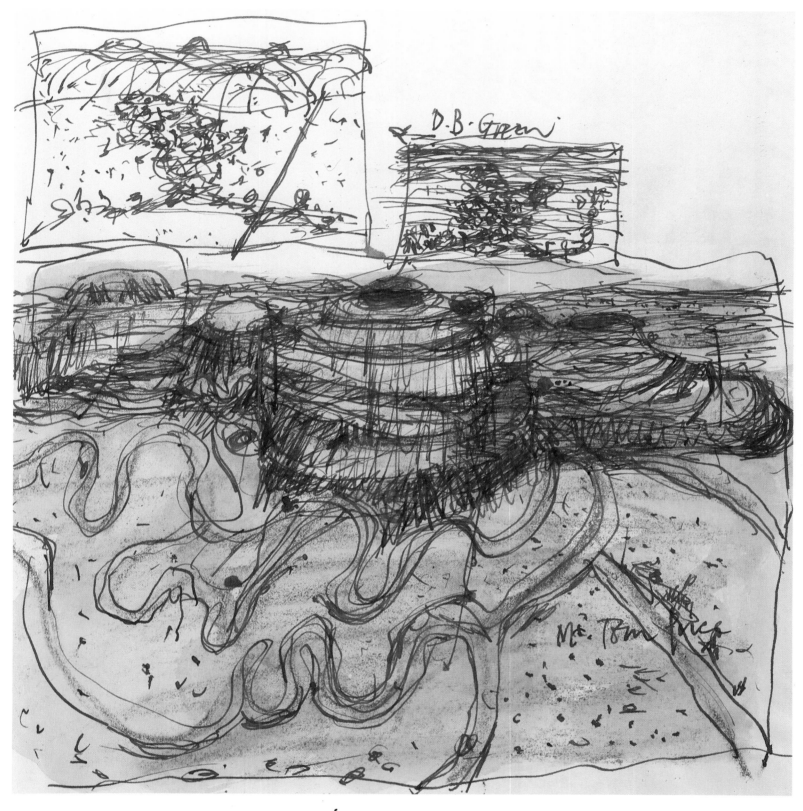

Mt Tom Price was like a
menacing ziggurat.

When you fly over this landscape it becomes clear that a great deal of nonsense is talked about polluting the environment. Such mining towns as Tom Price, Mount Newman, Paraburdoo and Pannawonica are of no more consequence to the immensity around them than termite mounds. You can see how tiny is the impact that man has made on this enormous country.

Musing thus I continued with my typing, alone except for the finches chattering in the trees, the corellas sitting on the blue marker lights along the runway, and one doleful crow warning about the dangers of walking into the blue-grey distances of the encircling mountains that had all been red in the morning.

At last my flight arrived, and I sat between the young odd job man from the International Hotel and a lean, redheaded man who had an earthmoving business in Karratha. The odd job man was flying 1500 kilometres to attend a friend's twenty-first birthday party in Perth. The earthmover had been twelve years in Karratha, and liked it, but his wife did not. She and the children had returned to Perth and he commuted to see them. What extraordinary distances people live with in the North-West!

The culture shock of flying to Sydney was acute. At first I had a physical revulsion from all those houses, all those people; nature parcelled out in blocks and strips; lives choked with news, advertising, sport; the children unable to play in the road, the women who cannot walk safely home across the park at night. But of course the resonant voices of the Pilbara may be heard in Sydney if you want to, and they may be blocked out, by boredom for instance, in the Pilbara itself.

Gallery Hill

From John Olsen's notebook: Travelling from Wittenoom to see Dales Gorge. Pass through spinifex country and stay overnight at an old station [Woodstock] now National Trust homestead, where scientists from the W.A. Museum [Dennis Callahan and Colin Harvey] were doing research. It was great luck that we came here for the landscape was dull and flat with miserable-looking trees and not a good campsite to be seen. The simple pleasures of a good shower and clean clothes . . . a beautiful mercifully dust-free night sleeping on the homestead verandah. Awoken . . . by cockatoos screeching in the dry creek bed.

We saw the Aboriginal engravings on Gallery Hill and Lucas Granites. Gallery Hill is the place that Drysdale wrote so enthusiastically about in the first edition of *Art and Australia*. The rocks are engraved in a style that has no relation stylistically to any other region in Australia. All the works are based on Dreamtime figures, extremely sexual in character, which give a notion of the birth and rebirth of the spirits.

I am, I hasten to add, in the region of supposition, for the culture that produced this remarkable art was dispersed because of pearling or died from white man's disease. Certain flat areas of granite rock are smoothed in sections because they were used as grinding stones.

Dennis told me that certain people have been offended by the sexual overtones of the works. Alas, alas. The real view, he said, should be 'a celebration of life'.

Vin Serventy comments on the rock art of Gallery Hill: In 1964, from Ron and Catherine Berndt's book *Australian Aboriginal Art*, I learned of Margaret Preston's attempts to interest white Australian artists in the art of the Aborigines. It was a lonely fight but she strove to persuade them that Aboriginal art could form a basis for a national art because it would provide 'a fresh stimulus and a return to simple symbols'. In the article about her work I read for the first time about John Olsen, '. . . whose direct linear forms and use of symbols show an affinity to some of the rock paintings of Oenpelli.'

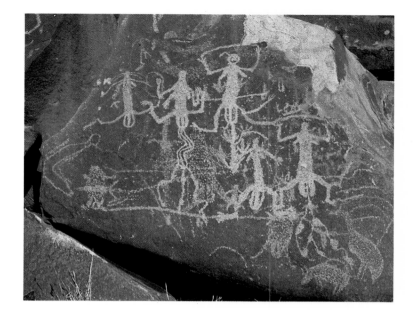

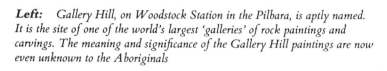

Left: *Gallery Hill, on Woodstock Station in the Pilbara, is aptly named. It is the site of one of the world's largest 'galleries' of rock paintings and carvings. The meaning and significance of the Gallery Hill paintings are now even unknown to the Aboriginals*

Below left: *The enormous penis on this figure indicates that some of the Gallery Hill paintings may have been part of a fertility rite*

Below: *Time, erosion and damage caused by grass fires is beginning to obscure some of the ancient art on Gallery Hill*

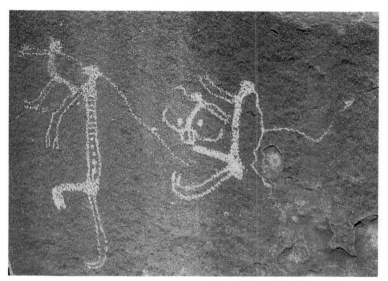

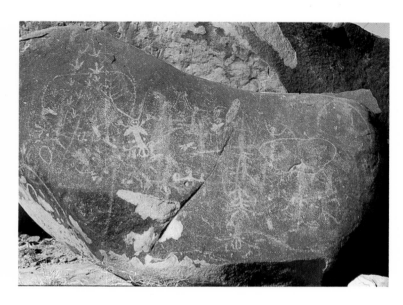

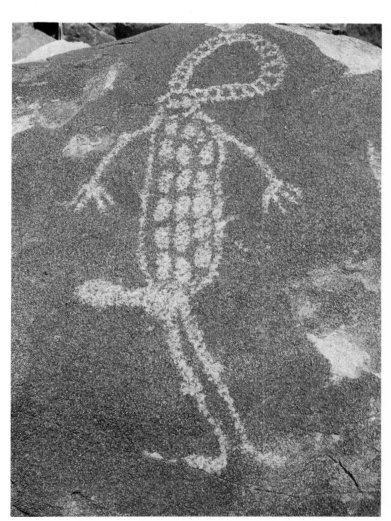

This Gallery Hill work seems to represent a semi-human being painted for some ceremony. The erect penis once again indicates a ritual connected with fertility

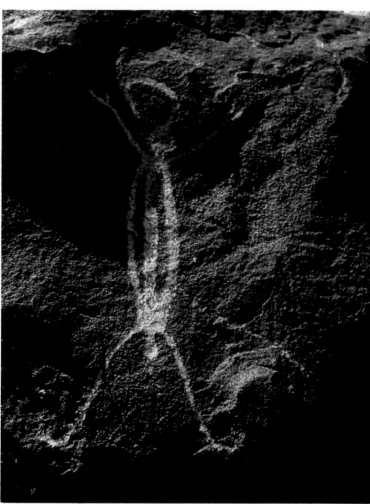

This still vivid, ancient work on Gallery Hill speaks across countless centuries of the rich and complex ceremonial life of nomadic tribes

Now I was actually travelling with John Olsen in a country rich with Aboriginal art, largely in the form of rock engravings. On the Burrup Peninsula we had argued about the links between the rock engravings there and those in central Australia, and we continued our verbal battle on Gallery Hill. It is an isolated tumble of red tors in a sea of spinifex, with most of the engravings on the eastern slopes where they glow red in the morning sun. I thought that the fortress-like National Gallery in Canberra, and its formidable neighbour the High Court, would be dull by comparison.

Tens of thousands of engravings cover the rocky outcrops of the Pilbara and those of Gallery Hill are among the finest. Most of them are of women so this may have been a fertility site.

European interest has made the local Aborigines well aware of the commercial potential of the various sites and so they are showing a new interest in them, although they seem to know nothing about the significance of the engravings. Either they were carved by clans different from those who now live in the area, or the artists lived so long ago that the reason for their carvings has been forgotten.

It is vitally important for this rock art, which the anthropologist Frederic McCarthy described as 'The finest aggregation of rock carving sites on the Australian continent,' to be preserved for posterity. They are already endangered by occasional grass fires, which cause the top layers of the rocks to expand and split in the erosion pattern known as exfoliation.

If only it were feasible, I would like to see the Gallery Hill collection transported to Canberra and set up in the grounds of the new Museum of Australia. I dislike the moving of historical monuments but there is always a danger that the bulldozers of mineral exploration will one day rip through this priceless heritage.

Years ago I saw similar engravings on the edge of the Kalahari Desert in South Africa. Many writers have pointed out the similarities between rock art in Australia and that in other parts of the world, but it is a mistake to classify such art as 'primitive'. The Aborigines should certainly not bear that stigma. They evolved a complex culture of religion, art forms, and oral literature during countless centuries before the coming of the white invaders. Their culture was as rich as that of the invaders even though it was totally different, and they lived satisfying lives under conditions in which Europeans could not survive for more than a few days. All they lacked was the technology of the Europeans, and I believe that the term 'primitive' should be dropped in favour of the anthropological term 'non-literate'.

Vin Serventy continues with some comments about the Pilbara:

These superbly beautiful ranges hold immense stores of mineral treasure. For tens of thousands of years the Aborigines mined ochre from surface iron ore deposits, and one famous spot south of the Pilbara was called Wilgie Mia: Home of Ochre. From Wilgie Mia the ochre was passed along Aboriginal trade routes to areas less richly endowed.

In the 1870s, the explorer Ernest Giles wrote of the Hamersley region '. . . it is stony, sterile and hideous, and totally unsuited for the occupation or habitation of the white man.' Despite his warnings, white men founded pastoral empires which, through ignorance and overstocking, have left a badly eroded landscape.

By the end of the nineteenth century it was well known that the region was rich in iron, but as one old prospector remarked to me when I was young 'What's the use of looking for iron? There's no money in it.'

The Hamersley iron ore province runs for more than 500 kilometres south-east from a point near Onslow. One estimate of the ore reserve is 24,000 million tonnes containing more than 55 per cent iron. Mount Whaleback has 1400 million tonnes averaging 65 per cent iron, the richest single deposit in the world.

In these ranges of rocks 2000 million years old, the ore bodies were formed by the silica content gradually dissolving and washing away. This left an iron formation much richer than the surrounding material. Millions of years of erosion have developed the hills and gorges such as Mount Bruce, Wittenoom Gorge, and Dales Gorge. The mountains are modest by comparison with those of other countries but they still have spectacular shapes and colours and they are rich in native flora and fauna.

The mining companies have added their own kind of erosion to that of time and the weather. 270 million tonnes of iron ore have been exported since 1969, but even with exports rising towards 100 million tonnes a year this still leaves sufficient reserves for another 240 years. However any conservationist must wonder what will happen when the quarries are empty. The mining companies have learned that environmental planning is essential before mining begins and they are doing what they can to minimise the impact on the environment. From the air Mount Newman looks like a green oasis, a tribute to the 70 000 trees already planted there. Re-vegetation of the mine waste dumps is being studied. There is no scientific reason why a quarry cannot be returned to something resembling its original condition.

Jigalong Tribal Elders

5 | MARBLE BAR AND THE STRELLEY MOB

PORT HEDLAND — MARBLE BAR — TABBA TABBA CREEK — MANDORA — WALLAL — LA GRANGE MISSION

From John Olsen's notebook:

En route from Woodstock to Port Hedland. Warm sunshine, as seems to be the regime at this time of year. Stopped at Abydos Station which was abandoned some years ago. The same story, I was told, of overstocking — all the grass gone and only spinifex remaining. The station is situated on a beautiful soak surrounded by palm trees. As Vin and Ninette groped through the dense undergrowth nine Nankin [nankeen] night herons took to the air, a very rare sight because of the solitary nature of the bird.

The ruined station buildings, constructed entirely of galvanised iron, had a pioneering integrity about them. With soft pastel colours of blue and eggshell ochre the patterns made them very abstract — like a bush Mondrian.

Arrived in Port Hedland, an ugly shipping port for Mt Newman and Mt Tom Price ore deposits, where mile-long trains regurgitate their huge loads. Geoff Dutton arrived from Sydney; much gaiety at the reunion.

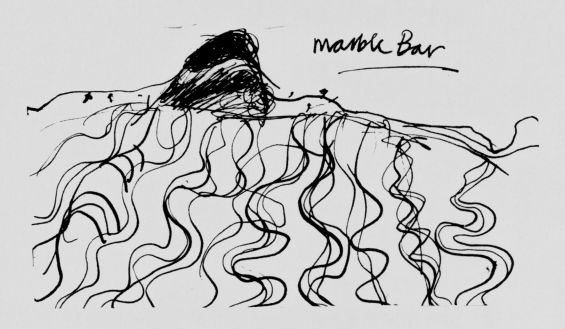

marble Bar

From Port Hedland the expedition drove to Marble Bar, where Geoffrey Dutton takes up the story:

Marble Bar, 'the hottest place in Australia', was not at all what we expected. There was a wide and neatly-mown grass median strip, very handsome Shire buildings, pleasant houses with lawns and gardens and some beautiful old stone government buildings erected in 1895.

We found a perfect campsite on thick grasses under old river gums by the Coongan River. The kilometre-wide riverbed was of sand with water-rounded stones, with long mirror pools reflecting white gums and dragon trees with their richly-swelling lily-white flowers, their petals bridal on the ground. All this against a bastion of red hills with bands of spinifex on the lower slopes, and a couple of chalk-white gum trees growing out of a rocky scree darkening to black. The Marble Bar is actually an immense band of jasper which cuts across the Coongan about six kilometres outside the town. It looks rather dull until you splash water over it and all the colours glow.

Long chains of corellas flew up the river near our campsite, their cries as slow as their wings. A heron flew past croaking and landed in a tree. Near my feet a little black-and-white sand wasp was fighting with a spider, the wasp deadly swift as the spider tried to escape and then succumbed to the slow ecstasy of the injection of the sting. The wasp paralysed the spider with this injection, then dragged it to the burrow where it will provide living food for grubs emerging from the eggs.

The bar at the 'Ironclad'

Deserted homestead Abydos

MARBLE BAR

Milan the grader-driver has four mistresses,
Graded, appropriately, from one to four.
His bulldog is called Révenger (he stresses
The first syllable), he's a terror to snore.
Sleek and brown as an onion, Milan is twelve days
Out on the road, two here when he plays.

In the Civic Centre, after an all-night party,
The Town Clerk takes his guitar and sings
Slow rambling songs. No one is hearty
But all are hale. The morning light stings
The eyes like salt, humbling urban pride.
There is nothing suburban. The street is too wide.

Milan is right, the black girls are pretty
Especially when the Ironclad Hotel releases you.
As for gold, it is not found in the city.
The old prospector with his little dog, who
Is called Spondulix, never struck
It lucky yet. Being humble is to count your luck.

At night in the driest of light the Milky Way
Swoops down on the answering river, while the bar
Holds closed secrets of jasper. Play
For Milan, number one, he is the star.
Snore by the door, Révenger, growl
In your dreams, Spondulix, let the dingoes howl,

Sleep like the stars still shining, gold
In the Ironclad's safe. And when before dawn
Light will already be resculpting fold
After fold in the barren hills, the day will be born
To birdsong, and life will flare again in the wilderness
Like a scarlet dragonfly on a pale blade of grass.

John was working with charcoal and crayon, Vin looking for birds, Ninette drawing, Alex talking on the radio to his assistant in Perth. Later we went for drinks at the Ironclad Hotel. It is built from iron sheets and is supposed to have been christened by some American miners, because it reminded them of the ironclad warships on the Mississippi during the Civil War. The Ironclad Gold Mine was opened in the 1890s but is long defunct, while the Comet Gold Mine is still working and a new mine, known as the Telfer Project, has a considerable potential.

A barmaid only just arrived from the coast served us rather nervously. Among the notices around the bar — 'No Shirt No Service' — was a board headed 'Local Drunks'. We were told that these gentlemen include an ex-RAF fighter pilot, quietly and happily boozing his last years away. He looks rather like Nöel Coward. Apparently he goes down to Perth twice a year and returns with an immaculate new outfit of clothes.

Then in came a grader-driver whom the party had met at Woodstock Station: a burly, glossy-skinned Yugoslav named Milan: twenty-seven, with an upward-curling moustache, one earring, and tattooed arms. This is the latest style in the North-West. In a bar at Port Hedland we saw a young man with a fat butt like a wrestler's bulging over his stool, drooping moustaches, blonde hair to his shoulders, three or four earrings in one ear and tattoos down both arms.

Milan drives his road grader on what is probably the longest run in the world in the largest Shire in the world. The East Pilbara Shire is 377 000 square kilometres, larger than the State of Victoria, but it has only 8500 people. Milan goes out for twelve days at a time, living in a caravan which he pulls behind his grader, and then returns to Marble Bar for two days. He keeps $100 in his pocket for his two free days, gets drunk on the first day and feels a bit ashamed when his girls don't mind his hangover on the second day. He has four girlfriends — 'Embarrassing the number of offers' — and has graded them in order of seniority. Number 3 does his washing and ironing — 'But she like my sister'.

When he returned from one trip he found that Number 1 had painted his place for him. He told her 'This bloody awful colour. Your taste is in your arsehole, no more paint.' He told us 'And it cost me three hundred dollars!'

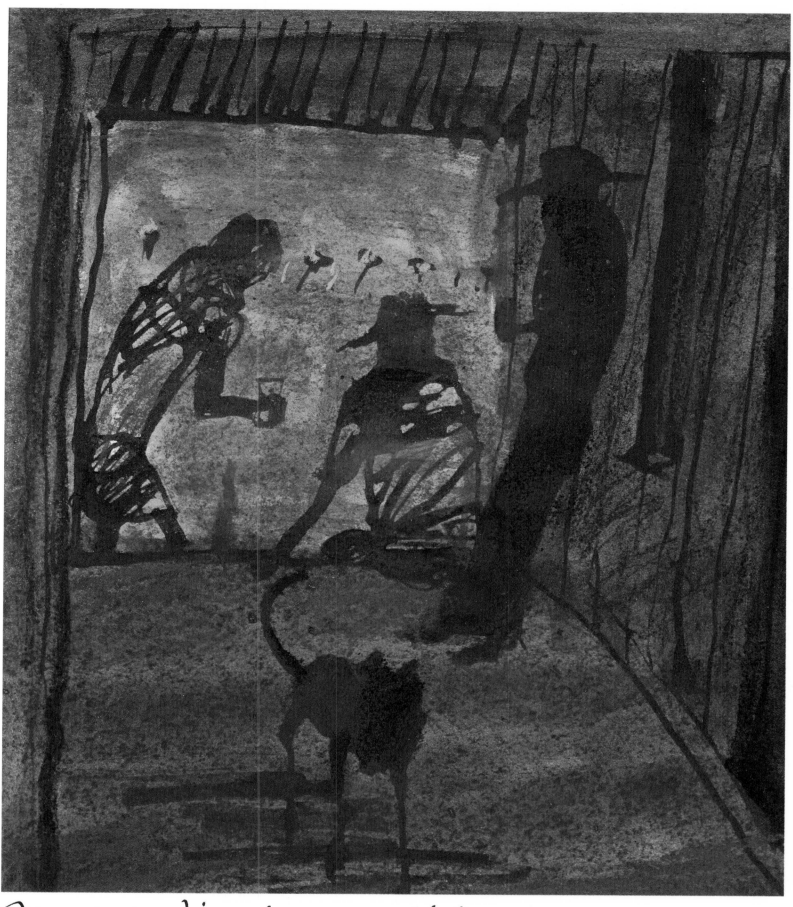

Aboriginals drinking Marble Bar

Normally grader-drivers work in pairs but Milan doesn't mind his own company. He has a bulldog named Revenger (pronounced Révenger) which cost him $300. 'He snores terrible. I kick him out of the caravan but he sleeps underneath so I hear him all the same. At dawn he hop in, pull the bedsheet off me, wake up, wake up!'

Ninette asked him why he had settled in Marble Bar. He said he was just wandering round Australia, stopped here for petrol and got drunk. Someone told him the foreman was stuck for a grader-driver. 'I go into the office, the foreman he is drunk, eyes hanging out on the table. He looks at me and says "You're drunk, you bastard. Right. You've got yourself a job." ' And so he stayed for five years.

There are fights regularly in the pub. One part-Aboriginal had been brutally beaten up by another, an older man, up in the hills. He met Milan and asked him what time the older man came into the pub. Milan said 'Four.'

'Right. I'll be here.'

Milan arrived at the same time, and he had just gone down the front bar when the young man came in with a shotgun and blew the older man's leg off. He got six months, but the police trooper said he should have got a longer sentence for not shooting straight and finishing the bastard off.

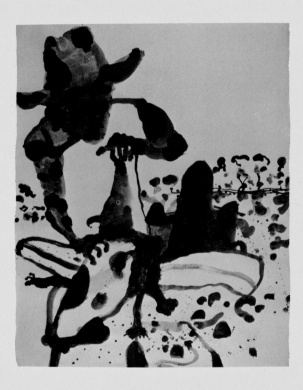

Feeding the Dog

When we wandered down the street we saw a group of very well dressed Aboriginal and white children. One five-year-old Aboriginal child sat under a tree eating a whole block of chocolate. Another Aboriginal child handed out sweets to whites and blacks impartially. I watched the walk of the teenage Aboriginal girls, with a swing to their ankles quite unlike the whites. A Toyota utility we had passed down the track, with ten or twelve people aboard, arrived in town and maybe twenty passengers got out of it.

Next morning we walked into town again and when we saw some people in the Civic Centre we went in. There was a party going on and they invited us to join in. The Shire Clerk, the Mines Department Registrar, the publican, the schoolteacher, a chunky Yugoslav and various girls had been up all night farewelling the Community Welfare man from the Aboriginal hostel. He was still wearing his pinstripe waistcoat.

John Read, the Shire Clerk, played a guitar and sang Californian rambling songs and we joined in the choruses. The G-string of his guitar broke and the other John, the Mining Registrar, said 'You'll be had up for indecent exposure under Section 54.' He told us 'Under Section 54 it isn't even safe to go into the toilet with another bloke.'

The Welfare Officer tenderly lifted the cover of a pram to put a couple of toys by his sleeping baby. A pretty girl drinking orange juice said 'I may be able to keep my eyes open but I can't stand up any more.'

John Read took us off and proudly showed us his Shire office. We wanted him to come to the pub with us but he said he had to go home and mow the lawn. In Marble Bar!

The Yugoslav told us 'Marble Bar is an earthly paradise, everything you want. No hassles.' John the Registrar said he couldn't live in Newman or Karratha or Dampier: they were just

Stockman

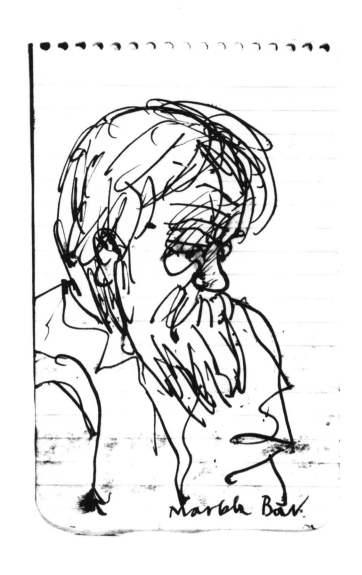

Marble Bar.

Marble Bar

Grader driver

bits of Perth. He said 'Marble Bar is most emphatically *not* suburbia' and that it was 'Not all that hot' even though it holds the Australian record: 160 consecutive days with temperatures above 100 degrees Fahrenheit.

Yes, he said, there was the usual problem of part-Aborigines 'not belonging' either to one race or the other. Recently there had been a soccer match between mixed teams of whites and part-Aborigines but it soon polarised into whites versus the others, 'Going at each other like Rugby.'

In the pub, John Olsen soon began 'making a notation': quietly sketching an old bearded prospector sitting with his dog by the door. It was a little Australian terrier named Pippa. 'Me old dog, Spondulix, I had him twenty years, he died on me a while back.' Brian the publican showed us some specimens of gold from his safe, and trustingly let Vin and me take a nugget worth $5000 up the street to a sunny spot to be photographed.

In an edition of the *Bulletin* I brought back from Sydney there was a reprint of Germaine Greer's article in the London *Observer* describing her trip to Marble Bar. She had daringly driven there from Port Hedland in a two-wheel-drive vehicle (surely she must have seen the old retired folk trundling along in their ancient Fords and Holdens?) and said it was a dreadful place full of dreadful people. She even seemed to resent the median strip they are so proud of. It was painful to think of outsiders taking her bilious and nervous article as gospel, though it was right for the *Bulletin* to reprint it to show Australians, in their innocence, what was being said about them in London.

From John Olsen's notebook: We leave Marble Bar in the morning travelling northwards towards Shay Gap. After leaving the Port Hedland road we were on a track that for the first time challenged our driving skills (much to my surprise the roads have been very good so far). Corrugations, crossing rivers, sand and awful dust. We came to a halt when we came to a road train with a load of cattle bound for Perth. The dust completely engulfed us, visibility was zero, the landscape was changed to a dusty pink.

A kilometre down the road they were mustering cattle, quite a social event. Whites, Aboriginal stockmen, women, all watching contentedly as the cattle were loaded onto a road train.

Geoffrey Dutton describes a similar scene: Three road trains were being loaded at Muccam Station, with black and white stockmen yelling and dancing, then leaping for safety onto the top rail of the yards. A handsome woman was the boss; her blonde twelve-year-old daughter obviously knew everything there was to be known about handling cattle. In that country most of the mustering is now done in those incredibly tough little Suzuki four-wheel-drives.

From John Olsen's notebook: The landscape before Shay Gap was spectacular old eroded hills, which gave the impression of antiquity oblivious of man.

Shay Gap itself was a prefabricated mining town, claustrophobically constructed in a hollow surrounded by the crumbling hills. Even though a miner told me he earns $850 a week I feel I would go mad in such a place.

Aboriginal
woman

Geoffrey Dutton has rather similar feelings about Shay Gap:

It lies like some kind of space capsule within its encircling ring of red hills. As an integrated architectural, environmental, and psychological attempt to overcome the North-West problems of heat, dust, cyclones, and isolation it has won the praise of architects and sociologists around the world, but it looked like a sanitised hell to me and I thought the people looked glum.

The official handout says 'Psychology has been applied to Shay Gap in many ways. Research has shown that wide areas of empty landscape tend to induce loneliness and isolation. So to combat this, Shay Gap has been subtly walled in from its environment.'

Something called a 'Distribution Road' encircles the buildings, and cars can only drive directly to the police station and the administration block. Shay Gap folk have to park their cars in sheds near the ring road and walk to their houses or flats or the single men's quarters. The hunched buildings are cyclone-proof; the tops of bigger trees showed the scars of cyclones in the last Wet.

A bowling green, tennis courts, a cinema, a club and a school are all located inside the circle. A central air-conditioning plant reticulates cold air to each house. About 700 people live there, mostly for no more than a year or so although we met some who had been there for ten years. They are very proud of something called a vacuum sewage system, which saves the water that has to come from the edge of the Canning Basin.

We lunched in the canteen, which served excellent food including turkey, and pressed on through Goldsworthy on a long drive which ended in a last-ditch, late-evening camp near Tabba Tabba Creek: in a dry riverbed, rather windy. At least there was plenty of firewood. There were noonflowers everywhere. I went to get my camera but by the time I returned the sun had gone off them and they had folded their little umbrellas.

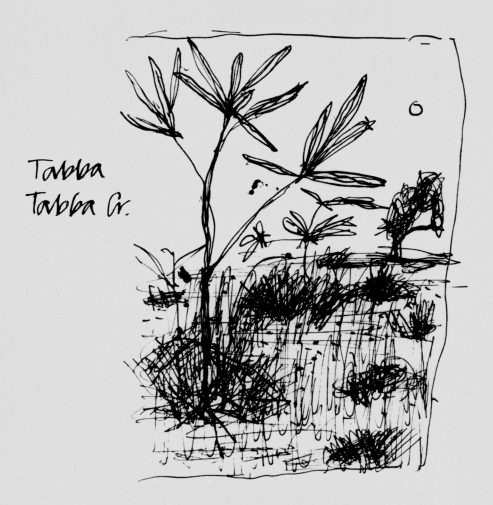

Tabba Tabba Cr.

Next morning we went to Strelley, perhaps the most interesting of the Aboriginal communities we visited although it was as depressing as all the others. Rubbish littered the landscape; shoals of abandoned cars, stainless steel washtroughs, old generators, bushes growing through a crane truck, broken windmills falling into tanks. There was no vegetable garden.

The resident doctor, Dr Scrymgeour, uses an aircraft to fly twice a week out to the desert camps. He told us that there is *E. coli*, the source of bowel infections, in the Strelley drinking water. It is ironical to read in Don McLeod's autobiography that nomad Aborigines always dug a soak near a waterhole, so that the sand would filter the water. As for rubbish, the Aborigines never had any that was not organic. The feeling that rubbish should disappear into the earth still seems to rule Aboriginal thinking and probably accounts for the unassimilable rubbish that degrades their communities. The Aboriginal attitude to their environment is a real crux that is seldom mentioned among their problems.

Talking
to the
dog

DAWN, TABBA TABBA CREEK

A little wind came before the dawn
Ruffling the singing birds.

All the stars were gone but one.
Light sifted through shades.

The little wind raced through the spinifex,
Upset the gravity of leaves,

Lifting ash from black sticks,
Growing a flame from the seeds

Of fire. Only the magenta moon-flowers
Refused to unfurl their petals.

The little wind impudently blew the fires
Of the sun and the wakened coals.

The last star went out.
The little wind fled over the hill.

A crow gave the last message of night.
Every leaf hung still.

Yet there is immense hope in the fact that Strelley is run by a council of ten Aboriginal men. (No women, but we were told they are 'Very influential in other ways'.) If the community makes mistakes or gains successes they are their own, and not the white man's.

Behind the Strelley Mob, as they are called, is the dynamic and eccentric figure of Don McLeod. He was not then at Strelley, although we were later to meet him in Perth where he talked with great speed and enormous vivacity about his life and work. John Buckland, a man of rare character and culture, with a remarkable wife, is in charge of Strelley but at the same time not in charge at all. He is simply the manager, to do what 600 or so Aborigines want to do on the five stations and the two desert outcamps. The latter are used for rehabilitation centres for drunkards and drug addicts and teenage prostitutes, and they are also very popular with the children who are taken there from the stations.

In the school we saw a lot of the children's drawings, and it was interesting to note that the drawings of people usually had white faces.

Vin Serventy tells the Don McLeod story:

In 1937, when he was working as a miner in the North-West, he saved the life of a part-Aboriginal by driving him to hospital. Don says that this simple act of kindness made him well-liked by the local Aborigines, but I have a feeling that his attitudes of racial equality and encouragement, towards a people despised by the local whites, were more important.

Five years later they asked him to act as their spokesman. After some hesitation he agreed, on condition that they should show their ability to work together. This was a difficult task for a people divided into many clans and he doubted whether they could do so.

But, to his surprise, he was invited to a meeting at Skull Springs where the leading law men of Western Australia, Alice Springs, and Darwin had assembled. They used twenty-four languages in their discussions and they took six weeks to sort out a plan of action which would take years to bring to fruition.

Slowly the people prepared their bombshell, with D-day set as 1 May 1946. Many could not read or write, but their leaders marked the date on calendar sheets and sent them around the stations. It was a simple matter for the Aboriginal station hands to ask their white employers how many days had to pass before reaching the mark.

On 1 May 1946 about 800 Pilbara Aborigines went on strike for the right to be treated like white workers in the area. The struggle was long and bitter but the strikers never returned to work on the stations. Gaoling the leaders failed to break their resolve and more subtle methods also failed.

Don McLeod's name became nationally famous — or infamous. He made the North-West and the Pilbara into front page news and he was both condemned as a dangerous radical and lauded as a progressive, although most people respected the physical and moral courage which underpinned his beliefs.

Don McLeod is still writing his three-volume autobiography, but the whole story remains a challenge to any historian willing to sift through the masses of available evidence, especially while most of the protagonists are still alive.

Don McLeod

The Strelley Mob, as they call themselves in the usual North-West way of using the word 'mob' as an all-purpose collective noun, includes many of the original 'mutineers'. In a report to the World Council of Churches, Don estimated that they now help about 2000 Aborigines. Strelley now has headquarters in Perth, the Nomad Charitable and Educational Foundation, and it runs its own financial, educational, charitable, and other affairs.

Don wrote in his report 'We buy stores at a reasonable rate and get them up to the Kimberleys, Pilbara, and wherever. We run two excellent bilingual schools, one at Strelley near Port Hedland and one at Noonkanbah. Strelley operates three annexes, one at Warralong fifty miles further east of Strelley, one at Lalla Rookh fifty miles south of Warralong and there is one at Sixty One Camp fifty miles east of Jigalong. We have half a dozen pastoral leases around Strelley . . .'

While we were at Strelley I picked up a community newsletter and found an article which gave the reasons for the success of the venture. The article said that the marrngu of Strelley have a strong sense of identity and that they are strong because they live by the Law; they have strong leaders; they are preparing other leaders to follow them; they have control over the cattle stations and the schools; they speak for themselves to the government; the marrngu language is strong and marrngu adults teach it to the children; wrongdoers are punished by the community and not by white laws, and cared for by the community; European teachers always try to know the wishes of the community, and the schools prepare people for jobs in the community.

When we met Don McLeod he was seventy-four but as fiery and vigorous as ever. He is certain that the only way for Aborigines to gain independence is by following the Strelley road, so that they may eventually become a separate nation able to deal with the white invaders as equals and sign a peace treaty which will ensure justice for all.

Geoffrey Dutton comments:

Of all the white men who have devoted their lives to working for the Aboriginal cause Don McLeod is probably the most interesting. He hates bureaucrats, anthropologists, big business, tourists, drunks, communists — practically everyone except Aborigines.

The lynch-pin of his cause is that, under Section 17 of the Constitution of Western Australia, one per cent of the State's revenue was promised to the Aborigines. But the politicians managed to sweep this under the carpet as long ago as 1905.

In his autobiography he writes 'Not enough has been written on the noble and sensitive nature of the Blackfellows.' He has an immense knowledge of and respect for their Law, and everything in Strelley and its satellite communities must be done according to that Law. The Aborigines are very strict about such things. As Don McLeod remarked to us 'They're buggers for protocol, the Blackfellows.'

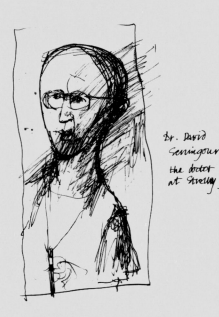

Dr. David Scrymgeour the doctor at Strelley.

On another aspect of the Strelley Mob and the Aborigines of the North-West, Vin Serventy writes:

Dr Scrymgeour told us that most of the people were 'out bush,' and we heard this often on our visits to Aboriginal communities. The Aborigines have not entirely forsaken the old ways of the hunter-gatherer: people who divide the task of feeding the community between the men, who hunt the larger game such as kangaroos, and the women, who gather edible plants, seeds, and roots and small animals.

The Aborigines now hunt with guns rather than spears but the throwing stick still has its uses. The women's digging sticks still unearth such delicacies as yams and honeypot ants, and

Emu Kimberley

they gather nardoo, lily roots, and seeds of innumerable kinds. They use matches now and do not have to carry fire with them but they still know how to make fire by friction. I watched one group produce a flame within two minutes of starting to gather firemaking materials.

Once, all mankind existed as hunter-gatherers, until some innovators learned how to till the soil and sow the seeds of grain, and others to domesticate various animals. These techniques enabled various tribes to settle in fixed places, build cities, and develop the social systems which allowed their leaders to plan schemes of conquest. The bondage of mankind started when primitive technologists made hoes and ploughs to cultivate the soil.

No doubt many of the earliest white agriculturists in Australia would look up from their labour and envy the Aborigines drifting past on their eternal search for food. The country yielded it profusely to those who knew where to find it, and the nomadic clans probably led fairly leisurely lives. They would spend five or six hours a day rather pleasantly in gathering food, and the rest in play or in ceremonial life.

The nomads carried their worldly goods along with them. Men wore belts of human hair and carried a stone axe, a throwing stick or boomerang, a spear and spear thrower, some spinifex gum, ochre, and a sharp cutting stone. Women might carry a wooden bowl, a pounding stone for grinding seeds, fur or hair for making string, and a smouldering firestick to start the cooking fire at the next camp.

Each adult knew how to create what he or she needed but there were some acknowledged experts. A friend who worked in the Kimberley once showed me a borora, a carrying bag of paperbark, containing thirty-four beautifully shaped spearheads of rose quartz. They were very beautiful as well as being efficient weapons. The maker was a crippled man who specialised in this work for the rest of the group.

Bush tucker might seem somewhat repugnant to the average white Australian but there can be no doubt that it is nourishing and sustaining. Australian journals have reported the experiences of two doctors, Kerin O'Dea and Randolph Spargo, who went walkabout with fourteen Aborigines from Mowanjum, near Derby. The Aborigines had an average age of fifty-four and ten suffered from diabetes, which is an increasing health problem of the Aborigines. When flour, tea, and sugar replaced bush tucker the change in diet and the resulting obesity helped to encourage diabetes, and the Aborigines have a level five times that of white Australians.

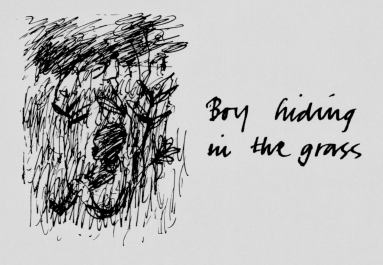

Boy hiding in the grass

After seven weeks in the bush, eating the variety of food available to their ancestors for thousands of years, the Aborigines were all the better for the experiment. They ate well of such delicacies as kangaroo, black bream, turtle, crocodile, prawns, figs, yams, and bush honey, and returned home with a loss of fat, a shiny skin tone, and a generally more youthful appearance. There was a marked drop in diabetic symptoms and the doctors believed that if the experiment had continued the diabetes would have been cured.

The doctors, however, did not do so well. They missed the bulk and the carbohydrates of the white Australian diet. Dr Spargo returned after two weeks, having lost six kilograms. Dr O'Dea was losing so much weight that she sent back to base for potatoes.

In Western Australia the infant mortality rate among Aborigines is five times that of whites. Disease and alcoholism are apocalyptic horsemen here. Their causes are many, but they may often spring from a diet unsuitable for descendants of a hunter-gatherer society which lived on fresh bush tucker.

The complexity of dietary influences is indicated by the results of another research programme. This showed that Aborigines at Mowanjum and Fitzroy Crossing have low zinc levels in their blood. A zinc deficiency affects physical growth, intelligence, and immunity from

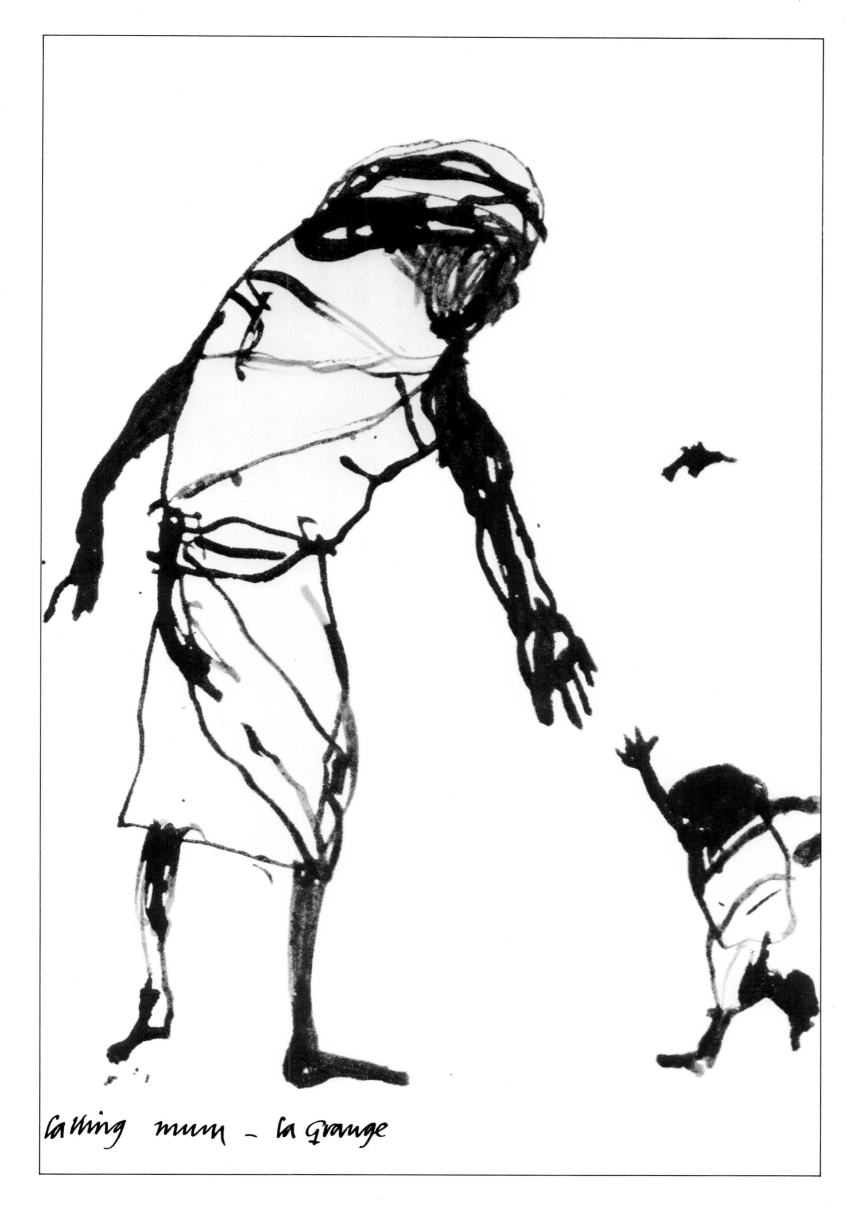

calling mum - la Grange

diseases, but in the old walkabout days the people would have absorbed all the zinc they needed from bush foods and especially from seafoods gathered on beaches and reefs.

When western technology attracts hunter-gatherers away from their ancient lifestyle the results are likely to be physically and spiritually disastrous. The same applies to attempts to force a nuclear family pattern upon people whose tradition is that of a much broader kinship: an allegiance to every member of the clan. In the past, this inter-dependence was one of the reasons why the Aborigines could survive. In the present, the breakdown of relationships which stretch back into the dawn of time is one of the reasons for Aboriginal hopelessness and despair, from which they seek anaesthesia in the white man's alcohol.

And yet there are great difficulties in any attempt to restore the hunter-gatherer lifestyle to the Aboriginal population of Australia. For example, those of us who feel that national parks should be places of refreshment and fulfilment for all the people of Australia think it is absurd that, in such places as Kakadu, the Aborigines should be allowed to use western technology such as shotguns, rifles, four-wheel-drive vehicles and speedboats to continue their 'traditional' hunting.

Perhaps it is time we tried to thread together the two strands into which mankind was divided. The tiller of the soil triumphed because of technological mastery, but we are beginning to realise that, to be whole persons, we need the joining of both strands of our nature.

The lifestyle of the hunter-gatherer has a lesson for modern man. Exploding populations threaten to destroy the fragile web we call civilisation as hungry mouths devour each new success in expanding our food supplies. The hunter-gatherers faced the same problem but they had their own solutions. They knew that the worlds of their clan territories could nourish only a fixed number of people and they limited their populations by strict marriage laws. A long lactation period helped, as a kind of natural birth control system, and children were spaced into about four-year periods. Small families meant that each child could receive the maximum of loving care and attention, including expert training for the life of an adult who could step into his or her proper place in the clan.

Vince at Mandora.

From Strelley the journey continued to Wallal, Mandora, and the La Grange Mission. Geoffrey Dutton writes:

The camp at Mandora-Wallal was the most desperate of the trip. We had arranged to call on the de Pledges at Mandora Station for permission to camp at an appropriate place near Eighty Mile Beach, but they were out when we arrived. Also waiting for them were Michael and Wendy Cusack and their children, from a farm in the south-west. Thomas Cusack, whose grave we saw at Tambrey Station, was Michael's uncle.

At last we all decided to look for a campsite, but we missed the turn and drove on down the old coast road with growing despair at the treeless expanse. It was almost dark before we saw some trees in the distance and drove across the plain, past a dam and a bore, to find a sheltering group of tall tamarisks and the remains of an Aboriginal camp: a heap of rocks for the fire, rusty droppers to support the cookpot, an old red car seat under a tree, bottles and cans everywhere, and the stinking carcass of a kangaroo hanging from a bough. But we managed all right and the Cusacks joined us around the campfire. It turned out a good camp after all.

In the morning there was a clear sky but the sound of thunder. It baffled us as it came steadily closer. Could it be an aeroplane? A truck? It turned out to be the hooves of a hundred brumbies, galloping up to the bore and dam, manes and tails flying, many of them as grey as the sand plains. The stallions wheeled around them, keeping them in tight formation.

A wise dog

Mandora. meathouse.

After breakfast we walked about three kilometres down to the beach. Down from the sandhills it stretched endlessly straight in both directions, in exquisitely soft colours of pearl, mother-of-pearl and the palest turquoise, the colours caused by the huge tides stirring sand into the water. There were shells to find on the long walk over the wet sand to the edge of the sea. It was utterly peaceful.

Vin Serventy writes of Eighty Mile Beach:

Aborigines of previous ages fossicked here for fish trapped in pools, and gathered molluscs both for food and for the shells which they traded on a system spanning the continent.

Baler and pearl shells from the Pilbara and Kimberley beaches moved east and south: some along the coast into Arnhem Land, others right into central Australia and as far south-east as the coast of Eyre Peninsula in South Australia. Years ago I bought a beautifully inscribed pearl shell pendant from an old man in Alice Springs. It was a type gathered and decorated on the Eighty Mile Beach, and worn hanging from hair belts by initiated men.

Many modern pearl shells can be traced back to Joe Nangan, nicknamed Butcher Joe, who still lives in the Kimberley. We were to meet him in Broome. Anthropologist Kim Akerman says that Joe's work is so distinctive it can be used to trace shell movements across the desert.

Pearl and baler shells were not the only trade items and it was not a one-way business. Bean wood moved from central Australian deserts to the region around the La Grange mission settlement. Ochre from Wilgie Mia was traded far to the north of its site near Cue.

Dr Phillip Playford has described a trade in the sacred boards, symbols of the culture heroes of the Dreamtime, which are shown only to the men of a tribe. Boys and young men between fourteen and twenty-four years old had to learn the Dreamtime legends from the markings on the boards, which are often maps of the travels of the culture heroes. Many of the boards are carried on journeys as long as those of the legendary heroes.

So many tonnes of pearl shell have been traded over the centuries that there would not seem to be any need for fresh supplies in central Australia, but the shells are worn away during rainmaking ceremonies and so there is a continuous need for fresh supplies. Pearl shell in central Australia nowadays have the scars typical of the pearl blisters from modern pearl culture farms, which shows that the trade still goes on.

The anthropologist Charles Mountford described rainmaking ceremonies used when he travelled with a group of thirty old men in the Mann Ranges. They faced the problem of a waterless desert, and so the men decided they should make rain. They used a method taught them by a perentie culture hero of the Dreamtime, and a pearl was a symbol of a mass of water in a place far to the west where giant lizards (possibly saltwater crocodiles) lived.

To release the rain, the rainmakers went through a complex ceremony in which they ground the edges of the shell, mixed the powder with blood from their own bodies, and spat it into the sky. But no rain fell and so the men performed a much more elaborate ceremony, and Mountford recorded that heavy wind and thunderstorms swept over the area where he was working.

If the rainmakers brought too much rain, then they used another ceremony to put a stop to the downpour.

On Eighty Mile Beach we saw flocks of small grey birds flying swiftly from one feeding place to another along the shore. They seemed comparatively few, and yet an accurate count of these wading birds has revealed astronomical figures. Keen ornithologists of the Victorian Waders Group carried out an aerial survey of the coast between Broome and Port Hedland, to count the birds which make the great annual migration from Siberia to Australia and back each year, and came up with the staggering total of 536 000.

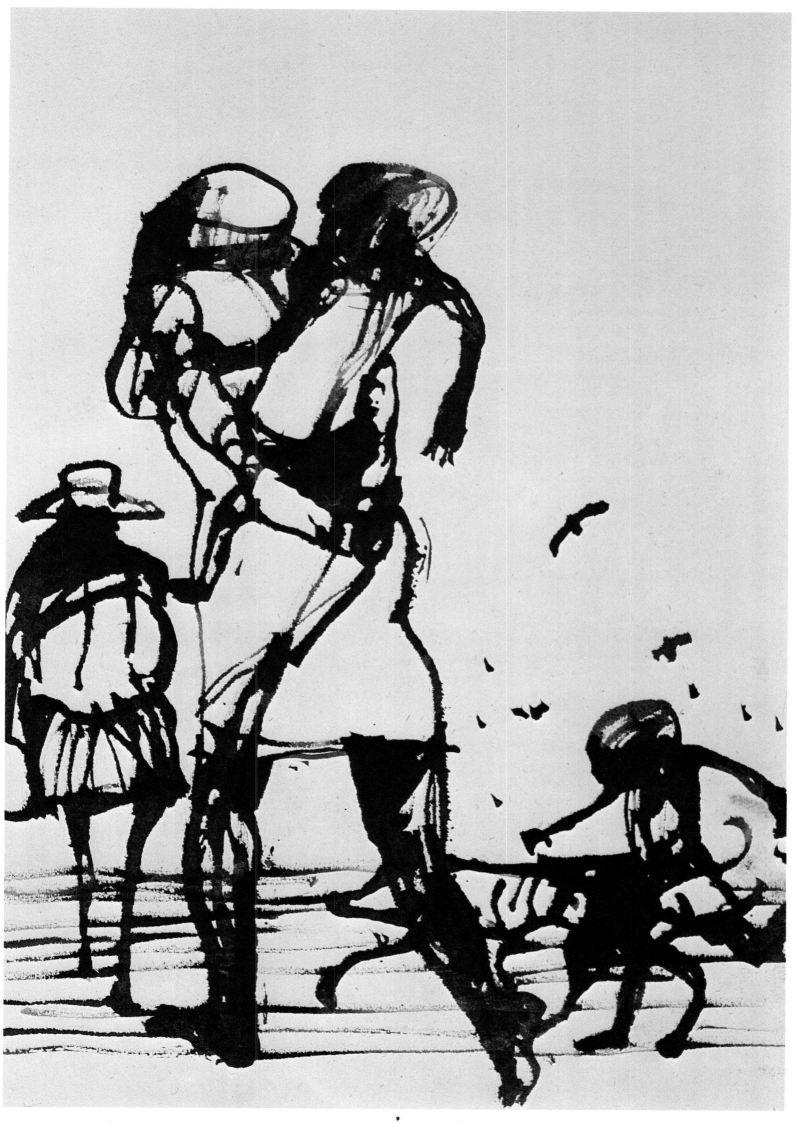

coming home from the mission La grange

Most of the birds we saw were youngsters hatched only a few months before, yet able to fly without guidance from their parents over a route they could know only by instinct. They pause for a few weeks on the sandy flats of Eighty Mile Beach, regaining their strength after the long flight from Siberia, before continuing their aerial journey to the feeding grounds of southern Australia.

Born in the far north, where the sun never sets during the brief summer, these birds would first experience darkness on their way to Australia. They would enjoy our long summer days and short nights but the coming of autumn would trigger their passion for daylight and start them on the long northward flight, back to their birthplace in Siberia. They continue this migration pattern, possibly established hundreds of thousands of years ago, for the whole of their lives.

From John Olsen's notebook:

We break camp after a walk across dunes to Eighty Mile Beach, the tide sweeping towards the horizon — a mile from the beach. The sea hung like a blue necklace. A drive to La Grange Mission. We make a comfortable camp just over the dunes from the beach.

At La Grange the church is bowing out, reluctantly, disappointed. The government is throwing in its hat, hoping to find the missing Aborigines.

The Pallottines acted with love and concern for their little 'sheep'. It cost the taxpayer very little, now everything will cost . . . certainly the Pallottines made an error in not delegating more authority to the black people — they never took them to the next stage.

Father McKelson shuffled sadly. [He is] a brilliant linguist who speaks five native languages. The bureaucrats arrived a fortnight ago, the church is about to disappear. He showed some slides of nomads, the last of their kind, who arrived as late as 1967. 'Those were the better days,' he said.

To quote Mary Durack 'The conversation between whites and Aborigines is interesting. Europeans stress material values; Aborigines stress human values. Unlike Europeans they were more concerned with being than becoming.'

CHILDREN'S VEGETABLE GARDEN, LA GRANGE MISSION

Dark eyes under
The gravid pawpaws,
"Cabbage, look, mister
Getting ripe, bananas."

Eyelashes long and
Soft as butterflies
Hide under foreheads'
Ancient histories.

Fingers stroking
And guiding lead you
To sweetcorn growing.
Laughing eyes gleam through

Silken tassels,
Sunflowers the height of
Measuring hands.
Grins grow wider

Than white radishes
"That one fat enough
To eat." He vanishes
In the leaves of mangoes.

The boys all proud of
Their T-shirts saying
'Kimberley Round-Up,
'82, Wyndham.'

One girl in cotton,
Lovely bare shoulders,
Looks down. "She naughty
Girl, not allowed to

Go." She runs away
Frowning, and the staccato
Words flow under
The sparks of laughter.

In the school they were drawing
Faces marked 'Happy.
In between. Unhappy.'
In between already,

She's happy by the tomatoes.
They are all growing
Together like gardens,
The water is flowing,

But what is hidden
Beyond the last row?
All good children
With nowhere to go.

Geoffrey Dutton describes the visit to La Grange Mission:

We camped three kilometres or so west of the Mission, in behind the sandhills along the beach, a good camp with plenty of wood. It was possible to swim, but because of the immense flat beach you could only lie down in a few centimetres of milky water and get wet. You could hardly call it swimming.

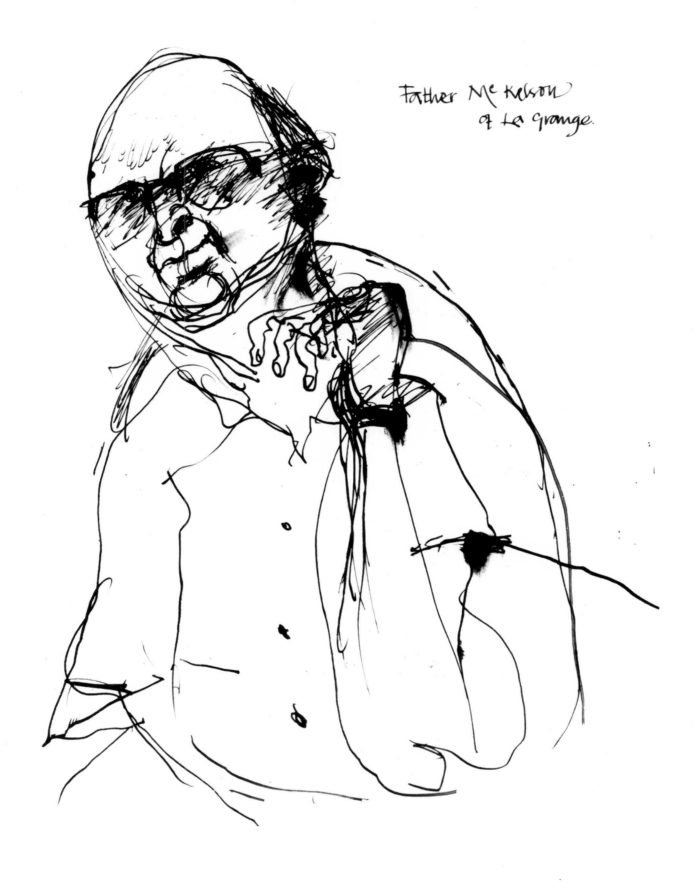

Father Mc Kelson
of La Grange.

The beautiful Mission, with its garden and trees and handsome housing, under Father McKelson, was in the process of being handed over to an Aboriginal community management. There was an aura of uncertainty, disappointment, and anxiety among the Mission workers. Whatever the rights and wrongs of mission relationships with the Aborigines, one could not help being impressed by the dedication of the priests, sisters, lay brothers, and men and women workers and technicians in this as well as all the other missions we visited. They have made these communities viable and one wonders what will happen when they go. Some were very bitter about leaving.

There was a splendid schoolteacher, rampaging about the idiocy of not being able to order the books she needed from Perth. She wanted fundamentals and they were sending her treatises about irrigation in ancient Mesopotamia. At another mission we visited, Balgo, the children were being taught about the cathedral towns of France.

Play time
— La Grange

All the Grade 7 children in the North-West had been to the Wyndham Round-Up, and the La Grange children were busily writing about their visit to Broome and Wyndham. The bus had broken down for two days on the way but the teacher said it didn't worry the Aboriginal kids, whereas white children would have been frantic with boredom and anxiety.

Some of the children were from the desert and were very slim with fair hair. One, Binji, was bewitching in her red skirt and T-shirt, washing her hands and face in a basin in the yard with the grace of a cat. *Very* naughty, we were told. A pretty girl in an off-the-shoulder dress took my hand and two of the boys took my arm — they love to touch — and off we went to the vegetable garden. Other children led other members of our party. The children were so bright, and so beautiful with their mobile bodies and big eyes and great fringed eyelids, all talking in staccato sentences about sweet corn, cabbages, lettuces, bananas, mangoes, melons. 'And big white Chinese radishes, getting fat, ready to eat.' They eat what they need of the produce and sell the rest and keep the profits. The next thing they were going to buy was a TV game. One boy had four brothers working in the garden: they all drove past us on one tractor.

I asked the pretty girl 'Did you enjoy Wyndham?' She hung her head and the boys giggled 'She naughty girl; not allowed to go.' She walked off, head low, but in a few minutes she was back again as jolly as before.

As we walked back to the school I wondered what would happen to these beautiful, intelligent children. What is in store for them in the North-West or anywhere else?

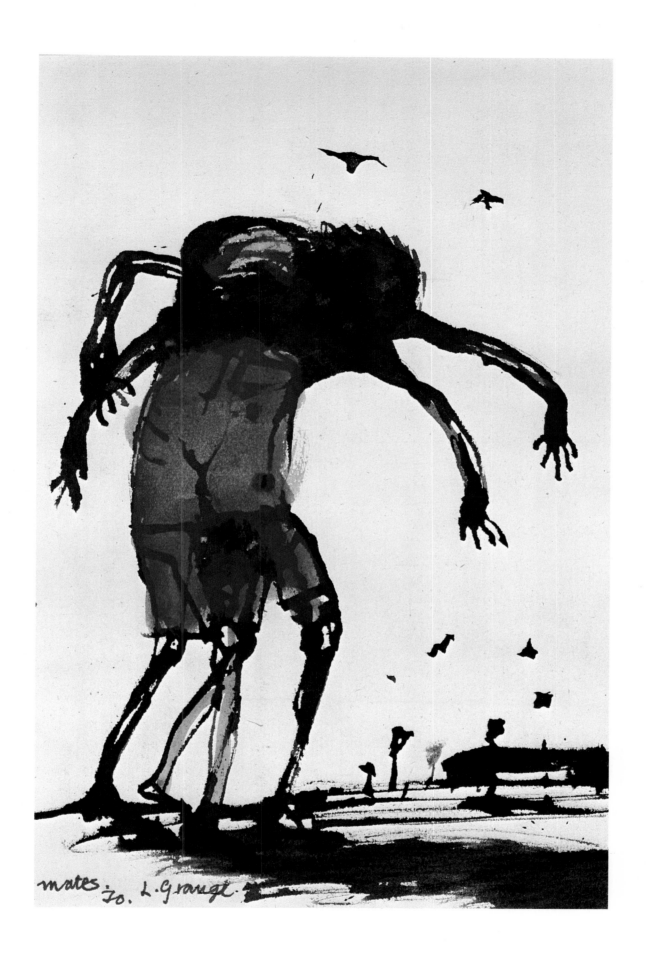

mates. 70. L. Grange.

In the evening we walked along the beach, where a man and a girl appeared with an Alsatian and a shorthaired pointer. Ninette and I saw the two dogs suddenly chasing a corella which flew just above their heads: diving, circling back, keeping just out of reach of their leaps before it swung back and landed on the man's wrist. They played the game again and again until the Alsatian lay down and the corella hopped onto its leg, put its beak into the dog's mouth and gently nipped its tongue.

LA GRANGE BEACH

At magical morning, at low tide, there are two horizons,
The sand slides into the sea, the sea ends in sky.

There are parallels of parting, pearl into milky turquoise,
The enormous tide makes runnels in the sand that dry

In the shapes of trees holding up dead branches
On which shells rest like flowers that do not die.

In the nacreous light man shrinks to a seed-pearl.
But in the evening it is different. How should the sun have a rival?

There is only one horizon, the water turns grey.
Then a girl and her man come running down the sand hills

Onto the beach with their two dogs, and away
The dogs go, bounding across the shallows, chasing

A bird, a white corella, its wings stay
Just out of reach. How could such an amazing

Thing happen in this immensity, a play
Of dogs and cockatoo? Suddenly the bird is landing

On the man's wrist, nodding, and saying "Goodday",
And a moment later it has hopped down onto the Alsatian's

Paws and is tugging the dog's tongue with its beak. Day
Is ending, the poet was right, love is the kelson of creation.

The man and the girl were teachers from La Grange and they said that they loved it but the missionaries had to move with the times. The corella was less than a year old. The Aboriginal children had taken it featherless from a nest and would have tortured it to death, but the schoolmaster saved it.

That night we had dinner at the long table in the mission. Father McKelson was soft-spoken and growing deaf: one could feel his sadness but he was not self-pitying. He said he had begun on the Left but was swinging to the Right, especially over the issue of alcohol. They used to ration it to the Aborigines but now it was unlimited. He introduced John Olsen to a girl, a very talented artist, 'But she drinks.'

Brother Richard Besenfelder, an old-style German, had been in the North-West since shortly after the Second World War. It was he who found the Dutch flying boat, carrying diamonds from the East Indies, which the Japanese had shot down at Beagle Bay. He had built a windmill every year of his stay in Australia, 'And every one just so,' said Father McKelson, running his hand up and down. Brother Richard was very tough, and he said 'You can't get the natives to be reliable. I can train them to service the windmills but they won't bother to do it. There is not one here who could pull an engine down.' One wonders how much responsibility they had really been given.

Father McKelson said that the children were virtuous and sensible within the parameters of the school, where there were clear rules, but when they went home there were no rules. He said the boys were delightful until their initiation, but after that they were 'Hopeless'.

We walked back to our camp, under the corpses of flying foxes hanging from power lines on which they had been electrocuted. The Aborigines of the mission do their cooking in the open and at least one fire, sometimes two, burnt outside each house. The men waved to us. The tempo of life was slow and agreeable, so different from the white southern cities of Australia which supply most of the money to run Aboriginal communities. Will they ever become self-supporting? The cattle on Strelley were a mere remnant of the previous herd and there was no garden to help to feed the people. La Grange had a magnificent garden but no real system to

24th

Mandora old meat house

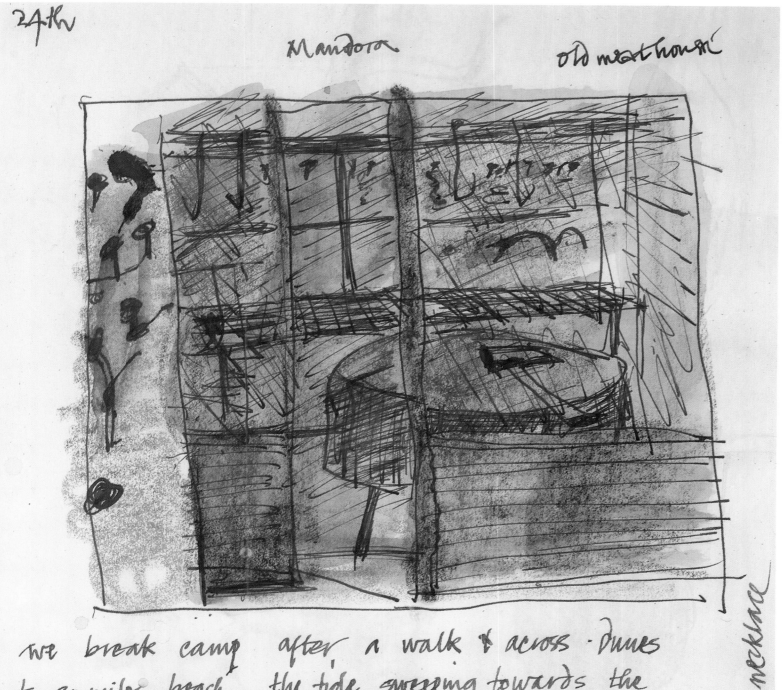

necklace

we break camp after a walk & across dunes
to 80 miles beach, the tide sweeping towards the
horizon — a mile from the beach. The sea hung like a blue
 necklace
 A drive to La Grange
 the dunes
Mission. We make a comfortable camp just over from
the the beach.

market its produce, although one longs for fresh fruit and vegetables in the North-West. When Vin asked whether they had thought of setting up a stall on the main road to sell garden produce they shook their heads and made excuses.

At present white people are trying to submerge their guilt feelings about Aborigines beneath a deluge of money: unemployment benefits, medical care, unmarried parent allowances, housing, community advisers, the provision of heavy equipment, and so on. The wrongs of black Australians are still legion, but most white Australians simply have no idea of how much is being done for the Aborigines and a great variety of part-Aborigines. There is in fact not simply one Aboriginal problem but scores of them, and they vary from one community to another. Unfortunately it would appear — and examples were quoted to us all over the North-West — that some Aborigines are now becoming as cunning as white Australians, and learning how to spirit away the funds and equipment that are supposed to improve the lot of their brethren.

La Grange

mates.

6 | PORT OF PEARLS

BROOME

Mary Durack and Carol Serventy flew north from Perth to join the travellers in Broome, and Mary writes:

Our arrival coincided with the port's annual Shinju Matsuri, which is as unique among festivals as Broome is unique among towns. The reason for its unusual character goes back into the port's recorded history of more than 100 years, and into many unrecorded centuries before that, of which a traveller may gain some impression from the colourful parade that opens Broome's gala week.

The procession is a jumbled summary of Broome's history, led off by a many-legged Oriental dragon of fearsome visage. The floats that follow remind us of the pearling industry and of the multicultural population which it attracted to this area. The Aborigines are represented by their descendants, painted in Dreamtime tradition and cheerfully waving weapons at the modern invaders of their territory.

So much for the past, and here come the children of today: an attractive mixture of the races dressed as fantasy characters of distinctly European origin. Here come Snow White and the Seven Dwarfs, Alice in Wonderland, the Phantom and his pygmy henchmen . . .

Visitors who want to fill in some of the gaps in local history left by the parade may begin with a visit to the Broome Museum, in the port's old Custom House. It was established by the local Historical Society with the dedicated assistance of Mrs Jean Haynes, the daughter of the early pearling identity Herbert Kennedy.

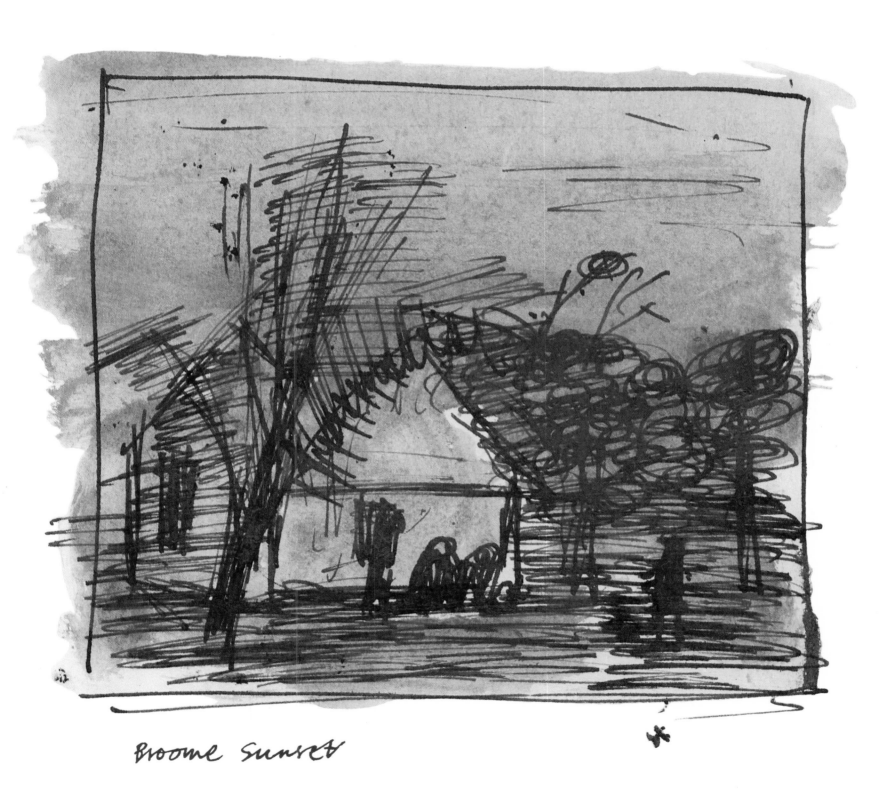

Broome Sunset

On entering the museum one is confronted by a diorama depicting the 1688 arrival of the buccaneer ship *Cygnet* in the bay that now bears its name. William Dampier, a member of the crew, returned ten years later in the more reputable role of captain of HMS *Roebuck*. He was the first Englishman to write an account of the Western Australian coast and its Aboriginal people but he did not see them as having any potential for European interests. In his book *A New Voyage Round the World* he described the Aborigines as 'the miserablest people in the world' and the coastline as a waterless region of sandhills and barren lowlands behind dangerous reefs and shoals.

He documented some interesting shells picked up in the vicinity but saw no promise of wealth in the waters or on the land.

Dampier's memory is kept well to the fore in this part of the world by such place names as the Dampier Archipelago, the Buccaneer Archipelago where the *Cygnet* was careened while the crew camped ashore, Roebuck Bay on which Broome is situated, and the Dampierland Peninsula which stretches north from Broome to Cape Leveque and south along King Sound.

Pearling began along this coastline in 1861, when James Turner in the vessel *Flying Foam* collected pearl shell and 150 pearls in Nichol Bay off the little town of Cossack. By 1873 more than eighty boats were pearling in Nichol Bay, using Aboriginal men and women enticed or shanghaied into service as 'skindivers'. Sometimes they were held in 'labour pools' on outlying islands to meet seasonal demands. Protest movements of the 1870s put a stop to this practice and caused the pearlers to seek divers from further afield. They used Timorese and Javanese to

Netting in Broome.

begin with, and when they introduced the conventional diving suits of that period, with air-fed helmets and weighted boots, there was no lack of eager recruits from Asia, the Pacific islands, the West Indies, Timor, and the Philippines. When the Governor-General visited Broome in 1901 the residents told him that the town could boast people of any race he could name. Local legend says that he challenged his informants to find him an Eskimo — and they did!

Broome was proclaimed a town in 1883 and named after the State governor Sir Frederick Napier Broome. Western Australians predicted it would become an important trading base — 'an Australian Singapore' — but it was to have a different destiny. There was no sign of permanent settlement until 1889, when the prefabricated materials for an elegant cable station for the British Eastern Extension Telegraph were unloaded in Roebuck Bay. These should have been delivered to a rather more advanced outpost of the Empire, Kimberley in South Africa instead of the Kimberley in Australia, but since the cable company was planning to establish a submarine cable link between Western Australia and Java, the building was, after all, erected in Broome.

Pearlers began to move from Cossack to Broome in the 1890s, when they found good shell offshore and realised that Roebuck Bay offered adequate shelter and freshwater springs. Broome suddenly found itself on the map as the centre for the best quality pearl shell in the world, and a fleet of luggers, cutters, sloops and junks converged on the embryo port. A few of the master pearlers, sailing in well-appointed 'mother schooners', brought their wives and families with them. As time went by they moved ashore to set up comfortable bungalows around the bay.

By that time, pearling was regarded as the most remunerative but most hazardous industry in the colony. The Broome cemetery bears evidence on tombstones and monuments of many lives lost in the unpredictable cyclonic storms, from the dreaded diver's paralysis or 'bends', and from attacks by sharks or other predators. But pearling had become a way of life to the people

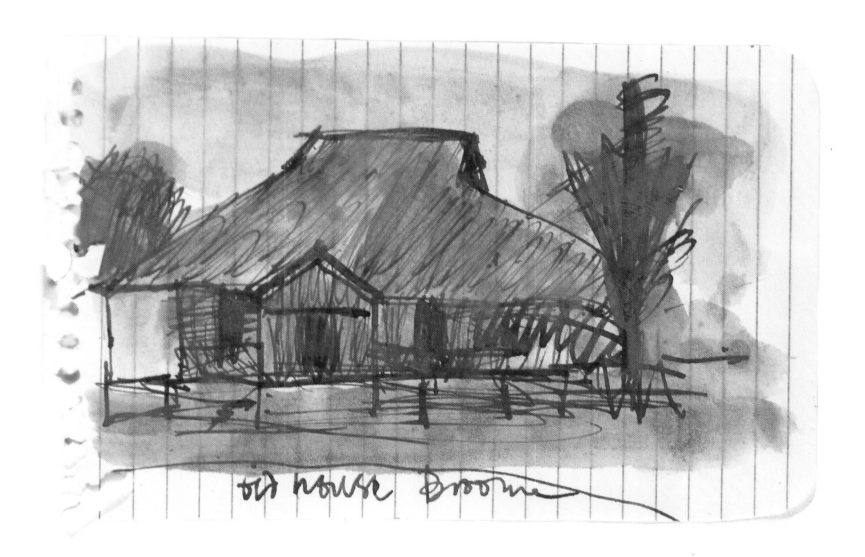

old house Broome

of Broome. Some of the world's most famous pearls were found in North-West waters, although the basis of the industry was pearl shell. In those pre-plastic days it was sold to the 'button trade', and people in many parts of the world fastened their garments with 'pearl buttons' made from North-West pearl shell.

By the early 1900s pearling in Broome employed over 2500 men in 300 luggers and netted some £200 000 a year, the equivalent of several million dollars in modern currency. Japanese pearlers first appeared on the scene in 1885 and they gradually became the most successful divers as well as the principal operators and manipulators of the industry. The local Japanese Club was a factor to be reckoned with. Chinese families had also emigrated to the region and they established shops, restaurants, gambling houses and joss houses in the business area, known then and now as Chinatown.

Broome grew into an attractive township of white-painted bungalows, along roads paved with shell grit that gleamed brightly in the sun, although there was no distinguished architecture apart from the cable station. It is now the law courts. The inhabitants sorted themselves out into a social pattern in which the various racial groups co-operated at a business level but otherwise kept more or less to themselves, and continued their own lifestyles.

As time went by, everyone shared in and enjoyed the annual national festivals of the various races. At New Year, gaily-bedecked luggers and schooners raced for the European Pearlers' Cup and everyone dressed for the occasion in traditional style. Chinese, Malays, Cingalese and Filipinos celebrated at different times and in their different ways, but the Japanese Bon Matsuri festival, the feast of lanterns for the dead, outdid them all. For this occasion the Japanese community dressed in their national costume and staged a ceremonial launching of miniature luggers laden with token gifts of flowers, food and wine to comfort the souls of their countrymen lost at sea. After the launching they lit lanterns in the Japanese cemetery.

In early years they left bottles of saki (rice spirit) on the graves, but when these were found to be more of a solace to the living than the dead they embedded the bottles in cement. Even so the saki was 'spirited' away, and when the Japanese found drinking straws strewn around the cemetery they abandoned this part of the ceremony.

For many of the Europeans, especially the so-called 'verandah pearlers' with coloured servants to cope with the chores, life was more like that of British India than Australia. In later years I heard many stories of these times from such Broome friends as Con Gill, a West Indian. Con, with his talking cockatoo, was one of the legendary characters of the town, and some idea of his memories may be gleaned from an extract from the verses in which I recorded them:

> *Nineteen hundred — round 'bout there*
> *I come here first with long, black hair*
> *Same gold rings in same brown ears —*
> *Carried 'em goin' on eighty years!*
> *The folks here then — old Con can't tell*
> *Which gone heaven and which gone hell . . .*
>
> *White man, yellow man, black man, brown*
> *All together in the little white town.*
> *Luggers lie out in the big blue tide*
> *Some pearl honest and some pearl snide.*
> *White man wink and yellow man nod*
> *For the pearl is Satan and the pearl is God . . .*
>
> *Nooo! Con don't marry, but he got two eyes —*
> *He seen things — oooh! You be surprise.*
> *But the kids grow fine by the good warm sea*
> *Filipino, Chinaman, Abo, Singalee;*
> *And no-one go hungry — everybody feast*
> *When the luggers roll home on the big south-east . . .*

Probably Broome's peak of prosperity was during the last two years before the First World War, when the population of 4000 included 3000 working as divers and crew for more than 400 luggers. After that time the fortunes of the town and its people assumed something of the tidal patterns of the locality.

Prospects improved after that war, which had seen the discovery of Australia's largest pearl, the Star of the West, off Broome in 1917. The 1930s depression brought another decline, especially since the inshore pearl beds had been over-harvested and divers had to go deeper and deeper in search of shell. The second World War ended Japanese domination of the industry, which faded away during the war. After that there was a fresh spurt of activity although the number of boats had sadly declined from the great days early in the century. Only about thirty boats worked out of Broome but the price of pearl shell was high. For top-quality gold-lip shell

Tjakamarra
'The Boy between two Worlds.'

it soared to £1000 per ton on the London market before plastic buttons virtually destroyed the industry.

My own memories of Broome begin in the early 1930s, when life seemed to proceed at a reasonably cheerful pace despite nostalgic talk of better days gone by. Broome today is more lively and cheerful than ever before but it is to some extent a ghost town for me. I have only to close my eyes and the pioneer pearlers who still lived there in my youth are all back again, in their topees and white drill suits, converging on the old Continental Hotel as the sun sinks below the yardarm. They were sometimes called the 'pearling fraternity' but one gathers they were not always united in brotherly love. Listening to the yarning of a group of men, or to the gossip sessions of their women, one would soon have plots for a dozen novels of mystery, chicanery, and intrigue. But none of the things they claimed to know about each other seemed to detract from their enjoyment of those evening gatherings, and we took for granted the strange and colourful stories of men who live for me now as vividly as they did in those vanished years.

Let me introduce you to some of those pearlers of the past. That handsome fellow is Devonshire-born Skipper Gregory, known to some as 'King of the Coast' and to others as 'The Buccaneer'. I've heard all about his reputation as a manipulator of shrewd deals and gullible women, but to me he is 'Uncle Ancel' whose stories hold me enthralled — especially one of how he survived the wreck of the schooner *Kalender Bux* in 1910 by making a sixteen-hour swim to an uninhabited shore. He is yarning to Claude Riddell, nephew of an early pearler who was murdered at sea by his Filipino crew in 1901.

That lean, distinguished-looking gentleman is another of my adopted uncles: Colonel Will Mansbridge, a family friend of long standing, who hails from India. I visit him at his residency overlooking the bay and relish not only in his humour, tolerance and wisdom but also the meals served in Oriental style by his Hindu servant.

Guests at his table sometimes included T. B. Ellies, the world-renowned Cingalese jeweller and pearl cleaner, and his charming Japanese wife. They have long since made Broome their base and their sons were at college in Perth with my brothers.

Over there, with his old crony Herbert Kennedy, sits 'Long Mac', another of the remarkable characters of the town. James Theodore Clavett McKenzie was born in Victoria in 1875, and he tells us that having the sea in his blood he struck out at an early age 'like a young turtle' for the Queensland coast, and came of age in the Celebes. He does not say where he acquired his education but he gives us something of his story in richly modulated tones. '. . . that was when I was managing the nutmeg plantation on Banda Island. When I was coming back from Makassar in the ketch I witnessed the surrender to the Dutch of the last independent Rajah of the East Indies. There's a story for you now!'

This can flow on to his association with James Clark, who, from a headquarters in Brisbane, controlled a fleet of ships operating from Thursday Island to Broome and around the Celebes.

Long Mac was in charge of Clark's pearling fleet in the East Indies for some time, and when it was decided to transfer thirty luggers to Perth in 1915 he sailed as manager in the mothership *Alice*. On her way south from Timor the *Alice* struck the treacherous Brué Reef off Cape Leveque and sank, leaving only her upper rigging above water. Long Mac and most of his Malay crew clung to this precarious perch while a few men set out in a small boat to seek help from the mainland. Mac rationed the contents of a single canvas waterbag and tried to keep up the spirits of his men by telling stories in their own language. Some tried to swim to a nearby reef in search of seafood but were drowned by an incoming rip tide. The others, after an agonising five days and four nights, were rescued by a schooner from Lombadina Mission.

Early in 1942, during the Japanese onslaught on South-East Asia, sixteen flying boats arrived in Roebuck Bay with refugees from the Dutch East Indies. They had only just landed when Japanese aircraft swooped down with machine-guns blazing. Some seventy people, including women and children, lost their lives in this attack. The remains of the ill-fated aircraft have now almost disappeared, but an engine from one Dornier flying boat was salvaged and mounted as a reminder of this tragic episode.

At the end of the war my husband, Horrie Miller, bought a house in Broome from a retired pearler. He never admitted that Broome's attraction for him played any part in this deal, but claimed it was simply a matter of business convenience for his occasional use on the Perth-Darwin route of the MacRobertson-Miller Airline. From that time the shady bungalow on a corner block, hedged by oleanders and shadowed by poincianas, frangipani and mango trees, became a second home for himself and his family. It was a base in our beloved Kimberley where we could stay, as circumstances permitted, sometimes for a few weeks and sometimes for months on end. In this way we became closely associated with the ups and downs of local fortunes.

The post-war town looked much as I remembered it from earlier days although there had been some major changes. The 'runway' on the edge of the marsh had become a major air terminal, while the meatworks, built in 1939 and maintained for the army during the war,

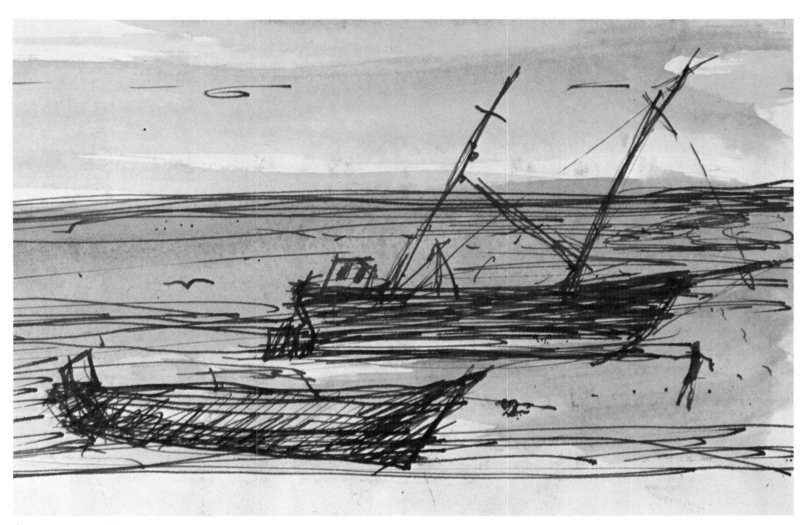

Low Tide, Broome

brought a new influx of population during the killing season. Pearling had a revival which lasted until the demand for shell began to decline during the 1950s, but it was given a fresh impetus when Sam Male, of the pioneer company Streeter and Male, began to investigate the possibilities of culture pearling which the Japanese had practised for many years in their own country. With Keith Dureau, of the Melbourne agency Brown and Dureau, he established a culture pearling base at Kuri Bay, 374 kilometres north of Broome, in 1956. Their small fleet of luggers fished the Broome waters for shell, which they transported to Kuri Bay in two ships designed to keep the oysters alive for treatment at the culture base.

They soon proved that culture pearls grew bigger, and twice as fast, at Kuri Bay than anywhere else, and the Japanese interests joined forces with the Broome partners. The association, a link with the old Broome tradition, operated successfully until 1983. Kuri Bay has now closed down, for the reasons explained in Chapter 16.

Sam Male is no longer with us but his widow Phyllis and son Kimberley are still very much a part of Broome. Phyllis, with whom I share many memories, still lives in one of the few remaining homes typical of the pearlers' residences of former days. The National Trust has classified it as being of historical significance.

Gone are the days when we knew the owners of almost every house in town; when traffic such as that which now roars around the streets was quite unknown, and when the idea of tourism becoming Broome's main industry, overflowing the caravan parks and campsites, would have been dismissed as fanciful. But there are still familiar faces around the town: familiar landmarks and coastal stretches that as yet are more or less unchanged. The tide still sweeps the beaches clean, except for such litter as lies beyond its reach, and at regular intervals it erases the tracks of beach buggies and windsurfers.

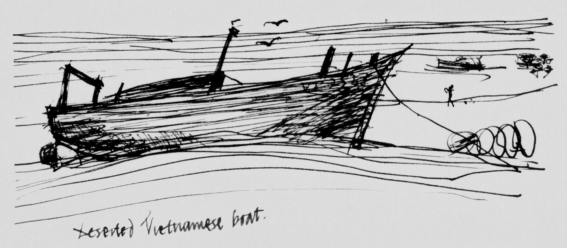

Deserted Vietnamese boat.

The outlying reefs exposed by low tides were once our happy hunting grounds for oysters, crabs, corals and shells, and in this pursuit we had the guidance of two remarkable authorities on marine life: Bernard Bardwell and his sister Mrs Dan McDaniel. Bernard, a Western Australian, first came to Broome in 1904 as a youthful veteran of the South African War, but his lugger *Phyllis* was soon wrecked in a cyclone. The same fate befell his next two luggers, but although he was aboard each of them when they went down he survived to acquire, through patient fossicking and trading, one of the world's greatest collections of shells. His home in Broome was a stone's throw from ours and whenever we passed by he invited us in to inspect his latest find. He seemed never to tire of displaying his treasures from the sea and explaining them in conchological terms.

I spent many a grey dawn with his sister, exploring the reefs at the extreme low of the king tide. The wife of a Broome pearler, and a champion swimmer in her younger days, she had no fear of the sea and she would often swim out alone, or with her brother, to prospect the reefs and sands across the bay. Both these enthusiasts instructed us in the careful lifting and replacement of rocks so that no sperm should be disturbed, no coral or other marine creature left exposed to the sun.

Bernard Bardwell's amazing collection went to the Melbourne museum after his death, and his sister's to the museum in Broome.

My husband, although a keen and usually successful fisherman, showed the same affinity for some of the creatures of the deep that he had for lizards and birds. At one time he enjoyed a curious mateship with a squid that lay in wait for him in a rock pool at low tide. He fed it with rock oysters fresh from their shells, and the creature would actually climb up his outstretched arms and spread its tentacles over his shoulders and chest. He sternly repressed any shrieks of excitement that caused his friend to drop back into the water, emitting an inky camouflage.

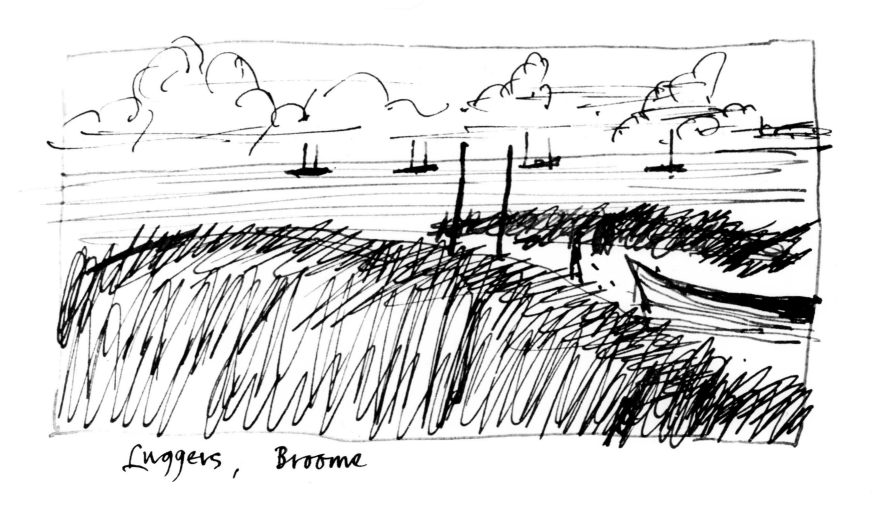

Luggers, Broome

At about that time, some curious tracks on the reef below Gantheaume Point were identified as those of a dinosaur that had roamed there some 130 million years ago. Soon afterwards, Horrie found similar imprints further out, that were revealed only at the lowest of low tides. He kept an eye on the tidal calendar in order to prove his discovery to anyone sufficiently interested to scramble down the cliffs, wade out through the mud, and swim the channels. I came to feel a certain affection for that prehistoric wanderer and its imprints inspired me to write some verses for the *Bulletin* in 1958:

> *Down there my Dinosaur*
> *on ebb-tide from the tumbled promontory*
> *where the tormented rocks, hell-hewn,*
> *upthrusted, burn*
> *fretted outlines on the brazen sea,*
> *came there on some primeval afternoon*
> *when fronded fern*
> *had place of coral and anemone —*
> *a day when rock was slime —*
> *not yet the troubled bed of moon-racked tide.*
> *Arch-necked in steaming swamp, my Dinosaur*
> *slow-humping, misty-eyed,*
> *stamping its signature of scaly claw*
> *to set upon the manuscripts of time*
> *this mark its own,*
> *more meaningful than skull or vertebrae.*
> *Bone is but bone;*
> *this was the sign of flesh, bluntly aware*
> *of darkness and the day*
> *and turn of time on Mesozoic air,*
> *the warm of ooze and cool of cloud and rain,*
> *wet scent of weed, green taste,*
> *quick prick of pain.*
> *This three-pronged hollow that my hands define*
> *spans in a thought the dim, eroding waste*
> *between that hour and mine.*

Since then a replica of the imprints has been cast in cement and placed high and dry for all to see, regardless of time and tide.

Reminders of a less remote prehistory are the Aboriginal people of Broome, most of whom still cherish the memory of their tribal past and retain at least something of their ancient culture.

Father Ernest Worms, the Pallottine missionary and anthropologist who came to Broome from his native Germany in 1931, introduced me to the myths and legends of the peninsula. He had no difficulty in reconciling his work and beliefs as a missionary with his respect for the Aboriginal tradition, and never ceased to wonder at the deep spiritual sense that was the mainspring of Aboriginal life and the ethical standards by which the people lived under their tribal law. He made it clear to me, at an impressionable age, that Aboriginal culture is part of an inter-structure at least as varied and complicated as that of multi-national Europe.

The people of the peninsula alone were divided into seven main groups, each with a different language and separate traditions and law givers, although most groups could understand the languages of the others. Despite their differences and occasional tribal conflicts they were all 'saltwater people' whose mythical heroes arose from the waters and coastal sands, and they saw themselves as distinctive from the inland or 'desert people'.

Some of their legends, like that of the teacher Galalang, may be based on historical fact rather than fantasy. The Aborigines believe that Galalang came from far away, in the time long past, to the country of the Nimanboor on Disaster Bay. The laws he made were simple and good. He allowed no magical practices and forbade any man to kill another or to take more than one wife. He was gentle but strong, and if the people disobeyed him he could summon up lightning and hurricanes. But for all this the Nimanboor people were won over by the powerful law of a neighbouring tribe, and they treacherously speared Galalang and threw his body into the sea.

Remembered sadly in dance and song, he may still be seen among the stars and shadows of the Milky Way, although he is spoken of more as a man than as a spirit being. His insistence on monogamy, his disapproval of witchcraft, and the fact that, in tribal lore, spirit heroes were indestructible by mortals, suggest that he may have been a shipwrecked mariner of whom there were many over the centuries.

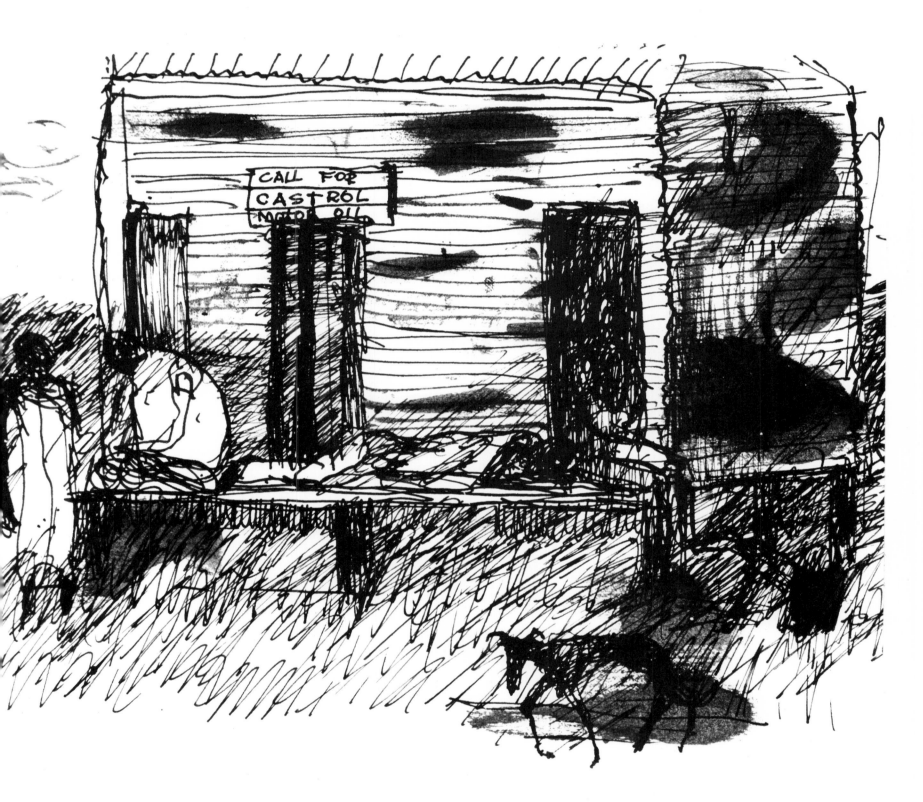

Another legend probably based on fact is that of the Guradidj: the 'little people' said to have inhabited the peninsula in bygone days. Their neighbours of the Bardi tribe watched them suspiciously, for although they were no bigger than children they were clever and strong. They built houses of paperbark and mud and adorned themselves with skilfully carved pearl shell ornaments. When one of them killed a precious Bardi dog their neighbours decided to get rid of them. They attacked the Guradidj at night, set their huts on fire, and speared a number who tried to escape. But others leapt into trees, which obligingly left the ground and transported them to the sky-world. The Bardi people still possess some carved pearl shell ornaments but disclaim credit for them, and say they were left behind by the Guradidj in their haste to escape to the stars.

Some anthropologists suggest that the Guradidj may have been a pygmy Negrito people, of a type known to have inhabited other parts of mainland Australia and Tasmania.

Two remarkable Aborigines, Paddy Roe and Joe Nangan, welcomed me and my friends to Mamabulanjum, the Aboriginal centre, and they soon transported us back to the Dreamtime. Joe and Paddy are recognised law men and they have been entrusted with many of the ceremonial artefacts of the local tribes. They keep them at the centre under lock and key, but they showed us a number of ornate tokens that do not come into the category of secret-sacred objects. Joe donned a water-snake head-dress and danced to Paddy's accompaniment of clicking sticks. Then they returned to their work in the shade of a tree, where Paddy chanted the legend of the Goanna Dreaming that he was carving from corkwood when we arrived. It is a fairly complicated story, of a human family that perished on a long and perilous journey. Only the youngest and smartest of the family knew that they were not really dead, but were to live on as blue-tongue lizards.

Paddy and Joe are members of the Nygina tribe and are conversant with the law and traditions of their own and neighbouring tribal groups, but although they were reared in the old culture they have also come to terms with the new. At home in the bush, and in the whiteman's cattle camps and settlements, they have maintained jobs, raised families, and won the respect and affection of their associates.

Joe, the last Maban or 'medicine man' of the Nygina, is a composer and keeper of tribal dances and songs. He is also a skilled artist, mainly in the carving of pearl shell and boab nuts. In the 1970s he enlisted the help of the writer Hugh Edwards to produce the delightful book *Joe Nangan's Dreaming*, published in 1976 and illustrated by Joe himself, in order to record some of his knowledge for the sake of future generations.

Paddy's father was a white man but his mother outwitted well-meaning efforts to remove him to the educational environment of a mission. He told us that when she was once surprised by the approach of a police party, in search of part-Aboriginal children, she rolled him in her swag and sat on him. The police questioned her in vain and went on their way. Paddy's stories, recorded by Stephen Muecke, have been published under the title *gularabulu*.

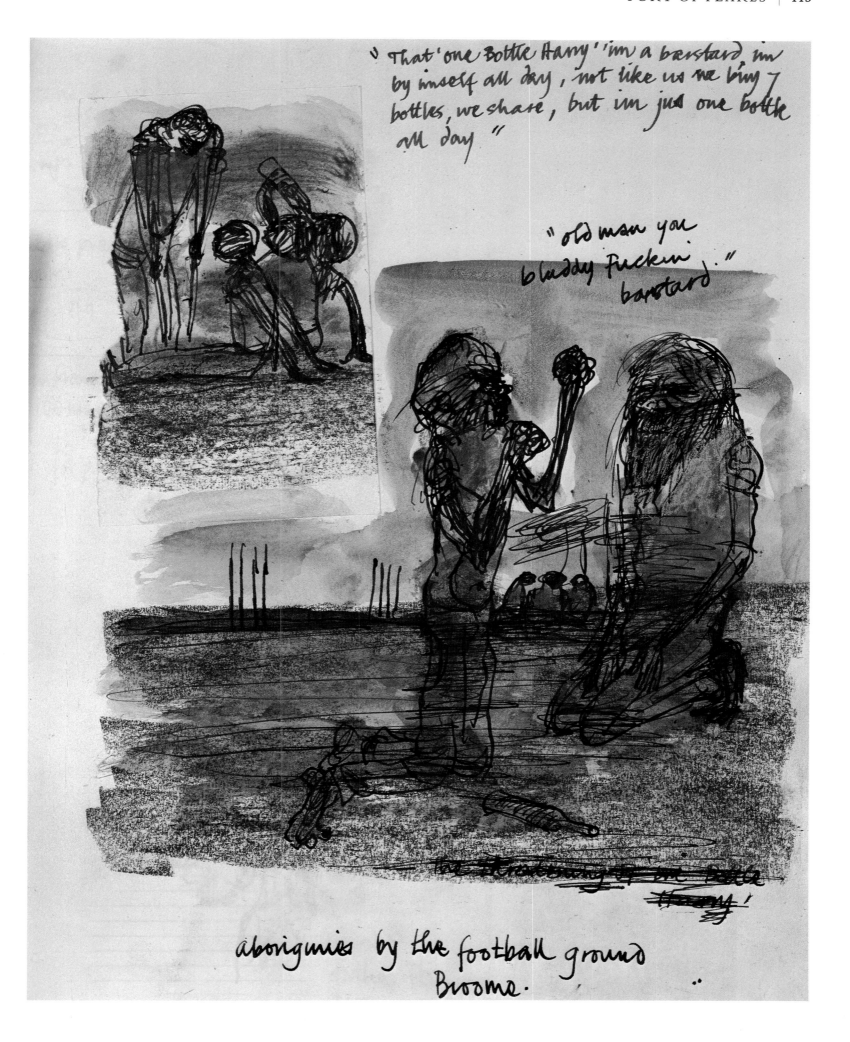

" That 'one Bottle Harry' im a barstard, im
by inself all day, not like us we buy
bottles, we share, but im jus one bottle
all day "

"old man you
bluddy fuckin
barstard."

aborigines by the football ground
Broome.

From considerations of the Dreamtime we moved on to a conference of teachers at Nulungu College, on the outskirts of Broome. I recall the college opening in August 1972, on the same day that the old Continental Hotel, for so long the centre of the town's social and business activities, was bulldozed. It has been replaced by a modern version of the old design and it serves much the same purpose now as in the past, but its demolition seemed to me to be symbolic of changing times in one respect as was the new college in another.

For many years there had been both State and Convent schools for the children of all the races living in Broome, but the new college was specifically for the education of young Aborigines and part-Aborigines of the entire Kimberley district. It is open to both boarders and day-students, and run by the Christian Brothers with the help of the Sisters of Our Lady of Missions and St John of God. The special needs of the Aborigines in adapting to a changing world have been carefully considered, and facilities provided to help them acquire the practical and technical skills needed for employment.

When our party arrived, the college, in operation for more than ten years, had gained a wide reputation as a happy and helpful establishment. Unfortunately the 224 students were on holiday, and I missed their bright faces and the cheerful clamour of the various activities.

Apart from the well-equipped classrooms the college provides for many different capacities, inclinations, needs and opportunities. The girls can learn to cook, sew, and housekeep with either modern or basic equipment; the boys to use tools for anything from the making of simple furniture to the building and upkeep of houses, the maintenance of machinery, and the principles of oxy-welding and metal work. The musically-inclined can join the college orchestra, and the artistic exercise their talents in a variety of mediums. Sporting enthusiasts have ample scope and space for their energies.

Nulungu students range from those whose parents and grandparents received some degree of education to those whose forebears were schooled only for work in the stock camps and households of isolated station properties. It is heartening to see the educational encouragement given to their descendants, and to find that twenty-three ex-students work at Nulungu as teaching assistants and office staff. A number have found jobs in local businesses or government departments or as nursing aides or other assistants in the hospital. All the students, past or present, have played some part in the construction or maintenance of Nulungu and they feel a personal attachment to the college. It is very much *their* college, and vandalism is unknown.

Festival activities had been proceeding during our wanderings around Broome. The lugger race had run its course and the pearl auction had gone with a swing at the Mangrove Hotel above the moonlit bay. The Pearl Queen of the Year was crowned at a ball in the Shire Hall, attended by visiting officials including, for reasons of historical association, the Japanese Consul.

Broome has changed considerably since the days when Japanese were interned during the Second World War. A deepwater jetty, opened in 1966, enables ships of up to 20 000 tonnes to berth without being left high and dry by outgoing tides, as happened in the earlier days of the port. It also facilitates direct shipment of meat to many parts of the world and has consequently been a great stimulus to the beef industry.

But the port's population, of about 4000 people, is now less dependent upon the quantity of local produce that can be shipped out than upon the quantity of visitors who can be encouraged to come in. The major source of income no longer lies in pearling, beef cattle, or even minerals, but in the mighty moneyspinner of tourism.

child pushing an
empty pram

Geoffrey Dutton writes of the party's visit to Broome:

What a time to arrive in the most interesting town in Australia! Right in the middle of the Broome Festival, with the town so crowded we were lucky to find beds in the Tropicana Motel. John made friends with the chef, Krem, a Moroccan artist married to an anthropologist. He was working as a chef in order to make enough money to paint and have an exhibition in Perth. He cooked special dinners for us every night and obviously enjoyed having a group of enthusiasts instead of indifferent tourists. You find interesting people working at hotels and motels and restaurants all over the North-West. Our waitress was a handsome girl from Victoria, who had been overseas three times and was now working her way around Australia. Her forthrightness was heartening. 'I don't know why I wasted my time on all those trips overseas. Australia's way and ahead the best place. We have such freedom.'

Broome has that freedom in a special category of its own, because so many races mix so successfully. And what a mixture it is! Australian, Aboriginal, Chinese, Japanese, Indonesian, Malaysian, Koepangar, Timorese, Mauritian, blacks and whites from many parts of the world. This melting pot produces some marvellous-looking people and the 'Broome cream' girls have long been famous.

The place to see them all is in the bar and beer garden of the Roebuck Hotel. We went with Mary's son John, who was greeted by a splendid Mauritian girl who had just been sacked as barmaid for giving away too many free drinks. An Aboriginal rock band was playing fortissimo. Aborigines and whites played pool together; men and women of every colour danced together. A couple of police wandered in and out but did not hassle anyone.

SALOON BAR, ROEBUCK HOTEL, BROOME

Annie from Eden, one shark's tooth earring
Jiggling as she dances with flicking hips
Naked under the cotton, daring
The smoky air with her finger-tips.

Annie with the fine bones and the red scarf trailing
Round her neck down her twisting back,
"I'm a lush," she says smiling,
Back to the bar for a rum and coke.

Has been working on prawn-boats, once at Port Lincoln sharking
They shot the white pointers in the head,
She felt sad. Her bright eyes darkening
"Don't you do that again," she said

As a long-haired yob put his tattooed arm around her
And his hand up her green spotted skirt.
"Don't you dance again," he warned her,
For no reason but that her beauty hurt.

She slipped a coin in the juke-box, tossing her black hair,
Leaned her little breasts across the red light
And danced to it solo as if the music could break her
Did her slender wrists not hold it tight,

Tighter than the old, bald, gap-toothed
Drunkard she has swept to the floor, solo
Dancing around him, while his jellied
Beer gut hangs down below

His T-shirt, sweating to the edge of his shorts that have fallen
Below his hips. His bare feet slap
The floor her toes scarcely touch, his swollen
Belly rubs her navel, his lips flap

Her white teeth and tongue, then the music is over,
Satyr and nymph from a Grecian vase.
"He's my de-facto," she says (not "lover"),
"I'm a lush," she repeats, though a hundred bars

Have not staled her cheek nor eye. Annie from Eden,
A south-coast town in New South Wales,
Still stealing the apples of the paradise garden,
Still in love with the sheen of the serpent's scales.

confidences.

A slim dark-haired girl with delicate features, and those smudged eyes of someone who is partly drunk but still flashingly sober, was drinking rum and Coke beside us at the bar. She had a shark's tooth earring in one ear, slender wrists and arms, and nothing on under her thin cotton dress. A red scarf curled round her neck and hung down her bare back. Ninette said hello to her and she happily talked to us. Her name was Annie: she came, appropriately enough, from Eden in New South Wales.

The bar Roebuck

'I am a lush,' she said, smiling. She had been working on prawn boats and on a shark boat out of Port Lincoln in South Australia, where she got the shark's tooth earring. 'I didn't like it when they shot the big white pointers in the head. I felt sad.'

Suddenly she left us, slipped a coin into the juke box, and tossing her black hair back leaned across the garish red lights of the machine and swayed to the music by herself, her little breasts pressed against the warm light. Then abruptly she swept an old bald gap-toothed man onto the floor and danced with him like a nymph with a satyr. His pot belly hung over the belt of his shorts and his bare feet slapped the floor that hers hardly touched.

She came back on her own for another rum and Coke. Laughing, she said 'He's my de facto. I'm a lush.'

There is always something happening inside or outside the Roebuck. Just before we arrived there on the next night a woman had slashed her wrists in the bar. No one seemed unduly upset. In the beer garden an Aboriginal danced with his cigarette to the music of the half-white half-black band. A white girl danced on her own. When the music stopped an Aboriginal girl went up to her and asked 'You lost him? I lost him too.' A little later a younger Aboriginal girl gave the white girl a hug and said 'Find him later.'

An old bloke like a caricature of The Old Digger lurched through the crowd into our group and harangued us unintelligibly. John shouted 'I'm sorry, we're all deaf. We were all in the artillery during the war.' The Old Digger buttonholed us one after another, talking incomprehensibly and spilling our beer until John, with the dignity of a colonel at a regimental ball, said 'I'm afraid, sir, I'll have to ask you to leave.' The old man swallowed some beer and continued to pound our ears, but when John repeated his words he came out with his first intelligible statement of the evening. 'Fuck the lot of yez!' he shouted, and moseyed off.

Broome seems to create its own festival atmosphere, whereas the official functions seemed more suited to a 'boojoi' city function in the south than to Broome. At the grand cocktail party at the Mangrove Hotel, waitresses in top hats, tailcoats, waistcoats and net stockings steered their way through guests who were nearly all white. There were half-a-dozen Japanese, a few Chinese, and about four part-Aborigines.

Saturday's procession also lacked the true diversity of Broome, although that was partially made up for by the cheerful and amateurish quality of its sense of co-operation. It was just right that it began with the police chief dignified in his official car and ended with two cars laden with singing hippies, the tyres almost flat under the weight. There were two bands, the most impressive being the police pipers in kilts. The children stole the show but there was not an Australian float. One of them was a 'Frontier' float with Aboriginal kids dressed as Red Indians — in the Kimberley! Only Paddy Roe and his friend Butcher Joe, with their friends and relations, had an Aboriginal float with the children correctly dressed and painted. The mothers' float was a flat-topped truck carrying an enormous man bearing the sign 'Breast Fed is Best Fed'.

Emoh Rou , Broome

In the afternoon the police pipers were playing in the Roebuck beer garden, looking immensely respectable and solid with their collars and ties; their puffing red faces betraying more than a hint of priming. In the white dust rising from the shellgrit the hippies, dropouts, layabouts, happy girls, wild girls, were all dancing reels of a kind closer to Broome than to Scotland. A girl with long red hair glittering in the sun whirled around with a boy with equally long blonde hair, both with their shirts open to their navels. One man leapt up and down wearing a back-pack. The skipper of a pearling lugger, next to me, said 'It could only happen in Broome. Those pipers have to look that solemn, they're so drunk that if they loosened up they'd fall over.'

An over-enthusiastic hippie tried to dance with the drum major. Swiftly the enormous manager and his barman seized the hippie and frog-marched him to the gate. A solitary girl shook to the music and waved him goodbye.

Drunken aboriginy acting as a guru to a hippie.

In Broome one is always conscious of the presence of the sea: the silky turquoise water by the town; the magnificent Cable Beach a few kilometres north which provides the only good swimming for a thousand kilometres. The prodigious ten-metre tides give the sea an added dimension and movement, of revealing shining secrets every day as huge expanses of sand and mud appear where there had been water. At high tide one saw from the Mangrove Hotel what appeared to be the mast and tip of a wreck, but when the tide went out this turned out to be a tower on a whole island complete with mangroves. Closer in to shore there was a genuine wreck: a wooden boat that arrived in Broome from Vietnam with sixty boat people aboard and no shelter but the wheelhouse. Someone should salvage it as a memorial to what those people suffered. It would go well beside the pearling lugger *Sam Male*, named after the pioneer pearler, and the bronze figures of his culture pearling associates, Keith Dureau, Kuribayshi and Toshio Iwaki.

At low tide you can stand on the rocks of Gantheaume Point, see the exposed reef where dinosaur footprints are visible at king tides, and look at Anastasia's Pool, cemented around the rocks for the wife of a pearler who had a cottage nearby. At low tide, when the waves are ten metres below the pool, you might innocently wonder why it is full of water, but if you return at high tide you see the waves slopping into it. On the day we were there a big blue octopus was sidling around Anastasia's Pool: I hope she always looked around before she went in for a swim.

I felt there was a great contrast between our visits to Paddy Roe at Mamabulanjum and to the Nulungu College — which Mary has described. When Paddy showed us a jabiru head-dress he said 'Have to keep him locked up. Some young people don't like. Others got big ideas.' He raised his hand in a drinking gesture. 'Think he's a little bit big.' His wonderful laugh tumbled out and his eyes sparkled. He tapped his head. 'He got two things mixed up inside, little bit too big for his head.' When he put on the jabiru head-dress he seemed immediately to turn into a jabiru as he danced and sang.

The 'two things mixed up inside' seemed to me to be exemplified by the big clean college, where there was no Dreamtime dancing and singing. Most schools ask tribal elders in to teach the children the traditional songs and dances, but this does not happen at Nulungu. Paddy says that if the children are not taught any of the old ways they grow up in ignorance of them and thus despise them, thinking the white man's world to be the important one. This tragic situation means that the Aboriginal culture can only be kept alive by the teaching of old men, while western civilisation booms around them arrogant in its vulgarity and materialism. The only alternative appears to be that of Don McLeod's at Strelley: complete isolation. And that is a kind of apartheid kept going by the white man's money.

Joe Nyngan performing ritual

Ninette and I went to Cable Beach to Paul's Nursery and the neighbouring orchard and garden of Doug Escot. Paul is a big young man with long blond hair and coppery skin, loving his work and happy he is doing so well. Doug, a survivor from the harshness of the Kimberley, also is doing well. He has an important job with Woodside and he lives in the midst of the orchard and garden he is building up, to help supply Broome with the fresh fruit and vegetables it needs so badly.

If anyone feels the old pioneer spirit has faded in Australia, Doug Escot's story will give him a different idea. Originally a Victorian grazier, he drew 3000 square kilometres and all the wild cattle ranging on them in a ballot for new country being opened up in the Drysdale River region, about half-way between Derby and Wyndham. He called the place Ellenbrae. He managed to get into it from the east in a Toyota, but there was no road in for three years and he had to fly all his equipment in to the property. He walked a stud Brahmin bull and ten cows in from Derby and was lucky enough to score six bulls in the first batch of calves.

Gradually he managed to muster and quieten the wild cattle on the property, and thought he was going to make a go of it when beef prices collapsed and the Whitlam government cancelled all the tax concessions for stations in the North-West. So he had to give it all away and start afresh in Broome, where we drank beer on his verandah and watched the butterflies zigzag, and the flight of the beautiful blue-winged northern kookaburras which have the unpleasant habit of eating the exquisite little finches. These kookaburras cannot laugh: they make a noise like a motorbike revving up but never burst into the characteristic happy cackle of their southern relations.

Dr. Peter Reid Shire Clerk. Broome

The land stretches into seeming infinity outside Broome, but there is a chronic housing shortage in the city. Weekly rents for accommodation — if you could find it — were $150 to $200 for a house and $50 to $60 for an inferior flat. There is an enormous floating population in the caravan parks and camping areas and, illicitly, in the sandhills, but there is also a growing permanent population with nowhere to live. The schools are operating far beyond their capacity: Mr Bubna-Litic, principal of the Broome District High School, told us 'The accommodation problem at the school has gone beyond the stage of being desperate.'

There are shortages in every direction: of ablution facilities for tourists, of funds for the Day Care Centre, of accommodation for the Infant Health Clinic. Dr Reid, the direct and vigorous Chairman of the council, is well aware that Broome faces an acute problem in preserving itself from the sort of onslaught that has made a horror of Surfers Paradise, and would destroy Broome's cultural identity as one of the most fascinating towns in Australia.

There was an application before the council for a hotel development on Gantheaume Point, and one can only hope the council will note the lesson learned in Bali. After the first disastrous high rise buildings arose there the local authorities forbade any new hotel to be built higher than a palm tree. Broome attracts tourists from all over Australia but it has plenty of space in which to develop. The old charm should be preserved at all costs and new construction kept as low as possible. Many of the fine old indigenous wooden houses, with their wide verandahs and cyclone shutters, have already been destroyed. One, alongside the Anglican church, was demolished while we were in Broome. Such perfect examples of the genre as Phil Male's house are as important to Australian architectural history as Como in Melbourne or Elizabeth Bay House in Sydney.

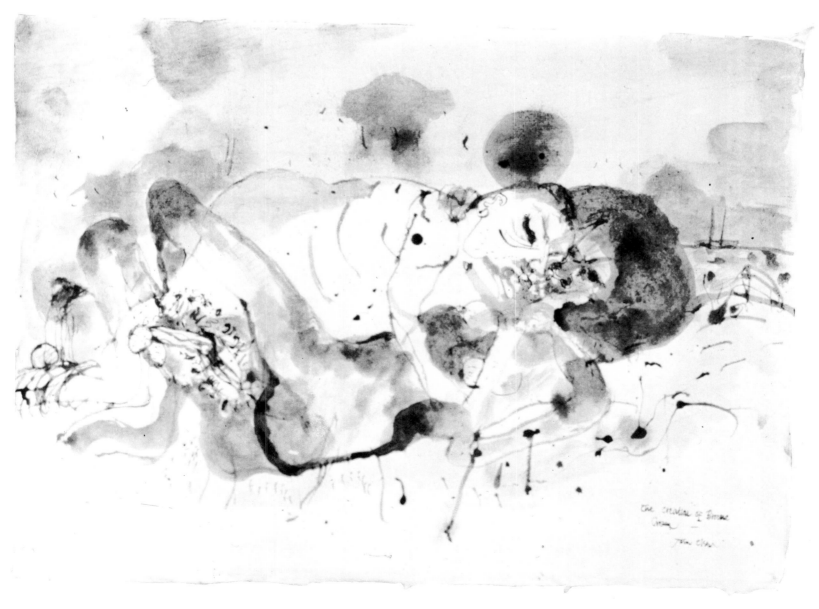

Vin Serventy gives his impressions and memories of Broome:

On a stone monument known as Dampier's Chest, presented to the young people of Broome by the Commonwealth government on 30 October 1938, is a quotation from John Masefield:

We little guess which deed
A future year
May mark to mortals from
Our passing here.

I am not sure what message the government was passing on to the youngsters of this fascinating town. Was it that piracy is a worthy occupation? Certainly the buccaneer William Dampier achieved both respectability and fame, having his name scattered liberally along the coast of Western Australia.

His first landing was for the purpose known as careening, when a ship fouled with marine growths was brought close inshore on a high tide and left high and dry when the tide went out, so that the crew could scrape the barnacles and weed from her bottom. The buccaneer crew of the *Cygnet* careened her on an island in what is now called the Buccaneer Archipelago: the four groups of small islands at the entrance to King Sound.

During the careening the crew feasted on fresh food. William Dampier wrote '. . . our Strikers brought home Turtle and Manatee every day, which is our constant food.'

We now know the manatee as the dugong, and fortunately both dugongs and turtles are protected animals except from Aborigines still living as hunter-gatherers.

Dampier wrote in his journal 'We saw no sort of Animal, nor any track of Beast, but once; and that seemed to be the Tread of a Beast as big as a great Mastiff-Dog.' The track may have been that of a dingo, although he did not record any sightings until he returned to this coast in the *Roebuck*. His men then described them as 'like hungry Wolves, lean like so many Skeletons, being nothing but Skin and Bones . . .' a condition still common in the more arid regions.

We occasionally saw dingoes on our travels, including two puppies which hurtled up a hill in search of sanctuary when our vehicles disturbed them along a bush track.

These wild dogs have a bad press. To call a man a dingo invites a punch in the nose, as it implies cowardice. Sheepmen around the world have always resented any animal, apart from themselves, that ate any of their flock, and there is no doubt that individual dingoes have created havoc among Australian sheep. They certainly have plenty of intelligence and cunning. In 1961 a correspondence school teacher showed me a letter from a child on Thangoo Station, out from Broome, about a dingo which had fallen or jumped into a deep hole and couldn't climb out. A few well-gnawed bones were in a hole, but the child thought they might be those of another animal which had also fallen into the trap — until, a few days later, he saw a fragment of a freshly-killed calf in the hole with the dingo. The parental guess was that its mate had been dropping food down to its trapped partner.

The Azaria Chamberlain case made dingoes internationally famous, and dingo experts became popular on Australian talk-back shows. I was interviewed but I was unwilling to commit myself, apart from saying it would be extraordinary behaviour for a dingo to drag off a sleeping baby.

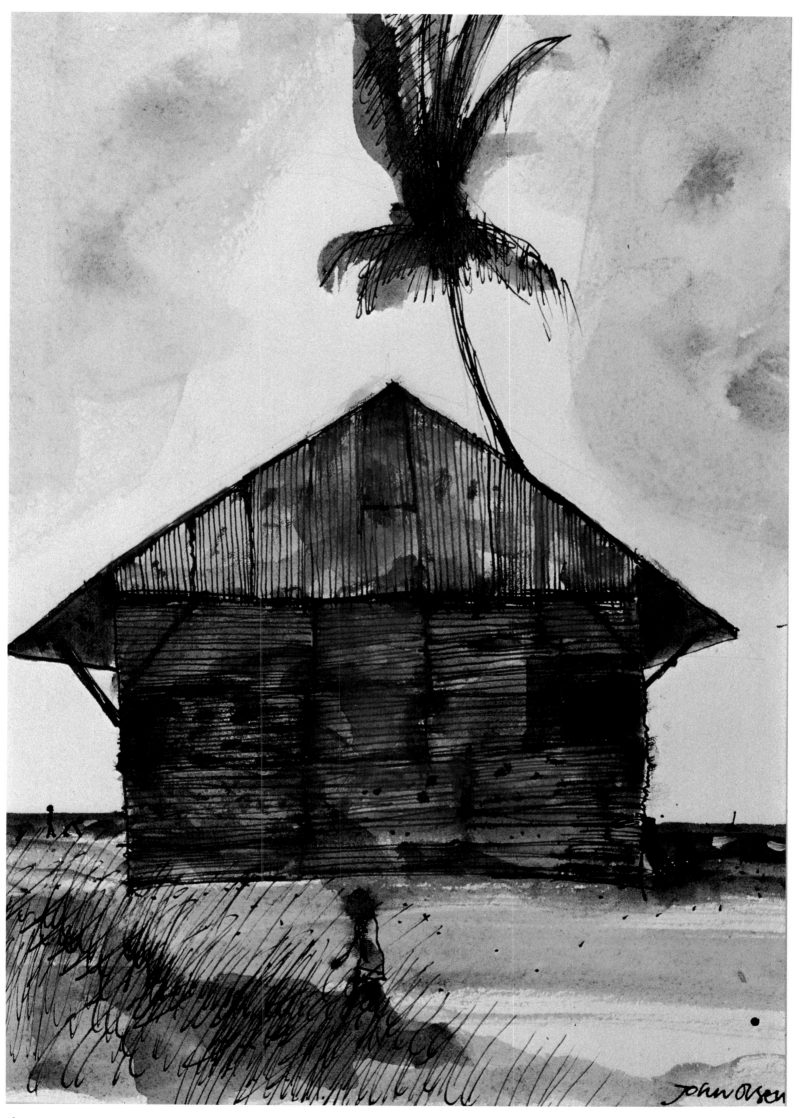

Rusted Broome House

The huge tides of the north-west coast would have helped the *Cygnet's* men to beach her for careening but they were a hindrance to the white settlers along the coast. To allow boats to berth at low tide the jetties had to stretch for kilometres out to sea, or the boats had to be built with flat bottoms so they could sit firmly on the sand at low tide. In the old days, one of the pleasures of passengers to Broome was that of walking around the ship as she lay tethered to the jetty like a stranded whale, but the deepwater jetty has removed that particular joy.

Sometimes strong winds, especially in the Wet, cause the surges known locally as king tides. At low spring tide the sand shows regular ripples and one afternoon while we were in Broome the setting sun produced, instead of a band of gold, a golden staircase leading to the horizon. As though this beauty was not enough, a few hours later the rising moon created a similar staircase to the stars.

I was keen to show the rest of the party the dinosaur footprints which Mary has already described. Ludwig Glauert, that grand old man of natural history and curator of the Western Australian Museum, mentions a Dreamtime legend in which the footprints appear. He writes 'The story is that a native walking along the beach noticed the tracks and at once began to follow them. Suddenly a large bird was seen trying to get across the bay in a southerly direction. When the bird turned and came towards him the man fled, not stopping until he reached Willy's Creek where his footprints can be seen.'

The three-toed prints certainly resemble those of an enormous emu but Mr Glauert says they actually belong to an ancient ancestor of birds, a dinosaur. Scientists working on detailed studies of other prints later decided that the one who left the Gantheaume footprints was a hitherto unknown species of a world-wide group, and they named it *Megalosauropus broomensis* in honour of the town where it left its imprint.

One of these birdlike dinosaurs, probably a swift-moving creature three to four metres tall, must have walked along a sandy beach very much like those along the coast today. It left its footprints on ripples in the sand 150 million years ago. A sudden flood of sand then covered the prints, preventing them from being washed away by the next tide, and more and more sand thickened the covering. During aeons of time the sand turned to sandstone, and erosion by the waves finally revealed the ancient rocks and their message from the past.

The footprints I saw so clearly about thirty years ago have worn away and I found only one large, clearly-defined three-toed mark heading towards the cliff. Some day it might be possible to uncover a line of footprints untouched by the sea. In Queensland a single trackway of dinosaur prints made by 130 animals, the largest so far discovered in the world, has been preserved in a national park.

Broome, for me, was not just the port of pearls. It was also a place where the Aboriginal presence was vivid and strong. Some thirty years ago I taught in a special 'camp school' there, of children gathered from schools and mission stations throughout the North-West. We lived in a camp, took walks across the sands at low tide, and went bush to teach the children about the native wildlife: lore that in the past they would have learnt from their parents.

The sight of black and white children, black parents and white teachers all eating, playing, and learning together, living in a common camp and even dancing together, was a cultural shock for the Broome of those days. At one morning tea a leader of the local ladies confessed to me that it was the first time she had met an Aboriginal woman socially. The biggest shock came when I partnered a jolly Aboriginal mother to lead off in a folk dance.

Attitudes to Aborigines have changed, although they are not yet invited to all the official gatherings at which people of Japanese, Chinese, Indonesian and other backgrounds, together with those of mingled descent, are welcomed. When I protested about this I was told blandly 'They wouldn't feel comfortable.'

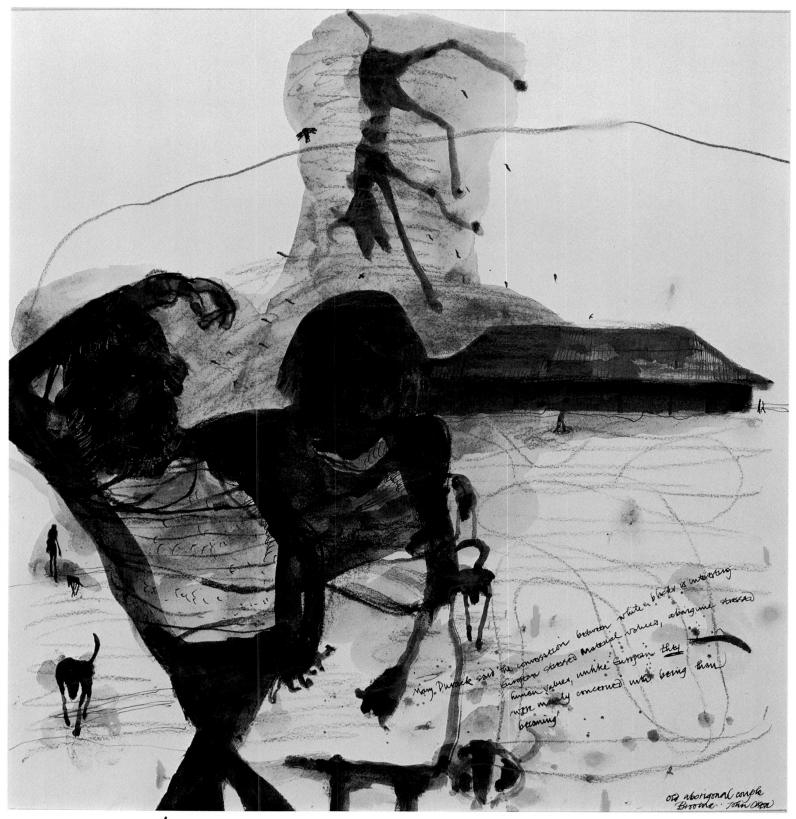

old Aboriginal couple. Broome

We certainly felt comfortable when we went to visit Mary's old friends Paddy Roe and Joe Nangan, also known as Butcher Joe. Joe, a fully initiated Aboriginal, carries the scars of his initiation and is deeply respected by his people as an elder and lawgiver.

In the 1950s I met another of Mary's friends, the legendary Con Gill. I remember him as a brisk upright figure with Edwardian moustache and sparkling blue eyes, although Mary assures me they were brown. Con was at home on the sea bottom, searching for pearls, and said that he had more worries when he was on land. Sharks could be frightened away by a burst of bubbles from his diving suit, but the 'harmless' manta ray was a far greater menace. That giant of the surface waters might become entangled in the lifelines and air hose, and drag the diver along like a puppet on strings as it threshed around in efforts to escape. When mantas appeared near a lugger, the crew heaved the divers aboard until the plankton-feeding monsters had moved on.

During that 1950s visit the Australian Broadcasting Commission asked me to record some of Con's memories, and I set to work with all the enthusiasm of the unskilled. I asked 'What about women in Broome? Have you seen many changes?'

Con twinkled 'Well, Vin, you know when I was a lad there was only one way a woman could earn money.' He burst into raucous laughter, and just as I was deciding that this line of approach was a bit too strong for the ABC he continued 'Now you're a bright young lad. When you go courting what must you take in your pockets?'

I did not know how to answer this, especially when he said 'A handful of wheat. And do you know why?'

I was hopeless at this quiz, but Con relented. 'You know when you leave a girl's place in the morning, what's the first thing awake?'

Again there was a dramatic pause, until he answered himself. 'The chooks! So you just scatter some wheat over your tracks. Most people in Broome can recognise anyone from their tracks, but when the chooks get to work they scratch out all those marks and you're safe.'

After this gem of wisdom for courting males he showed me his bankroll: two great bundles of five-pound notes held together by rubber bands. I exclaimed 'You don't walk around at night with all that in your pockets!'

'No fear. I never go out at night, and when someone calls I tell them to come back in the morning.'

When Con died they found £500 still in his pocket.

Wherever we went in Broome, pearls formed a background: the luggers tied up in the mangroves for the cyclone season, the bronze figures of pearl culture pioneers standing before the old lugger preserved on the Oval, the cemetery where the price of pearls is spelled out on the headstones. The sailing of a pearl lugger was an art in itself, and I remember a thrilling day out of Fremantle when I sailed in the crew of a lugger refitted after being laid up during the war years. It was a rugged boat, not easy to handle for someone accustomed to yachts. It passed its trials, sailed north with a crew of three, and disappeared without trace. This was not an unusual story on this dangerous coast, where losses during the cyclone season between November and April make a grim record.

In 1887, during the 'big blow', 140 men and twenty-two boats were lost; in 1893 twenty men and ten luggers. In 1912, 138 passengers and crew perished when the steamer *Koombana* disappeared in a cyclone between Port Hedland and Broome, and in 1935, 140 pearlers and twenty-one luggers never returned. Apart from these disasters, the town itself has suffered from such cyclones as those of 1910 and 1925. Nowadays, more accurate weather forecasting and rapid communications help ships to seek safety before a cyclone hits.

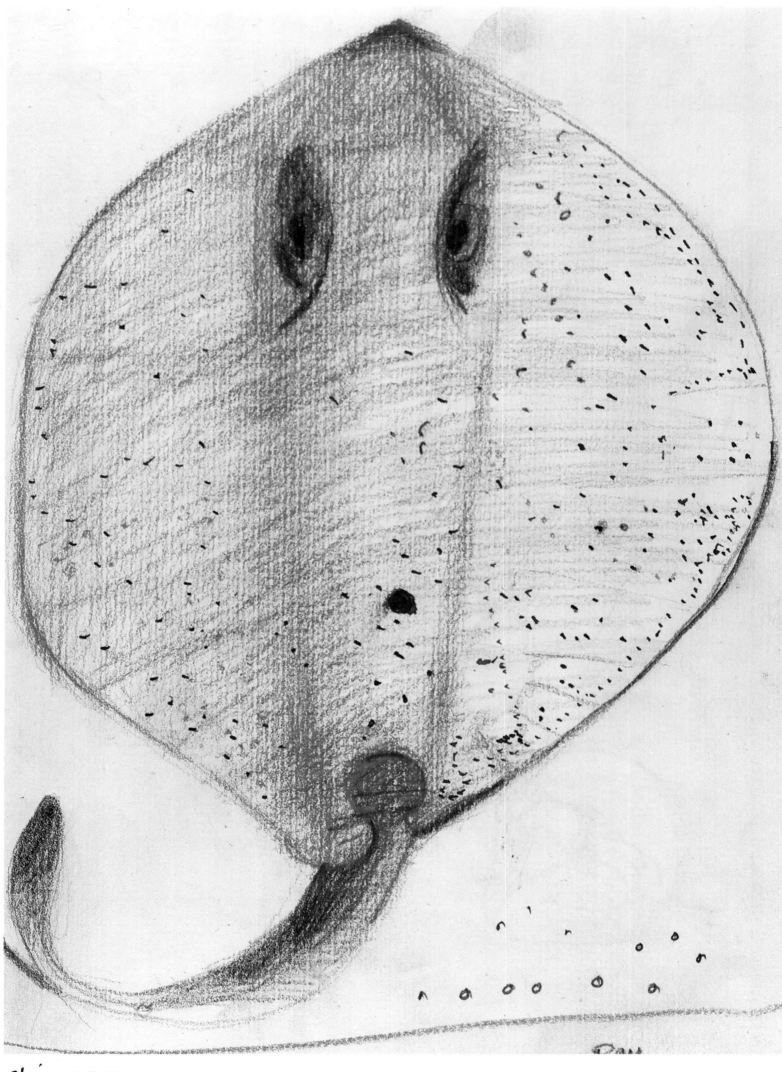

Stingray

In 1965 I travelled north from Broome to Cygnet Bay to spend a few idyllic days with my old friends Dean Brown and his son Lyndon, who lived in a Robinson Crusoe-like shack of local timber with a roof and walls of paperbark. We lived royally on roast goat, turtle steak and goat's milk.

The Browns collected oyster shells from offshore reefs and held them on rafts to be used as hosts for pearl culture. This is a delicate and complex process in which plastic hemispheres are placed in the living tissue to grow into half-pearls, and rounded pieces of special shell to grow into whole pearls.

Originally the culture industry was dominated by the Japanese, who had experimented with the process since about 1904. The expert Kokichi Mikimoto lodged his patent in 1916, but the methods used in Western Australia today are based on those of Tokichi Nishikawa, who was the first to produce a spherical culture pearl.

spiny tailed Gecko

At the Shinju Festival I met Lyndon again. He told me that his father died some years ago, and is buried on a hill overlooking their ultramarine bay, and urged us to come and see what had happened since those early days.

We found a tiny kingdom with electric power, a school, tennis court, and other amenities of an outback town. Lyndon, his brother, and their two wives have trained skilled assistants, and have developed a reputation for pearls which fetch top prices at the pearl auction of the Broome Festival.

The Browns have abandoned half-pearl culture and now work only with full pearls, and Lyndon is skilful at 'skinning' pearls. If a pearl is not perfect he peels off the first skin. If the final beauty is revealed all is well. If not he continues peeling, risking increasing blemish and a valueless pearl.

Some baroque, or misshapen, pearls are fascinating, and are used in sculptural modern settings. Some strange baroque pearls have been discovered, including the famous Southern Cross comprising nine pearls growing together in the form of a crucifix. It was found by a boy gathering shell on the beach near Broome in 1883, and valued at £10 000 when it was displayed in London in 1924.

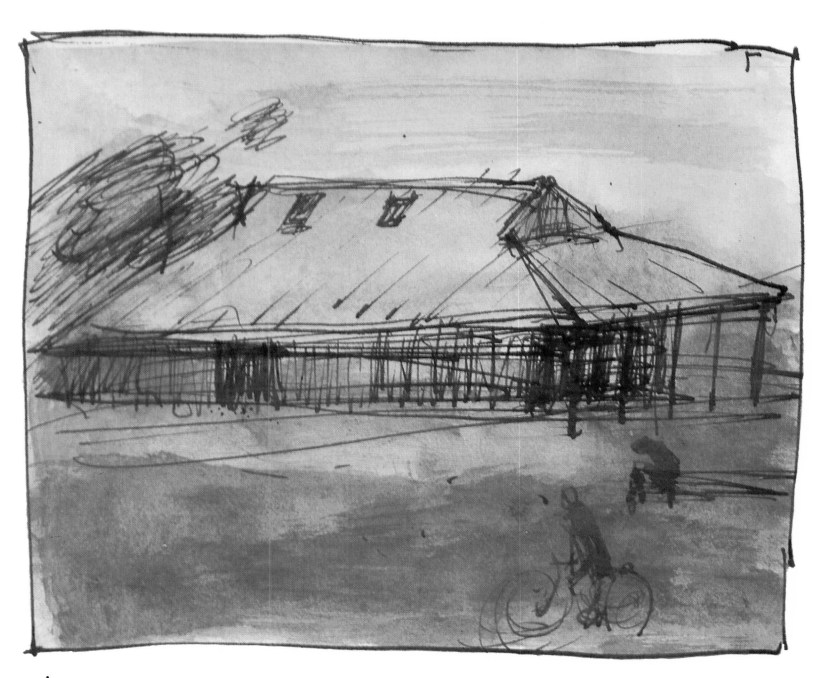

Old Broome House

7 | SIDE TRIP TO BEAGLE BAY

BEAGLE BAY — LOMBADINA — KOOLAN — CAPE LEVEQUE

From John Olsen's notebook:

Leave Broome for Beagle Bay, which is another RC Mission. The road was abominable — 117 km of rutted, corrugated, potholed road that took three hours to reach the mission.

The mission due to holidays was nearly empty, rather different from the vivacity of La Grange.

Mary Durack was delighted to see Father Francis, an elderly tiny priest who was in charge of affairs there.

Ninette, Geoff Dutton ill with a stomach upset, Vin Serventy off colour as well.

30th. Return with Geoff and Nin early for this morning I am off colour as well. Spent the day in bed reading *Madame Bovary*.

Father Francis listening to Mary Durack.

Geoffrey Dutton writes:

At the mission the priests and nuns seemed to be elderly, with the exception of young Sister Brigida. She was writing the history of the mission and turning up some sad stories among the old letters and telegrams. In 1907 a white man wanted to marry an Aboriginal woman with whom he had been living for fourteen years. They had several children. The bishop refused to marry them and the police then arrested him, under the law of that time, for co-habiting. He was fined £24, eight weeks wages. Sister Brigida said 'No wonder with that tradition the Aborigines don't want to marry.'

Mary Durack remembers the Beagle Bay Mission from at least thirty years ago, and she comments:

So much of the past and present of the Dampierland Peninsula people is associated with the outlying missions that we have included them in our itinerary. There are a few cattle stations on the peninsula but open pasture and natural watering places are limited to say the least. The area consists for the most part of what is locally known as pindan, a word of Aboriginal derivation meaning wild or scrubby country of which a stranger had best keep clear. After the rough and dreary drive through this uninhabited wilderness the traveller finds himself suddenly at the gates of an orderly village, spread around a neatly grassed common graced by an elegantly proportioned stone church with an impressive spire. Visitors with no clue to its history must be as puzzled today as were those who chanced upon its founding fathers towards the end of last century.

30th Return with Geoff & Nim early for this morning I am
of colour as well. Spent the day ~~~ in bed, reading
Madam Bovary.

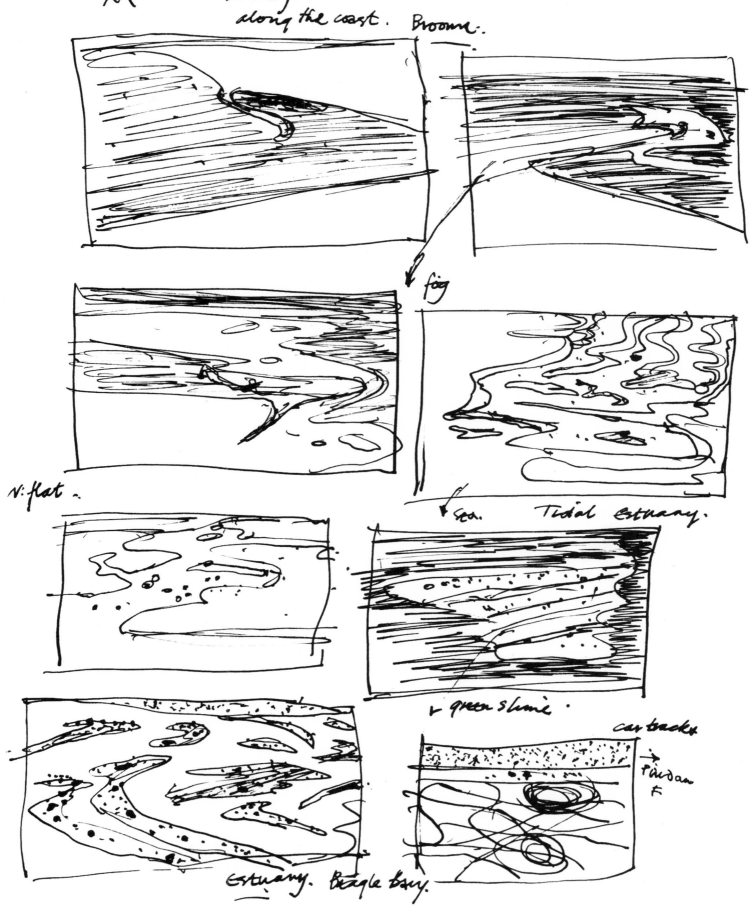

along the coast. Broome.

fog

N. flat.

Sea. Tidal estuary.

green slime.

car tracks
Pandan
F

Estuary. Beagle bay.

Among the strange collection of people drawn to the turbulent peninsula in the 1890s, none seems more unlikely than a band of Trappist monks from the French monastery of Sept Fons. In fact those men, pledged as they were to an essentially contemplative rule, did not arrive of their own initiative. Their order was threatened by radical factors in France and Pope Leo XIII had urged them to seek entry to other lands. Several other Trappist communities had dispersed to China, North America and New Caledonia, and they decided to establish a base in Australia. They thought that, by the exercise of their traditional agricultural and other skills, they could help an aboriginal people who were reputedly in dire need. In so doing they could soon inspire others to carry on the task, and allow themselves to withdraw into the spiritual seclusion of their choice.

Bishop Matthew Gibney, the forthright Irish prelate who had protested effectively against the misuse of Aborigines in the pearling industry, had relayed information about their condition in Western Australian to the Vatican. Gibney had also successfully urged the Western Australian administration to declare the greater part of Dampierland as an Aboriginal reserve, thus allowing the people reasonable security within their traditional hunting grounds.

It soon became apparent that this did not protect them from the lure of the pearling camps, where the exotic luxuries of flour, sugar, tea, tobacco and alcohol were traded for the favours of the women with the consent of the men. Before long, children of mixed parentage and diseases hitherto unknown to the Aborigines had become bewildering facts of life in the tribal camps.

In 1890, when the first French monks arrived, Bishop Gibney gained official approval for a 40 000-hectare mission reserve, on which they established a base a few kilometres inland from Beagle Bay. The chosen site was a park-like area of natural springs, to which they were led by friendly people of the local Nyul Nyul tribe. Very soon they had set up the nucleus of a settlement, including expansive gardens of tropical fruit and vegetables reported to be flourishing 'as luxuriantly as if indigenous'.

The Aborigines flocked willingly to the mission, and seemed eager to learn the white man's skills and the handling of his tools and implements. They appeared equally keen to join in the Christian hymns and prayers, and the monks anticipated not only their ready conversion but the abandonment of their nomadic life. The good fathers expected the Aborigines would settle into self-supporting village communities. They did not realise that the nomads saw the beliefs and practices of their kind new friends as possibly supplementing, but never supplanting, those of their Dreamtime culture. They were increasingly puzzled that the monks should find it necessary to work so hard for what their own increase rites achieved without further human effort. When the continuous and repetitive labour began to pall they tended to down tools, pick up their spears, and disappear in pursuit of kangaroo.

Problems also arose within the Trappist community, where opinion was divided between those who saw their main duty as the extension of temporal enterprises and those who lamented the breakdown of their true vocation.

On visits to Beagle Bay some thirty years ago I met a few old people who remembered the Trappist regime. One of these, christened Remigius but generally known as 'old Raymie', recalled most of the original monks by name and claimed to see them clearly in his mind's eye. What strong men they had been, and holy men too! When they were not working they were praying. No one knew when they slept or how they kept alive without meat or even fish.

Communication must have presented something of a problem, although the monks somehow learned a kind of English from the Aborigines who in turn endeavoured to speak French. No wonder it was said that the Trappists spoke English like the Aborigines, who for their part spoke it with a French accent.

Many of the old people then at Beagle Bay remembered the hymns and songs the monks had translated into the Nyul Nyul tongue. To prove this to me, Raymie signalled to several men who stood and took off their hats, while their women knelt in the sand. Suddenly it was as though the years had rolled away, and they were children again in the little timber church that was destroyed by fire in 1901. The deep Aboriginal voices were true and tuneful still and their expressive faces reflected the happiness and pathos of their memories.

Branch missions at Lombadina and Disaster Bay were also established during the Trappist regime but at the end of ten years the majority of monks feared their order was being 'twisted out of shape' in their missionary role. Anxious to return to their contemplative vocation they set sail for France, leaving two of their number in charge until others were found to carry on. One who elected to remain was Father Nicholas Emo, a Spaniard of aristocratic background and apparently some medical experience. He remained for the rest of his life and left his mark on the history of the area.

In 1901 members of the Pallottine Society took up the task. The Society, founded in Italy in 1835, had spread throughout Europe and to the missionary front in Africa. Father George Walter, appointed superior for the Australian mission, was a German, as were most of those who followed him in this field. Beagle Bay made 'a miserable impression' on the newcomers because the so-called 'monastery buildings' were little more than timber shacks with earthen floors, while the flourishing gardens had more or less returned to the scrub. The Pallottines lost no time in clearing, replanting, sowing grain crops, moulding clay bricks and grinding tons of shell for the making of building lime. Their struggle against the hostile environment, against anti-mission prejudice and lack of funds, though long and formidable, was to prove remarkably fruitful overall.

In 1907 the arrival of the St John of God sisters was an important event, not only for the mission but for Broome and, as time went by, for places considerably further afield.

At that time there were fifty Aboriginal boys but only seven girls at Beagle Bay. Within two months of the nuns' arrival the number of girls had risen to seventy. A few were accompanied by their parents but the majority, neglected or orphaned and mostly part-Aboriginal, were brought in by the police and government protectors. But for this intervention by the white men, few if any of these children would have survived. Others were sent to the mission by genuinely concerned white fathers, some of whom were among the early pastoral settlers whose names have gone down in local history.

The years of the first World War were times of stress and sorrow for the German Pallottines. Security regulations forbade them to leave the missions under any pretext; supplies were low and feeling against them and their work ran high. They tried to carry on their daily tasks in a normal fashion but their every word and action were supervised by resident police officers.

Their Superior, then Father Thomas Backmair, decided that since it was no time for commercial enterprises, and the world was rent by hate and doubt, the community should labour on a symbol of love and faith. By the end of the war, with the help of the Aborigines and his fellow religious, he completed the church which now stands at Beagle Bay. They baked

The Beagle Bay church was built from local materials during World War I.
The priests and Aboriginals baked 60,000 double bricks and decorated the altar,
arches and sanctuary floor with more than 10,000 pearl and other shells

60 000 double bricks in stone kilns for use in its construction, and decorated its altars, arches, and sanctuary floors with more than 10 000 pearl shells and countless shells of other varieties. The altar rails, of polished timber, are inlaid with biblical symbols, carved from the gleaming shells for which the peninsula had become world-famous.

Despite continuing vicissitudes, Beagle Bay had become to a great extent self-supporting from the sale of its cattle, fruit, and vegetables. Its reputation as an efficient training centre for Aborigines had begun to spread, but its critics began to accuse it of segregating the Aborigines rather than integrating them, as was the current administrative policy. The missionaries had in fact hoped that the young people they trained in many skills would be able to find employment in a normally expanding economy outside the mission. But there was no lack of skilled labour in Broome and the surrounding districts and many of those encouraged to seek outside jobs returned disappointed to Beagle Bay. The pearlers did not need tradesmen but labourers and domestics, content to work for pocket money and keep. Before long every white family in Broome acquired a mission-educated couple, some of whom left their children and old people behind while others transferred in groups. For a period at least this arrangement worked well for all concerned. The white families were delighted with the willing, good-natured people who worked in their homes and gardens, while the Aborigines took readily to life in the port with its shops, ships, and picture shows.

The St John Sisters had long since set up a convent school in Broome and they kept in close touch with the Aboriginal families from Beagle Bay. The latter were still half-way between the white world and their own, but they were at ease enough in both and probably happier than their descendants today.

1928, the year preceding the Great Depression, saw the arrival of a bearded Bavarian: Father Otto Raible. Under his practical and cultural influence the mission kept afloat as a largely self-supporting community until the outbreak of the Second World War.

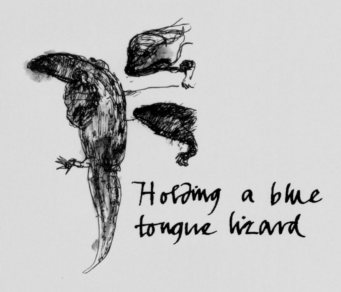

Holding a blue tongue lizard

During the 1930s, Father E. A. Worms began the anthropological work that was to have such a far-reaching influence. When I first met him I had already heard puzzling reports of his activities. A station manager told me 'Funny sort of missionary, that. Instead of spouting at the blacks he sits there by the hour taking down what they say to him. It'll be a pack of lies too, you bet your life.'

It would have been difficult for such critics to understand the respect in which he was held by the Kimberley Aborigines, to whom he was 'Ibala': a learned elder of the tribes, a man they were prepared to entrust with the secrets and sacred emblems of their law. He realised that many of the mission people had come to adapt their beliefs to Christianity and to carry, as he said, 'a faith on either shoulder', and he discouraged evangelistic efforts to destroy or underestimate the quality of Aboriginal faith in tribal law. He saw an Aboriginal's belief in his 'dreaming' as a flame of spiritual vitality, that once extinguished could not be rekindled from another fire.

In 1936 Father Raible had become an Australian citizen and he was appointed Vicar Apostolic for the Catholic diocese of Kimberley. On the outbreak of the Second World War his fellow Pallottines, six priests and seven brothers, were escorted to the Broome gaol but his influence resulted in their release and return to the mission under police surveillance. When Singapore fell in 1942, orders were issued for the evacuation of all white women in the North-West but the St John Sisters pressed for permission to remain. This was granted, on condition that those in charge of the school and orphanage in Broome accompanied their charges to Beagle Bay, with the rest of the port's Aboriginal population.

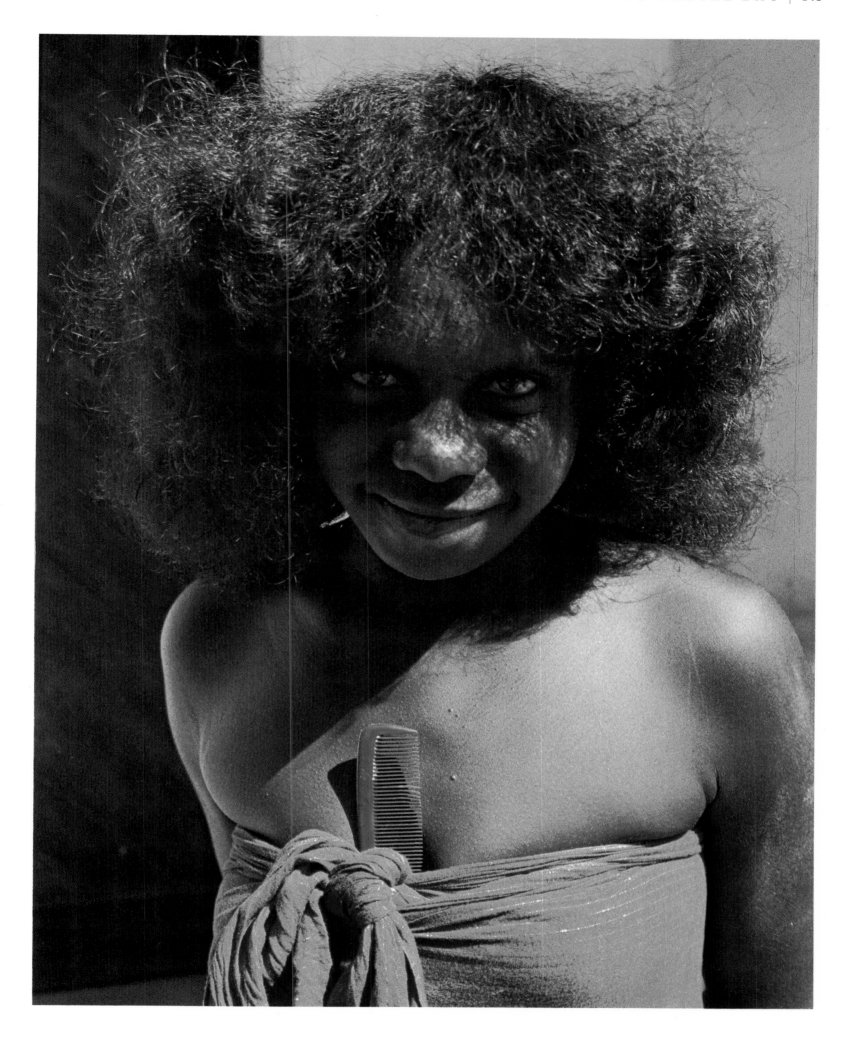

As in the previous war, bitterness mounted as hostilities progressed. Rumours spread that the German religious were to be interned and their mission closed for good and all. This did not happen but at the end of the war the Bishop was faced with the near ruin of nearly half-a-century's dedicated toil. Most of the pioneer brothers had passed away, their garden was a wilderness, and most of the stock had been killed to feed the community during those hungry years. It is little wonder that the good man suffered a heart attack and realised that he must soon surrender the administration of his widespread diocese.

But he toiled on until 1959, when the Bavarian-born Father John Jobst, who arrived in 1950, was appointed his successor. Bishop Jobst, who was not yet in his forties, brought a realistic and practical approach to the problems of his office. He saw the need for a new approach to the education and technical training of full-blood and part-Aborigines, who were increasing faster than the white population throughout the Kimberley. His appeal for funds, equipment, and helpers both religious and secular received an encouraging response, which resulted in an updating and expansion of the school, hospital, and housing facilities at Beagle Bay.

Few aspects of our society are as complex as those pertaining to the Aborigines. Policies and attitudes change from year to year and from one State or district to another. From the brief rundown of Beagle Bay history which I was able to give to the other members of our party we could not take for granted the way we would find things at the mission on our arrival. In fact we found the place to be unusually quiet, because most of the 230 residents had either gone to Broome for the festival or to their holiday fishing camps. Two sisters of St John of God, a Pallottine priest and two brothers, all of whom I had known for many years, were holding the fort.

Father Francis Huegal, who came here from Germany in 1931, has had wide experience of mission life at bases as far apart as La Grange, Hall's Creek and Balgo. He speaks a number of tribal languages and has recorded much of the law and legend of the ancient culture, as well as translating hymns and prayers into Aboriginal tongues. A gentle man, of kindly humour and keen intellect, he stands high in the affectionate estimation of the mission-reared people.

This was warmly demonstrated by an unforgettable rally of several days at Beagle Bay to celebrate his Golden Jubilee in 1979. Those present included people ranging from full-blood Aborigines to cultural mixtures of many kinds, gathered to pay tribute both to the jubilarian and to those who had worked with him over the chequered years.

Beagle Bay has seen many changes in recent years, the most radical being that introduced through the Labor government of the early 1970s. With the aim of encouraging more independence in mission communities, it decided that future financial assistance would be given only through councils under Aboriginal control. Priests could carry on in a pastoral capacity and other religious continue as teachers, nurses, and aides, but none were to perform administrative roles. Government funds were to be handled by council members with the help of lay 'project officers' for bookkeeping and secretarial purposes.

We were unable to see the Beagle Bay Council in action, but we gained the impression that, whatever else may have changed, the traditionally harmonious and co-operative association between whites and blacks, religious and secular, continued much as in years gone by.

Geoffrey Dutton continues the story of the visit to the missions of the peninsula:

We flew up the misty coast to Lombadina Mission. Father Chris Saunders, in charge of Lombadina, is a dynamic, athletic man who looks more like the manager of a top cattle station than a priest. We had tea under a pergola by a paw paw with huge fruit. Chris told us that all the vegetables for Beagle Bay are brought up from Broome, and that the great vegetable and fruit garden that in the old days used to supply Broome is now untended.

Peter, one of the elders, and William, a part-Aboriginal painter with a shrewd and worldly look, joined us but said little. Peter looked dignified and remote: there is even less hope of getting into conversation quickly with older Aborigines than there is with white outback Australians. Later, Chris offered us beer and whisky in his house and talked very frankly. Yes, the women are second-class citizens. The missionaries try to split the welfare cheques so that the husbands would have to pay for the rent and the food, otherwise they 'Toss the women the cents and keep the dollars.' Although Lombadina sells timber and cattle, and the Aborigines catch a lot of fish, everything depends on Social Security priming the pump. Meanwhile all the bright young men go off to the towns.

Lombadina has one of the architectural gems of Australia: a lovely bush church made of mangrove poles, with a polished sloping floor and a roof thatched with paperbark, later covered with galvanised iron. All the floorboards are hand-sawn. Only the big outside posts have given trouble, because termites have weakened them and they have had to be shored with iron. The raked wooden ceiling is held by horizontal brown beams; one almost has the feeling of being inside a tree house.

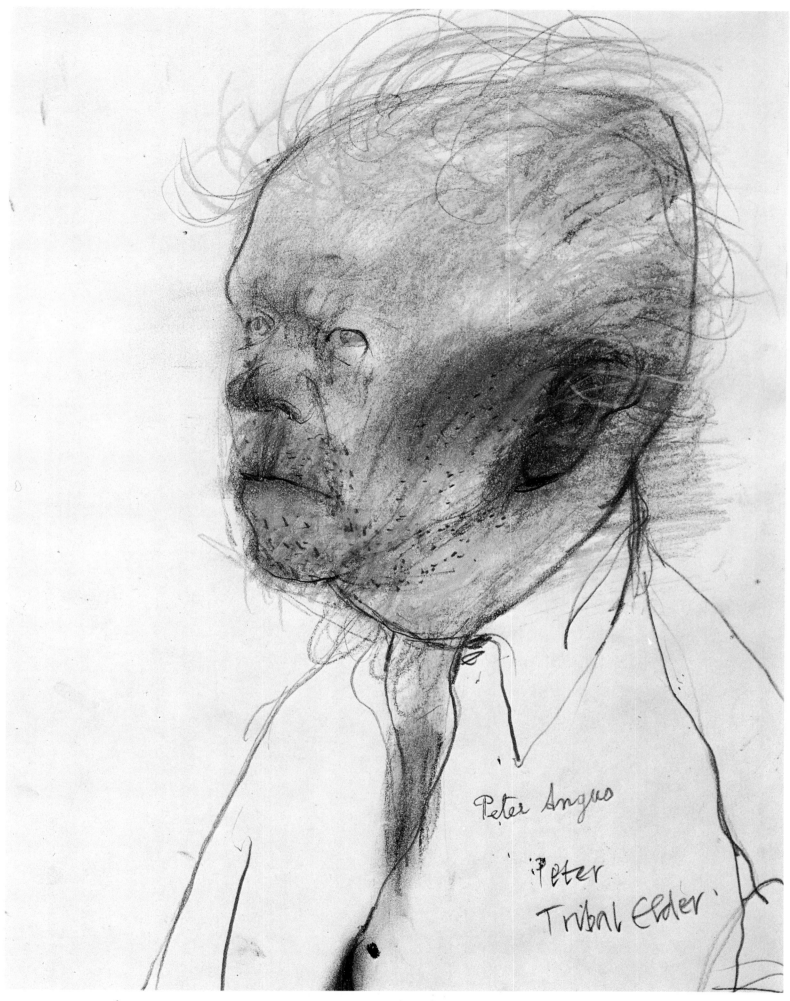

Peter, tribal elder Lombadina

Mary Durack tells the Lombadina story:

Lombadina may give the impression of being far removed from the problems that beset the outside world. Spread out between the shelter of the high white dunes and a bushland dominated by friendly paperbarks, it looks to be a place of peace and tranquillity. But its history contains as much strife and hazard, and as complicated a cast of characters, as could be conjured up in the most fertile imagination.

This mission outpost dates back to 1892, when Bishop Gibney saw its acquisition as a strategic move for the protection of Beagle Bay. In the same year he obtained government approval for a land grant at Disaster Bay on King Sound, where the monks' efforts soon showed encouraging results.

The Bishop assumed that work at Lombadina would be even more successful, because it was known as a favourite camping ground of the Bard, or Bardi, tribe. The largest group in the vicinity, it spread across the peninsula and also occupied nearby Sunday Island.

The church bought the Lombadina site from two of the most interesting and colourful characters of the contemporary scene: Harry Hunter, a London-born hatmaker, and Sidney Montague Hadley, who was said to be the son of an English peer. They carried on a mixed business in pearl and turtleshell, trochus and bêche-de-mer, and to overcome the restrictions on the use of Aboriginal labour in the pearling industry they took up grazing rights to the adjacent coastal area. Here they introduced a few cattle, sheep, and goats, which were a satisfactory source of 'payment in kind' to their Aboriginal labour but were nowhere to be found when the missionaries moved in. Nor were the Aborigines, who had departed with their employers to another of their tribal campsites.

The partners' subsequent careers are among the better-known sagas of their time. Hunter continued successfully enough in the role of pearler-pastoralist, and could well figure in the *Guinness Book of Records* for the size of his part-Aboriginal family. Hadley claimed to have 'seen the light' and declared he must serve the people whom he had exploited. In 1897 he assisted with the establishment of an Anglican mission at Forrest River in north Kimberley, which was soon abandoned because of the hostility of the local Aborigines. This project was taken up again in 1913 by which time Hadley had long since founded a mission among the Bardi people on the coast of Dampierland. Here he was welcomed back and having insisted on being actually initiated, was accepted as a 'proper man' of the tribe.

On the whole his relationship with the Catholic missionaries was not notable for its Christian charity, but by the time he returned to England in 1923 they had developed a mutual tolerance. His story sounds unlikely, but it is no more so than that of many men who found their way into the Kimberley on one pretext or another in that period.

When the Pallottines arrived they found Hadley's mission to be an unsettling influence on their communities and this factor, together with a shortage of funds and staff, decided them to concentrate their resources at Beagle Bay. In 1905 they abandoned Disaster Bay and sold the Lombadina lease to Thomas Peurtollano, a Filipino who had helped them for a number of years. After their departure he worked hard to make Lombadina into a home for his growing family, and to earn what he could by selling meat and garden produce to the lugger crews. More than 100 Aborigines were camped on his property, mostly prepared to work for their keep as they had done before, but Puertollano, having been classed as an Asian, was not permitted to employ Aborigines. He did his best to satisfy their needs, but when this proved beyond his resources they took to killing his stock and pilfering his stores.

The situation was saved when Father Nicholas Emo agreed to take over the Lombadina title deeds and help Puertollano to carry on, an arrangement which appears to have been a God-sent solution for both men.

Father Nicholas' life, from the time of his arrival in Australia, had been fraught with problems that were hardly in keeping with a Trappist vocation, but since he had joined the order to participate in missionary activities he had no intention of returning to a monastic life. When his fellow-monks returned to France he was left in charge at Beagle Bay until the Pallottines took over, hoping thereafter to devote himself to Aborigines not yet 'contaminated' by invading cultures. On learning that the Benedictines in the south of the State had much the same idea

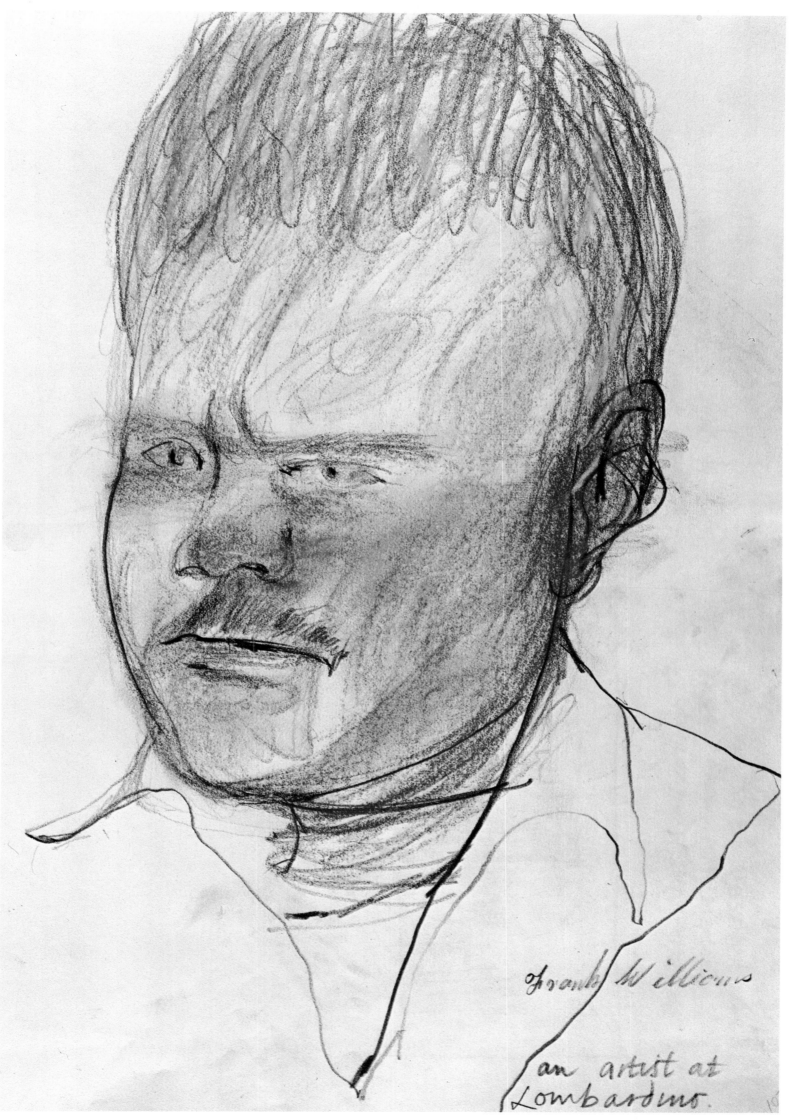

Frank Willious

an artist at
Lombardino.

An artist at Lombadina

he offered his assistance and the use of a lugger he had been given by a friendly pearler from Manila. In company with the Benedictine Abbot, Fulgentius Torres, he explored the coast between Broome and Wyndham and selected a site for a mission in the remote Drysdale River region.

The Abbot returned south to organise his new venture while Father Nicholas set himself up as a 'doctor-priest' at Cygnet Bay on King Sound, then one of the most notorious trouble spots on the peninsula. He found that the inhabitants were hardly the innocent children of nature for whom he yearned, and when the Benedictines began their task near the Drysdale River in 1908 he had no hesitation in accompanying them.

After two years, during which the missionaries found themselves besieged and rejected by the 'uncontaminated' tribespeople, Father Nicholas began to think of his previous mission field in Dampierland in a different light. He saw it less as a hotbed of corruption than as a place where the mingling of races was inevitable and not necessarily tragic. It was, moreover, a place where he was known and needed: not only by the Aborigines but also by the Filipino divers and crewmen who related to him by religion and ancestry.

He made the decision to join Puertollano at Lombadina, where he was soon able to enlist the co-operation of the Aborigines in forming a mission which came to be regarded as a branch of Beagle Bay. The Pallottines were unable to help financially but they made staff available for building activities, while Father Nicholas held his lugger *San Salvador*, skippered by himself, at their disposal.

When the St John Sisters were joined by new recruits in 1913 their Superior, Mother Antonio O'Brien, sent three of the more experienced of their community to Lombadina. Conditions were primitive, with paperbark huts serving as school and 'dining hall', the hides of goats and donkeys as bed-coverings, and sugarbags stuffed with dry seaweed and chaff as pillows and mattresses. But the Sisters were accustomed to the makeshifts of outback life and took it all in good heart.

The First World War seems to have made little impression on the remote community but the restrictions imposed on the Pallottine religion resulted in heavy demands on Father Nicholas and the *San Salvador*. The *Liber Defunctorum* of the mission registers his death in March 1915. At his own request he was buried, wrapped in a blanket, in the dunes within sound of the sea. Years later he was re-buried, and his gravestone centrally situated and suitably inscribed to the memory of one of the most interesting and controversial characters of a controversial time and place.

Immediately after his death there were misunderstandings about the actual ownership of Lombadina. The Irish priest Father John Creagh, who had been appointed Pro-Vicar Apostolic on the outbreak of war, assumed that the title deeds belonged to the church, whereas Puertollano had merely 'lent' them to Father Nicholas in order to solve the problems of Aboriginal employment. Puertollano, justly offended by doubts of his story, declared he would sell the deeds to the highest bidder. Eventually Father Creagh bought them in his own name and resold them to the church after the war.

Under the succession of superintendents who followed Father Nicholas, the mission grew and flourished. When windmills were established to pump water, and guano from nearby islands was added to the sandy soil, the garden produce became plentiful and the livestock was at least sufficient to keep the people well supplied. Under these circumstances they came back to the mission and regarded it as a place of peace and security.

The administration of Lombadina, as at Beagle Bay, has changed with the times. The Aboriginal community, now about 180, is nominally self-managing and funded by the Department of Aboriginal Affairs.

The background of its efficient projects officer, Basil Sibasado, is closely associated with the history of Lombadina. His grandfather, Martin Sibasado, was born in Marble Bar in 1893 of a Filipino father and a Japanese mother. Martin told me years ago that he had 'knocked about the country' as an unwanted waif until Father Nicholas picked him up and took him to Beagle Bay. In 1910 he joined Father Nicholas at Lombadina and he was known thereafter as the mainstay of the mission, where he and his part-Aboriginal wife reared a large and vigorous family. It is surely significant that the grandson of a boy who once 'knocked about', neglected and alone, should now have a reputation for practical leadership and stability.

From John Olsen's notebook: The father of Lombadina, F. Chris Saunders, was young and vital, the most impressive ecclesiastic we have seen.

The old church at Lombadina was one of the masterpieces of church architecture in Australia. Built of corrugated iron on the outside, lined with paperbark and supported by bush timber, it had a divine ease of spirit and spoke eloquently of the sense of peace.

The old church at Lombadina
was one of the masterpieces of church
architecture in Australia. Built of
corrugated iron on the outside, ~~a book~~
lined with paper bark & supported by
bush timber, it had a divine ease
of spirit & spoke eloquently of its
sense of place

Geoffrey Dutton describes the party's journey after leaving Lombadina:

We flew on over the hundreds of bare islands of King Sound, all fretted into innumerable bays and coves with little beaches and rocky headlands; islands where one could dream of spending weeks of fishing and swimming and lazing. But you would need a good boat engine; the tide races are ferocious.

We were heading for the mining islands of Cockatoo and Koolan. The day we arrived was the annual holiday, when there is a golf tournament between the two islands. The airstrip at Koolan is also the longest fairway on the golf course. I will never forget the sight of the golfers returning to the strip after we had landed, and driving off down the runway.

If the other mining towns in the Pilbara had seemed islanded off from the vast country all around, the ultimate is in Koolan and Cockatoo, which are islands in their own right. There is something schizophrenic about them. On the one side are the huge roads and cuts and heaps of rubble of the BHP, going down to the landing jetty. On the other side are beautifully-sited houses with rich gardens and marvellous views, looking like an expensive holiday resort. I was not surprised to hear that some people had lived there for as long as twenty-seven years.

Solitude has a different dimension when it is surrounded by sea. It is partly a question of colour, the blue and the red, and partly of the different rhythms of life between the land and the sea. If you lived in the inland Pilbara you would have to give yourself entirely to the spirit of the place: grow close to the rocks and birds, the flowers and the trees. But on these islands the sea provides endless diversions and there is a holiday atmosphere to those hours of the day not spent in working. This atmosphere is balanced by scare stories of the tide races, and of the rumour that crocodiles nearly five metres long are increasing in numbers.

On the way back to Broome our dashing pilot, Ziggy, a burly and charming Austrian, flew us up an astonishing turquoise fiord between walls of loose red rock, and over a hole-in-the-wall where whirlpools whiten the entrance of the cliffs, through which the water cascades metres down to the other side when the tide changes.

We landed at Cape Leveque on the northern tip of the Broome peninsula, where the rusty red earth shades into the sandy beaches and the rocky headland. The houses stand in a lush green oasis, demonstrating the old story of the North-West: give it water and it turns green.

The houses are those of the lightkeepers. Max, the head keeper, was on holiday, but he and his family like the place so much they were camping on the beach. The temporary keeper was an Englishman, who seems to enjoy going from one lighthouse to another to relieve the permanent men. The assistant keeper, who showed us the light before he went fishing, was a handsome young Californian with a big moustache and a straw hat, married to a Queensland girl. So there were three nationalities in this little settlement, all swearing it was a good life. The only annoyance seemed to be the campers on the beach, some of whom stayed for a month and were noisy. Some were rich enough to hire helicopters to drop them on one of the islands for a week or so. So much for a lonely lightkeeper's life. The place was too damn crowded.

We flew back over huge bushfires, lit deliberately by whites and Aborigines to burn off the pindan and bring up fresh growth. The thunderous smoke clouds went up more than 2000 metres and the flames swept like orange surf across a ten-kilometre front. The North-West is so big that it can even take no notice of fire.

The mine at Koolan

Japanese pearl seeders at Cygnet Bay delicately implant plastic 'seeds' in oysters.
The molluscs will cover them with the nacreous layers which convert them into
pearls. The culture pearl industry has been of great importance to the North-
West but the industry is now suffering from recession and at least one of the
'factories' has closed

CAPE LEVEQUE LIGHTHOUSE

Lighthouses stand in lonely places,
Symbols of the solitary,
Flashing out their shining faces
Then hiding themselves in ordinary
Darkness, as if the code of light
Spoke two languages at night.

To understand those dark pauses
As sailors who know their charts decipher
The flashing beam, is to hug the causes
Of absence and despair, the chances of life or
Death, shipwreck or safety, land
Or sea, this is to understand.

For in the simplicities of daylight
Here is this cast-iron tower,
And the keeper painting the chipped white
Walkway around the glass, the power
Of the sun reducing its magic to a toy
And the keeper, hardly more than a boy,

Just about to go fishing, with various
Complaints about campers down by the pandanus,
Not a lonely fellow at all, gregarious
As a salmon, as profane as
A seagull and as tucked-in clean.
All his cogs have a discreet sheen.

Day makes banal communications.
It's different at night, in rain and thunder,
Or when cyclones, like mad relations
With homely names, stumble and blunder
Around breaking things. But not cast iron.
There are some things you can rely on

And one is that contact is not always presence,
That darkness is light's true companion,
That loneliness is only the flash of absence.
In the worst times, in the bottomless canyon
Of night, the sea breaks on the land's end
But remains the sailor's dangerous friend.

King Sound in the Buccaneer Archipelago glows in the golden afternoon light as the powerful 12 metre tide ebbs and flows through complex mangroves and mud banks

Mary Durack
relates how John
and Alex return to
look at the
Buccaneer
Archipelago:

John had been so enthralled by the colourfully patterned seascape to the north and east of the peninsula that he would have liked to have hovered around longer than the immediate fuel supply allowed. So strongly did he feel about it, in fact, that he and Alex returned together soon afterwards for a more in-depth look at this fascinating and still enigmatic part of our western coast.

This time they circled over the mouth of the King Sound and the Buccaneer Archipelago, so named by Philip Parker King during his survey of 1821 in memory of the buccaneer ship *Cygnet* that had sailed there in 1688.

At full tide the turquoise seas can look deceptively serene, but, with a rise and fall of up to twelve metres, the waters between the scattered islands can surge in whirlpools of formidable power. It can well be seen why the locality was known as 'the graveyard' by the pearling crews of later years.

The idea that the area might have potential for an industry of less hazard to human lives was first mooted in the 1930s but it was not until after World War 2 that Australian Iron & Shell Ltd., a subsidiary of BHP, began mining Cockatoo and Koolan Islands for what proved to be high-quality iron ore. The first loads were shipped from Yampi Sound to Port Kembla and Whyalla in 1951 and later to Newcastle. It is anticipated that mining will continue on Koolan Island for the next twenty years or so, though Cockatoo is thought to have been practically worked out.

This attractive island settlement is now seen as becoming a supply base for coastal surveillance boats and a centre for fishing operations and tourist activities.

In the early 1960s attention was drawn to the possible use of the hitherto wasted tidal power for the generation of hydro-electricity. In 1964 this was examined by members of the French hydraulic-engineering company, SOGREAH. They were particularly impressed with the possibilities of Yampi Sound but at the time the cost of developing the scheme and distributing the power was seen as being beyond Commonwealth resources. It may not be long, however, in view of our increasing mineral potential and of diminishing world sources of energy, before the scheme will be viewed in a more optimistic light.

Meanwhile, as John has demonstrated, the area under review is of immediate importance to an artist with the insight and initiative to get up and look down on it.

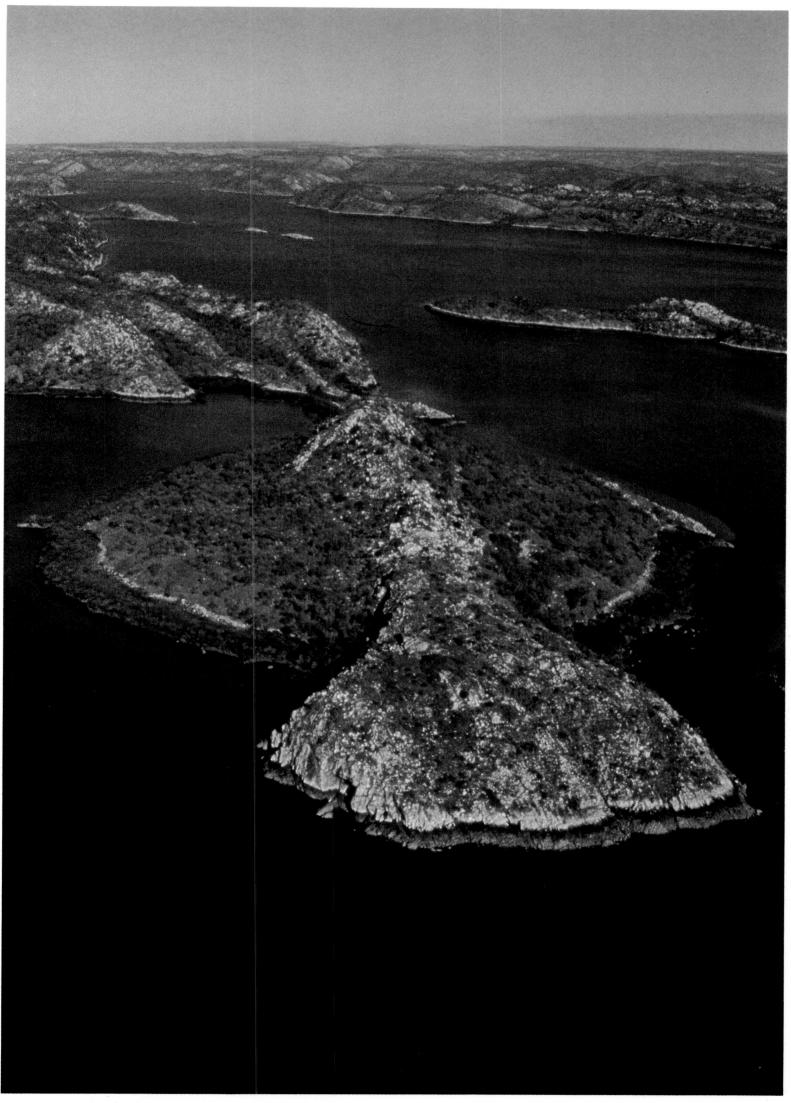

Stunning Buccaneer Archipelago consists of more than 820 islands including the one in the foreground — known to locals as 'Manta Ray Island' because of its obvious resemblance to the benign Manta Ray

8 | BAOBAB COUNTRY

DERBY — MOWANJUM

From John Olsen's notebook:

We leave for Derby. The landscape changes from red to ochre. Vast expanses covered with termite mounds — not unlike the forms in the Japanese Cemetery at Broome.

Mary Durack describes the country between Broome and Derby:

Compared with so much of the Kimberley district the 220 kilometres between Broome and Derby are scenically monotonous. The straight road runs on through pindan scrub, no doubt interesting enough to botanists, ecologists, and wildlife connoisseurs who can identify the trees and grasses and the occasional bird, wallaby, lizard or snake that may show up along the way. For the average traveller there is little of significance until the bridge across the Fitzroy River, the mighty waterway that was the incentive for the district's pioneers and is its main force today. The Fitzroy rises somewhere between the Leopold and Mueller Ranges, forges its way through 520 kilometres of ranges and plains, and extends itself to a width of more than nine kilometres before disappearing into King Sound.

It is little wonder that Alexander Forrest, who led the first expedition to cross the Kimberley from Beagle Bay to the Northern Territory in 1879, returned with glowing reports of good pasture and deep-bedded rivers that held water all year round. Attracted by his reports, the first settlers on the Fitzroy shipped their stock to Beagle Bay in the early 1880s and overlanded to Yeda Station, through which property we approached Derby.

The substantial bridge overlooking verdant river frontages is a modern amenity, that put an end to the days when fording the Fitzroy was a long and often hazardous experience. Though even today, when the river happens to be 'down', the water level hereabouts is extremely high. The situation can be almost as difficult as it was before the engineers got to work.

From here on the baobab trees, usually known as boabs, which are few and far between on the Broome side of the Fitzroy, become a fascinating feature of the landscape. One wonders at the many shapes they can assume without losing their identity, although it is obvious why they are locally known as 'bottle trees'. They range from elegantly tapering wine bottles to squat demijohns, often fused into double, triple, or even quadruple trunks. Some have been forced down by sheer weight, or struck by lightning from the parent tree; but upright or prostrate they flourish gamely on.

Derby was officially proclaimed in the same year as Broome, but it has a different history and a very different character. There has always been an element of rivalry between the two ports. Broome asks why Derby should be considered the capital of the 10-million-hectare West Kimberley shire, and Derby asks why Broome, founded on a now almost defunct pearling industry, should have been favoured with that costly deepwater jetty which keeps its meatworks functioning. And why the buildup of that superior and very profitable tourist image, when Derby has so much to offer too?

From an objective viewpoint the answers are clear. The grazing country behind Broome is limited and of fairly poor quality, whereas that extending from Derby is vast and relatively rich, but Broome was topographically the more practical site for a deepwater port to service West Kimberley. The new jetty transformed Broome into the main port for the district and its modern

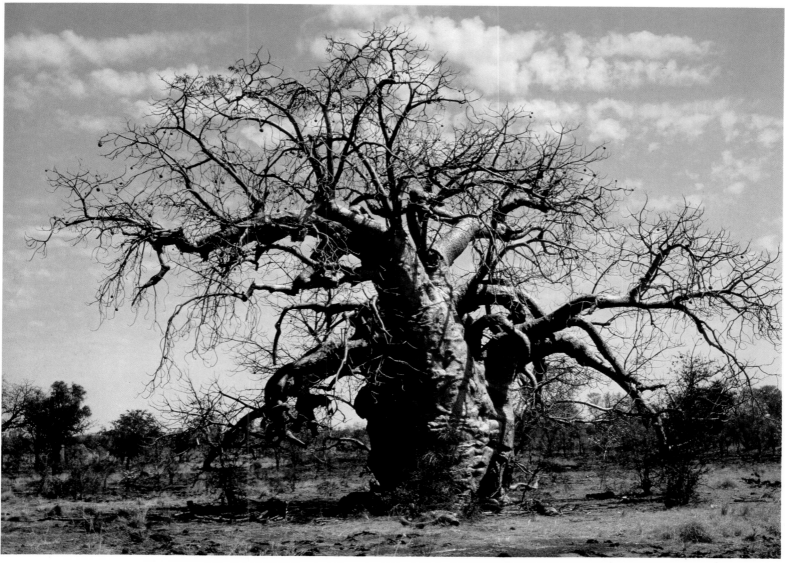

*Baobabs grow only in northern Australia and in parts of tropical
Africa. With boles that grow up to ten metres in diameter, they are among
the largest trees in the world, although they never rise very high*

abattoirs are the most convenient for the processing of beef cattle. Consequently the Derby meatworks closed in 1980, but the town has continued to grow vigorously. This is due to its proximity to large mineral and oil deposits, the growing output of cattle from its hinterland and its planned expansion as a defence base. All these factors are likely to increase its population of 3600 to five times that number, and they cause its spokesmen to press urgently for a deepwater jetty to service the Derby region.

Some months after our visit to Derby, oil began to flow at a site called Blina, 120 km to the east. It is being transported to Broome for shipment and excitement runs high as further rigs go into operation. There is a possibility of great oil reserves both on-shore and off-shore.

At the end of the last century Derby was described as 'a hot, ugly little trading post, hurriedly thrown together from bush timber and galvanised iron, its inhabitants a few business people and a contingent of police and the inevitable chain-gang of native prisoners.' It now holds much to interest tourists but it lacks Broome's inviting beaches, good fishing, and evidence of a romantic past to tempt the tourist to linger on.

Appropriately to the administrative centre of the district, Derby has a fine Shire Hall, a Cultural Centre which includes an art gallery and a library, modern hotels and caravan parks and the Kimberley's biggest hospital. Boab trees, successfully transplanted from outlying areas, give shade and character to its thoroughfares and its spreading suburbia. The chain-gangs belong, thank God, to the past, but Aborigines are still very much part of the Derby scene. A group with whom I have been in contact for a number of years lives at the Mowanjum Community Centre a few kilometres out of town. Their history goes back into the far past of the north-west Kimberley, and since we planned to travel through their tribal territory we had arranged to visit them.

TERMITE MOUNDS, BURNT COUNTRY, NEAR DERBY

It is a blackened battlefield. Strokes
Of charcoal on the blue canvas of the sky,
Burnt pindan leans over
Windowless tenements that hide
Millions of inhabitants
Thriving in a landscape of old massacres.

They reveal the earth on which they're set
By taking everything from it,
In surly ochre or expansive red
Or the dispirited grey of old concrete.
It is an illusion that each mound looks different.
Each has an identical government.

Yet there is no more a word between
Their citadels than the hawk leaves in the air.
The termites are sowing dust in the trees,
Eating dead grass away.
In endless corridors of darkness
Their white bodies are never parted.

Dormitory suburbs where no-one sleeps,
Indifferent to fire, cool in the sun,
Industrial areas where work cannot cease,
Queens for all, holidays for none.
When we have made the world a desert
The termites will demonstrate how pleasure

And leafy ease were a delusion,
How cities could stand up on the plain,
Communities in isolation,
Where nothing but the law prevails.
No sentinels on these towers make
Furtive signals to sight or sound.
There is no poetry in a termite mound.

Poinciana

Like fantastic modern sculptures, the great ant hills or termite mounds of the North-West form insect cities in many parts of the territory. Termite mounds shaped like this one caused William Dampier, who saw them from a distance, to believe them to be 'Kaffir huts'

What an incredible tree is the baobab! Boab, Australians call it, forever shortening long words and often adding on another for good measure. Yet the baobab is bulky enough to need nothing extra. The girth of a large specimen can be ten metres round.

It is a Caliban among trees, with a grotesque appearance most noticeable in the dry season when the leaves are dropped. The witchlike, writhing branches spread from a huge bole, gouty in elephantine grandeur. The grey bark accepts all cuts and bruises and grows a tough skin over each wound.

The first white explorer to write about the trees, George Grey in 1837, thought they had 'the appearance of suffering from some disease, but from the circumstance of all of them being affected in the same way, this was evidently their natural state.'

Young trees have the slim beauty of adolescents but I expressed an affectionate regard for the more mature shapes, and suggested to Mary a book title *In Praise of Older Trees*. This led her to reveal an unsuspected ribald humour, and as we drove through thousands of entwined baobabs she conjured up scenes of bacchanalian orgies.

The large fruits of these trees contain a soft white pulp, very pleasant to eat and a source of food for the Aborigines. The pulp led some people to name baobabs 'Cream of Tartar trees'. When the fruits dry out the seeds rattle inside them and they were used as musical instruments by the Aborigines.

George Grey also wrote that 'upon the bark of these trees being cut they yielded in small quantities a nutritious white gum, which both in taste and appearance resembles macaroni . . . and upon this bark being soaked in hot water, an agreeable mucilaginous drink was produced.'

Early explorers found the trunks an ideal surface on which to leave messages for posterity. The North-West is dotted with such carved memorials, looking as fresh today as when they were carved 100 years ago.

Travellers from Derby to Halls Creek often found fresh water stored in the decayed trunks of baobabs. Sometimes these hollow trunks were very capacious and two particularly famous baobabs are called 'prison trees'. The best-known is a few kilometres from Derby and the other some distance out of Wyndham.

But it is hard to credit the story that police escorting prisoners to the gaols of these two towns would use the hollow trees as temporary prisons. A prison is no use without a door and even the least agile Aborigine would have no difficulty in climbing out of the open tops. Until a few years after the Second World War the police secured travelling Aboriginal prisoners with neck chains and at night these would be padlocked to a tree trunk or log. A hollow baobab would be of no use, especially when it was so close to home, but the idea pleases tourists and they must have taken thousands of photographs of the Derby Prison Tree.

An ambitious scheme to sell about 200 mature baobabs to Japan collapsed under the cost of transportation. Each wooden crate to hold a tree and its bole would have cost about $2700, and shipment to Japan would have brought the cost to about $12 000 for each tree. However the experiment proved that the baobabs are tough individuals. One, left in its prototype crate in a backyard in Derby, has already sent roots through the crate into the soil. Another, lying on the ground at Mowanjum Settlement, had begun to sprout although it had no roots. It was using the stored food in its bole to begin life anew.

The Australian baobabs have a very close relative in the baobab trees which range over much of tropical Africa, and as our trees are found only in the North-West it seems that Africa was their original home. The nuts or trunks may have drifted across the Indian Ocean, although the prevailing winds would make this voyage a long but not impossible adventure. They could have drifted south into the Roaring Forties and then picked up the southerlies to reach a suitable home in Australia. The age of individual trees, and their range from the western Kimberley to the western end of the tropical Northern Territory, make this seem a likely route, unless the first Aboriginal voyagers brought them in their boats.

The most recent theory on the origin of the Aborigines is that they came from Indonesia, possibly as long as 120 000 years ago, with a second invasion from eastern China. Yet thinking on this subject has changed so often that any theory is only as valid as the most recent archaeological discovery. The baobab is one mysterious piece in the jigsaw puzzle of evidence that must be fitted together to discover the origin of the Aborigines.

The local saying, that if King Sound is the arsehole of the world then Derby is what is up it, is perhaps a bit hard. This straggling town between mudflats does not have the charm of Broome but it does have the endless fascination of its baobab trees, its magnificent wide main street and, unexpected bonus, an excellent Chinese restaurant.

We drove out to the Mowanjum Community where Mary's 'nephew', Paddy Mulumbun, a courtly old gentleman in a handsome embroidered white shirt, talked to us in front of his

Paddy Mulumbun, of the Aboriginal community at Mowanjum near Derby,
was appointed a Member of the Most Excellent Order of the British Empire
in recognition of his leadership of his people

house, by trees planted in truck tyres. We sat on petrol cans while he spoke of the Prince Regent country. He is almost the only one left who knows that country, since a missionary named Love brought all the tribespeople down to Derby. When George Grey landed there, on his ill-fated 1838 expedition, hundreds of Aborigines lived along the coast, but even by that time they had had enough bad experiences with visitors from the sea to give Grey a very hostile reception. We are going to be flown by helicopter into this otherwise almost inaccessible country.

The Mowanjum elders were away at the Fitzroy River and were expected back at 7.30 p.m. We returned, but they did not. The Aborigines have their own attitude to time; there is no point in being infuriated by it.

The Community shop sold baobab nuts beautifully carved in a wide mixture of contemporary and traditional styles. The nuts are the size and shape of emu eggs, with the white carving showing clearly in the brown skin. There were notices in the shop: 'No Loans'; 'This shop belongs to you. And if you take things from it without paying you are taking them from yourself.'

Nearby, young men were sitting on Toyotas without windscreens and with immensely long roo-bars with tyres attached to them. These are used for knocking down scrub bulls in the bush.

One can just sit and watch Aborigines walking around for the sheer pleasure of watching human beings who move so differently from whites. Pretty girls with bare shoulders go swinging by; the children seem to flow from the ground on the slender stems of their legs. They look at you quite differently from white children, and their laughter is caught out of the air like breathing. The young men's curly-brimmed hats top their heads, as much a part of them as a canopy of branches is part of a tree.

Every now and then the peace of the community was shattered by a loudspeaker: 'Will so-and-so come to the office, please.' A certain amount of rubbish lay around but it was not excessive, and there were blessedly none of the broken cars of which there are often so many in Aboriginal communities, sometimes even with their noses into the verandah of a house. The Mowanjum homes looked practical and comfortable, with breezeway roofs.

We drove on to the huge and beautifully kept leprosarium. Its magnificent new hospital was empty because there were only twenty patients, one of them a child, and none was sick enough to be in hospital. Lorikeets tumbled among the ripening mangoes. The poincianas, some of them being killed by termites, dangled their enormous phallic seedpods as we talked to down-to-earth Sister Francis and elegant Irish Sister Bridget. They told us about Mother Alphonsus, who had a fifty-piece orchestra at the leprosarium. She taught them all the violin by ear, and the second row watched the fingering and bowing of the front row. Sister Francis said they would be treating the patients in the needle room — in those days there was only one room for all treatments — when the bell would ring and Mother Alphonsus would call 'All out for orchestra practice'. Sister Francis said 'But she was quite right, it was the entertainment that was important.'

The sisters told us how difficult it was to keep the lepers in isolation in the hospital. Either all the relatives would turn up, with all their children, or the patients would hop out of bed when no one was looking and walk thirteen kilometres to the Derby pub.

They showed us Michael, the child patient. His ears had been the first to show the onset of the disease, then it became visible on his legs, and then his fingers began to thicken. His mother had abandoned him as a baby and he had just been brought up anywhere, with no proper home. He was a quiet, nice-looking, self-contained child.

They showed us photographs of the incredible response that comes within two years from the new drugs, and also terrible pictures of the sufferers in the old days. Leprosy destroys feeling in the affected areas and the photographs showed alcoholics with almost no feet, usually burnt off by going to sleep by a fire, or huge ulcers where a thorn or nail had gone into the flesh.

Excellent follow-up treatment is now available from travelling district nurses. In the old days the patients were given pills which they never bothered to take.

They also showed us photographs of some of the parties at the leprosarium. Sister Francis said the Aborigines normally took beer or port to the parties but one night someone brought in some vodka and 'Things were really wild. I've been here forty years and never heard some of the words they were using, especially one young girl. I wish I'd had a tape recorder, I'd like to hear them again.' She laughed.

She showed us pictures of Mary Ann, a leper who had been in gaol in Fremantle. She and her cellmate had killed another woman in their cell. After eighteen months in the leprosarium her terrible puffed-up face was looking quite pretty again. She was a hefty girl of 103 kilograms, and Sister Francis said that when she was in fighting mood a 'look would come over her'. Sister Francis, who was quite a small woman, had on several occasions had to hold her and prevent her from bashing another girl, saying 'Stop, stop, Mary Ann! It'll count against you — you'll lose your probation!'

Sister Francis examining Michael
a 10 years old later to see how he
is progressing. It is common to look
behind the ears for signs of progress.

Mary Ann did not lose her parole but she did have a baby, although drink, smoking, and having babies are bad for lepers. Presumably a course in contraception was not on the sisters' agenda.

Sister Francis said the worst fights were between woman and woman, out of jealousy. Sister Bridget said how sad it is that the sixteen-year-old girls have nothing to do. 'They come back from Perth educated; they go out to the camps and are just degraded.'

The sisters gave us tea in the airy old house, and said they did not know what was to become of the great complex of buildings with only twenty patients in them. The only certain thing, as we all agreed afterwards, is that Sister Francis and Sister Bridget were two of the finest people any of us had ever met.

Michael 10 year leper.

From John Olsen's notebook:

The visit to the leprosarium at Derby was very moving. The quiet dignity of the nursing sisters was one of the most indelibly Christian actions. Sister Francis came there about 40 years ago, a time when little was known about the disease. Contact with lepers was considered dangerous. She described how horrible leprosy was, continuing high temperatures of about 102 degrees with great muscular pain. The treatment was very doubtful and only two per cent managed to recover. The disease is grotesque, huge swellings, great open ulcers, loss of feeling at first in extremities such as hands and feet and eventually these are reduced to stumps. Death came as a release.

Europeans were [almost] immune to leprosy after the Middle Ages. Leprosy came to Australia at the time of pearl diving and was probably contracted by the Aborigines via Japanese or Chinese.

Today because of a wonder drug B663 the cure of leprosy is all but absolute. When Sister Francis came to the clinic there were 360 patients. Now the numbers have made the hospital almost empty — a mere 20 people.

Mary Durack writes of the Mowanjum Community and the Derby Leprosarium:

The Mowanjum people welcomed us with characteristic warmth and seemed pleased to hear of our plans. We had hoped that Paddy Mulumbun, custodian of the sacred sites and traditions of the Prince Regent River, might accompany us to that area. Unfortunately this could not be as he had injured his leg and had some difficulty in getting about. He had no hesitation, however, in answering our questions and giving us permission to see and photograph any evidence of the ancient culture that we might chance upon. Paddy, like Joe Nangan of the Nygina tribe, is not only a keeper of traditional lore but a maker of song and dance and a valuable source of oral history.

I had already learned from him that the community consisted of three distinct and once-neighbouring groups: the Worora, Ngarinjun, and Wunambul. They have different languages but understand each other and share the same beliefs and spirit ancestors. The story of how they come to be living on the outskirts of Derby, to some extent a part of a European community, extends far back into the time before memory.

For centuries, voyagers in strange craft had touched on the coast of the Prince Regent area, but found nothing to their advantage and sailed away again. The Aborigines believed that this might continue to happen but that the visitors would always leaves them to pursue their own lifestyle in their timeless land. They were not to know that they, like the rest of mankind, were a part of the ever-changing pattern of human history.

One of the visitors, the explorer Captain George Grey, was unwittingly to be the first to interrupt the immemorial lifestyle of those three groups of Aborigines. He reported that the region had rich agricultural and pastoral potential, and a well-funded Melbourne-based syndicate equipped a party of settlers to take advantage of this virgin country. In 1864 they landed at Camden Harbour, near the mouth of the Glenelg River, with stores, building equipment, and 4000 head of cattle, horses, and sheep.

The white men and the Aborigines soon clashed when the latter discovered that this strange livestock was good to eat, but it was the environment, rather than the Aborigines, which

defeated the would-be settlers. During the first monsoonal summer, four of the party died and a quarter of the stock had either escaped into the bush or fallen prey to Aboriginal spears. The project was abandoned before the next wet season could take further toll of man and beast.

Despite the reports by these defeated settlers that the tribes were 'savage and intractable', another attempt at settlement followed in 1892. Captain Joseph Bradshaw and his relation Aeneas Gunn took up 44 500 hectares on the Prince Regent River, where Gunn and his helpers began to build a homestead and stockyards while Bradshaw went off to bring sheep and cattle in from Queensland and the Northern Territory. Finding that a recent State government Act would force him to pay tax of a pound a head on every beast brought across the border, he gave away the north Kimberley venture and set up what became known as 'Bradshaw's Run' at the mouth of the Victoria River.

Aeneas Gunn, who had discovered the Prince Regent tribes to be just as savage and intractable as they had been described, was not sorry to leave the Prince Regent country and join Bradshaw in the relatively civilised Northern Territory. He later became manager of Elsey Station and was to be immortalised by his wife in her book *We of the Never Never*.

The Worora people and their two neighbouring tribes did not establish an understanding relationship with the Europeans until 1912. This was brought about by an initiative of the Federal body of the Presbyterian Board of Missions, which sent a husband and wife team by lugger from Broome to attempt friendly contact with the Aborigines and, by interpreting the Christian message, prepare them for harmonious integration with white society. Their success in this task, under conditions which had defeated previous newcomers, is surely a tribute to their selfless ideals.

The seemingly impossible venture began at Hanover Bay, opposite Augustus Island, on a site named King George IV Mission. Here the first superintendent and his wife made contact with the Aborigines, who soon came to understand that these members of the suspect race had not come to take over the country for their own use. Eventually they accepted the mission as a place where they could rely on the friendly exchange of language and customs, and skilled help in cases of illness or injury.

By 1916 the missionaries were in contact with 400 to 500 people of the three tribal groups, who agreed that the mission should be moved to a more suitable site known as Kunmunya, further inland. Circumstances that arose during and after the Second World War resulted in a second relocation of the mission, this time to Wotjulum. After five years at this base, the Aborigines faced problems arising, somewhat ironically, as a result of their integration. They still retained their languages and traditional culture but were, for the most part, at least attuned to Christian concepts. The majority were literate and trained in various capacities, including stock work, agriculture and carpentry, and some had begun to see their isolation less as a welcome refuge from the white man's world than as a dead end for their future prospects. Those who had visited Derby were impressed by its educational and medical facilities, entertainments and job opportunities. When the people heard that a small property a few kilometres from Derby was up for sale, a number thought it should be purchased as a new centre for them although others strongly opposed the idea.

The missionaries had a long-established policy of giving advice and information when the people asked for it, but of leaving decision-making on policy matters to the Aborigines themselves. In this case, having ascertained that finance was available from the Department of Native Welfare and the Presbyterian Church, the community at last agreed they should buy and take over the Derby property.

They completed the move by the end of 1956 and gave the name of Mowanjum, meaning 'settled at last', to their new home. A village soon took shape for the Aboriginal families and their white helpers, including storehouses, a church, a community centre and recreation areas.

When I first visited Mowanjum, during the 1960s, I was impressed by the character of the people and their apparent stability. The men had jobs in Derby or on their own property, while some of the women worked at the Derby hospital or at the school attended by the Mowanjum children.

In more recent years the community moved to a site about the same distance from Derby but further from the airport and the main road. Like other Aboriginal groups nowadays it is an incorporated body administered by an Aboriginal Council, with the help of a project officer and a clerk. The Council employs its people on housing projects, on home management, and as stockmen on Pantijan Downs, a cattle station of 265 000 hectares within their tribal territory over the Leopold Ranges.

Many of this community are outstandingly artistic and they have built up a good local market for their traditional handicrafts. In the annual Derby festival they bring out their tribal totems and take a fascinated audience back to the Dreamtime of their spirit ancestors.

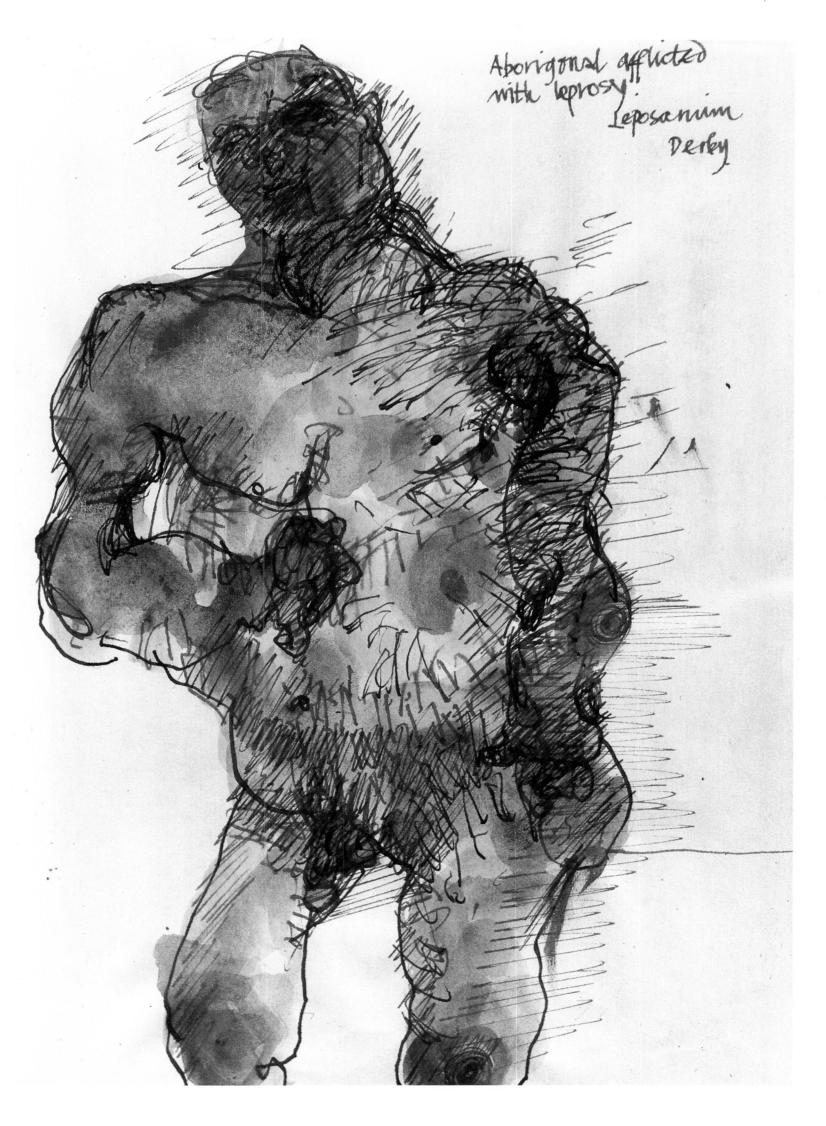

Aboriginal afflicted
with leprosy.
Leprosarium
Derby

The updated policies probably work as well here as anywhere, although communal decision making is no new concept to the Mowanjum group. They do not appear to be as united and confident as they were when I first visited them, and the elders are worried about the younger people in an age when unemployment cheques and other 'benefits' rob them of initiative and provide an incentive for drink and gambling. The loss of several outstanding leaders during recent years also weighs heavily on their hearts.

A number of these were also dear to me, especially Paddy Mulumbun's 'cousin-brother', Albert Barunga. I was his 'tribal aunt' and I covered much of rural and urban Australia with him over the years. During the 1970s we were both associated with the steering committee of the Aboriginal Cultural Foundation, of which I write later in this book.

Albert often spoke of the remarkable men and women who gave so much of their lives to his people. They include the Reverend J. R. B. Love, whose book *Stone Age Bushmen of Today* is a detailed account of his association with the three tribes represented at Mowanjum, and with whom Albert worked on a study of local lore and languages. As a Christian minister, Love's approach to the Aborigines of the North-West appears to have been similar to that of some of the Catholics and Anglicans working in the same field. Many of the observations made by the Pallottine Father E. A. Worms could almost have been those of Love, who wrote 'As I looked at these rites the amazing realisation flashed upon me that here . . . were rites akin to the most sacred observances of the Christian faith. I had been witnessing, in all their primitiveness and crudeness of administration, the rites of the Laying-on of Hands, of Baptism, and of a sacred meal that could without irreverence be called a Communion . . . All were here, practised in the spirit of the deepest reverence and awe by naked savages in north-western Australia.'

There is a tendency today to denigrate the activities of missions which worked among the Aborigines, but surely few could underestimate the value of those involved with the problem of leprosy in northern Australia. While we were in Derby we saw something of the situation as it exists today.

Despite its forbidding name, the leprosarium is an attractive place in a setting of bright tropical gardens and shady trees. Its large modern hospital is surrounded by well-kept buildings, including residences for the superintendent and staff, a convent for the nursing sisters and a community chapel. Its cheerful impression on a visitor is by no means a false one despite its beginnings as an outpost of desolation and despair.

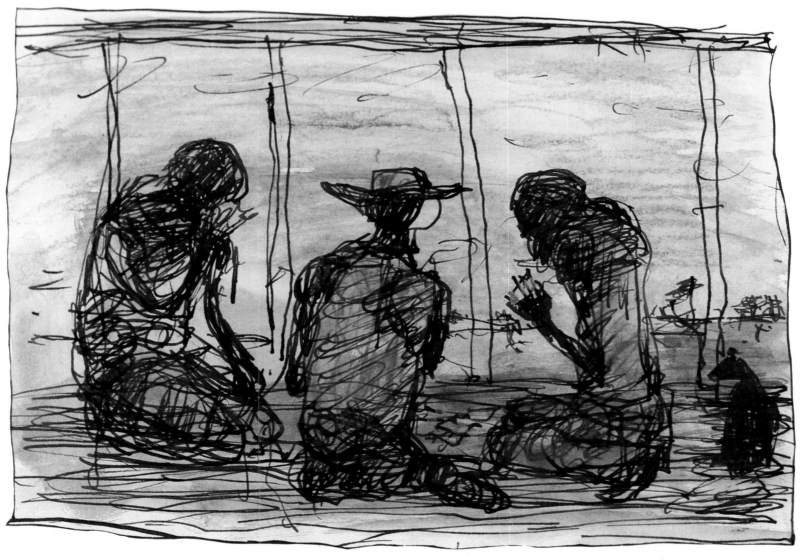

playing cards.

Leprosy, now usually called Hansen's Disease, is not indigenous to Australia. It is thought to have been introduced to the Northern Territory and the Kimberley with the influx of miners and pearl divers from Asia, Indonesia, and the Pacific islands towards the end of the last century. After that, occasional cases of what the Aborigines named 'the big sick' were quarantined and treated according to the limited knowledge of the time, but as far as the general public was concerned the problem did not surface until the 1930s.

In 1933 a few concerned government officials and medicos urged an investigation into leprosy in Northern Australia, which revealed an alarming incidence of the disease on missions, pastoral stations and in bush camps. In an attempt to limit the spread of the disease, cases from Western Australia were sent to a leprosarium near Darwin: a procedure which caused great distress to both the victims and their families.

The Sisters of St John of God appealed for permission to open a hospital in the North-West, so that sufferers might be cared for in their own country, but this was turned down. Adverse publicity caused the authorities to set aside a section of the Native Hospital in Derby as a quarantine area, to be looked after by a trained nurse and her husband. These two people carried on until differences with local authorities caused them to resign. After that the lepers were removed to a compound about twenty-two kilometres from Derby, where they received the basic necessities of life but little other attention.

Continued medical concern at last gained political backing, and in 1937 the government accepted a renewed offer from the Sisters of St John of God. Although it was believed that the four volunteers were to cut themselves off from the world for the rest of their lives, the news that they had been accepted by the government was received at the Broome convent with joyful thanks.

It was soon found that about half of the 340 supposed lepers in the Derby compound were not suffering from leprosy at all, but from lesser complaints that could be treated successfully. When these were discharged the news spread quickly through the Aboriginal community. Those who had previously regarded a diagnosis of leprosy by a medical survey as tantamount to a sentence of life imprisonment gradually lost the fear that had driven many to hide away, sometimes to die alone in the bush. The work of the Sisters was also a source of great relief to white residents on station properties, who had been shocked by the presence of the disease among their Aboriginal employees.

Leprosy was then believed to be incurable, but modern research into the leprosy organism *Mycobacterium leprae*, new methods of treatment and the development of modern antibiotics, gradually brought the situation under control. Many long-term sufferers were eventually allowed to go home, subject to their returning for occasional checks. In more recent years, more advanced methods of plastic surgery and muscular therapy have to a great extent overcome the disfiguring and crippling effects of the disease. The chances of contagion, although not to be entirely dismissed, are known to be minimal.

The once-dreaded 'Lep' became known as a place of such caring and comradeship that many patients considered ready for discharge would happily e stayed on. The essential 'therapy of distraction' gave encouragement to the development of new and traditional skills, and for some patients it was a chance to acquire at least the rudiments of education that would not otherwise have come their way. Entertainments, including concerts and plays, sporting and social activities, were very much part of life at the 'Lep' and when, during the war, a few musical instruments were donated to the hospital, they were certainly put to good use.

Mother Alphonsus Daly, a skilled musician, embarked on the unlikely task of training an Aboriginal orchestra, and the aptitude of her pupils surprised everyone. Not only did they excel in beating out the rhythms of popular tunes on their instruments but they also rendered excerpts from Beethoven, Mozart, Wagner, and Handel, to Sister Alphonsus' piano accompaniment. After the war, incredulous audiences, including passengers from visiting ships, flocked to the once forbidden premises. Mother Alphonsus became used to answering such astonished questions as 'How did you teach Aborigines to read music?' Her answer was that she did not need to do so. They have a great love of and memory for music, together with a keen sense of harmony and rhythm. These qualities, combined with a natural perseverance, enabled them to copy the movements of more experienced players and to develop a technique of their own.

Everyone was disappointed when official disapproval put an end to visitors without permits entering the Leprosarium. When the leading players either died or were discharged, the leper orchestra passed into local history.

It is always a pleasure for me to visit the Leprosarium, where I have had the privilege of knowing most of the pioneer nurses and those who succeeded them. On this visit we were escorted around the spacious hospital built in 1942 for more than 300 patients. The question is no longer that of dealing with a major medical problem but whether these premises should be used for other purposes, and the few remaining cases cared for in a smaller hospital.

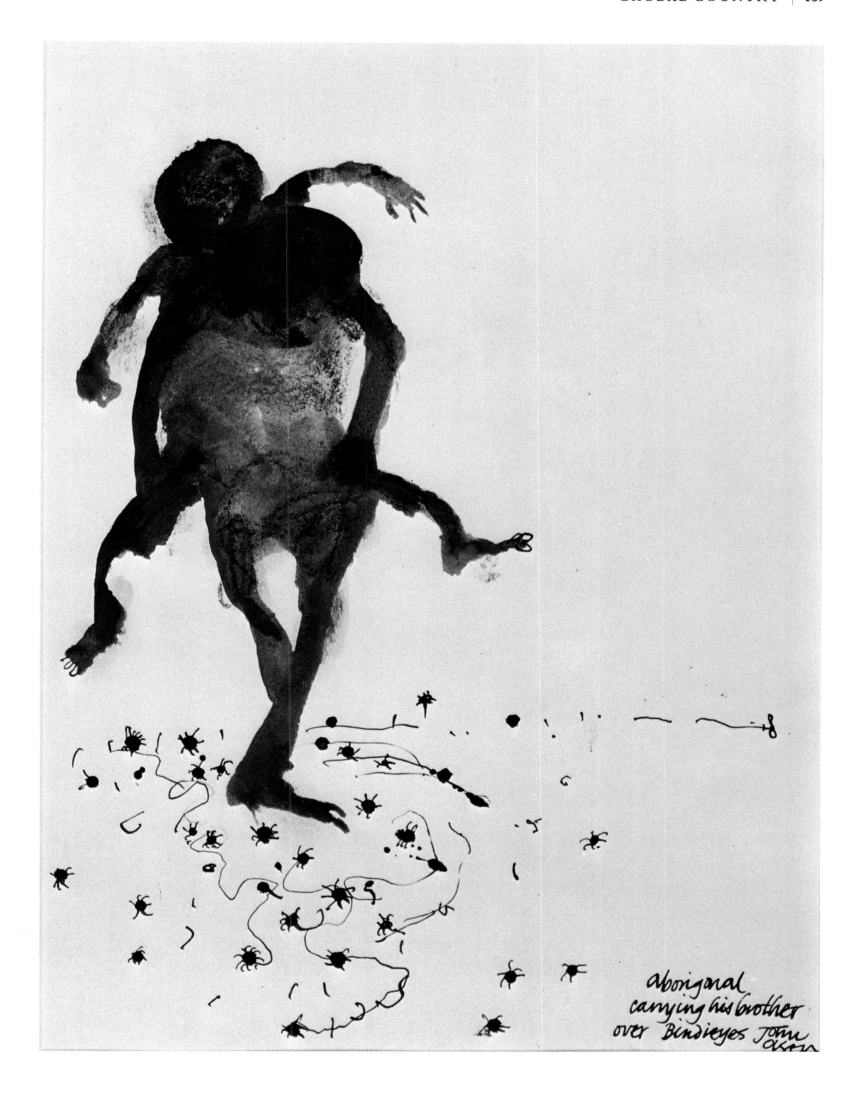

aboriginal
carrying his brother
over Bindieyes John
Olsen

9 | LAND OF THE WANDJINAS

LENNARD RIVER — WINDJANA GORGE — TUNNEL CREEK

Mary Durack writes of the next stage of the northward journey:

On overland journeys such as that from Derby to Windjana I have always been accustomed to intermittent verbal exchanges on such matters as the condition of the country and the stock beside the road, a few items of local gossip, rambling recollections, and the all-important question of when or whether we should stop for a meal. With Geoffrey Dutton at the wheel and John Olsen in the back seat I enjoyed a different kind of running commentary. It would seem that John is concerned less with the state of the pasture than with the fascinating patterns and subtle colourings of its eaten or burnt-out areas, the wonders of its ant-hill cities, the grotesque shapes and sometimes uninhibited behaviour of its baobab trees.

We discussed the development of the Australian vision by which our artists and writers have come to interpret the country as insiders, rather than as people with hearts elsewhere and eyes accustomed to a different vegetation and a different light. It was amazing how the kilometres sped by until we were suddenly confronted with the formidable Devonian shape of the Napier Range. Geologists tell us that this sunbaked rock face, 450 kilometres long, acquired its character under the sea some 300 million years ago, and that it is the finest example of a fossil barrier reef to be found anywhere in the world.

The enthusiastic young ranger and his wife live in a caravan parking area on the banks of the Windjana Gorge. They are well-informed on the geology and history of the area, which is especially associated with Pigeon, the Aboriginal outlaw, also known as Sandawara. Pigeon is the subject of at least two books, *Outlaw of the Leopolds* by Ion Idriess and *Long Live Sandawara* by Colin Johnson. I had grown up with his story as told from various points of view, and I was anxious to explore the gorge where he and a number of his followers met their end.

In the late 1880s, Pigeon was arrested as a young man for sheep and cattle spearing and imprisoned in the Derby gaol. His intelligence and personality soon won the favour of his gaolers and the police trained him as a tracker, a role he filled with apparent loyalty and considerably agility for a number of years. But in 1894 he and a fellow-tracker named Captain, having assisted in the arrest of sixteen of their countrymen, shot the constable in charge of the party, released the prisoners from their chains, and escaped with them into their tribal territory.

According to one version of the story, Pigeon was shamed into this action by a tribal elder who held that the only hope for the Aborigines and their sacred culture lay in driving the white intruders from their land.

Soon afterwards, Pigeon and his followers ambushed a supply wagon, killed the two men in charge, and made off with a number of firearms and a good supply of ammunition. This enabled them to carry on a kind of guerrilla war against the police and the settlers enlisted as 'special constables'. In a two-year conflict six white men and fifty-four Aborigines are recorded as having lost their lives. No doubt the figures are accurate enough for the whites, but it is probable that many more Aborigines were shot during this period.

Conflict between whites and Aborigines was common enough at that time, but there has probably been no other instance of an organised uprising of tribesmen equipped with European weapons and operating in a country where they could have hidden out indefinitely. If ammunition had been readily available to them their defiance could well have had more serious consequences for the scattered settlers, but the outcome could hardly have been in favour of the Aborigines.

In 1897, the pursuers trapped Pigeon and nineteen of his followers in Windjana Gorge, and killed or captured all the rebels. The site of this last battle is a canyon about five kilometres long, cut by the Lennard River through the Napier Range. Its steep limestone cliffs, with their summits forming a jagged silhouette against the sky, are an awe-inspiring spectacle. Tunnel Creek, said to have been Pigeon's favourite hiding-place, has eroded its way through the gorge over the centuries. We were there at a time when the creek which pours out of the tunnel in a torrent during the Wet had run itself dry, and we were able to peruse its winding course with the aid of a torch.

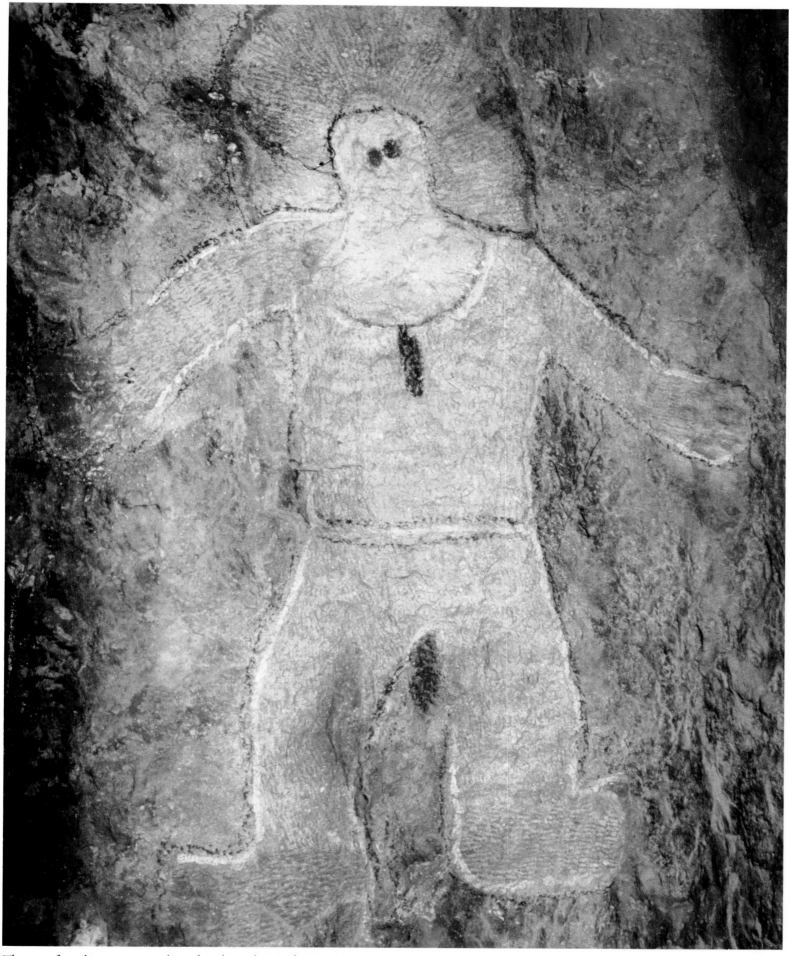

This type of wandjina gave rise to the modern theory that wandjinas were 'space travellers' who visited the North-West at some time in the distant past. It is easy to see that the 'space suit' might prompt such modern imaginings, but wandjinas are really the spirits who control the ultimate sources of life

The ranger told us that the gorge was once known as 'the cave of bats', and suggested that if we wanted to know why then we should return at 5.50 p.m. We did so, and saw the astonishing exodus which began at precisely that moment. I am familiar enough with flying foxes (or what Vincent insists are 'fruit bats') which haunt the banks of the Ord River and the mangrove forests of the northern coasts. I have often seen them swoop past in hundreds like a cloud across the sky, but never as they were on that night, pouring in hundreds of thousands through the gorge en route to some nocturnal feeding ground. The noise was tremendous, from vast flocks of white corellas squawking shrilly from the trees that line the gorge. A spellbound tourist from Victoria shouted in my ear 'Now I've seen everything!'

Towards Gibb R.

Geoffrey Dutton writes of the day's experiences:

We approached the great bastion of the Napier Range, a dusty grey organ-pipe structure with patches of bright orange where the rock had broken away, and sometimes rosy or flecked like marble. John talked interestingly about the tonalities of this country and said he could paint it all in only four colours. Even the sky could be mixed with ochre.

The ranger, Jeff Marchant, and his wife Judith, met us at their caravan at the entrance to Windjana Gorge. They had already had 8000 visitors during the year. If you just pick out the gorge on a map of Australia, 140 kilometres out of Derby on a fairly rough road and situated in an area of some 200 000 square kilometres where there is not a single town, you will be as astonished as we were at the number of people wandering around Australia looking at things.

It is a pity that two such splendid people as the Marchants should be so fed up with their government employers that they had decided to leave the job. Not one of the $30 000 a year National Park bosses in Perth had ever visited the Marchants in all the time they had been there. They had had to provide their own caravan and tent, he had to make his own plan for the layout of the tourist camp, and his letters to Perth went unanswered. One day a bore contractor, who was working while we were there, arrived and said 'Right, where do we put the bore?' They told us that the Perth bureaucracy never showed any interest or co-operation. I must say that if I were an official in Perth I would be continually inventing excuses to visit such a wonderful place!

The gorge itself is magnificent, with great buttresses and lovely deep pools in which we swam, ignoring the little freshwater crocodiles. But the major attraction was the exodus of more fruit bats or flying foxes. Exactly on time they began to fly out in silent hordes, black against the red sunset, beyond the white corellas on the tall gums. For eight to nine minutes they flew at perhaps the rate of 10 000 a minute, and after fifteen minutes lesser numbers were still following. It is amazing that they all find enough to feed on.

On the next evening Ninette and I sat alone on a red sandhill to watch their rocking flight, again silent except for some little chirrups and at the end one calling like a sportsmaster chasing children out onto the playing fields 'All out, all out!' Night came down and it was dark by the time the last of the bats had gone, and one star came out.

Vin Serventy writes:

Windjana Gorge has always been an exciting place for naturalists because of its extraordinary geological history and also for its wildlife and its importance in the Aboriginal story. It has been one of my favourite places since I first camped here in 1965. The name, a corruption of the more common 'wandjina', is a reminder of tens of thousands of years of Aboriginal occupation. Wandjinas are the extraordinary paintings found in the overhangs of the Leopold Ranges and in many places of the western Kimberley.

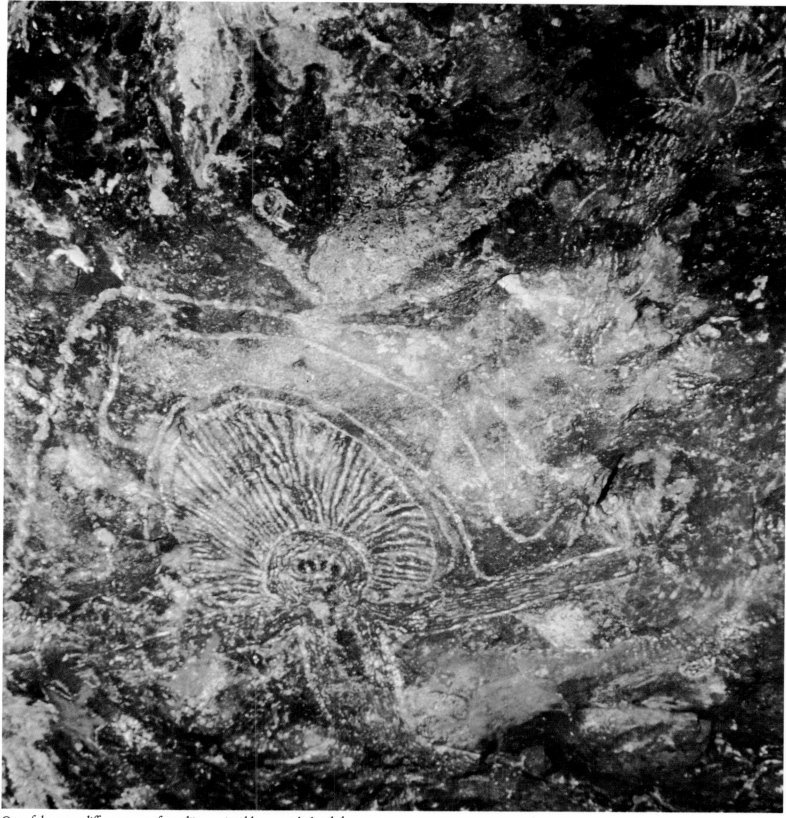

One of the many different types of wandjinas painted by a vanished tribal
group of the Napier Range

Most wandjinas are human in form but often about three times life size. They vary from black through yellow to red, often on a background of white, and they have large fringed eyes, a nose but no mouth, and a variety of head-dresses.

Purveyors of nonsense tell us that the wandjinas were spacemen who arrived in a flying saucer to educate and civilise *Homo sapiens*. The figures are seen as men in space helmets, but no one who believes in this myth is able to explain why superior beings from outer space should copy our own primitive helmets — or why they did not educate the Aborigines in such technology that they would have been able to blast the white invaders with ray guns.

In fact, the Aborigines explain the wandjinas as being the most important of the spirits of the Dreamtime, because they bring the lifegiving rains of the Wet. As spirits of the cloud, they can be seen each year when the towering cumuli appear. The wandjina hair may be the feathers the spirit wears or the lightning it controls. In *The Art of the Wandjina*, anthropologist Ian Crawford of the Western Australian Museum says that they could 'exist in either human form or cloud, so the paintings of the Wandjinas range from human figures to stylised representations of cloud.'

Crawford points out that the small pool in the southern entrance of Windjana Gorge contained the spirits of children ready to enter either a fish or a crocodile. If a man eats either of these then the spirit child enters his body, later to be transferred to a mother. Even a walk past the pool is enough to tempt a spirit child to follow.

It is often said that the Aborigines had no knowledge of the facts of conception, but they believe the physical process is less important than the knowledge that the spirit of the child comes 'not from man, but from the Gods, the Wandjinas . . .'

Wandjinas control the beginning of all life as well as the fertility of humans, so that, in essence, they are the ultimate sources. The Aborigines believe that if the paintings and their rituals should be forgotten then the natural tribal world could not continue.

Vin Serventy also gives more details about the great flight of the fruit bats:

Australia's earliest settlers gave the name of 'flying foxes' to these massive invaders from the skies, when they poured out of the Sydney summer skies to devour the fruit from the orchards. Their size and fox-like faces inspired the name, which was eventually changed to 'fruit bat'. Later research showed that both names were erroneous, because these huge bats feed basically on nectar and blossoms and only turn to soft fruit when their natural food is short in a poor flowering season. Francis Ratcliffe, the English scientist commissioned to study the bats which caused so much damage to Queensland fruit crops, described colonies of a quarter-million bats and said that even larger ones were probable. The bats eat blossom for their nectar and pollen and crush fruit to drink its juice, discarding the fibrous parts.

It seems probable that various species of bats are the most common mammals in Australia, far greater in number than kangaroos, wallabies, and possums.

These giants of the bat world lack the sonar which enables their smaller cousins to navigate in the dark, and so they must use the dim light and their sense of smell to find their way and their food. Research on fruit-eating bats in America indicates that many flowers have an odour favoured by these night fliers, and that such flowers are pushed well out of the tree tops so they are easily seen. Rainforest trees often have flowers and fruit growing from their trunks rather than from fragile branchlets, apparently to allow large mammals to feed and thus spread pollen or seeds. It seems very likely that bats which eat fruit and blossoms are important in pollinating many of our native plants.

At our camp on the Drysdale River we had a retinue of bats feeding all night in the flowering paperbarks along the pool. Scented fragments fell in a constant shower on our mosquito nets. Although most of the blossom is destroyed the bats gather enough pollen on their snouts to transfer this male material to the female part of another flower, so that nature's urgent purpose of the continuation of the species is carried on.

I have found well-chewed fragments of leaf material under places where bats had been eating, so they must sometimes eat the growing tips of trees. The sweet-toothed sugar gliders and their cousins cut into the sap of trees to gain a short cut to the plant sugars and bats apparently do the same.

Geoffrey Dutton (first) and Vin Serventy describe the party's camp on the Lennard River:

This was a lovely camp in thick forest, under big-leaved trees with corky trunks, going down to a dry riverbed. The dawn chorus was deafening: the delicate liquid calls of golden orioles and butcher birds occasionally emerging uncrushed from a battering of cockatoos and the klaxons of friar birds.

Finding a good place to camp is an art. An ideal site would offer a pool where we could swim, shade for our food and cooking gear, plenty of firewood for cooking, easy digging to bury rubbish and a dawn chorus of birdsong. We also liked it to be beautiful. Sometimes we were unlucky but most of our camps were excellent and some were memorable.

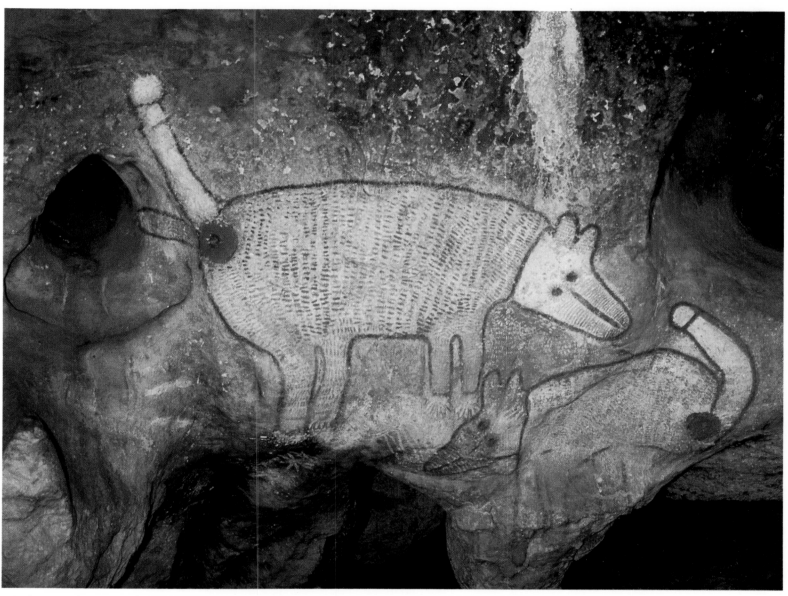

The famous rock painting of two dingoes seen by the travellers in the Napier Range

Our site on the Lennard River was typical of winter camps in the north. The river was dry but occasional permanent pools were held in the sandy bed. Growing in the sand, and most strongly along the edge of the river, were the huge paperbarks called cadjeputs. River redgums grew on the alluvial river terrace, with white corellas roosting in their branches in the evening and heralding the dawn with cheerful yelling.

Bottle trees & King Leopold R.

On the second day at the Lennard River camp, Jeff Marchant the Ranger guided the party to see the Aboriginal rock paintings in the caves along the northern face of the Napier Range. Geoffrey Dutton describes the experience:

You climb up steep rocky slopes and there are the caves deep down in the cliff, not dark, but well-lit from the sunlight that comes in over the lip of the rock that protects the paintings from the weather. The entrance rocks are worn smooth from hundreds of years of passage of bare feet, and as you turn around to face the light you see a great panorama of the country stretching to the far Leopold Ranges.

The paintings, one of the great art galleries of the world, have become part of the whole structure of nature. They are not detachable works of art; they have to be seen where they are. Aboriginal art has a prodigiously powerful sharing of the spirit of place. Western art can to a certain extent be detached from its origins and still preserve its power — although one cannot imagine the rose window of Chartres Cathedral anywhere else, and the Elgin Marbles look sad in the British Museum whereas they could look joyful in their rightful place in the Parthenon — but Aboriginal cave paintings are like those of pre-history. Ninette and I were lucky enough to be in France when the Lascaux cave paintings were discovered, and we were able to view them before they were sealed off to prevent deterioration. They had the same tenacious sense of belonging as these paintings in the Napier Range. The caves are full of treasures in deep rusty reds, yellow, white, and black: wandjinas, lightning-men, crocodiles, and other cultural and fertility symbols.

The greatest of all the Napier Range paintings, of two dingoes, is in a different type of site; up a valley and visible from 100 metres away. The two dingoes are waiting by a waterhole for a kangaroo to come and drink. Behind them, further into the cliff, is a cave where, Jeff told us, dingoes still come to have their pups.

The painting is a work of genius, with a strength of animal and sexual presence. The flecked markings of the fur of both dingoes ends abruptly at the neck, so that it looks, oddly, as if they are wearing some form of knitted garment. Their tails are thick with knobs on the ends, like extraordinary phalluses, and each dingo has a brilliant deep ochre anus. In Western art this would seem comic: a jest fit for Plautus or Rabelais. Here, for some mysterious reason, the element of scatology remains but there is something almost sacred about it. Without knowing any of the motives of the Aboriginal artists one could easily get into deep aesthetic water, citing Swift, Pushkin, and Patrick White, over the nature of the relationship between excretion and creation.

The ears of the dingoes stick up vertically but both eyes are drawn on the one side, so that it seems as though they look ahead and also look directly at you. It is impossible to say, aesthetically, why some images are far more compelling and haunting than others. Why is the Mona Lisa not just another portrait of a lady? So it is with these dingoes.

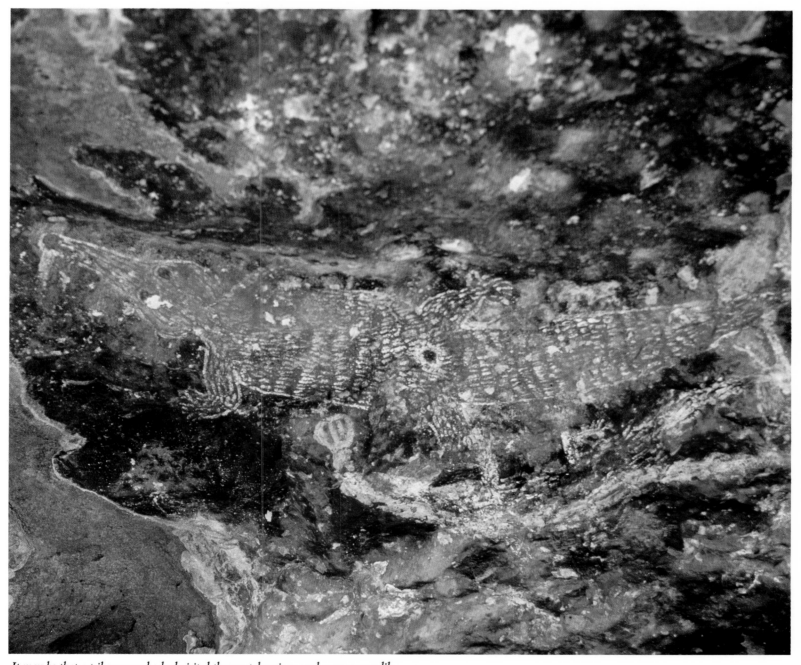

It may be that a tribesman who had visited the coastal regions, and seen a crocodile there, painted this representation in the art galleries of the Napier Range

Jeff took us to another cave where there were skeletons; it even had the smell of death about it. Nearby, to his excitement, he picked up a perfect fossil shell, like a turban shell. It was the first he had found; a token of the ancient barrier reef we were walking on.

When we yarned over lunch, Jeff told us he had only had trouble once with all the tourists who had visited Windjana Gorge. One of them came up to him with a menacing look and asked 'D'you ever have any trouble here?'

Jeff answered 'No, but if I did I've got a seven-foot stockwhip hanging there.'

He said that the locals are very local. The owner of a (relatively) nearby cattle station came to call one day and Jeff asked him how often he went south. The cattleman said 'Been t'fucking Broome once. Jesus, that was too far bloody south for me.'

It was about eight in the morning and so Jeff offered him a cup of tea. 'Jesus, Jeff, you ought to know I never drink fuckin' tea.'

'Would you like a beer, then?'

'Now you're talking!'

In the evening we returned to Windjana Gorge and had a swim in the deep pool by a white rock, with a red cliff hanging over it. Mary and Vin were sitting by another pool and were recognised by a group of tourists. Obligingly they each gave an impromptu talk on the human and natural history of the region. They were great travelling companions, always knowledgeable and always happy to share their knowledge. Travelling with Mary in the Kimberley was like having a gold passport. Everyone knows and adores her, including the Aborigines who nearly all seem to be her ' 'lations': a spiritual kinship from the years she has spent with them.

That evening, when Ninette moved our bed, there was a blue-tongue lizard curled up under the inflated rubber mattress.

Mary Durack comments on the Napier Range paintings:

The northern side of the Windjana escarpment is a comparatively sheltered aspect of the gorge, and so its caves have been used by the law men of the Unggami tribe to perpetuate the memory of their spirit ancestors and to hide away the bark-wrapped bones of their dead. The paintings, not having been touched up of recent years, are mostly faded images, but for some reason the two representatives of the Dingo Dreaming might have been painted yesterday. It is difficult to say what they are up to though it would seem possible they are encouraging their kind to procreate.

The wandjinas represented in the caves are among the most important of the creator spirits: the makers of land and sea and of man himself. They existed both in the forms of men and clouds, and left their portraits in sacred caves so that people will remember they are still the bringers of rain and the guardians of spirit children. Wandjinas are the friends of man, but when they are offended they bring punishment in the form of cyclones and floods and they have been known to call on lightning to strike men dead. When the people remain in their tribal areas they keep the wandjina paintings in repair and sing placatory songs as the wet season storms blow up. We will no doubt see many more of them as we travel north.

It was surprising to find, in these caves, spritely figures rendered in silhouette, for which the Aborigines disclaim responsibility. They look like examples of the Mimi paintings of the Northern Territory and resemble ancient art forms found in the Pacific islands, the south-east of Spain, and South Africa. Some Aborigines say these paintings are the work of mischievous 'little people' who, like the Guradidj of Dampierland, inhabited the country in ages past. Others told the anthropologist Ian Crawford, who found similar paintings further north, that they were not the work of men but of birds, sometimes working under instructions from spirits that only birds can see or understand. Whenever they turn up they raise a puzzling question that anthropologists have yet to solve.

Vin Serventy reflects on various aspects of the Napier Range:

About twenty years ago an American geologist, Professor C. L. Camp, wrote of it '. . . it runs like an old ruin, black castellated walls for a distance of some forty miles . . . Along the entire length of this escarpment the cliff faces are perforated by cave entrances and fissures. These when partially eaten away by erosion produce the most remarkable and varied rock forms; windows, arches, spires, domes, and pinnacles of continuous interest to the traveller . . . the area is one of great potential . . . and our generation will be called to account if vandalism occurs through lack of foresight or interest.'

Fortunately, steady pressure from conservationists has led to a national park being declared over the main geological features, and Jeff Marchant told us that new watering points will allow the gorge to be fenced off against cattle.

The remains of the stone walls of Lillamaloora police station, the place where Pigeon released the fifteen chained prisoners and started his war against the whites, are a treasured relic in the national park. They speak silently to us not only of Pigeon's struggle against white domination

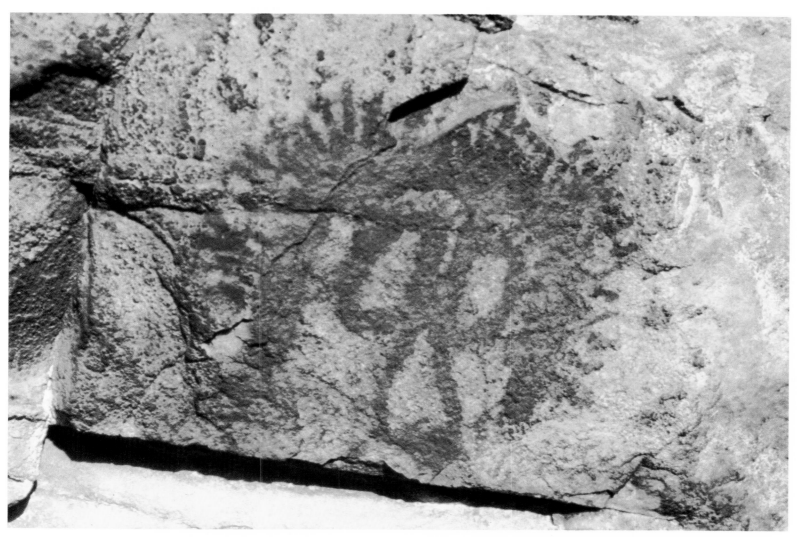

Above: *This rock painting, resembling an heraldic crest in red ochre, is in Drysdale River National Park*

Below: *Wandjina heads look out over the centuries from one of the rock art galleries in Drysdale River National Park. One legend says that the wandjinas have no mouths because they contain all the elements of the climate, and if they had mouths they would release unceasing rain upon their territory*

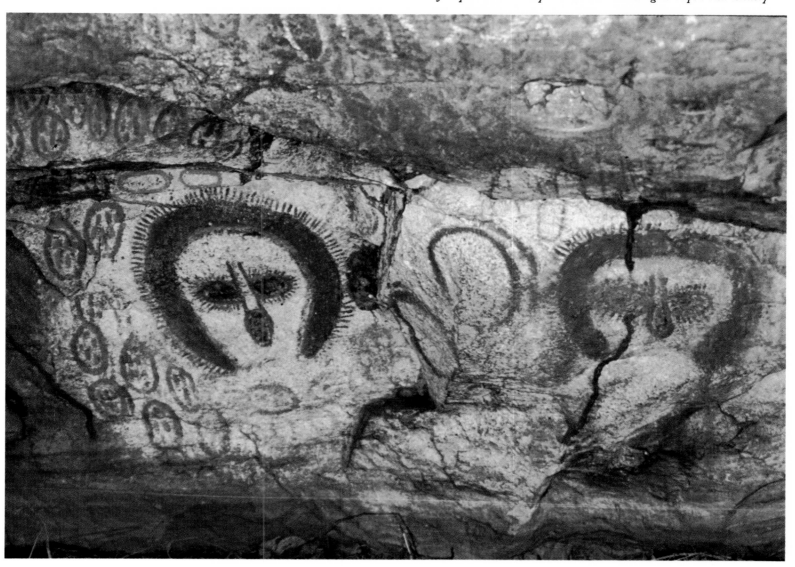

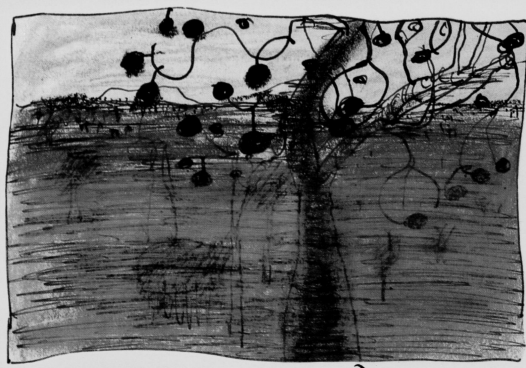

Bottle tree & seeds

but also of the other conflicts between black and white in the Kimberley area. Dr Bruce Shaw, in his book *My Country of the Pelican Dreaming*, tells the story of the Kimberley people through the life of Grant Ngabidi, an Aboriginal born in 1904. He writes that Grant was born into 'a culture that was under siege. His country was under enemy occupation . . . Aboriginal society in those years had a kind of ''underground'' and in many cases a highly efficient intelligence network. These terms are chosen with care, for the situation was in many cases analogous to war. The killing of uncounted Aborigines, the cunning and viciousness of European and ''native'' police, and the keeping of women and children virtually as hostages were the first steps in a policy which established semi-feudal patronage on cattle stations.'

Dr Shaw points out that before the coming of the whites there were probably about 30 000 Aborigines in this rich country. We have no exact figures of the number killed during the 'pacification' of the Kimberley but there was a policy of killing the leaders in order to convince the others that resistance was useless. The higher technology overwhelmed the lower and even fostered a belief that the white man's god must be stronger than the Law.

In the Daly River region of the Northern Territory there was apparently a period of near-anarchy, but Dr Shaw is not certain that the same condition applied in the Kimberley. However his studies make him believe there was 'a high level of violence'.

In other countries the breakdown of the old ways often resulted in an anger which expressed itself in various forms. In Canada, it led a group of indigenes linked with the Beaver God almost to exterminate the beavers in their region, ostensibly to sell the pelts to the white invaders but probably to punish their god for betraying them. In the Kimberley and in other parts of Australia, it is possible that similar confused feelings prompted the senseless burning of country by Aborigines and the tribal killings which occurred after the end of resistance to the whites.

The resurgence of the Kimberley Aborigines during the last two or three decades, following their long slow decline, is something of a mystery. After their surrender to the whites they lived like serfs in feudal times, often despised by the whites who employed them. Even the whites who wanted to help them believed, like Daisy Bates, that they were a 'dying race' and that there was nothing to do but 'smooth their pillow' before they disappeared as completely as the Aborigines of Tasmania. Politically and socially they had become a non-people, rarely even mentioned by the vast majority of white Australians. Only the anthropologists expressed their alarm at the passing of a fine race of human beings, who were even beginning to forget their immemorial Law under the impact of the Christian religion.

Then came the great revival, which has gathered impetus during the last ten to fifteen years. It may have been helped by the payment of age pensions and the institution of other social services, together with the devoted work of such organisations as the Royal Flying Doctor Service which has done so much for the physical health of the people. A gradual change in the attitudes of some whites towards the Aborigines must also have been of assistance. The interest of anthropologists in Aboriginal culture, and the respect paid by more and more whites towards many aspects of this culture, has helped to renew Aboriginal dedication to their ancient Law.

This strange figure in the Napier Range has some resemblance to the 'cave man' of European mythology

The anthropologist Kim Akerman, in *Aborigines of the West*, discusses the renaissance of the Law in the Kimberley. The initiation of young men had degenerated into mere circumcision, with little of the ceremony and teaching which once accompanied this procedure, and much to the alarm and contempt of the old men the operation was often performed in hospital. But a restoration of the initiation ceremonies has developed into a revival of more and more ritual activity, of which a great deal has been inspired by the desert people whose Dreamtime legends reached settlements fringing the desert. The important centres in this northern country are Jigalong, Strelley, La Grange, Looma, Fitzroy Crossing, Balgo, Hooker Creek and Yuendumu.

The movement and development of rituals is demonstrated by a new legend concerning a man and his horses. The man is represented by a carved post, while drums of water are symbols of the horses which moved underground across the country. Akerman points out that such 'wandering cults' are a part of the Aboriginal religious belief in 'emergence in birth, renewal in initiation, rebirth and transition in death.'

The strengthening of the ceremonial bonds in these northern communities also has political significance, because the ceremonies bring people together and give them 'opportunities . . . to discuss developmental programmes, the role of community advisers and employees, questions of land rights, decentralisation and other matters . . .'

But the achievement of Aboriginal black power is not a simple struggle. Among many other things it concerns dignity, pride of race, the right to share material goods and justice. And, in a people whose traditional lifestyle is that of the hunter-gatherer, it conflicts with the white man's common law, inherited from Europe, that the land may be apportioned to individual owners. Aborigines have always regarded the land as a communal heritage, and the notion that portions of it may be sequestrated as personal property is anathema to them. Consequently land rights — the right for the Aborigines to occupy their traditional territories in their own way — have evolved as the keystone which supports the fabric of the Aboriginal renaissance in a steadily strengthening structure.

Professor Berndt feels that reserve lands should be restored to the people as a secure base for Aboriginal aspirations. He describes the Aboriginal view of mining on tribal lands as 'A drama of life and partial death — spiritual and social, if not physical death.' He says that the importance of various sites to the people should be investigated before mining exploration begins, so that agreement may be reached before commercial exploitation. The mining companies should also consider all the ways in which their activities may affect the companies concerned.

These would appear to be commonsense suggestions, but commonsense has usually been lacking in our dealings with Aborigines.

There is a comfortable feeling that the changes during the last two or three decades have altered the attitudes of whites towards Aborigines: that we are not a racist society and that we tolerate all colours and creeds. Aborigines have become rather 'trendy' and most of the white intelligentsia support the Aboriginal renaissance. But the vast majority of us only talk theoretically because we do not have to encounter blacks at first hand. Many years ago a vociferously pro-Aboriginal white scientist travelled with me to the Western Desert, and all went well until, as the only smoker, he found himself much in demand as the only possessor of tobacco. The Aboriginal practice of communal sharing of all necessities and luxuries did not sit well with his western background, and he soon took to his heels whenever an Aboriginal appeared. You can remain tolerant when a problem is at a safe distance. At close quarters it is not so simple.

A more serious example of this clash of cultures occurred in Nowra, New South Wales, on 9 July 1982. On that day, Aborigines hoisted their own black-red-yellow flag but the mayor hauled it down. After the resultant public storm the University of New South Wales made a detailed study of the incident, reported in the State newspapers. Using a survey method which enabled complete anonymity, the researchers interviewed a carefully selected cross-section of the townspeople and produced frightening data. About half the interviewees approved the mayor's action. Some were very much in favour. Those in high-status occupations were the most prejudiced against the Aborigines, whereas the lower socio-economic groups felt the most sympathy with them. This is exactly opposite to the attitude of Americans towards the black population of the United States.

I use the word 'frightening' because, during our short history, there have been many examples of violence or prejudice towards blacks, Chinese, and other ethnic minorities. We must not be complacent about the situation today. Whenever we use the alibi 'It's not my business' we are condoning racism.

*A smooth rock face in the neighbourhood of Drysdale River Station proved
an ideal 'canvas' on which some long-forgotten Aboriginal artist painted this
dancing figure of a wandjina in red ochre*

10 | 'THE RUINS OF HILLS'

KING LEOPOLD RANGE — DRYSDALE — PRINCE REGENT RIVER

After the party left their Lennard River camp they had what Geoffrey Dutton describes as 'a hot, hard day of 385 kilometres driving, the last part of the road being bad, through the splendour of the Leopold Range to Mount Barnett.' He continues the story:

This was the most beautiful camp of our entire journey. We were on the bank of a long reach of the Drysdale River by pandanus and paperbarks, huge cadjeputs above us and birds everywhere at all times of day. Cylinders of blossom hung down by red seedpods from the paperbarks, and nectar dripped over our beds. Thick pollen lay in lazy loops on the brown water and changed colour according to the light: pink at mid-morning, red at noon. Red-tailed black cockatoos flew slowly over, peaceful doves were calling, a hawk cruised down the river, two brolgas came to inspect us, swarms of scarlet finches drank at the water's edge, lorikeets were larrikining about. The corellas, for once, were not so noisy as usual, and for a while before and during the dawn they kept quiet and allowed full solo rights to the orioles. Theirs was the most lovely dawn call I have ever heard, sounding its haunting melody in utter purity down through the still trees and across the glassy river. The length of each call, its rhythm and the placing of the melody at the beginning of each day, made me think of the words of Thomas Vaughan, an English seventeenth-century poet who could scarcely be more remote in time and place: 'Mornings are mysteries'.

There is a strange synthesis here in the North-West between the teachings of the Tao and the insights of the Christian mystical poets. Lao Tse wrote: 'Life springs into existence without a visible source and disappears into infinity. It stands in the middle of a vast expanse, without visible exit, entrance, or shelter . . . the Heaven cannot help being high, the earth cannot help being wide, the sun with the moon cannot help going round, and all things of creation cannot help but live and grow.' In the vastness of the North-West, in which the impact of human activities seems no more significant than a candle in the night, one has a strong sense of this 'cannot help' aspect of nature, while Vaughan sees the content which lies within a self-surrender to natural powers:

> Work with our fellow-creatures: note the hush
> And whispers amongst them. Whereas not a Spring,
> Or leafe but hath his morning-hymn; Each Bush
> And Oak doth know I AM; canst thou not sing?
> Leave thy Cares and follies! Go this way
> And thou art sure to prosper all the day . . .
>
> Mornings are Mysteries; the first worlds Youth,
> Minds Resurrection, and the futures Bud
> Shrowd in their births: the Crown of Life, light,
> Is stil'd their starre: in this stone, and hidden food.
> Three blessings wait upon them, two of which
> Should move; They make us holy, happy, rich.

From John Olsen's notebook:

The whole landscape seems to sprawl endlessly — conventional European compositional devices based on geometrical patterns and triangles (vide Leonardo), ovals and circles would be totally inadequate to this landscape. I am inclined to the Taoist attitude as a possible solution, i.e. to infer a world without end, a frame put across this endless flux and give the impression that the artist is part of that.

Mary Durack writes of the King Leopold Range:

In 1879, the explorer Alexander Forrest named the range after King Leopold of Belgium: 'an eminent patron of the sciences'. It is not hard to understand why Forrest chose a name that he hoped would give some impression of its majesty.

The range, over 994 metres at its highest point, sweeps away to the south-east from Collier Bay and is actually a broken escarpment forming the edge of the Kimberley plateau. Fortunately it was the task of John, with his artist's eye, and Alex with his camera, to portray a scene for which this pen is inadequate. But the fact that we drove through an ageless landscape in modern vehicles does involve historical references which a writer may attempt to summarise.

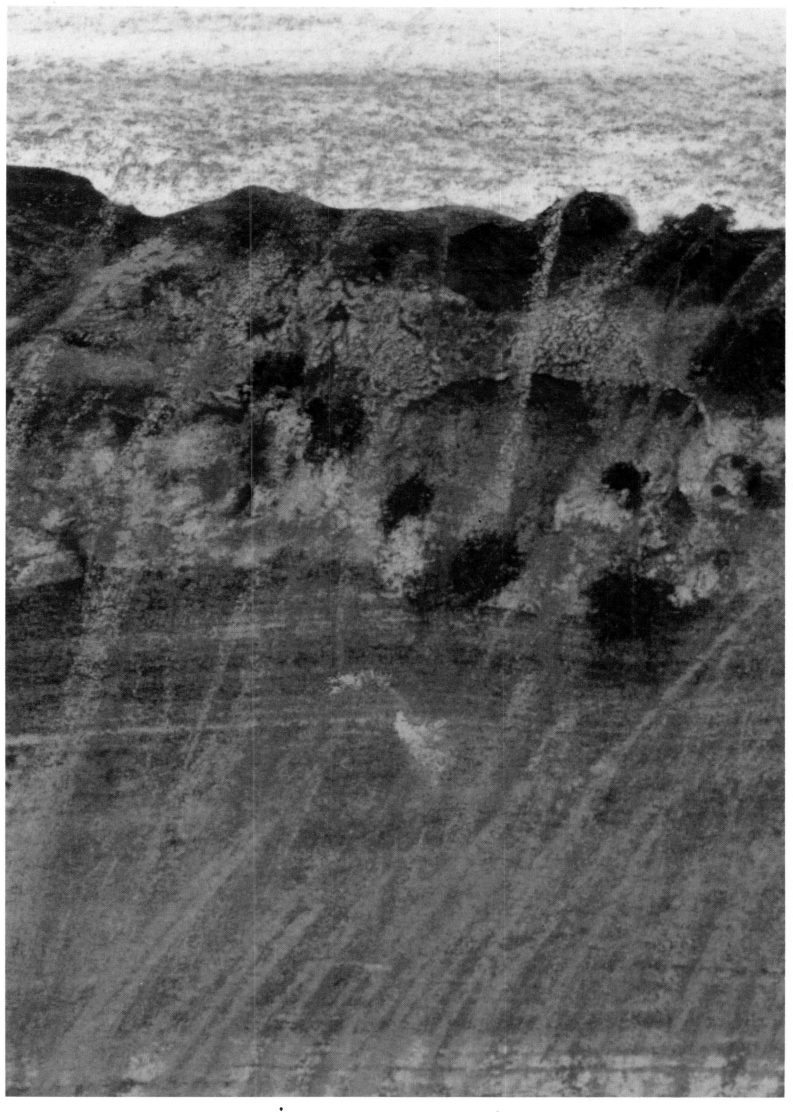

Scrub turkey in the King Leopold R. (Detail)

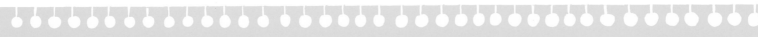

Drysdale R.

For many years these ranges were a serious obstruction to settlement in Kimberley's far north-west, although Captain George Grey reported the potential of the country behind them as early as 1837. In that year he landed with a party of fourteen men at Hanover Bay, under instructions from Lord Glenelg, the Secretary of State for the Colonies, to make their way overland from thereabouts to the Swan River settlement in the south. That settlement, of course, is now Perth and its suburbs.

Even had Grey and his party taken the only possible route, along the coast, this would still have meant a journey of some 2000 kilometres. It is surprising that they got far enough for Grey to discover and name the Glenelg River, and to examine and write of the rock paintings of that area. Obviously neither the local Aborigines nor their country appreciated his interest for he was not only speared in the leg but nearly drowned in a rip tide when attempting to cross a river.

He and his party struggled back to their waiting schooner with their mission incomplete, although his reports led to the ill-fated Camden Harbour project of 1864, and the Bradshaw venture soon after as mentioned in this book.

Forrest and his party tried vainly to find a pass through the Leopold Range in 1879, as did Michael Durack and his men on their exploration some three years later. The prospecting party led by Charles Hall, whose fossickings triggered the Hall's Creek goldrush of 1886, are believed to have been the first Europeans to penetrate the barrier.

Anyone attempting to find a way across obviously needed to be as strongly motivated as was the redoubtable stockman and bushman Tom Chapman. In the mid-1890s he eloped from Wyndham with the wife of Jacob Kuhl, the manager of the Three Mile Hotel, and their adopted five-year-old daughter. They made off at night with a string of horses and an Aboriginal helper named Pilot, having ingeniously tampered with the telegraph line so that the news of their disappearance would not precede them. Considering the route they are reputed to have travelled one wonders whether this precaution was necessary. At all events the quartet made it through the ranges, although their subsequent adventures are a matter for speculation.

The sturdy pioneer Joseph Blythe and his sons, who founded Mount House and Glenroy stations in the late 1890s, were the first to push cattle through the Leopolds, as by the time of Tom Chapman's elopement the best country in the known parts of the Kimberley had been taken up. The so-called 'battlers', anxious to establish a footing in the district, had to look elsewhere. For a number of years the only means of transporting stores to the few scattered holdings over the ranges was on the backs of camels, bullocks, or donkeys. It was 1910 before an intrepid bullocky manoeuvred a dray through and pioneered a rough but passable wagon track. Twenty years later a member of the Blythe family made history by coaxing a motor-car from Derby to the ranges and across them to Mount House. It seemed that progress was catching up at last though still against formidable odds.

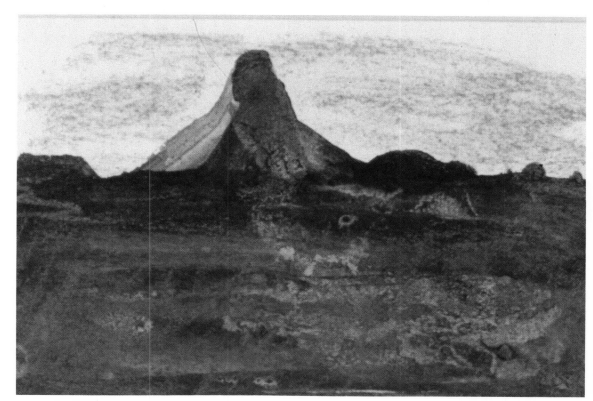

King
Leopold
Range

Station owners in the region could make little from their properties because it was almost impossible to overland cattle to Derby. Even the stock route to Wyndham involved a gruelling and expensive journey of nearly 200 kilometres, which only hardy five-year-old beasts could survive at the cost of considerable weight loss and bruising.

In 1949 an exciting new day dawned for pastoralists 'back of the range'. This was the result of a scheme in which an abattoir was set up at Glenroy, complete with all facilities for the killing, processing, and chilling of beef to be flown to Wyndham and then shipped to Australian markets. As my husband's airline company was involved in this Air Beef project I was kept well informed of its progress, and soon after it began operations I was flown from Broome to write the story for the *Walkabout* magazine. I enjoyed talking with the enthusiasts of the new scheme and making a one-hour flight to Wyndham with a consignment of meat which, travelling on the hoof, could not have been delivered in less than three or four weeks. In the first year's operation Mount House alone put through 1100 head against less than 500 in the previous year.

The scheme continued to work successfully and provided a brighter outlook for the 'way back' pastoralists but it was not a lasting solution to their difficulties. The steady increase of airfreight and other costs eventually put an end to Air Beef operations but by the 1960s good roads had been established throughout the Kimberley district — including the one on which we travelled — and pastoralists have since sent their live cattle out by road trains to meatworks in Wyndham and Broome.

We did not pass any travellers on our way north from the Leopolds but a refuelling depot at Mount Barnett Station was indicative of changing times. Clyde Russ, the young man in charge, proved to be a grandson of Frederick Booty of Lambo, one of the most interesting characters in local history. In 1894, then a student at Oxford University, he travelled to Australia to visit his uncle, the millionaire W. S. Osmond, who with the Melbourne magistrate Joseph Panton had taken up the Ord River Station lease in the early 1880s. The stock driven to this holding was the first to reach the East Kimberley district.

Booty asked his uncle if he might have a 'taste of colonial experience' on the northern property, and Osmond agreed. Evidently Booty found the Kimberley so very much to his taste that he remained there, later to acquire properties of his own. He held one of them, Lambo Station, until his death in 1946.

My father enjoyed Booty's company whether at Argyle Station or at his home in Perth, although it always puzzled him that a man of such cultural background should have become a captive to this limiting environment. He remains clearly etched in my memory as a charming man, well-versed in classical literature, music, and history.

I was aware of his concern for the welfare of his four part-Aboriginal children, one of whom married Fred Russ, first manager of Mount Barnett and later pioneer holder of Gibb River Station further north. Young Clyde Russ was surprised to find that this chance traveller had been acquainted with his interesting progenitor. I wished I could have stayed on to hear more about his family but we were expected at Drysdale Station and still had 166 kilometres to go. On arriving there we found a pleasant homestead and received a friendly welcome from the young manager, Peter Reynolds, together with his wife Jan and small daughter Sarah. Here also were the helicopter pilots Carl Spann and Doug Martyn, to whom we were to entrust ourselves on the following day.

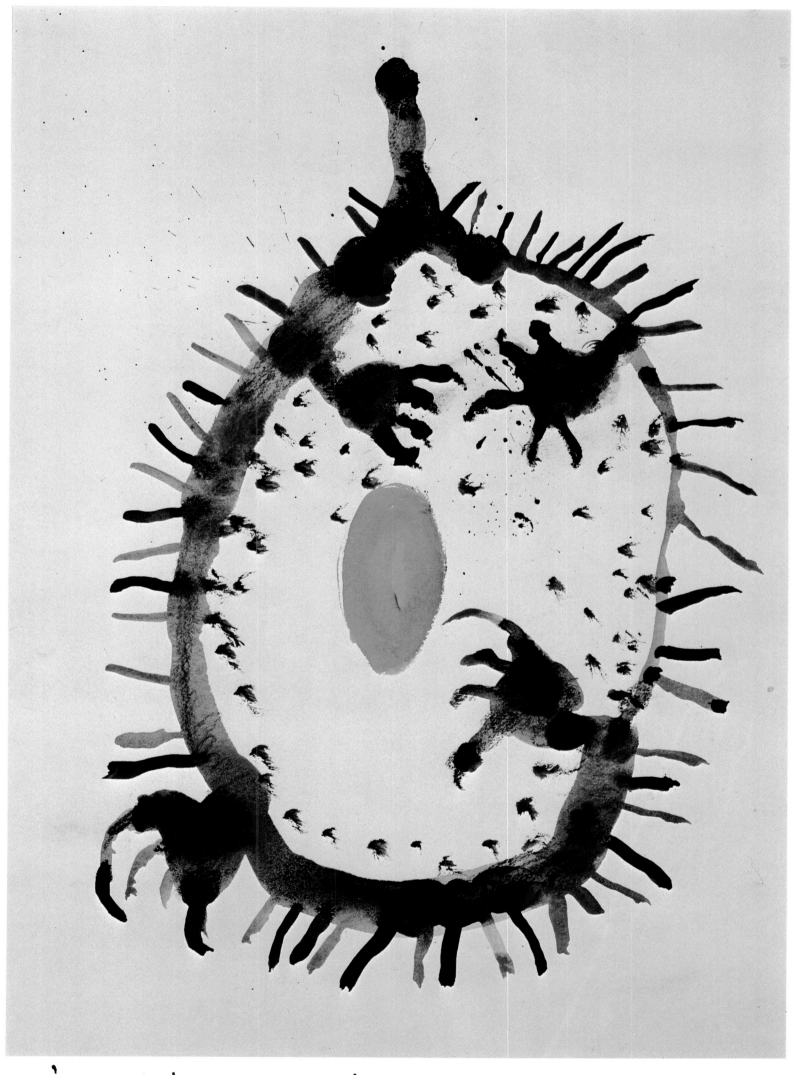

Echidna upside down King L. Range

When Alex was arranging our itinerary he had made it clear that we should not impose ourselves on the traditional hospitality of station families. We withdrew therefore to a campsite on the broad Drysdale riverbed where we dined in an open air salon enclosed by palms and paperbarks with an orchestrated background of night birds and bats.

Vin Serventy writes of the Drysdale River campsite:

The river was not running but we had a pool 200 metres long. It seemed almost a sacrilege to disturb the splendour of the fine yellow dust of pollen from the flowering cadjeputs which covered its surface, glowing golden in the early morning and late afternoon, as we swam from end to end of the pool. An early-morning dip was part of our ritual and we had cool-off swims later in the day.

Our stretchers were spread out under the flowering cadjeputs along the riverbank, and lying there in the early morning we could watch the birds cavorting among the blossoms and listen to their songs.

Cadjeput is not an Aboriginal name but an Asiatic one, for a tree found across northern Australia and north into Indonesia, Malaysia and India. It was the first plant to be described scientifically as a melaleuca, of which Australia has about 150 kinds. I say 'about' because there is still argument as to whether a population of plants should be divided into more than one species. Cadjeput is a classic example, because some Australian botanists have split those in northern Australia into five species. A local text states that even those along the Drysdale River are of two kinds, a tall cadjeput with pale green leaves and a smaller one with milky green leaves, but we saw numbers of trees with both types of leaves.

Melaleuca translates as black and white, and refers to the general appearance of the white bark which is often charred black by bushfires. The trees have the vernacular name of paperbark and the bark is a remarkable feature of many species. It pulls off in thin sheets of papery material and it is ideal for covering makeshift huts, for roofing bush shelters, for food-carrying baskets and even as a wrapping for the bones of the dead.

One enterprising manufacturer has chopped the bark into particles for stuffing infants' pillows. The virtue is that if a baby turns onto its face it can still breathe through the papery fragments.

Another industry associated with cadjeputs is the distillation of an oil used in medicine, and sometimes as an insect repellent, from their leaves.

The trees may grow twenty or more metres high and they form thick forests in swampy places. In fact most paperbarks like nothing better than having their feet in water, and in dry periods their presence is a good sign of water not far below the surface, whether in deserts or coastal areas.

We enjoyed our paperbarks' sheltering canopy, and the nightly chorus of fruit bats arguing vehemently over their share of nectar and blossom, for more than a week. The Drysdale River camp was an ideal base for our forays by helicopter into the wild country to the north, west, and east.

THE DAWN CHORUS, DRYSDALE RIVER

FOR VIN

*The dawn chorus
Can never bore us,*

*Softly falling
Liquid calling.*

*Along the river
The cadjeputs shiver,*

*And then a corella,
That immaculate yeller*

*Of obscenities, smothers
The music of all others.*

*But what if the corellas
Like all good fellers*

*Think that their voices
Are the sweetest and choicest?*

UNSEEN BIRD, DRYSDALE RIVER

Before the red dawn the birds
Are already lifting the day
By swaying ropes of sound, as words
Create more than they say.

And through the busyness of under and over
One pure call
Parts itself from the crowd like a lover,
Its rise and slow fall

Crossing the tranced river, waking
In paperbark blossom the scent
Of morning, long drawn out, making
Present what's absent,

Unseen bird. And like love
Its song is tireless, transmuting
Air into music, from high above
Stroking the dust, soothing

The skin of the river, again and again
Calling. And when the day
Bursts into burly light, half pain
Half joy, it fades away.

Silent all day and night, lingering,
It is a hidden spring, withdrawn
But flowing, until again it is singing,
Pouring light into the dawn.

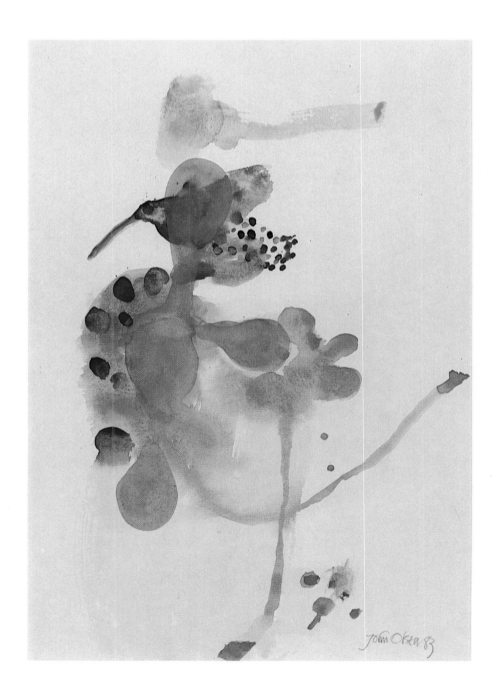

Honeyeater
& flower

Geoffrey Dutton writes of the helicopter flights:

Helicopters are very much a part of the life of the North-West, used for rounding-up cattle, mining exploration and supply, and every sort of communication in impossible country. The pilots love them, which is reassuring to an old fixed-wing pilot like myself. To begin with they seem very peculiar indeed. I was for some years a wartime instructor in the RAAF and helicopters do everything that I spent hours telling my trainees *not* to do. Nose up, speed dropping, the signs of an imminent stall and spin into a crash. Not so, of course, with a helicopter, which just hovers, and then goes vertically up, and then banks nonchalantly into a terrifying tight situation with that derisive sound, somewhere between a fart and a burp, which at first sounds so disastrous.

Away we went over the vast wooded plains with outcrops of rock, cattle drifting along the creeks, until we reached the desert of rock that runs in a plateau to the edge of the chasm of the Prince Regent River. There are great shelves and slabs and shields of sandstone, tumbled heaps of rock, impassable clefts, a certain amount of low vegetation and black streaks where fire had run across the rock.

The river comes darkly out of deep gorges and broadens into a long straight between high rocky banks, with some magnificent waterfalls cascading down them from the edge of the plateau. There are occasional open sandy beaches and we landed on one of these to establish a fuel dump for our journeys around the mouth of the river. It was uncomfortably hot and humid. Creepers tried to trip you on every footstep you took. The cliffs on either side were menacing, shutting you in. There were bushes but no shade. Only the butterflies were happy and free. We were all relieved when the drums of fuel were in place and we could fly off again, over lilies and dark pools on which the tall spoonbills showed up incredibly white. Occasionally a brilliantly green tree grew out of a cleft in the rock.

water goanna

Despite the presence of water this was the harshest landscape I have ever seen. A sandy desert would seem soft and gentle beside it. Our flight over it brought another passage from the Tao strongly into my mind: 'An image of what existed before God . . . Nature is unkind: it treats the creation like sacrificial straw-dogs . . . cleanse your spirit! Throw away your sage wisdom! . . . Tao is dark and elusive, difficult to describe.'

This country allows no human demands. It is literally fearful country, and you feel totally rejected until you realise that, in the face of such indifference, this is an impertinence. Surprisingly, this leads to an acceptance.

Later that day, John said to me that there had to be a new system for painting this country. European or Asian landscapes are based on geometrical forms, but here there is no such frame of reference. On a less aesthetic, more contemporary level he asked 'Do you know what is a true definition of a desert, a pure desert? No beer cans.'

As we approached the St George Basin the river developed weird patterns. At first there were long sandbars going out into the grey river from the narrow strips of mangrove along the rocky banks. The river became olive as it entered the estuary and then shifted to flecks of green, with bright pink areas behind and between the mangroves. Through a huge mudbank, for it was low tide, ran snake-patterns from the estuarine maelstrom caused by the ten-metre tide. An eagle with wings lit up in burnished copper and gold circled below us. Then came the red cliffs of flat-topped Mount Trafalgar and Mount Waterloo. The latter seemed an incongruous name for a seaman to have bestowed but Mount Trafalgar was of course the highest, 1284 feet on the helicopter's altimeter.

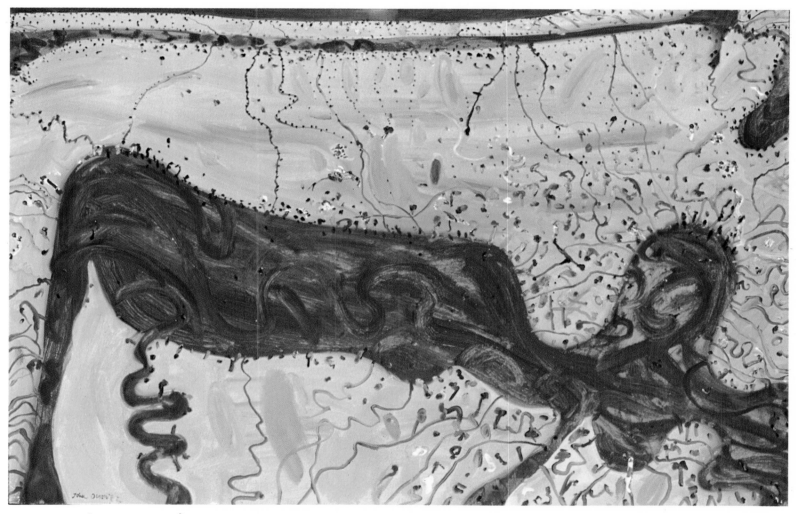

Dry river bed, Drysdale Nat Park.

We landed in Careening Bay, the only sandy beach for a long way along the convoluted coast with its dark green fringe of mangroves. Phillip Parker King careened his leaky cutter *Mermaid* on this beach, and produced for us a true *frisson* of shaking hands with ghosts by having his name, ship, and the date carved in big letters on the double trunks of a huge-girthed baobab: KING HMC MERMAID 1820.

The letters are still deep and clear and I took a photo of Mary with her hand looking small inside the letter A. It was searingly hot. Behind us the scratchy obdurate scrub stretched back into the hills; in front of us the lovely beach sloped into dazzling blue water between the headlands of black rounded rocks, by a little inlet of small mangroves. The cabbage palms were blasted yellow by the salt winds. There were no birds or other animals. Except for the red helicopters it was no doubt exactly as it was when King landed in 1820.

Drysdale R. fish

The others flew off for further examination of the coast while I sat in the shade of the only tree on the beach (the baobab was a little way inland) and thought of the minimal nature of human contact in these regions. When George Grey landed in 1837 he met groups of up to 200 Aborigines, tall healthy people who lived along the coast and left their wandjina paintings in caves along the Glenelg River, but of whom no other traces remain. Grey's drawings of the mouthless haloed heads caused immense confusion and speculation among European savants, especially since his drawings were not altogether accurate.

I took *Grey's Expeditions in Western Australia 1837–1839* out of my bag and re-read some of the passages relating to the area where I was sitting. With unbelievable improvidence he went ashore in Hanover Bay, only a few kilometres from Careening Bay, on 2 December 1837 with two officers, three seamen, three dogs, and *only two pints of water between the lot of them*. What followed is best told in his own words:

'I soon found that we had landed under very unfavourable circumstances. The sun was intensely hot. The long and close confinement, on board a small vessel, had unfitted us all for taking any violent or continued exercise, without some previous training, and the country, in which we had landed, was of a more rocky and precipitous character than any I had ever before seen; indeed I could not more accurately describe the hills, than by saying, that they appeared to be ruins of hills; composed as they were of huge blocks of red sand-stone, confusedly piled together in loose disorder, and so overgrown with spinifex and scrub, that the interstices were completely hidden, and into these one or other of the party was continually slipping and falling . . .

'A feeling of thirst and lassitude, such as I had never before experienced, soon began to overcome all of us; for such a state of things we had unfortunately landed quite unprepared, and with only two pints of water with us, a portion of which it was necessary to give to the dogs; who apparently suffered from the heat, in an equal degree with ourselves. These distressing symptoms I can only ascribe to the extreme heat of the sun reflected from the sand-stone rocks, and our previous long confinement on board.

'Our small supply of water, though but sparingly used, was soon exhausted; and the symptoms of lassitude, before so excessive, now became far worse. As usual, the endurance of the animals gave way before that of the men. We had not completed more than a mile of our route (although it was far more, if the ascents and descents were taken into account), when Ranger, a very fine young dog, dropped behind some rocks, and although we turned back to look for him directly he was missed, he could not be found.

'The next to give way was Ringhalz, a fine Cape buck hound; he fell amongst the rocks, and died almost instantly. The only dog now left was a greyhound, who manifested his extreme distress by constantly lying down. For some time we dragged him along, but he was at last, from necessity, abandoned.'

One of Grey's phrases, 'the ruins of hills', is a classic of description. Ranger, the first dog to disappear, was found alive three days later, quite mad, and 'Ran wildly away into the woods.'

Grey, an extremely intelligent man who later became intimately involved with both the Aborigines and the Maoris, was nevertheless the archetypal bumbling explorer. After an Aborigine speared him he shot one of them and suffered tortures of conscience. He tells an

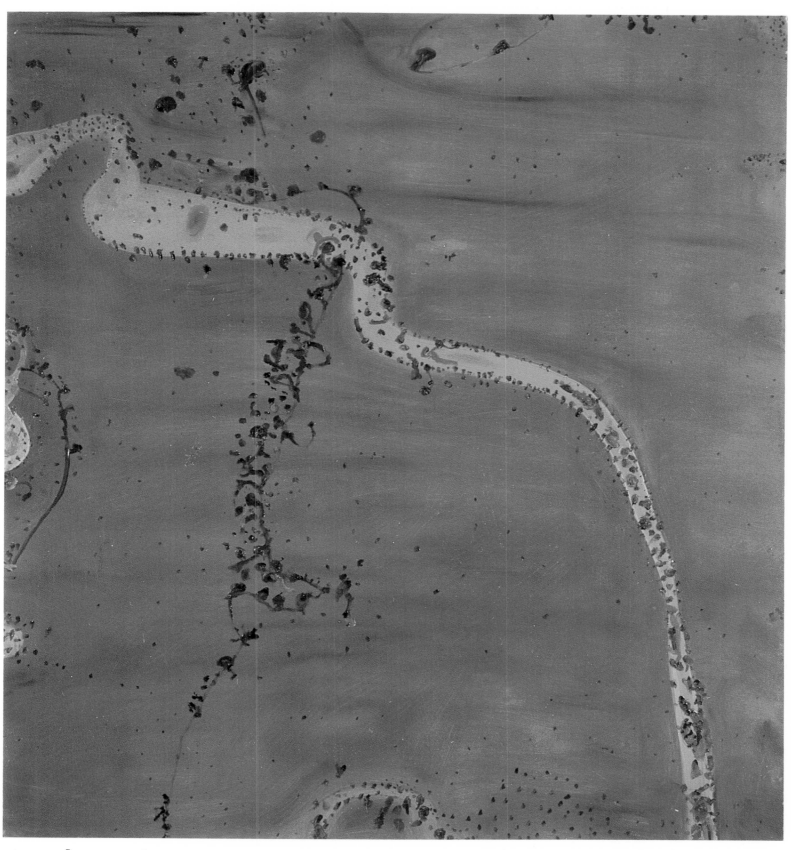

Drysdale River

enlightening story of Ruston, one of his sailors, who looked after him most kindly when he was recuperating from his wound in a tent where one day the temperature reached 138 degrees Fahrenheit. Ruston was a sensitive fellow who divined that, in Grey's words, 'The death of the native I had shot was preying upon my mind,' and told him 'Well, Sir, I'm sure if I were you, I shouldn't think nothing at all of having shot that there blackfellow; why, Sir, they are very thick and plentiful up the country.'

Grey also nearly drowned himself swimming across the channel when a twelve-metre tide was running. He lost ponies, sheep, and goats, and nearly lost his whole party later on when two of his boats were broken up in the surf on Bernier Island. Yet he did not hesitate to hoist the British flag, and 'Take possession of the territory in the name of Her Majesty and her heirs forever.' After that he explored some of the coastal hills and he and his officer Lushington between them penetrated about ninety-six kilometres up the Glenelg River.

The country rejected him almost contemptuously, yet he felt its fascination and attempted to leave some mark. He let loose his remaining Timor ponies, and the coconut palms, breadfruit trees, and pumpkins he planted were flourishing when he left. He wrote: 'Our whole residence in this country had been marked by toils and suffering. Heat, wounds, hunger, thirst, and many other things combined to harass us. Under these circumstances, it might be imagined that we left these shores without a single regret; but such was far from being the case; when the ponies had wandered off, when all the remaining stores had been removed, and the only marks of our residence in this valley were a few shattered bark-huts, young cocoa-nut, and bread-fruit, and some other useful trees and plants, I felt very loath to leave the spot.'

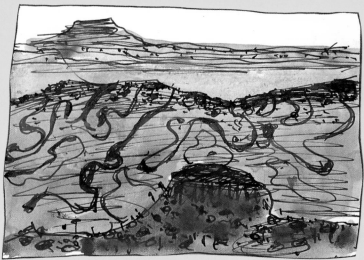

Mt Trafalger & Mangroves

We could have done with some of Grey's breadfruit and pumpkins on the night we spent there. Most of our sleeping gear, stores and utensils had been left behind. It was my turn to cook but I could only drop the pieces of meat onto the coals of the campfire and cook the potatoes, peas, and marrow all in the one billycan which also made the coffee and tea. Somehow all the ingredients did not quite synchronise and it was undoubtedly the worst meal of our trip.

But at least there was some whisky and John and I drank enough of it to be able to talk about the harmony between the shapes and colours of rocks and flowers in the North-West, with that profundity which seems so rare at such times but would no doubt, if tape recorded, be exposed as inanity.

I slept and woke and slept again in great discomfort on the ground, and at 4 a.m. I decided the only thing to do was to have a swim. When I walked over the sandhills I found John and Vin already on the beach, also having had a sleepless night. When the dawn came there were little furry, almost spiky clouds with pointed noses like echidnas.

From John Olsen's notebook: The Prince Regent River was wild and rugged. It was generous to no one except itself. Eroded vertical gorges — a scrub so dense it revealed itself reluctantly. Tree ants and intense heat make it a place of disquieting mood and presence. Vin was bitten on the eye by a tree ant — v. painful.

We camped at the extreme edge of Prince Regent River, Careening Bay . . . a pleasant beach where we swam in the warm sea. Uncomfortable night sleeping in the sand.

[Next day] we alighted right on top of the flat-topped Mt Trafalgar. We felt we were [among] the few people who have been there. To our dismay we found discarded tins and batteries.

Ash of Burnt trees Drysdale N.P.

Aftermath of Fire

Vin Serventy writes on the Prince Regent River experience:

More than twenty years ago, the report of a sub-committee of the Australian Academy of Science looking into the need for national parks contained the words 'Without doubt the Prince Regent River could become one of the world's most outstanding scenic and natural history reserves.'

Today that dream is a reality. We saw the world of the Prince Regent in comfort, dropping from the sky in our helicopters. Previous explorers had edged their way along dangerous coastlines or toiled across rugged escarpments to find a world almost unknown a few decades ago, except to the Aborigines.

This came home to me with stunning effect when we landed on the top of Mount Trafalgar and gazed over an exhilarating landscape of mountains, valleys, bays and mangroves. I did not feel joy, excitement or elation but a kind of shame. The helicopter took us so effortlessly to the top, to allow us to walk on the edge of the abyss and exult in a view which had cost us no struggle, no climb up steep slopes, no battle with the scree on the path used by rock wallabies that shared the mountain top with us.

So paradoxical is the human mind that earlier on the same morning, when I woke after an uncomfortable night on the dune sand at Careening Bay, I felt only pleasure and anticipation — and yet the same helicopter had landed us there.

The bay was a delight, and the sense of ancient and recent history is very strong there. The Aboriginal hunter-gatherers would have welcomed it as a camping spot, if only for one night. Out to sea, the Dutchman Abel Tasman passed in 1644. Some forty years later William Dampier sailed south past the bay but did not land in it. The first recorded white feet to step on its sands were those of the crew of the cutter *Mermaid*, commanded by Phillip Parker King.

Like us he was on an exploring expedition. His ship developed a severe leak and so he pulled into this sheltered spot for repairs. While the carpenters laboured, the scientists gathered information. They included the botanist Allan Cunningham, whose collection of Careening Bay flora comprised so many new species that the bay is of scientific importance as a type locality: an area where new plants were made known to science. Exploration of the region still continues, and scientists from the Western Australian Museum, Herbarium, and Fisheries and Wildlife divisions have climbed over the hills to the east of the bay.

The most evocative relic of all those who have visited Careening Bay is the great baobab on which some expert hand, probably that of the ship's carpenter, carved in huge copperplate letters the record of the *Mermaid's* visit. When I ran my hand over the letters I felt the gentle touch of those long-gone people who had sent a message down the stream of time. They had beached their ship, slept on the same sand we had slept on, and enjoyed a few days of peace after the strenuous exploration of the nearby coastline.

Geoffrey Dutton continues the story:

Growing on top of Mount Trafalgar were a delicate little melaleuca and acacia, and another plant with large leaves and a great busyness of copulating cockroaches: nature going on with her own concerns. We really felt as if no human foot had ever trod there before. Indeed the climb up the sheer 300-metre sides looked to me quite impossible. I called out my thoughts to John. 'Oh yeah?' he said, and leaned down. 'Look, mate.' I walked over to him and saw a neat little pile of rusty tins and old wireless batteries between two rocks. Later we heard that a survey party, also using helicopters, had landed there some years before.

Our cheating helicopters then whisked us across to the delicious luxury of the King Cascades, in the pools and rocks above the Prince Regent River. We landed on great slabs of stone between waterfalls, by tall golden-green trees and pandanus with big black butterflies and (more copulating) mating dragonflies. An endless abundance of pure water tumbled white down terraces of rock into deep, blue pools. There were giant square blocks of smooth rock laid one on top of another. We swam in the pools and Alex sat in supreme luxury under a waterfall.

Prince Regent River

KING CASCADES, PRINCE REGENT RIVER

In the desert of rock
The pessimists thrive. Being locked
In their grid of human reference they find it shocking.

It is true it gives
Some life to scrub in its rifts,
To lizards and cockroaches a certain standard of living.

But otherwise, nothing
But scumbled stone singed
And blackened. A land to stop an angel singing.

But always through the red
Sandstone cliffs, bedded
In labyrinths of rock, gentle water is threading

Webs of life.
Suddenly nature is kind,
Over black pools white spoonbills gliding

Like cascades
Over flat, black rocks to placid
Shallows of little fish where herons are wading.

Should we then all
Dive in the pools and be called
Optimists, and not hear the rocks falling?

No, without death
Life would be bereft.
The mistake was in demanding instead of accepting.

Far in the distance there was the sound of a bull bellowing, and after we took off again we found him inland by a pool: a solitary old outcast who must have wandered hundreds of kilometres across the Caroline Ranges.

We flew back to Drysdale River Station over the deep gorges of the higher reaches of the Prince Regent River: always the thread of water leading through the labyrinth of rock, and black water and lily-leaved pools far down between the cliffs.

Mary Durack found the flight to Careening Bay to be full of new impressions:

We flew far beyond any signs of human habitation. Here were no roads, homesteads, fences or yards, and if there are wild cattle and brumby horses among the ranges and riverbeds of this forbiddingly beautiful landscape we saw little sign of them.

Here before us at last, cutting its determined way through towering cliffs and flowing on across flat country between borders of tropical vegetation, is the Prince Regent itself. It is a river easier to describe in legendary than in factual terms and I recalled something that my Mowanjum friends had told me over the years.

Those cascades surging over the steep cliffs were created and are maintained by the Wandjina. Their waters are good and fresh but if the spirits become angry they will devour anything — man, beast, or bird.

Those apparently harmless river waters contain pythons that disguise themselves as floating logs, and rocky mounds that have been known to swallow people trying to cross at high tide.

According to Dreamtime legend, the mountain we now call Mount Waterloo (Ngiangananya in the Worora tongue) was for some reason envied by creatures of another tribal area and a flock of determined black cockatoos heaved it from its home ground, to set it down somewhere near the present site of Wyndham. All the inhabitants of the stolen monolith's original territory — with the exception of the white egret, which was too vain to soil its feathers — banded together to bring it back where it belonged. They succeeded in doing so, and in the process acquired many of the physical characteristics by which they are known today. The creatures included the eagles and hawks, whose efforts caused their wings to become awkwardly bent; the porcupines, who grew protective spikes; and the mud-crabs who developed big strong claws and flattened backs.

After our night at Careening Bay I was dreamily recalling this when I noticed that both aircraft were hovering dangerously close to Mount Trafalgar's rocky summit. Don't tell me they are trying to land! . . . So help me God — this is absurd! . . . but sure enough we were soon

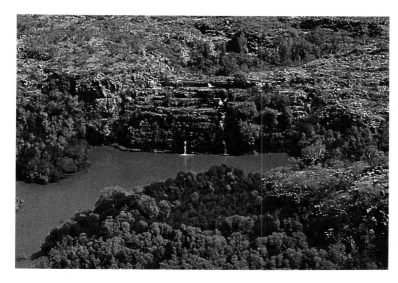

These gigantic shelves of rock form the bed of the King Cascades when water comes thundering down them during the Wet. It falls away to a comparative trickle during the dry season

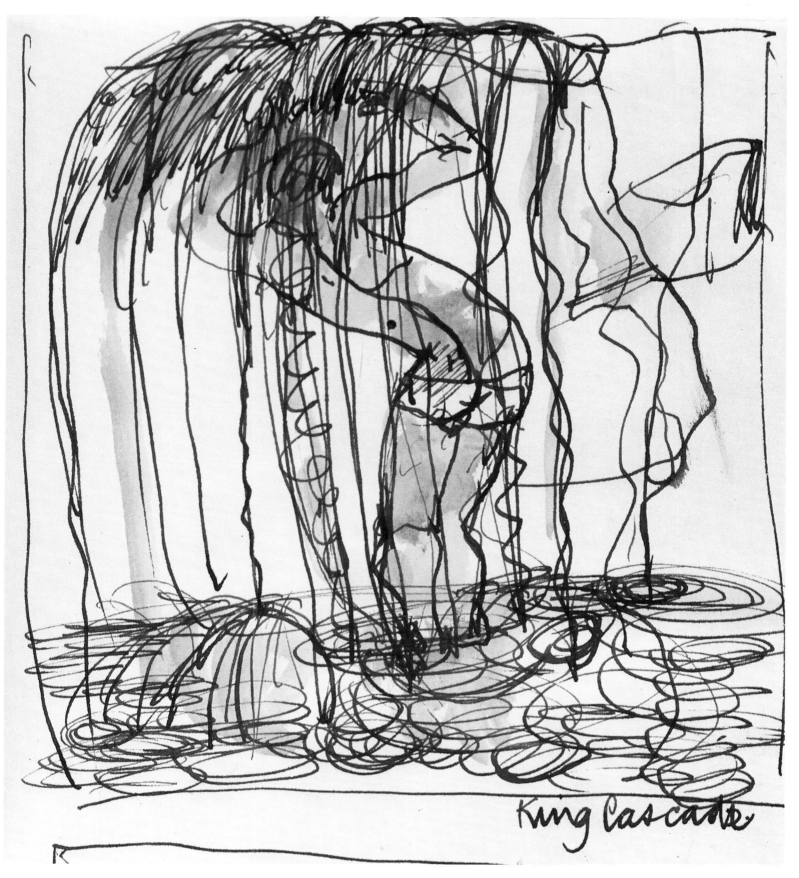

King Cascade

perched on a flat piece of rock within a few yards of a sheer cliff. We piled out and gasped in wonderment at the vista surrounding us. Geoff said enthusiastically 'Where the foot of man has never trod!' but this illusion was soon spoiled by the discovery of litter left by a previous party.

After that adventure, our landing on the cliff beside Cascade Creek hardly astonished me. We watched the falls tumbling through massed pandanus and cabbage palms, and set off again to follow the creek to its source on the summit of the Catherine Range. On the way back we travelled through magnificent gorges that descend from ochre-coloured summits to the lush green of their riverbeds.

Soon we were back in the sandy bed of the Drysdale, regaling Peter and Jan Reynolds with the story of our experiences. They said that we hadn't seen anything if we missed Solea Falls and Pitta Creek, and told us of little-known Aboriginal sites which Peter would show to us on the following day.

I had mislaid my mosquito net and after retiring for the night I was woken up by what I thought was rain. I soon discovered that the falling moisture was nectar dripping from the big paperbark overhead, that had attracted a great flock of hungry bats. I wrapped a scarf round my hair and went to sleep again.

Next morning we sailed over the Drysdale to the fantastic Solea Falls. As we circled and hovered over the riverbed we disturbed flocks of cockatoos, sandpipers, and many other species that I left Vin to identify. Crocodiles sunning themselves along the banks leapt hurriedly into the water and the occasional tortoise glided past indifferently. The falls, like those of the Prince Regent River, come surging down all the year round, though judging from the expanse of those blackened cliffs they would be even more spectacular in the wet season.

That evening we dined with Jan and Peter at the Drysdale River homestead, talking with them and our helicopter friends of the past, present, and possible future of this ancient and still enigmatic land.

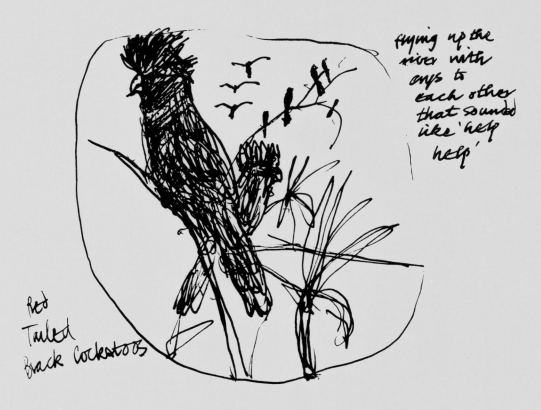

flying up the river with cries to each other that sounded like 'help help'

Red Tailed Black Cockatoos

Geoffrey Dutton comments on the cave paintings seen on that day's journey: Peter Reynolds took us to some magnificent recently re-discovered Aboriginal rock paintings that few white men have seen. There were some huge wandjinas gazing out from the rock: one of them most unusual, with clearly defined shoulders and what almost looked like an Elizabethan doublet and wide collar. Another fascinating figure had the usual halo shape, but instead of the clearly defined eyes and nose it had a vertical wing shaped like that of an aircraft or a dragonfly, the fuselage being the nose and the wings the eyes. There were also some quite different figures, slender and elongated, and one of those enchanting dancing women with a tall head-dress, like the Mimi figures of the Northern Territory. After the Napier Range caves, these were the most interesting Aboriginal paintings we saw on the whole journey.

From John Olsen's notebook: At the camp on the Drysdale River, red-tailed black cockatoos flew up the river with cries to each other that sounded like 'Help, help!'

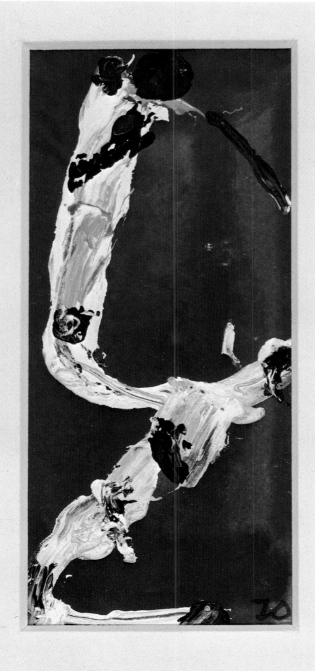
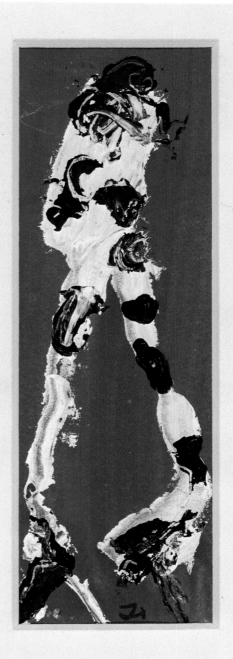
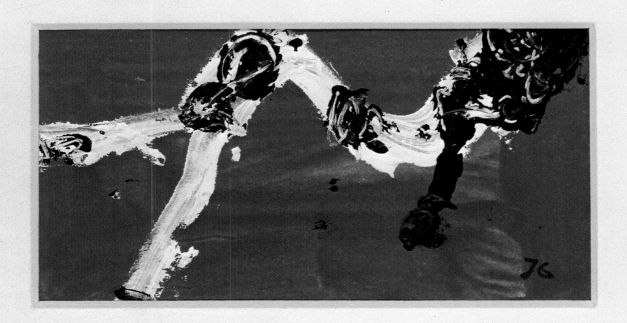

Three burnt trees Drysdale N.P.

**Vin Serventy
writes of the
flights to King
Cascades, Solea
Falls and Pitta
Creek:**

Ferns and mosses cover the walls over which the cascades leap.

I enjoyed a natural shower in a bathroom which eclipsed all others I have known with its glittering green walls and a ceiling of blue sky. Screw palms flourish, with cadjeputs towering above them. Grey-green mangroves grow where the cascades plunge into the river.

We had no time for more than a fleeting glimpse of the wildlife, mainly birds, although I knew from the research of other naturalists that the Prince Regent is a treasure house of animals. Graceful antilopine kangaroos, agile wallabies, three kinds of rock wallabies, two kinds of bandicoots, northern quolls, a number of bats and rats and rarities such as the scaly-tailed possum live there. Men brought in cattle, donkeys, and cats which became feral and invaded this fastness.

The Prince Regent is fascinating for a naturalist but does not offer easy access to the average visitor. Fortunately the Drysdale River National Park, to the north-east of the river, is much more accessible. The park, comprising 424 000 hectares, was set aside in 1973 and named after the Melbourne businessman who was apparently connected with the Victoria Squatting Company which leased land in this region. The park is rich in wildlife and many rivers wind through its forests and bushland.

Fires burned through much of this country during the dry season, and when we looked down from the helicopters we were all struck by the almost perfect outlines of trees drawn in ash on the brown soil. They would have been created when fire ate slowly through the bases of the trees until they crashed to the ground, where the fires continued to convert all the timber, including the topmost branches, to ash. John found these patterns of nature irresistible and by the end of the flight he had covered page after page of his notebook with sketches.

The whole region is a portion of that enormous art gallery which stretches across northern Australia from Cape York to the Kimberley. In the overhangs and deeper caves, countless generations of Aborigines have created literally thousands upon thousands of paintings, which must be regarded as one of the world's great outpourings of the human spirit. Often the first white men to see them were the pastoralist-explorers such as Joseph Bradshaw, who frequently made important discoveries during their search for good grazing country during the nineteenth century. Bradshaw published an account of his wanderings in the Kimberley and included some sketches of Aboriginal paintings he had seen, with the comment '. . . indeed, looking at some of the groups one might almost think himself viewing the painted walls of an Egyptian temple.' Anthropologists who later studied these paintings called them 'Bradshaw figures' in his honour.

Ian Crawford remarks that the Egyptian comparison need not be taken seriously but he points out that similar figures are found in the rock art of South Africa. As mentioned earlier in this book, some of them are a mystery even to the Aborigines. When Carol and I saw the famous Mimi paintings at Kakadu, the local Aborigines dismissed them as rubbish paintings unworthy of serious consideration, and explained them as the work of birds.

Burning Trees. I II III IV

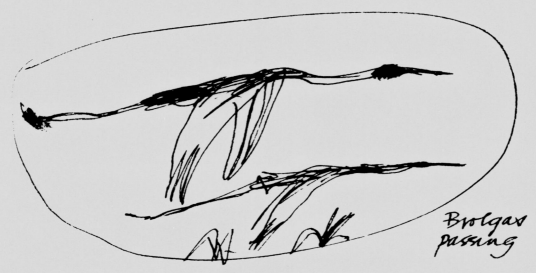

Brolgas passing

To European eyes these paintings have a vivacity, a flow of movement and an economy of line that puts them in the top rank of expressionist art. We were delighted when Peter Reynolds showed us a number of these Bradshaw figures in a rocky overhang, and he later took us to another cliff where a line of wandjinas stood like spectators of some Dreamtime ceremony.

Many hand stencils and a few weapon stencils had been made among these figures. Such impressions of human hands have been found the world over and their purpose is still argued by anthropologists. Herbert Basedow, who wrote about the Worora tribe of this region, said 'It is compulsory for members of a certain rank . . . to have their hand shadows perpetuated on the walls of caves in which the bones of their ancestors reposed, because the spirits of the dead are thus supposed to be apprised of any visits which have been made to their last earthly resting place.' He said that others could recognise the handprints or stencils and identify their owners.

The anthropologist David Moore listed many possible reasons for handprints: as 'calling cards' to record individual visits; as memorials to be mourned after death; as messages to the spirit ancestors; as actual messages to other Aborigines; as records of actual events; as storytelling devices; as a means for using the power in a particular site, to gain the spiritual strength stored there; for sorcery; and as prints actually left by totemic ancestors.

These art galleries from the past had a profound effect on us, and we returned to camp that night with thoughts of the people who had lived in this country, 'owned everything and nothing', and left relics of a presence which goes back tens of thousands of years.

When Mary Durack reflected on the various attempts to tame the land traversed by the spirit-haunted Prince Regent River, she wrote:

Come then if you must, inquisitive man
in your flying craft —
its voice so loud, what could you hear from me?
Look down upon my face and read there what you can
of my antiquity.
Some beauty find, perhaps,
some timeless grandeur see.
Dark men in ages past
have called me 'mother',
carved on my cliff heights
their spirit sign,
pounded my sands in dance of increase rites
for all the life I fed.
But that they come no more
I do not pine
nor care should they live on
or they be dead.

Come if you must then, white man
in your hovering craft.
Look down upon my face
and read there what you can.
But read no promise for your mortal schemes.
I give way to no roads, no pasture yield
for any creatures other than my own,
nor grant an inch of soil for your frail seeds.
Seek not in me fulfilment of your dreams.

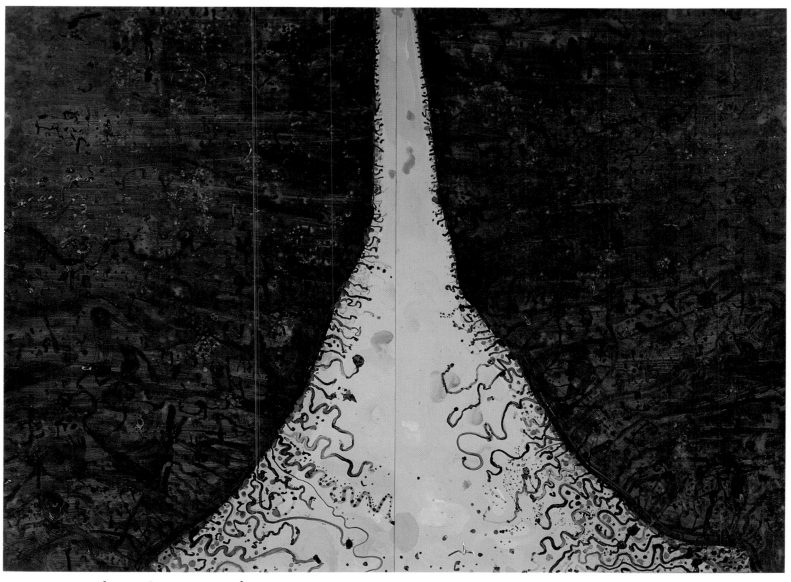

Ebb Tide Prince Regent R.

11 | 'KNOW YE THIS PORT?'

WYNDHAM

From Drysdale River Station the party drove down to the coast at Wyndham. Geoffrey Dutton writes:

Back to the luxury and dullness of a hotel. Wyndham is strung out in sections down the main road — the Twelve Mile, the Six Mile, the Three Mile — rather dismally heralded by some very dilapidated Aboriginal settlements. It culminates in the meatworks and the port. The sea, hidden far out on the muddy estuary of the west arm of Cambridge Gulf, is not a presence as it is at Broome or Dampier.

Hope and John Harlock, who run the Royal Flying Doctor Service radio network, had dinner with us. He had been in the police as a telecommunications officer but he became bored with a nine to five existence and accepted the RFDS job when it was offered to him. She said that she missed playing bowls but they both loved Wyndham, which like Marble Bar is quite un-suburban. They said it is different from company towns like Karratha or Dampier, where people don't talk about how long they've been there but how long they've got to go. In Wyndham, people settled in for good.

I was reminded of the publican at the Three Mile. He said that when he arrived in 1969 people told him he would make his fortune in two years. 'Still looking for it.' He had two excellent landscapes by an Aboriginal artist over the counter in the bottle shop. 'Yeah, they're good,' he said. 'The artist's in gaol.'

John Harlock was very depressed by some of his contacts with Aborigines. He said they came asking him for a job, but when he managed to wangle one for them they left it after three weeks. If he gave them gardening or some other odd job they would start in the morning, ask for their pay at lunchtime, and go off to the pub.

There were four or five highly respected Aboriginal families settled white style in Wyndham but some of them had trouble with relations who came to camp on them, and just had to close the door to them.

John told us that most of the Flying Doctor work is now for the Aborigines. All Aboriginal babies are now born in hospital. As I knew from a Perth doctor friend, the mothers are flown all the way down to Perth when birth difficulties are expected.

Opposite the hotel is what is known as the Aboriginal Reserve. It is an open lot almost entirely covered with bottles.

Mary Durack writes:

Alex and I flew to Wyndham by helicopter while the others drove down by car. The journey was a nostalgic one for me. I thought, as I always do when travelling this way by wheel or wing, of those explorers of 100 years ago with their perishing horses and blistered feet, who found and named those wild wandering rivers and rugged ranges that we now float above with such serenity. I have heard of the cascades in the river and the grandeur of the ranges that bear the name of my family but have never before had a chance to hover over them as on that day.

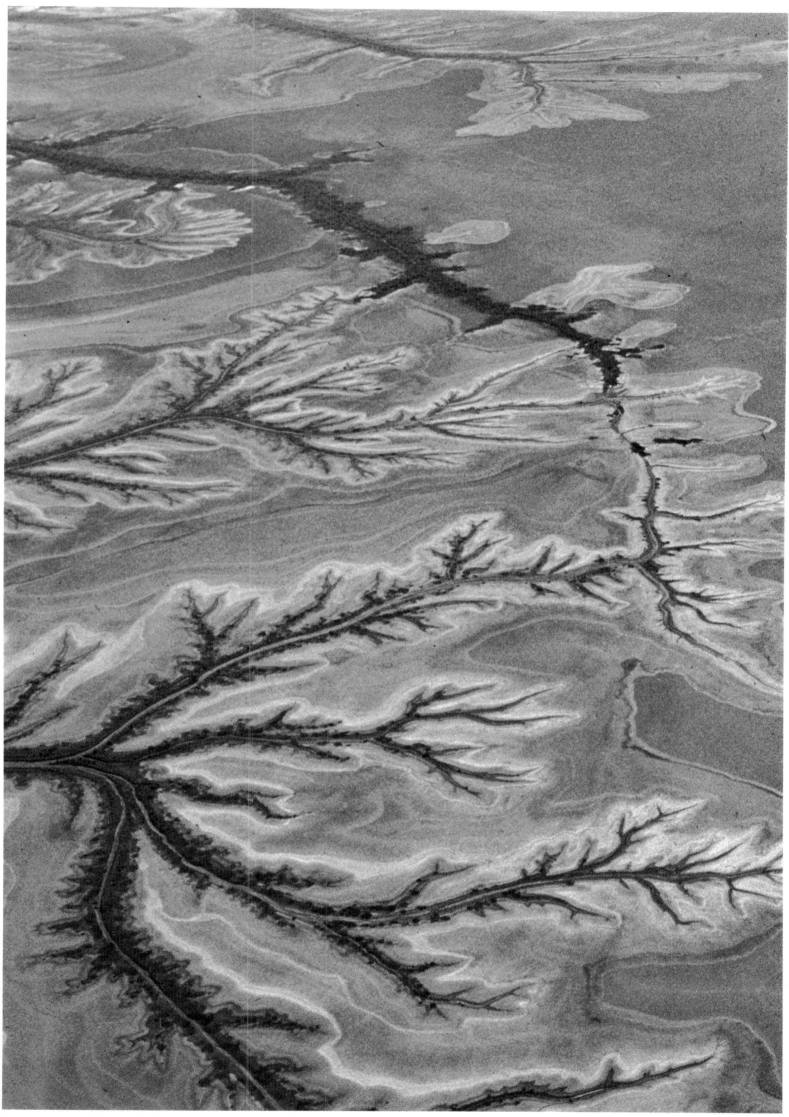

These tributaries which drain the harsh terrain around Cambridge Gulf have some resemblance to the skeletons of dead leaves

The names of the landmarks that loomed in sight as we approached Wyndham are links between the history of this area and much of that in the Drysdale and Prince Regent River districts. Cambridge Gulf, cutting through the white salt marsh on which we descended, was named by Phillip Parker King after the Duke of Cambridge, before he sailed on to Careening Bay. King investigated the possibility that the gulf was the mouth of that great navigable river of contemporary imagination, and followed the muddy inlet up as far as his ship could go. He found another possibility in what is now the King River, running into Cambridge Gulf from the south-east. He and his crew rowed for some distance up stream but found no obvious potential.

During these explorations he recorded an anchorage offshore from what 'so perfectly resembled bastions and ramparts of a formidable fortress that it needed only the display of a Standard to render the illusion complete.' He named this feature the Bastion Mountains before sailing away with little of promise to report.

King's chart of the coast was the only one available sixty-two years later, when the Durack-Emanuel expedition arrived in Cambridge Gulf from Brisbane in August 1882. This party had been encouraged to investigate the Kimberley district — which was named after a British Colonial Secretary, the Earl of Kimberley — by Alexander Forrest's report of his 1879 expedition from Beagle Bay to the Overland Telegraph line and thence to Darwin. Near the Territory border he found what he thought might be that still dreamed-of 'Queen of Australian Rivers'. If Captain Wickham of the *Beagle* had not used the name Victoria for a Northern Territory river in 1839, Forrest might have used it for this other great waterway. Instead he named it the Ord, after the State governor of that time, and recorded that it was probably the river which King had charted as entering the Cambridge Gulf on the western side.

This supposition led the Durack-Emanuel party far astray. In their search for Forrest's survey peg at the junction of the Ord and the Negri they followed up four major rivers, which they named the Pentecost, Durack, Dunham, and Bow, and took several weeks more than they had planned for the journey to the Ord. They lost so many horses they were forced to abandon a number of packsaddles and cut down on precious stores.

They were lucky to survive the perils of a six months journey inland from Cambridge Gulf and back to Beagle Bay, where they were picked up by a ship and taken to Fremantle. Despite the vicissitudes they had undergone, they had been deeply impressed by the natural resources of the country they traversed. The geologist of the party, John Pentecost, even found indications of gold.

The Emanuels of Goulburn lost no time in shipping sheep around the coast to stock country they had taken up around the Fizroy River of West Kimberley, while the Duracks and their associates embarked on their monumental cattle drive from western Queensland to the Ord. They and their surviving cattle arrived in September 1885, having covered nearly 5000 kilometres in a journey of two years and four months, by which time a remote station had already been established on the upper Ord for Osmond and Panton.

Wyndham sprang to life in 1886, after Hall and Slattery discovered payable gold at Hall's Creek, some 300 kilometres inland, in 1885. Early in 1886 the famous explorer and State premier John Forrest took a survey party to Cambridge Gulf to choose a location and plan a port for the incoming settlers and a possible rush of prospectors. They selected a site on the gulf clear of the dominating Bastions, where a town would have room to spread, and sailed away confident they had acted in the best interests of posterity. They were scarcely out of sight before the goldseekers began to pour in, intent on getting rich and getting out as quickly as possible and totally uninterested in Forrest's proposed township. Approximately 5000 of them brought their belongings ashore at the most convenient landing place, a narrow strip of marsh between the

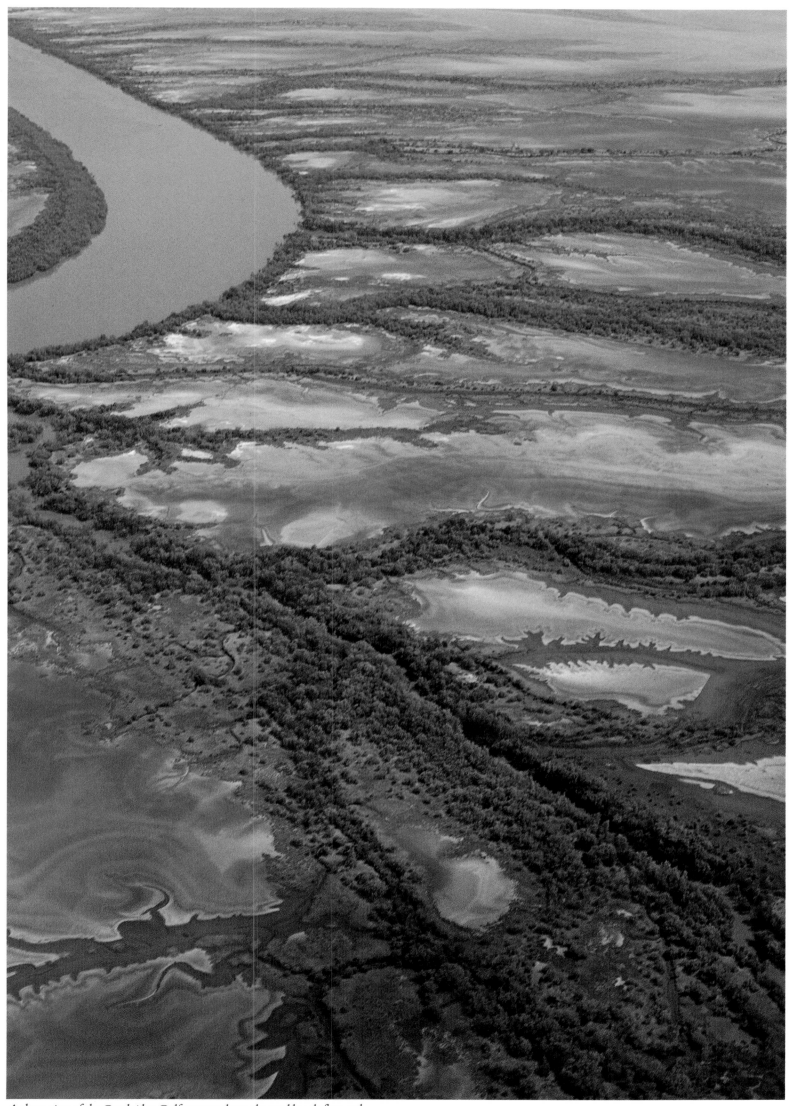

A closer view of the Cambridge Gulf country shows the muddy salt flats and inhospitable country which did not deter explorers in their search for 'good country'

mountains and the crocodile-infested gulf. The majority made a beeline for the goldfields, but a few set themselves up as storekeepers and publicans in what the government regarded as a 'temporary location'.

The goldrush petered out and the diggers drifted away, but the restricted one-street town was kept alive as an outlet for the pastoral industry. For the next thirty-three years cattle were driven over the Bastions and negotiated down a race onto waiting ships, until in 1919 the government built a meatworks and a fine jetty for the shipment of frozen beef on Forrest's original port site. This new development brightened the prospects of outlying pastoralists and the annual influx of 300 workers for the killing season brought new life and vigour to the town.

The government operated the meatworks until 1967, when they were taken over by a private company. By that time a new era of agricultural enterprise on the Ord had given increased significance to the port, and much of the population began to move from the 'temporary' town to a more suitable site about five kilometres inland. This has since become the administrative and business centre of a rapidly-growing community, with an impressive civic hall, a new post office, a modern hospital and school, sports grounds, shops, motels, caravan parks, and homes with lawns and bright gardens.

It is all a far cry from the Wyndham of my early memories — the town which inspired Harry Skinner, a one-time Clerk of Courts, to poetic heights:

> Know ye this Port? It's a place of some note
> Where the bullocks come clambouring down to the boat,
> Where no-one could fancy a township could be
> For the hill jams the township right into the sea . . .
>
> Know ye this town where the whisky is bad
> And most of the people who live there are mad?
> If ye know not this place 'tis a spot I know well
> That is only a very short distance from hell . . .

For all that, I have pleasant memories of race meetings on the marsh, balls at the old hotel, high jinks with the young people and low-key sessions with the old-timers, some of whom still remembered the goldrush days and their fabulous 'characters'. We enjoyed meeting and farewelling ships whose captains and crews were mostly known to us, and on occasion we even enjoyed climbing the most formidable of Captain King's Bastions that stood firmly between the town and the cooling effects of any passing breeze.

While Alex and I waited for our companions to join us we climbed the Bastions in an air-conditioned car, driving up a road engineered at great expense to reveal the magnificent landscape stretching to the horizon. From this vantage point one may observe the five big rivers that flow into the gulf, and appreciate the confusion of those early travellers trying to locate the Ord.

Although the town centre has been moved to The Three Mile, the main hotel, now rebuilt on modern lines, still stands on its old site. In those early memories of mine the hotel was a mere 100 metres from the old jetty, where I stood clinging to my father's coat-tails as he counted the cattle bellowing and thundering down the 'race'.

We booked into the hotel and began to make contacts, and familiar faces of long association emerged from all sides. Across the road were the Lee Tongs, a Chinese family that has kept a general store for many years. As always, Bessie Lee Tong insists on presenting me with a token of remembrance — on this occasion a silver spoon with a handle ornamented by a sprawling saltwater crocodile. We exchanged news of family members and old friends.

Further down the street we encountered a group of Aborigines attending a Lands Trust meeting in the Shire Hall. They included my beloved 'tribal son', Jeffrey Chunuma, whom I arranged to meet with other 'relations' when we reached Kununurra. Another is Tim Tims of Wyndham, with whom I have travelled to Darwin and Groote Eylandt for meetings of the Aboriginal Cultural Foundation.

At the Royal Flying Doctor Service base, which is financed and administered by the Victorian Section of the RFDS, we met Hope and John Harlock with whom we had already been in radio contact on our way north. They kindly put us in touch, by radiotelephone, with places still lying ahead on our itinerary.

As the Australian reader hardly needs to be reminded, the RFDS is the ongoing fulfilment of the Reverend John Flynn's dream of a medical and communications service for isolated outback areas. As we stood in the efficient Wyndham base it all seemed a very long way from the time about fifty years ago when Alf Traeger, John Flynn's associate pioneer of outback radio, was with us at Argyle Station making seemingly incredible communication through his pedal-operated transceiver.

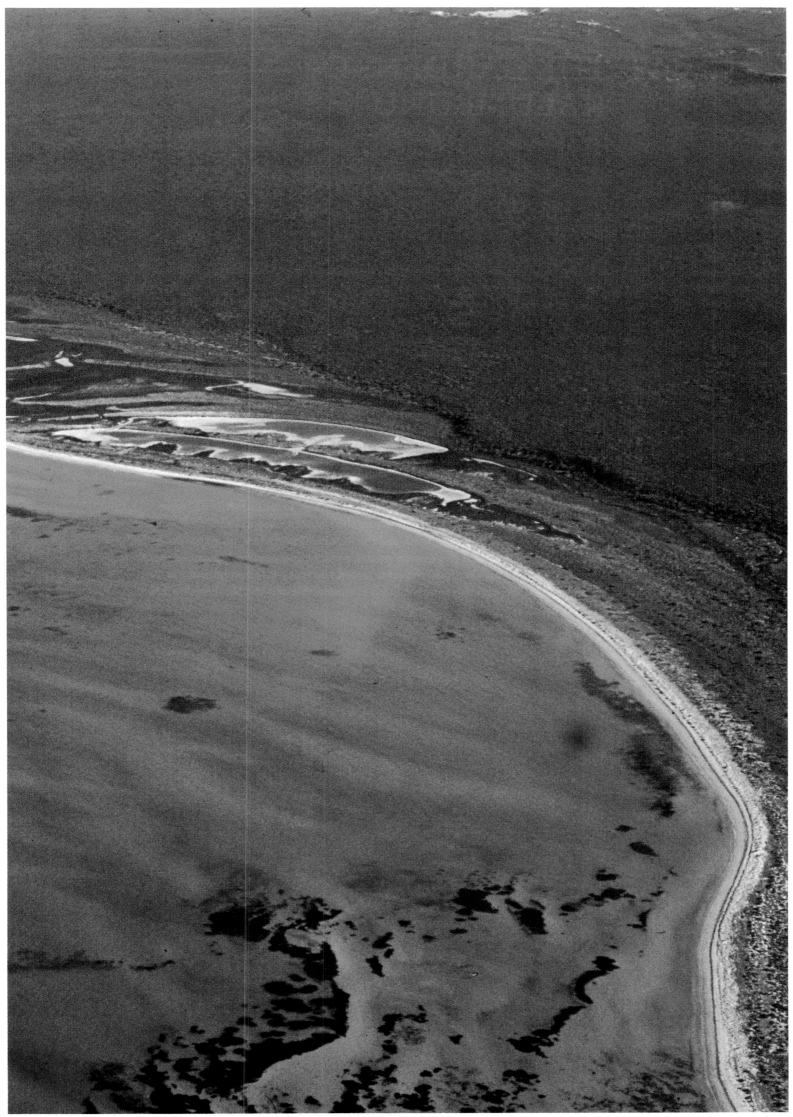

The land fringing the Joseph Bonaparte Gulf in the Wyndham region appears
to be as flat as the calm waters of the Timor Sea

12 | THE GARDENS OF KALUMBURU

KALUMBURU

From Wyndham the party flew to the Aboriginal Centre of Kalumburu, which Mary Durack and Geoffrey Dutton had both visited before. Mary Durack writes:

It would be hard to find a more remote outpost in Australia, or indeed anywhere in the world. Piloted by Peter Reid, Shire President for East Kimberley, who runs the charter service by which we travelled, we flew for 196 kilometres north-west from Wyndham, soaring over the Forrest, Berkeley, King George and Drysdale rivers to the mouth of the King Edward River at Napier Broome Bay. As we descended, Kalumburu appeared to be an incongruously well-ordered village for such a wild region. If we had been in ignorance of its background we would certainly have been puzzled by the stone buildings, one obviously a church, and the spread of small houses in well-kept grounds backed by vegetable gardens and tropical trees.

What we saw was the end result of the missionary project begun by the Spanish Benedictine monks in 1908. Members of the Order came to Western Australia in 1846, established a mission for the Aborigines at New Norcia about sixty kilometres from Perth, and had been there for sixty-two years when Abbot Torres decided they should form a branch mission in the far north of the State. They chose a place called Pago on Napier Broome Bay, about two kilometres from the present site of Kalumburu.

The local Aborigines, whose contact with other races had been so far unfortunate, were anything but welcoming. It was about six years before their hostility began to break down and communication became possible between them and the monks. During that time the monks had devoted themselves to building, and to growing garden produce and introducing cattle, sheep, goats, pigs and poultry. The mission founders were anxious to make it self-supporting as soon as possible, because there were no government funds then available and the Mother House was responsible for maintenance.

Plains
Turkey

when the helicopter
approached. birds took
to the air

Dried leaves.

The vegetable gardens and farm animals of the mission interested the Aborigines, who slowly realised that the monks had no intention of exploiting the people and their land. By the early 1930s, when the monks were joined by Sisters of the same Order, a considerable Aboriginal community had grown up in and around Pago. A number of these people were then nominally Christians but the monks were under no illusions as to their wholehearted conversion. They were well aware that, with very few exceptions, Aboriginal participation in Christian prayers and ceremonies had much to do with an acquired taste for tea, sugar, flour, tobacco, and the produce of the farm and gardens. The monks also found that in the mission situation the Aborigines did not display the same initiative and self-reliance as they did in their tribal environment. Many were prepared to work side by side with their white friends, but attempts to encourage them to use their acquired skills for individual or collective advantage met with little success.

The mission chronicles, which form the basis of Father Eugéne Perez's history of Kalumburu published in 1977, reveal an impressive story of selfless courage, perseverance, and practical commonsense. They also recall incidents that made world headlines in their time. Among these were the forced landing of Charles Kingsford Smith and his companions in the *Southern Cross*, on the mudflats of the Glenelg River in 1929, and the mission's participation in the search for the aircraft. The flyers repaired their machine and flew on to Wyndham, but the two young airmen Anderson and Hitchcock crashed in the central desert while on their way to join in the search, and died of thirst.

A similar story is that of the German flyers Hans Bertram and Adolph Klausman. In 1932, while flying around the world in a Junkers seaplane, they were forced to land near Cape Bernier. When they failed to arrive at Darwin from Timor a fruitless search went on for more than a month and little hope was held for their survival. In fact they were close to death when found by a party of Aborigines from Kalumburu, who fed and cared for them until the arrival of a rescue party from Wyndham. When Bertram returned home he obtained a beautiful harmonium from the German government and sent it to the faraway mission as a token of gratitude.

The chronicles also tell of problems that caused a move from Pago to Kalumburu shortly before the Second World War. The monks and their helpers took several years to build the new mission, but it was almost entirely destroyed, and one Brother and five Aborigines killed, by a Japanese air raid in September 1943. By the end of the war the mission had been made habitable again, and as things settled down so facilities improved and the community of something over 200 was happily reunited.

The gardens of Kalumburu, already famed for their flourishing citrus, bananas, mangoes, coconuts and vegetables of forty-seven varieties were now also producing good crops of peanuts, sorghum, and maize. Most of the livestock had run wild until the 1950s and was used mainly for local consumption, but better roads and improved facilities for getting the stock to market encouraged the purchase of new breeding cattle and the improvement of paddocks and pastures. In 1962 the mission extended its pastoral activities by taking up the lease of an adjoining property on the Carson River.

The mission thrived as an agricultural and pastoral community until the radical changes imposed by the federal government's pressure for the phasing out of 'paternalistic' mission influences, and the formation of self-governing Aboriginal Councils, began to take effect. The Benedictines, who like the Pallottine and Presbyterian missions in other parts of the Kimberley had earnestly encouraged Aboriginal independence over the years, were somewhat sceptical about these changes but not unco-operative. The administrators of Kalumburu had previously offered control of the Carson River property to the Aborigines, free of charge, but they turned it down on the grounds that they lacked the necessary knowledge and experience. They also declined the management of a crocodile farm, to be run for the benefit of the community as part of a programme of applied ecology.

At the time of our arrival we found the community to be in an interesting if in some ways sadly puzzling transitional stage. Of recent years the mission, administered from the Benedictine base at New Norcia, had been in the nature of an island in the Catholic diocese of Kimberley, but the Vatican expressed disapproval of this state of affairs and decreed that the Catholic Bishop of Kimberley, John Jobst, should assume responsibility for the Benedictine outpost. This decree, coming at much the same time as a government ruling that control of all material aspects of mission activities should pass into the hands of Aboriginal councils, further confused the situation.

Father Basil Noseda, who has spent much of the last thirty years at Kalumburu, met us at the airstrip and escorted us to the monastery he shared with one Brother. They were to leave for New Norcia as soon as Father Basil was replaced by Father Chris Saunders from Lombadina. On Father Basil's departure, it seemed likely that he would have been the last Benedictine to

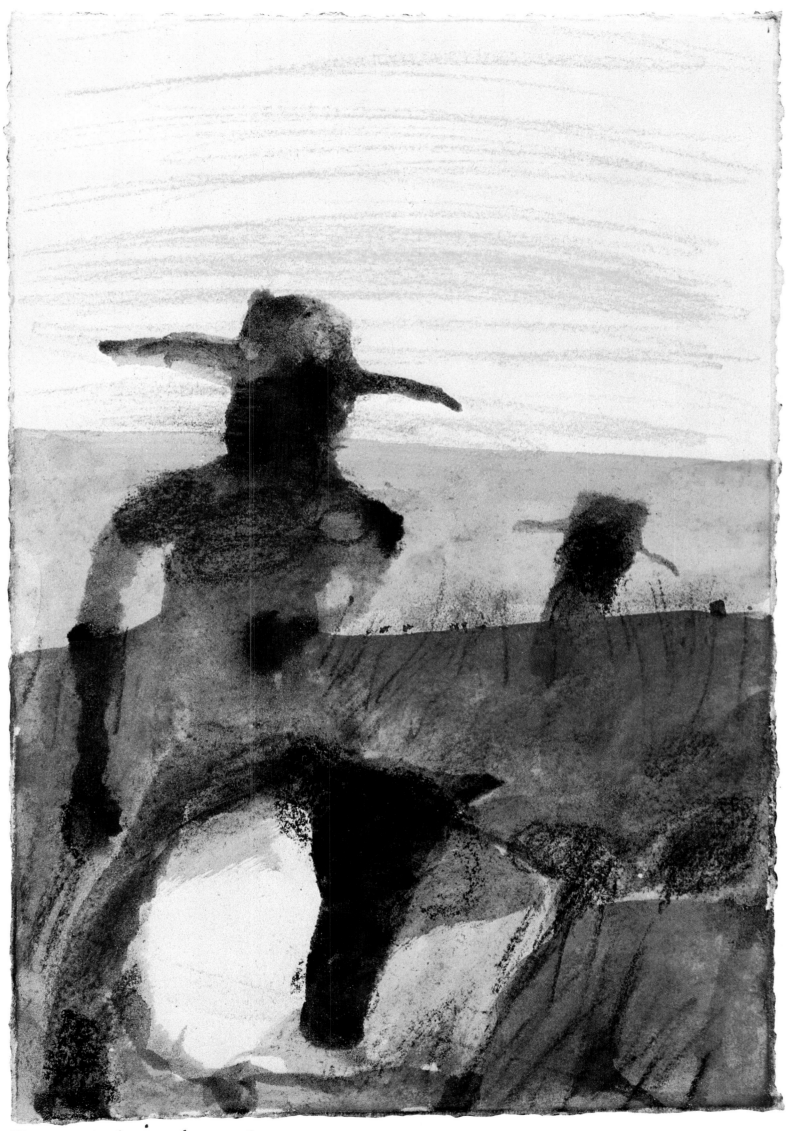

Two aboriginals on horses

hold office in an area to which members of his Order have contributed more than may easily be appreciated.

We were joined at lunch by three Sisters, one of whom, New Zealand-born Sister Philomena, was presented by Peter Reid with a certificate of Australian citizenship. Since she had worked in this country for more than twenty years it was hardly before time.

During our conversations we learned that, as in the other transitional centres we visited, the Church no longer holds authority but its representatives remain in a pastoral and supportive role for as long as the Aborigines claim to need them. Carson Station is now in the hands of a pastoral company jointly owned by the Western Australian Lands Trust and the Kalumburu community, and if the property can be run successfully for the next two or three years the full shareholding will be transferred to the Aborigines. In the meantime a team of Aboriginal stockmen runs the station with the help of a white man experienced in the cattle business, who officially takes his orders from the Council.

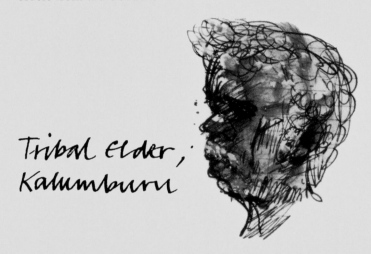

Tribal Elder,
Kalumburu

For a few hours after lunch we moved around meeting members of the community including some of the Aboriginal Council. It is not in their nature to talk with forthright confidence of a situation that is still unresolved, but we gained the impression that they regarded the new state of affairs as just another with which the inconsistent white regime had confronted them. Their unspoken question was: Why, after the newcomers had effectively conditioned them to trust the white man's experience and judgement, must they be told to manage their own affairs in a still fairly incomprehensible economy? Such feelings are to be sensed more clearly here than in places where the Aborigines have been in closer contact with a wider range of people in both bush and urban surroundings.

Only one of the men to whom I spoke seemed inclined to express himself as an individual. Born and educated at Kalumburu, he had somehow got himself to Derby where he worked as a hospital orderly. He then went to Port Keates Mission in the Northern Territory, and worked for wages there until he had saved enough to buy a car in which he hoped to travel further afield. He said 'But drink was my problem, like so many of us. I wrecked myself and the car in a silly accident and when I got out of hospital I came back here and worked in the bakery.'

He appeared to be working not only in the bakery but also in the garden, which is still impressive enough although it is obviously dwindling for lack of hands. He told me he is worried about the young people receiving social service and unemployment benefits when they have nothing better to do with their money than gamble it away. He feels that such benefits should be paid as wages, like his own, as an incentive to keep Kalumburu up to its former standards of productivity, and that those who walk out on a job should cease to receive hand-outs in any form. He said that such views are unpopular with most of the Kalumburu people, who think he is against them when he talks in such a way.

As we flew back to Wyndham over the one-time mission and the Carson River I was reminded of what I wrote in my book *The Rock and the Sand* in relation to missionary work elsewhere: 'The extent to which past missionary work has benefited the Aborigines will be differently assessed according to the reader's own criteria. One who sees progress in purely material terms may find little to have justified the continuance of these establishments in the face of such terrific odds. Those who seek evidence of the wholehearted conversion of the Aborigines and their satisfactory integration into the white man's social system may also find reason to doubt. Be that as it may, it seems clear to me at the conclusion of my task that the work of the missionaries, sometimes inspired, sometimes blind, was the only evidence the Aborigines had of anything in the nature of consistent altruism within an otherwise ruthless and self-seeking economy. It provided a ray of hope in the prevailing gloom of their predicament. It was for many their only means of survival and their sole reason for regeneration.'

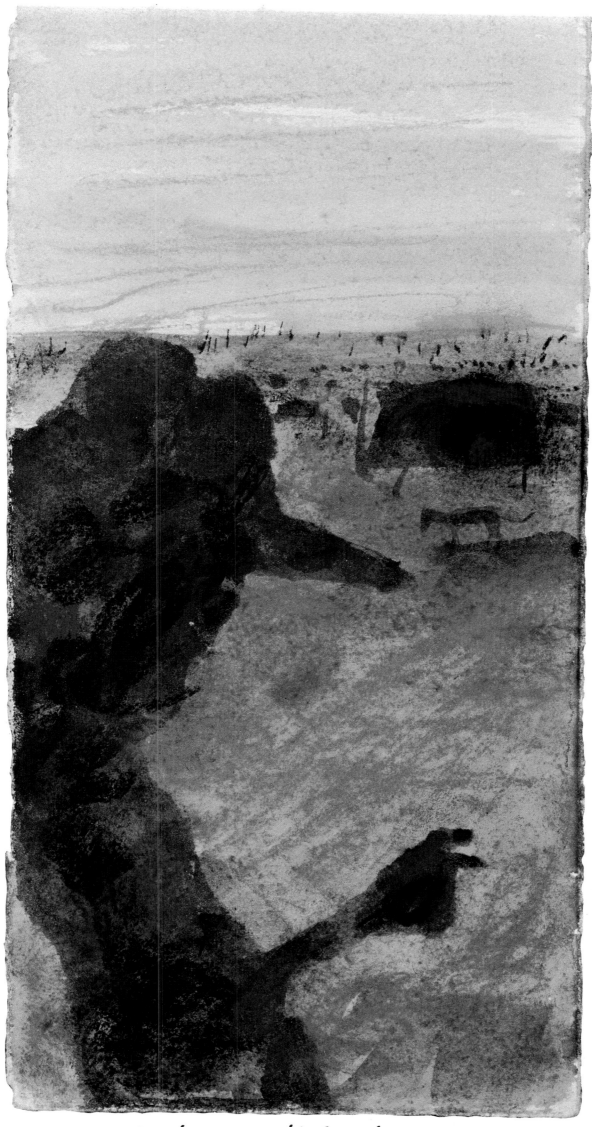

Stockman, Kalumburu

Geoffrey Dutton adds his impressions of Kalumburu:

On the way to Kalumburu we flew close to the site of Forrest River Mission, where Randolph Stow worked as a storekeeper and gathered material for his novel *To the Islands*. That mission has a grisly history, beginning when its founder Harold Hale, son of the Bishop of Perth, was speared and clubbed in 1898. The mission was reopened in 1912, and from 1914 to 1928 it was in charge of E. R. B. Gribble. The anthropologist A. P. Elkin made a field trip into the area and reported that Gribble himself flogged Aborigines and chained them to posts for alleged sexual offences. In 1938, the report of Chief Secretary W. H. Kitson revealed further atrocities at the mission.

It must have been a very different place from Kalumburu, where Ninette and I spent several days in 1978. We stayed with the Spanish Benedictine missionaries, who then included Father Perez the historian, with Father Sanz in charge. He ran the mission on strictly paternalistic lines and there was no doubt that the missionaries, who had saved the local tribes from extinction, maintained them as the best-fed, best-housed, and best-educated Aborigines in the North-West. The vegetable garden was enormous and beautifully cared for. Father Sanz was a fine cattleman and he ran the mission in association with the nearby Carson River Station. We had plenty of time to observe how fond many of the Aborigines were of him, despite his strictness.

But the Aborigines were in a sense captives. They were given no responsibility; there was nothing for them to do with their education.

On our second visit to Kalumburu we found that everything was changing amidst great upheavals. Father Sanz and Father Perez were in Spain and about to retire to New Norcia. Father Basil was in charge only of the small area around the main buildings and of the garden, with access to the river. Kalumburu was being transferred to Aboriginal ownership, together with Carson River Station which had been bought from the Church — amid rather more than murmurs that the Church should have given it to the Aborigines. Bishop Jobst, that remarkable man who was a Panzer officer at Stalingrad and now flies himself around his enormous diocese in the North-West, later told us that the government got a bargain. It paid only $600 000 for a property valued by the Department of Agriculture several years earlier at $1.2 million. He also told us that when Father Sanz was running the station only two men from Kalumburu wanted to work there. The other thirteen were from various parts of Western Australia and the Northern Territory.

As we drove in to the mission it looked rundown compared with 1978. There was cowdung and gravel and rubbish on the big basketball court and the goal rings were cockeyed. At lunch the quality of the food and drink was still generous and excellent, and there was still the delicious homebrewed beer, but Father Basil was clearly an unhappy man. A practical straight-talking man, with a square jaw, he used his hands as he talked, his face turned slightly sideways. He was undeterred by the tough demands of the country; he used to make two trips a week to Derby for stores, a distance of perhaps 720 kilometres each way, mostly over bad roads. Sometimes he would have six tyres staked on the trip.

But now the spirit had left him: the changes seemed too great to accept or understand. At Mowanjum we had been told that the Kalumburu people were starving, which had seemed impossible to anyone who knew the vast garden and the cattle station, but Father Basil said the rumour had been started so that the Council might claim an emergency grant from the government and cover up the fact that one of its members had swindled the community out of $12 500. Yes, they knew who it was.

Everything was slipping into chaos. There had been no cattle muster for two years. I asked 'How are the crocodiles?', knowing that the crocodile farm had been Father Basil's special interest. They were still there and later he showed them to us in their enclosures, but he said that the Aborigines would let them die. He was hoping that a friend in Wyndham would take them over.

He began to talk on a more metaphysical level, and became very eloquent on the need for the Aborigines to have some purpose in life. He said they need tension in order to achieve progress. (John whispered to me that the Chinese would say you need understanding for that purpose.)

We walked in the vegetable garden under great dangling crops of mangoes. Brother John was still running it but under a new system. The men who worked in the garden received free vegetables but the others had to pay. He said this was the only way to get them to work. The general opinion, from both black and white, is that the garden will wither away when Brother John leaves.

When we returned to the mission buildings there was a long queue of Aborigines around the verandah, where Father Basil was handing out the money from the welfare cheques. We heard him say to one man 'There's no way I'm going to give you the whole cheque at once. You can have it bit by bit.'

Aboriginal
leader looking
into his dreaming.

We had a meeting with the tribal elders.
The aboriginies have taken over the running
of the mission & the cattle station. The
dialogue was very tentative with us asking
most of the questions. They were courteous
& gave the impression of being very
inexperienced & lacking in confidence.
How could it be otherwise? when the
mission was run for them not ever by
them.

We went to talk to David Moraltadj, a big barrel-chested Aboriginal with a handsome strong face, a quiet voice and a wide-ranging vocabulary. He was the community baker, and the pilots told us his bread is first-rate. Against his wishes he had been made a stockman, and he fell off his horse, broke his leg, and spent six weeks in Wyndham hospital. He returned to stock work, fell again and broke his arm, and after that was sent to work in the garden, where he was sacked twice. He said he loved being a baker but really wanted to become a priest. Sister Philomena, who runs the kindergarten, said he was the only one who came and helped. She said no one worked in the kitchens any more.

We had seen some of the Kalumburu people at Mowanjum, and I asked David about these. He said 'They are all back. They're mission-trained people, you know. They think they can survive outside but no way.'

He had recently taken part in a '60 Minutes' TV programme on Kalumburu. 'I was the star!' A big laugh. 'They should have said in their programme there's nothing wrong out here except that they're too bloody lazy. They won't work, that's all that's wrong with them.'

He talked about the bakery. 'They used to have half a loaf a day, now one loaf, two loaves, all getting fat.'

He paused. 'Now Father Sanz, he was a *good* man.'

David was fed up with it all, and wanted to go to New Norcia and study for the priesthood.

Lillian Karadada, a slender, softspoken young teacher's aide in a pretty red dress, took us over to her house. It was quite unlike her, being untidy, with junk in the yard and a broken-down Holden with its front bumper bar across the verandah. In chalk over the door was 'Happy day Lillian and David only and always yours', with a heart pierced by an arrow. Childish, she said, but David had written it and she wanted to marry him.

Around the corner was Dolores, a big handsome greyhaired granny with a high chuckle. She sat with her two daughters, one of whom was writing initials on her arm with a sharp stick. The other suddenly took her baby into the house, not pleased to see us.

whistling Kite

Down on the main road Basil, who looked like Ronald Colman with his clipped white moustache and curling grey hair, a jaunty scarf around his neck, stood by his wife Ros who had a finely carved baobab nut. I asked Basil if he had carved it. He laughed. 'No, I hire feller to carve him.' He talked quite openly about the councillor who had gone off with the $12 500.

Peter Reid, our pilot, knew Basil well. He told us that Basil had bought a new car. It had blown up because he forgot to put oil in it. He ordered a new engine and took six months to pay for it. Peter finally delivered the new engine and had tea with the Fathers while Basil and his mates fitted it into the car. Within ten minutes 'There were crashes and bangs enough to make the church bells ring. They'd got the timing wrong and the engine was completely ruined.'

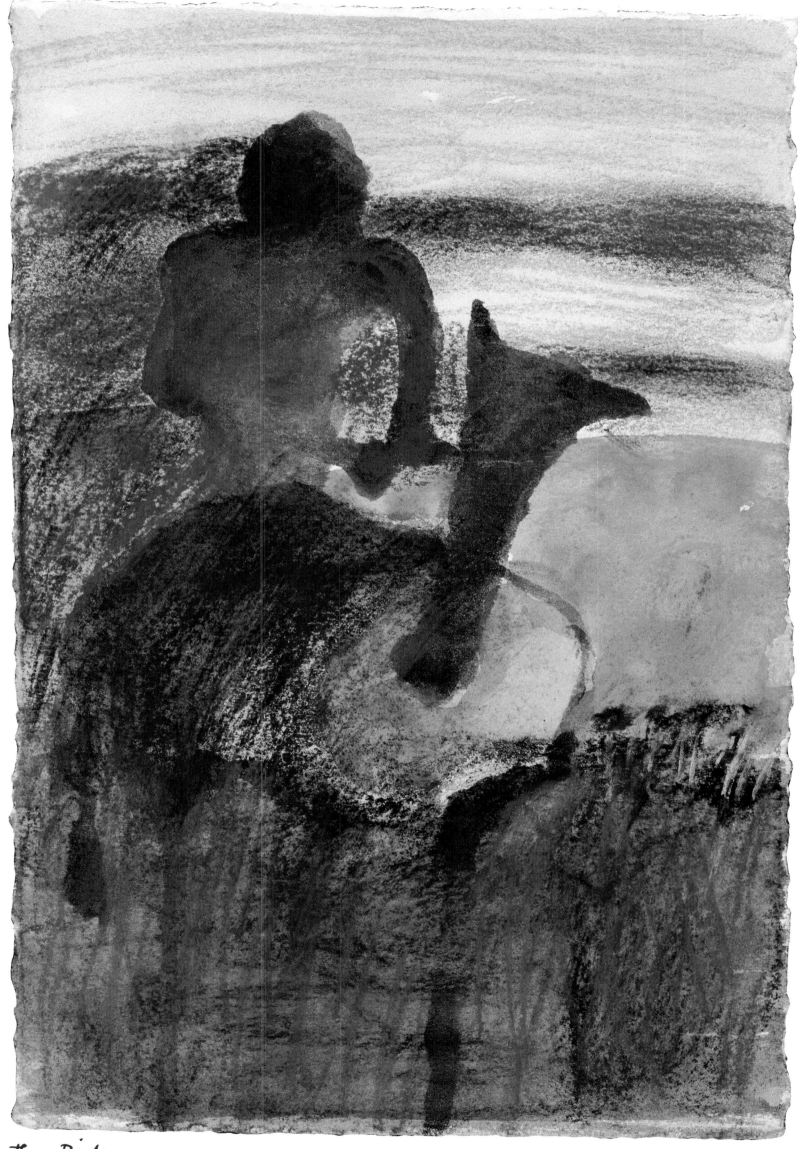

the Rider

There was no mechanic on Kalumburu, an astonishing situation for such a big and isolated community and yet another example of the missionaries' failure to make the Aborigines genuinely independent and self-confident.

We had a meeting with three of the councillors: Robert, Laurie, and Lewis. John Moraltadj, David's brother, is the chairman. David said 'He drinks, I don't.' Officially, of course, there is no alcohol in the community.

We sat facing each other and exchanged bland inanities. Aborigines, like Irishmen, will usually tell you what you want to hear. Knowing that the white manager was leaving Carson River Station, and that there had been no cattle muster for two years, I asked how they were going to run the station. 'No trouble, plenty stockmen. Some of us go and live there.' We heard later that some of the wives objected strongly to this plan.

The answer to another comment was 'Yes, garden going well.'

'Who's running it?'

'Brother John.'

'If there's no mechanic here, why not train one at Broome?'

'Oh that *bad* place, boys and girls living together.'

We had heard a story that, when they were asked how they were looking forward to Father Chris Saunders, from a Pallottine mission, taking over at a Benedictine mission the reply was 'We don't like them Palestines, we like to stick to Benedictions.'

At the end Carol asked whether, since they had been so kind as to talk to us, there was anything we could do for them. Robert said quickly 'Yes, you bring 'em us two four-wheel-drive Toyotas.'

But as we rose to go, Robert made all Kalumburu's problems seem capable of eventual solution with his comment 'You see, we're starting to learn something, bit by bit.'

At the time of our visit Kalumburu was an unhappy place. The missionaries, who had taught the Aborigines many things but not how to run their own show, were bitter about what they saw as the coming dissolution of years of work and building. We walked down to see the crocodiles with Father Basil's brother, who had driven up from the south to see him. He said 'It's the last time I'll see Kalumburu. It's a bloody shame.'

I asked him how he thought Chris Saunders would get on. 'He's a bloody martyr, that's what he'll be.'

Basil

From John Olsen's notebook: Basil looked like Ronald Colman, very handsome. Basil is a dancer. Basil has been on TV. Basil has charisma, sure. Basil is an artist — you can recognise it.

. . . During the journey I have been most interested in how Aborigines dispose themselves into groups — quite different from the European [way] which is stiff and awkward. They are more like Greeks or Romans and lie and recline in graceful positions.

. . . We had a meeting with the tribal elders. The Aborigines have taken over the running of the mission and the cattle station. The dialogue was very tentative with us asking most of the questions. They were cautious and gave the impression of being inexperienced and lacking in confidence. How could it be otherwise? When the mission was run for them and not by them.

. . . Father Basil gave them little chance of running the show — 'I love them dearly, I love them dearly, but really they couldn't organise to throw two spears together.'

Stockman riding through dry grass

13 | THE WATER DREAMERS

KUNUNURRA — ORD RIVER DAM

The travellers' itinerary took them deep into country with which Mary Durack had been familiar since her childhood. As they drove to Kununurra she noted:

These eighty kilometres of bitumen highway between Wyndham and Kununurra, on which we now speed, follow a different route from the winding bush road we travelled in years gone by. The old track, which the more adventurous can still take if so inclined, follows the course of the Ord for much of the way and veers off through the ranges to Ivanhoe Station on the riverbank. Before the cement crossing was built in 1929, motor traffic continuing past Ivanhoe had to negotiate the rocks and sand of the riverbed. This was possible only in the dry season and even then it usually meant vehicles having to be hauled across by horses, mules, or helpful Aborigines. Water flows year-round since the dam was constructed and this crossing is now best left to the fish-hungry pelicans.

The new road from Wyndham is direct and hazard-free, bridging the Ord at the diversion dam which is the site of the town. In former years it was the site of the first agricultural research station in the Kimberley district — a project that began in controversy and led to the controversial situation which still exists today.

Pelican on L Argyle

Vin Serventy gives the background to the Ord River dam and irrigation scheme:

Nature provided the perfect background for the scheme. The Carr Boyd Ranges provide a hard quartzite ridge, the natural rock barrier at Bandicoot Bar and the foundation for the diversion dam. Upstream the same ranges form a perfect barrier, ideal for the building of the main dam to hold back the vast mass of the waters of Lake Argyle. The ranges are cut by a narrow gap eroded by the Ord River.

The huge reservoir of Lake Argyle covers 740 square kilometres, and beneath its waters lie the old Argyle Station property which was selected by members of the Durack family in the early 1880s. The station was 'drowned' because it lay in the natural basin which collects the rain that falls on the 48 000 square kilometres of the surrounding catchment area. Many of the Duracks' lands were inundated when the dam was built, but the old Argyle Station homestead was taken apart and stored away with the idea of rebuilding it as a historical monument on a new site. It is now a museum.

Lake Argyle is inelegantly measured as nine Sydarbs, which means it is nine times the size of Sydney Harbour. A great deal of the lake is shallow, which is unfortunate for the irrigation engineers but fortunate from a natural history point of view. The shallow waters attract the wildlife so sadly lacking from deepwater dams. Man has created a magnificent wetland for waterbirds as well as a turquoise gem set among red hills.

L. Egret

The economic aspect of the irrigation scheme has not been nearly so inspiring. The hyperbole of Prime Minister Menzies and other politicians, expressed on that euphoric day of 20 July 1963, when the Diversion Dam was opened, lasted for many years, long enough to encourage the building of the Main Dam, but then the dream went sour. A recent *Bulletin* article on the project was headed 'A nasty billion dollar dream', and the real cost of the scheme is only now beginning to appear. More than $100 million of taxpayers' money went into its building and critics are now beginning to calculate the vanished value of the drowned pastoral land and of the diamond reserves possibly hidden under the waters of the lake. And, on the debit side, there is the potential health threat described in some detail by Professor N. F. Stanley of the University of Western Australia. He believes that the great artificial lake and the irrigated areas may be a breeding ground for disease and foresees '. . . a serious medical challenge in the field of infectious disease'.

Why then did the project ever begin? The answer may lie in 'hydromania', the conservationists' name for an endemic disease of white Australians. We have been so conditioned to the idea that Australia is desperately short of water that, when a politician suggests that a dam should be built if his party is elected, voters fall over each other in a Gadarene rush to bring him to power.

The facts that Australia already has about three times the amount of water stored, per head of population than any other nation; that few irrigation schemes in the world pay their way; and that 100 000 small dams built on farms would produce a larger return per hectare than one big one, all count for nothing against the dream of huge man-made lakes in this second driest of all continents.

There can be no question that when Robert Menzies offered to build the Diversion Dam he was more interested in trapping Western Australian votes than in trapping the waters of the Ord River. In those terms the scheme was a great success, but — except as a wildlife haven and tourist attraction — it was the last success it has had.

The planners of the scheme saw cotton as the wonder crop which would bring in the millions. This dream faded in 1974, when the cost of controlling insect predators on the cotton plants became too high. Rice, peanuts, sunflowers, safflower, and sorghum have all been tried on the irrigated areas, with sugar as the latest highflying contender. The rising cost of fossil fuels has increased interest in growing crops for fuel, and power alcohol derived from sugar may become a substitute for petroleum products if their cost rises too high.

Ironically the rubber plant or calotropis, an introduced weed which now flourishes over much of the irrigated area, may have commercial potential because its leaves and pods contain a high level of resin.

Bert Kelly, farmer and ex-politician, should have the last word. He wrote in the *Bulletin*: 'Every time an election looms politicians suddenly ''feel a dam coming on''.'

Hydromania is one disease that Professor Stanley did not mention when examining the ecology of the Ord!

spoonbill & frog

Mary Durack writes from her own knowledge of the area and the background of the scheme:

The story takes me back to the mid-1930s, when my brother Kim, fresh from Muresk Agricultural College, erupted on the northern scene. I say 'erupted' because, despite his carefully scientific approach, his views tended to have a disruptive effective on established thinking.

Kim spent his boyhood in the south of the State but he was always keenly interested in the country his family had pioneered. From the time of his return to the family territory he became actively involved in the future of the region, although little is now remembered of the role he played.

He acknowledged the courage and fortitude of the first white settlers but he was concerned by the erosive effects of their open range grazing on pastures and river frontages, which they had done little to control. He said 'I'm not blaming them. They didn't know what they were doing to the country. Now we do.'

After long argument he won his case for an experiment in growing cereals and improved pastures, irrigated by water from the river. He enlisted the support of the CSIRO and of State government departments and began his research work at Carlton Reach on Ivanhoe Station, a property of the family company.

There, with water pumped from the river, he irrigated six hectares of cereals and of imported and local grasses. The results inspired optimistic forecasts of far-reaching possibilities.

But Kim, although a catalyst for advanced policies, also had the meticulous honesty of a true scientist. He pointed out that, although small irrigated plots could show significant results, the outlook might be very different in an agricultural operation which became too large for close control. He also saw the need to study the established graingrowing interests, which might obstruct the marketing of grain from the Kimberley. He believed that a whole complex of environmental and economic factors demanded careful investigation before anyone could responsibly embark upon extensive crop farming in the area.

It is ironical that, although he was the first to experiment with irrigation, his plea for caution led him to be labelled as an 'obstructionist'. He had moved to another project, on the Fitzroy, when the Federal and State governments established the Ord River Research Station in 1945. The experiments carried out there encouraged the two governments to agree to share the cost of a scheme to irrigate 12 000 hectares for crop farming on the Ivanhoe black soil plains.

After the opening of the Diversion Dam its waters were used to irrigate thirty cotton farms averaging 293 hectares apiece, while the establishment of Kununurra township attracted 2000 residents. Besides cotton farmers these included public servants and businessmen. The cotton flourished and was rated as 'world class'. Two cotton ginneries, to separate the flower from the seed, went into operation and the future seemed promising enough to warrant the second stage of the Ord River dream. This was the construction, at the cost of $27.5 million, of the Lake Argyle reservoir and dam: the biggest man-made lake in Australia.

juvenile
Jabaru

In 1972 I was present when Prime Minister William McMahon opened this mighty reservoir. Naturally I had mixed feelings about the inundation of the fertile valley of the Ord and the major part of Argyle Station, but I hoped it would bring new life and vigour to that undeveloped area. In a country where so much conversation always revolved around 'the good old days' it was refreshing to hear lively discussion of future prospects. The prevailing optimism was infectious and the blue expanses of the lake, where familiar mountain summits had shrunk to islands, gave the landscape a new beauty and mystery.

Ord River
in the
wet

During our 1982 visit, we tried to gain some new perspective on the locality. At the opening
of the spectacular project, it was said it had succeeded at last in taming the waters of the Ord
for agricultural and pastoral development and the generation of hydro-electric power. But critics
contend it is an impractical pipe-dream, perhaps even 'Australia's biggest white elephant'.
Where does the truth lie? Could it be that the river's Dreamtime spirits find ways and means,
as Aboriginal elders warned, of keeping mankind in his place?

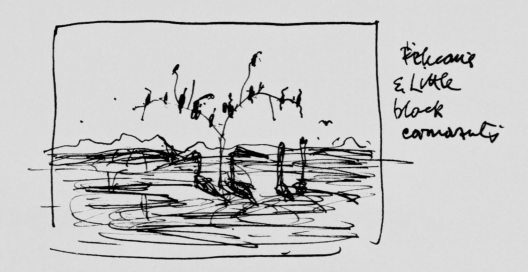

Their prediction might well explain the problems encountered by the pioneer cottongrowers,
who were drawn to the Ord from all parts of Australia and from as far afield as the United
States. At first their crops flourished and the future looked bright. They believed that established
pest-control measures would protect their cotton, but they did not reckon on the voracious
heliothis caterpillar. This persistent insect multiplied so exceedingly well under ideal conditions
that the cost of controlling it, including the need for increasingly frequent aerial spraying, soon
wiped out any profit from the crops.

An attempt to grow sorghum, both for export and to improve the quality of local cattle,
was sabotaged by hungry flocks of magpie geese, brolgas, and cockatoos: protected species which
came in their thousands to feast on the new bounty of their land. Many farmers left with
frustrated hopes but others replaced them with new ideas. If cotton and sorghum were ruled
out there were many other crops to try, including sunflower, safflower, peanuts, mung beans,
and rice. Sugar cane, the brightest prospect since cotton, produces almost double the Queensland
yield, but interstate and Federal government politics hinder planning for an Ord River sugar
industry. Some authorities recommend sugar-growing for the production of ethanol or power
alcohol, but local farmers do not see sufficient return from this and wish to concentrate on the
production of sugar for human consumption. Who will win the argument remains to be seen.

Despite all the disappointments, the prevailing spirit of Kununurra is still one of optimism,
sustained by the increasing number of tourists who flock to the scenic wonders of the great
lake and its surrounding countryside. In the 1970s, the district received its biggest boost since
the goldrush of almost a century ago. This came from the discovery of rich alluvial diamonds
in Smoke Creek which runs into Lake Argyle — a sensational development that could have a
major influence on the future of East Kimberley and possibly on Australia as a whole.

My father, a keen prospector, never abandoned the hope of finding mineral wealth in this
area and he discovered what he thought to be promising indications of gold, silver-lead, copper,
tin, and oil, but the thought that he might be riding over diamonds certainly never occurred
to him. This was despite the fact that, when he was in Cape Town in 1902, he noticed the
similarity of diamond-bearing specimens in a geological museum to rock formations in East
Kimberley. After the Lake Argyle discovery some writers said that the district had been named
for its resemblance to the Kimberley diamond fields in South Africa, but this was not so. They
were both called after Lord Kimberley, Secretary of State for the Colonies. The Australian
district was named in 1870: more than a year before the discovery of diamonds in South Africa.

Whatever the future for diamonds in the Lake Argyle region, it is certainly of importance
to the State and to Australia. At the time of our visit it was also the subject of contention.
The companies concerned, Ashton Joint Venture and CRA, had discussed the matter of
encroachment on sacred sites with a tribal group who claimed rights to a portion of the mining
area. These people were given a small cattle station encompassing the disputed country, but this
led to altercation when others of the tribe claimed equal rights to the property.

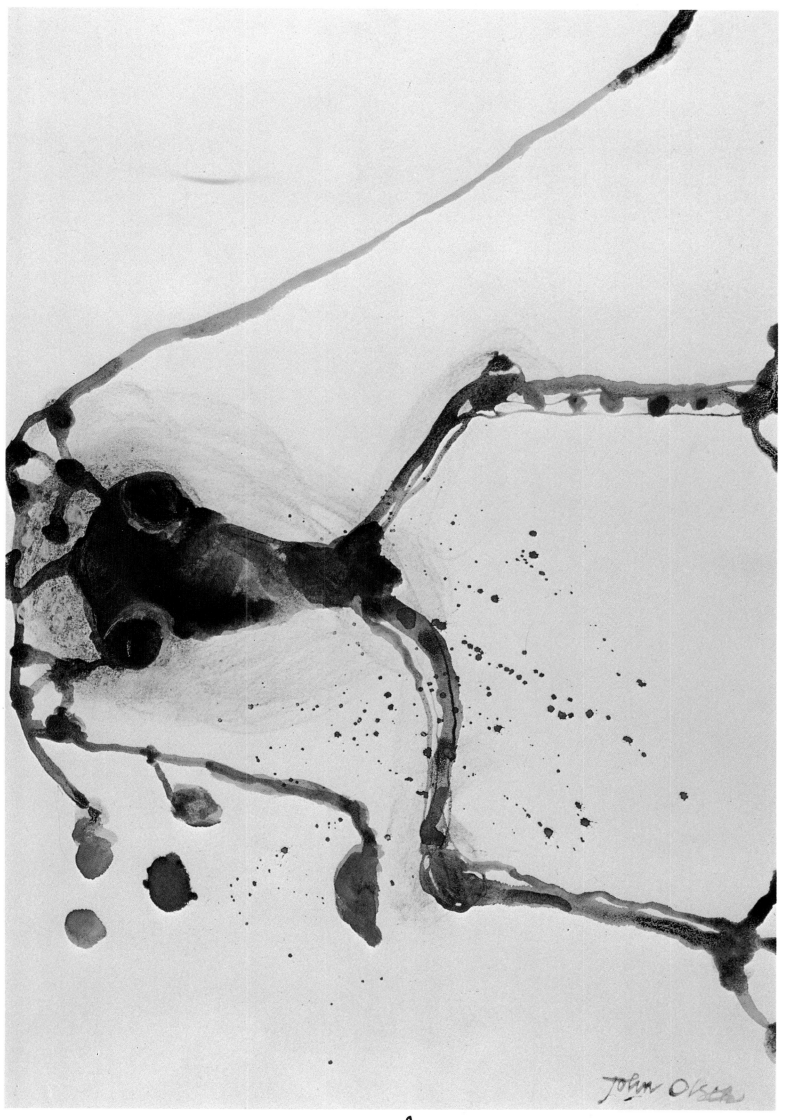

Tree frog

This argument was in progress during our time in Kununurra, as was another over the setting up of a township adjacent to the mine, a project urged by the Government. The company argued that this was contrary to their agreement with the Aborigines and that their workforce of 400 should continue to be accommodated in basic quarters at the mine-site and commute regularly to Perth. This issue has now been resolved, with the surprising outcome that the State Government has acquired a five per cent interest in the diamond enterprise. The company is no longer required to set up a mining town but has agreed to build fifty houses and a civic and sporting complex at Kununurra for the key workers and executives.

Whenever I visit the Kununurra area I contact the Aboriginal people who were part of our one-time station families. The ranks of our faithful stockmen and household helpers grow thinner each year, but those who remain are always ready to return with me to places of old association and happy memories. On the 1982 visit we decided to show my travelling companions the site of the old Ivanhoe homestead which was burned down in 1950 — the result of a kerosene refrigerator exploding while the manager was away.

My sister Elizabeth and I were in charge of Ivanhoe during the depression years of the 1930s, but we certainly never felt depressed. We had no such amenities as electricity, radio, or TV, but we never felt deprived and were never lonely. The Aboriginal community at Ivanhoe, including the station employees, women and children, and members of old 'King' Paddy's camp nearby, numbered about fifty. There were no drinking problems among station Aborigines at that time, and if there were any fights they were carried on out of earshot. We shared the joys of the river, the rock pools in the ranges and their wildlife inhabitants. We also shared a pet rock wallaby, a few tame birds and lizards, and even a friendly rock python — none of them ever caged. We were welcome to attend corroborees and 'secret' rituals carried on by the women when their men were away in the stock camps.

There were eight cheerful young stockmen in the Ivanhoe camp. Bungledoon, married to 'King' Paddy's oldest daughter Nida, was the 'head man' where Aborigines were concerned, but the brisk and capable Johnnie Walker, a part-Aboriginal, was officially in charge of the stock camp. He reported conscientiously on the conditions of the cattle, pasture, and waterholes. Until recent years these old friends and others, including Jeffrey Chunuma's father Mundi Moore, lived on the Kununurra reserve. On my occasional visits we would get together to recall our memories. This was the way the sessions usually ran:

> Do you remember, Bungledoon, Johnnie Walker, Mundi,
> The day when the river mustered its barramundi
> into the channels, and you running with your long spears,
> and the fish hanging from your poles, shoulder to shoulder?
> All of us young then, and laughing above the voice
> of the brown floodwaters thundering in our ears.
> And Dave Wilson, pointing like a prophet of old
> to Bandicoot Crossing?
>
> Saying 'The wealth of a nation flowing to waste in the ocean.
> They'll dam that river someday. They'll turn that
> useless water into gold — you mark my words.'
>
> And then, because it was Christmas —
> painting the kids' tummies with aluminium,
> and talking of the pig Bill Jones had brought from Carlton;
> but no one would kill it because we had named it
> and kicked it from under our feet for just too long.
> The seeds from Ah Kim's garden that you had scattered
> this side of Hidden Valley — exploding melons
> pink as galahs' feathers. And then Bob Skuthorpe
> through with the Christmas mail when we'd given him up
> for bogged on the Mantinea flat deciding to stay
> and join the station fun. Do you remember that day —
> the centipedes crawling out of the cracked plain
> brolgas calling and a resurrection of frogs
> acclaiming the green miracle of the rain?

Ivanhoe Station, along with most of the family estate, passed into other hands shortly before my father's death in 1950 — strangely enough on the same day that the old Ivanhoe homestead was destroyed. A new house has since been built on the riverbank and few today recall what was the only residence on the 160-kilometre track between Wyndham and Argyle. The old homestead was a square structure, surrounded by a broad verandah and surmounted by a tower which one could climb to scan the horizons for the dust of approaching travellers.

cat eating
a lizard.

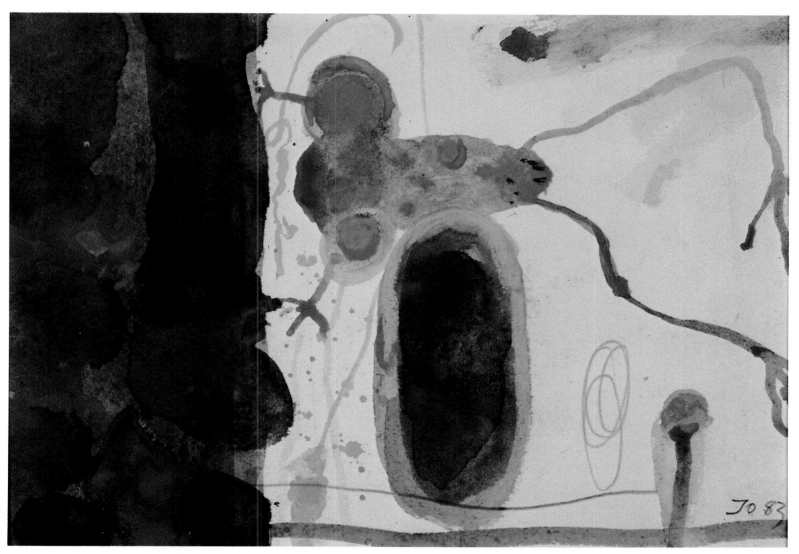

Frog & Dark bank

The Aboriginal camps were spread around the nearby billabong and under rocky outcrops much frequented by a flock of Angora goats. For many of my Aboriginal friends in Kununurra this place was home during their growing years. They were the children drawn by my sister for my station stories published in the *Bulletin* of that era. Jeffrey Chunuma and Sheba Dingarri, now both grandparents, were the juvenile hero and heroine in *The Way of the Whirlwind*, the book which I wrote and Elizabeth illustrated. We dedicated it to them in memory of those happy days:

> To you brown children of those northern years
> that saw the flowering of your childhood through
> revealing to us your laughter and your fears
> and ways bush-wise and secrets that you knew.
>
> For we have shared the hours of your delight
> and sighed that so much sweetness pass away
> of days that knew no darkness but the night
> and ways that knew no parting save in play.

They were anxious to come with us to Lake Argyle to visit the old Argyle homestead, which was rescued from the waters of the dam and now serves as a local museum. On the seventy-two-kilometre drive from Kununurra we stopped at Dingo Springs, an Aboriginal reserve area in charge of Bulla O'Sullivan. He seemed to have sensed our coming and he was ready to accompany us. Born early this century he grew up and spent most of his life on Argyle Station. Always a reliable stockman, he is also a reliable source of information on the personalities and genealogies of both black and white. Though remarkably vigorous for his years he knows that time must catch up with him and he has bequeathed to Jeffrey Chunuma, his tribal son, the authority he now holds at Dingo Springs. This indicates that Jeffrey, who is also my 'tribal son', has not been degraded by destructive aspects of white influence and so it is good news for me.

At Lake Argyle we stood together overlooking the waters and the spillway which controls them, in a part of the gorge forged in Dreamtime legend by the spirit Moolarli to let the fish escape from a greedy jabiru. Moolarli, with his lightning spear and wandering ways, left many landmarks hereabouts. Goodness knows what he is up to now. We recalled that Daylight Merinji, another Argyle stockman, law-keeper and 'dreamer', salvaged the sacred tjuringas of the area. He told me at the time that he had seen fit to burn them, rather than leave them to drown with the country where they belonged.

Bulla trod thoughtfully through the gate leading to the old Argyle homestead, and as his hands felt their walls he commented on their careful reconstruction. The rooms are not furnished as they used to be but now contain items of regional and personal memorabilia, some more meaningful to Bulla than to me. He knows what items of stock-camp equipment were obtained from somewhere 'down south', and which were made by various itinerant saddlers in the Kimberley. He has no difficulty in identifying old associates from photographs, no matter how long ago they were taken. One was of my mother at the time of her marriage in 1909, and others were of my father and his brothers and cousins in their youth.

Bulla asked me 'Why did you have to leave us? If your old man thought he was getting too old we could have looked after things all right.'

Bulla's question touches on tender ground. The reasons for my family being in the country to begin with, and for our eventual selling out, are more complicated than he or most other people realise. But it is true to say that, although the country no longer involves the family in a business sense, it is still the 'spirit country' with which we are linked in so many other ways.

Brother Kim, who is no longer here to uphold or modify his opinions, probably was right in saying that the major dam and irrigation projects were premature. The fact remains that the dam is there: a challenge to initiative and stimulus to ideas in a country of intriguing potential and tantalising contradictions.

From John Olsen's notebook: I am uncertain how I will solve the problem of [painting] the majestic bulk of the Hamersley and Ord Ranges. After all most of my work has arranged objects on a flat picture plane, reducing modelled bulk to a minimum.

At this point I am inclined to experiment with underpainting and scumbling or even glazing, a method that gives an illusive and aged vision of the scene.

I must be patient and wait till I return to Clarendon [his home in South Australia].

Frog & waterlily

Geoffrey Dutton
retains mixed
feelings about the
Kununurra region
and its people:

Kununurra seems the most artificial of all the company and government towns in the North-West because it is harnessed to an enigma, the Ord River scheme. Some of the crops seem, at last, to be succeeding, and there are some optimists around, but one sceptical southerner seemed to sum up the feelings of many Australians when he said to Ninette and me 'If they'd spent those bloody millions of Ord money on improving the existing farms in Australia then Australian farm production would be just about double by now.'

But whatever the present truth may be, the enormous expense has created an agricultural complex which anyone with a long view must see as having potential for the future, especially with the development of the North-West's natural markets in South-East Asia. The construction of a better port at Wyndham will of course be an essential.

Two dynamic young people who believe in Kununurra and the future of the project are David and Susan Bradley, who are so handsome and agreeable and intelligent that you in turn believe in them. David is the famous 'flying vet' of the North-West. In his veterinary practice he has three aircraft and two assistants, who also fly. They spend eight to nine months of the year servicing stations all over the North-West and in the Northern Territory. Susan runs one of the most attractive caravan parks in Australia, on the edge of the Ord, and they have 1500 acres of irrigation country. Their vigour and enthusiasm make you believe in the optimists rather than the pessimists.

We told them we were going to see Lake Argyle, and Susan recalled the occasion when she and Mary Durack had taken a guided tour around the lake in the tourist boat named *Mary Durack*. The guide, who did not know Mary, told the party of tourists 'Now to explain why this boat is called *Mary Durack*. She was the last surviving member of her family. She was a writer, but she did all right for herself. She married Reg Ansett.' (Mary, of course, married Horrie Miller, the pioneer aviator and co-founder of MacRobertson Miller Airways, and is not the only surviving member of her family.) On a later trip with some visitors Susan asked the guide why they were going in a different boat. He said 'Oh, *Mary Durack* is gone in the guts.'

Even if nothing of economic importance ever comes out of the Ord scheme at least Lake Argyle will have given pleasure to tens of thousands of tourists. You reach this prodigious expanse of water through the dry red splendour of great hills, slashed by the absolute whiteness of apple gums and the corellas which fly out of them. On the day we went through the hills they showed great patches of a particularly beautiful red grevillea, hugging the ground where there had been a bushfire.

As the boat glides around the promontories and bays of the lake it reveals a Chinese delicacy of water and distances. The clearest lines are in the foreground; of pelicans by dead trees and snake birds weaving their long necks. Wallabies still live on some of the islands; they wait for the arrival of the boat and like to be given an apple.

If Lake Argyle raises the spirits, Kununurra alternately dashes and lifts them. The tensions and tragedies in the district surface in the local newspapers, the *Kununurra Forum* and *Kununurra Echo*. On 13 September 1982 there was a stern note in the *Echo* from the Citizens' Action Group. It said that a group of young people and members of service clubs had recently combined to clean up Kununurra, but 'Since then we have seen the deliberate attempts of a certain group of children to undo the good work. People have seen these acts, such as writing on shop walls, emptying garbage bins on the footpath and smashing bottles, and identified the morons responsible.

'When these louts come home one night with a liberal coating of tar and feathers or their parents wake one morning to find a truck load of rubbish in their front yard, they will know the reason why.

'We assure you it will happen if the moronic acts continue.'

There is considerable underlying resentment by the white people against white men and women who work for the Aboriginal Legal Service, and this surfaced in an *Echo* paragraph about an ALS lawyer with a de facto partner who had been given a State-owned house soon after arriving in Kununurra. The paper said that 'Many people on the waiting list have complained bitterly about the allocation,' while the Ministry of Housing blandly explained that it was merely a 'temporary allocation' of the type arranged when there was immediate need for housing for 'essential services'.

The sad tale of the results of Aboriginal drinking goes on and on wherever you travel in the North-West, and the *Echo's* lead story was that of an Aboriginal who murdered his de facto wife while he was drunk. The murderer, Tommy Rose, drove from Balgo to Hall's Creek with Teresa Connie and her father and camped just outside the town at a place called Dinner Camp. In the afternoon they went to the Halls Creek Hotel and drank there until the evening, when a police aide told Rose to take Teresa 'home' because she was quite heavily under the influence.

The trio went back to Dinner Camp but Tommy Rose returned to the hotel and stayed until closing time. As he walked back to camp again, Teresa met him on the track, screaming abuse

LAKE ARGYLE

Light is an exercise in humility.
Those brazen assertions that rock is red
Ask for an answering civility.
Look south, it's true,

Look north, through soft diffusions
That melt in water, rocks are greying
In a mist of blue.

The sun is the certitude of pride
But atmosphere is the delicacy of illusions.

What was written in rock by cursive heat
Is interpreted by light, it is saying

Rocks are not dead
But old people waiting
To tell their stories, and at their feet

Already in the mirror
Of the water their reflections
Are answering, softly relating
That the message of light is to ask questions.

Aboriginal boys swimming

and 'causing humbug'. He kicked her numerous times and beat her with a stick to 'shut her up', but when she continued to scream at him he walked to their parked car and found another weapon. It was a 'jack stem' which he took from the boot and used as a kind of knife to stab her several times on the head.

Even though she was bleeding profusely from her wounds she kept on screaming until Tommy dragged her to the car and banged her head on the front fender. Her father was asleep in the camp but when he was awoken by her screaming he took no notice than to tell them to 'Shut up,' and fell asleep again.

Teresa at last stopped screaming and asked for a glass of water. Tommy then dragged her to their nearby bedroll and went to sleep. When he awoke the next morning he could not rouse Teresa, and after he had washed her face to remove the blood and dirt and tried again to awaken her he shook her father out of his bedroll. Her father went for an ambulance from Halls Creek Hospital but she was dead.

When Tommy Rose appeared before the Honourable Mr Justice Pidgeon and a jury of twelve men and women, in the Kununurra court of 1 September 1982, he pleaded guilty to manslaughter but not guilty to murder. However the jury found him guilty of the graver charge and Mr Justice Pidgeon sentenced him to life imprisonment.

It all seemed a long way from the smart smiling lady on the front cover of that issue of the *Echo*, standing by the Wyndham racecourse with an infinite landscape stretching beyond a hessian-screened toilet. The heading was 'Georgina Lilly. Best Hat Winner'.

In the North-West you hear many stories of the strange things that go on among Aborigines at election time. The government issues 'educational voting cards', such as one which carries the picture of a pig with the slogans 'Pig will support you. 'Vote Pig.'

To 'vote Pig' an Aboriginal had to fill out his ballot paper in the following style:

Cow [3] Sheep [2] PIG [1] Horse [4]

One wonders whether the bureaucrat who dreamt this up had ever been in an Aboriginal community of the North-West, where pigs are rarely seen. Perhaps he had been in Papua New Guinea.

For 'Your Senate Team' you are invited to vote:

Water	[1]	Sun	[4]	Dog	[7]	Truck	[10]
Milk	[2]	Moon	[5]	Cat	[8]	Bike	[11]
Beer	[3]	Stars	[6]	Car	[9]		

Apart from the fact that no Aboriginal in his right mind would vote 1 for Water and 3 for Beer, the whole concept is both degrading and confusing.

But the ultimate cynical degradation is the How-to-Vote card issued for the Independent candidate, Keith D. Wright of Kununurra, for the electorate of Kimberley on 17 December 1977. It was a replica of a Social Service cheque overprinted with the words 'Vote for Keith D. Wright 1' and his signature. Apparently dozens of these cards were handed across hotel bars in payment for drinks.

We heard innumerable stories of the manipulation of Aboriginal voters by both parties. When the Aborigines first got the vote, station owners who supported the LCL used to tell them how to vote and then drive them to the polling booth. Ernie Bridge, the MP who sings bush songs at gatherings, recently brought a court case over a police sergeant who told a lot of Aboriginal voters to go home before they had voted. A Labor candidate took truck-loads of Aborigines into the Northern Territory before his Liberal opponent arrived in the constituency and sent back bags of postal votes all marked for Labor. And so on. The Aboriginal vote is an increasingly powerful element in Western Australian politics and the implications of such stories are alarming.

On our Sunday in Kununurra the hospitable Bradleys took us up the Ord River in a jet-boat, for a swim and picnic in an idyllic place among smooth rocks where the river curves between craggy hills. We drank beer in the shade of a great boulder and looked out over the wide green river, soft reeds, jacanas walking across the weeds growing in the river, young grey and black jabirus by a nest, brolgas, spoonbills, a darter's nest on a high branch of a paperbark, and not another boat to ripple the reeds.

Susan had been playing tennis with a front-end loader driver, an entomologist and a diamond sorter. This mix of people getting along together is the most positive aspect of Kununurra. You even found the mix operating in the post office, where the archetypal Drysdale stockman goes in rocking on his high boots with his skinny frame and tattooed arms, a wild turkey feather in the band of his wide hat. The postal clerk, who is also a keen tennis player, says 'Nothing for you today, Dan,' and turns to two Aborigines. 'One for you Billy, and nothing for you Peter.' Then he has a long chat with a woman about her baby. It is a pleasure to wait for one's stamps under such circumstances.

Tree frog hanging from a branch

Susan took us to visit Don and Meg Shedley, a remarkable couple who run the Bethel Inc., the Kununurra children's sanctuary which looks after abandoned mothers and children. Meg is browned and toughened by the North-West but the heart of gold shows through; Don is a wiry, humorous entomologist. They introduced us to Paddy, an old Aboriginal who made millet brooms, and told us that $8000 worth of millet remained uncut on Aboriginal land because no one would cut it for less than $120 a week. The Aboriginal reserve at Kununurra has an allocation of $188 000 per annum for fifty men, women, and children, plus $35 000 in unemployment benefits. The Aborigines in the reserve pay $25 a week for board and lodging: the Shedleys charge $5 for a single and $8.75 for a mother and children. They and their boarders run it all themselves without government support, though the supporting mothers of course receive their government cheques. Young men, if not working within two days, are ordered to leave.

Susan estimated that the Shedleys had saved more than 100 children from death by disease or neglect, and they were also involved in the accounting for a cattle station run by Aborigines. When they took over the accounting the books were in such confusion that they could not be audited, although the white so-called bookkeeper had collected a $15 000 fee. The last muster had brought in only sixty-two head from a million acres. One white 'helper' had sent a big batch from the previous muster to the Wyndham abattoirs and received a third of the sale price.

The Shedleys showed us a letter from the Aboriginal Legal Service which gave a good idea of the rights and powers of the Aborigines today. Addressed to the manager of Berati Pty Ltd it concerned 'Ivanho' Station, and advised him that two groups of Aborigines proposed to enter upon an area of Ivanhoe Station land traditional to the groups, and owned by them in Aboriginal Law, 'for the purpose of their setting up a camp and seeking their sustenance in the accustomed manner'.

These 'clients' of the Aboriginal Legal Service had 'advised it' that they were entitled to enter on the land under the provisions of Section 106(2) of the Western Australian Land Act, 1933 'as amended'. This section reads 'The Aboriginal Natives may at all times enter into any unenclosed and unimproved parts of the land, the subject of a Pastoral Lease to seek their sustenance in their accustomed manner.'

The ALS solicitor who signed the letter said that 'my clients' proposed to remain indefinitely on the land for the purposes of fishing, foraging, and educating the young people in Aboriginal life, customs and the Law. However they would 'naturally at times travel to Kununurra and other places, particularly for stores.'

The letter explained that the connection of the two groups with the Ivanhoe Station land, 'and very strong feeling for the land', had never been severed 'despite their having been forced to leave their country some years ago. They have continued to visit the land in order to retain their links with it.'

The letter concluded with a request for assent within fourteen days, and a statement that if 'a positive response' was not received then 'my clients' proposed to issue a Supreme Court writ. Two lists of the families who allegedly wished to use the land, with fifty-two names on one list and forty-three on the other, were attached to the letter.

It was enlightening to hear the Shedleys, who knew all the people concerned, checking through the lists. ' ''Ben Ward and wife and five children.'' They've been split up for years. ''Major Clyde.'' He's never heard of the application. Speaks good English. ''Button Tom and three children.'' Button hasn't got any children. Connie Mingamarra's name is on both lists.' And so on.

The hostility of many whites in the North-West towards the Aboriginal Legal Service should make one sceptical of stories, but I couldn't help being amused by one we heard in Kununurra. Apparently the white solicitors and advisers of the ALS have their ears very close to the exploring operations of the mining companies. Recently an advance party of one of the companies laid out a big ring of stones so that helicopter pilots could see it when dropping supplies. Shortly after that a museum expert and some tribal elders arrived on the spot and claimed it as a sacred site: a Bora Ring.

Lilly Trotters Ord River

14 | THE FIVE SEASONS OF BALGO

LAKE GREGORY — BALGO — WOLF CREEK CRATER

From Kununurra the party made a side-trip by air to the Lake Gregory and Balgo Aboriginal communities. Geoffrey Dutton writes 'This must be one of the great flights of the world' and continues:

First we passed the pale blue expanse of Lake Argyle, and after crossing the curves and gorges of the great ranges came to the Argyle Diamond Mine with its loops and swirls of the cuts in the hills, the grid of tracks, the spokes of the housing, and a long pointing arrow of the pipeline from the lake. Then we were back to dry hard sand ridges and a band of black-iron hills, before the absolutely astonishing, unique sight of the Bungle Bungle Ranges. They are like beehives or breasts or eastern temples rising abruptly in islands of banded colour from the sea of the plain, all pressed tightly together in a way totally unlike the long wavy folds of the other hills.

Next came the immense blacksoil plains, where the stretches of dry grass look like sandy desert in the daytime and like lakes in the evening. Then the Fox River Government Agricultural Research Station, an overgrazed property where the land is a mass of scars from cultivation in experiments with various grasses.

Fire, both past and present, is with you all the time. The black stains of dead fires ooze over the plain; the waves of live fire rage over the ranges and create walls of red at night.

Then we flew over the Wolf Creek meteorite crater, so odd because there is no hump in the middle where the meteorite landed. Apparently it exploded and vanished when it hit the earth. Then over the seismic survey grid lines, Lake Gregory, and Lake Gregory Station. The lake was a rare sight because the great muddy invasion of the red and yellow land was the first for forty-two years, and no one remembers when the lake was full before that. We circled over it and saw the heart-rending sight of about 300 cattle starving to death on a red island in the midst of the pale, brown water. Roads and a riverbed disappeared into the edge of the lake, with only the trees along the riverbanks showing above the waters that flooded into the lake from an unusual 1000-millimetre rainfall. In normal years the region is lucky to receive 350 millimetres.

Vin Serventy comments on Lake Gregory and Wolf Creek Crater:

In David Carnegie's book *Spinifex and Sand* he commented 'On nearing the lake the creek assumes so dismal an appearance, and so funereal is the aspect of the dead scrub . . . that one wonders that Gregory did not choose the name of ''Dead'' instead of merely ''Salt Sea''.'

Francis Gregory, who saw the lake as a salt sea, would certainly have been astonished by the huge freshwater lake resulting from floods that were staggering even to those who have lived in the district all their lives. John and I, remembering our exploration of the great inland sea of Lake Eyre when it filled for the second time since white settlement, were fascinated by the sight of Lake Gregory and we made many comparisons between the two.

Wolf Creek Crater was another fascinating sight. From the ground it appears to be only another low hill, depressingly similar to many others in that area, but from the air you can see that the 'hill' is the ridge around the crater formed by the impact of the meteorite. The crater forms a perfect circle with a diameter of about 850 metres.

The inner slope is steep and few would care to scramble down the bank of scree to the bottom, where a claypan at times holds water. Sizeable trees flourish in this natural dam.

An aerial reconnaissance team officially recorded the crater in 1947, but Mary told us that her husband had seen it from the air many years before that. He assumed it was well known and did not bother to publicise it.

From the air the crater looks exactly like those great scars on the moon also believed to have been caused by meteorite strikes. Erosion is slow in this arid desert and the rim is as sharp-edged as when it was formed aeons ago.

When the meteorite hit the earth, many thousands of tonnes of rock glowing white-hot from air friction and exploding like an atom bomb, the incident must have left an indelible impression on the minds of any Aborigines who had moved into the area by that time. Their Dreamtime legends do not seem to mention the arrival of the meteorite but research shows that they fitted the great crater into their mythology. They account for its presence by saying that two giant

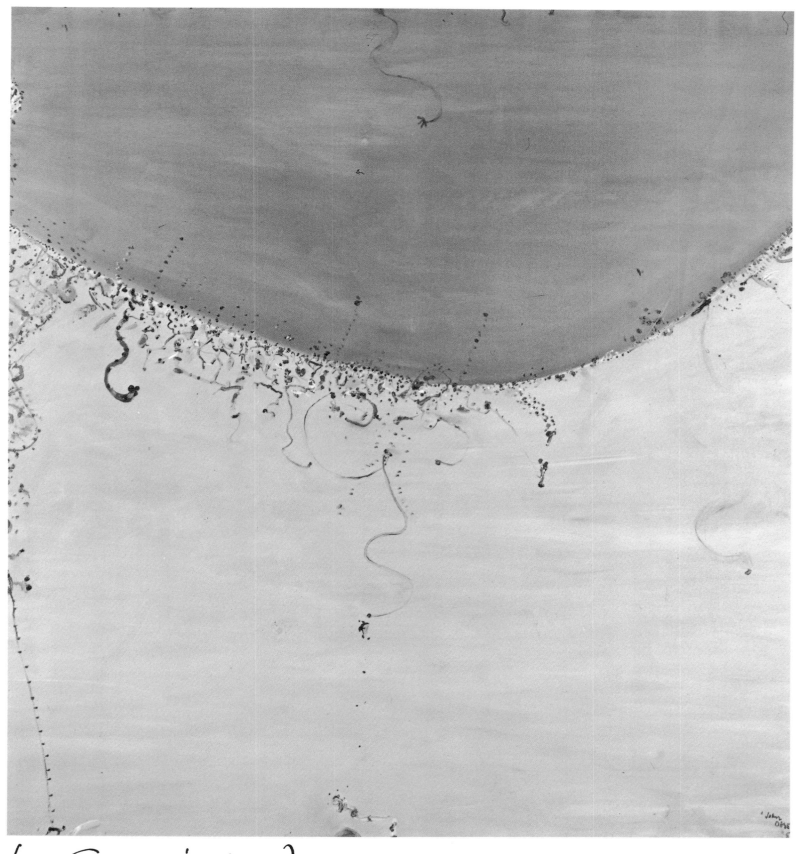

L: Gregory in Flood I

rainbow snakes moving across the country created Wolf Creek and Sturt Creek, with their typical sinuous curves across an arid landscape, before one of them plunged into the soil and emerged again to create Wolf Creek Crater. More prosaically, white geologists simply claim that it is the second largest meteorite crater in the world.

The party landed at Lake Gregory settlement, of which Mary Durack writes:

The settlement is a comparatively recent experiment in Aboriginal communities. The government purchased the surrounding pastoral lease, together with the adjoining station of Billiluna, a few years ago, and the two properties are administered by an Aboriginal Council with the help of an experienced stockman and station manager named Richard Barton. We met him with several of the Council members and they told us that the two properties carry about 16 000 cattle and provide employment for some twenty Aboriginal stockmen. The Council's aim is to increase employment opportunities within the settlement, so that young people who go away to further their education can return to take jobs within their own communities.

The school here accommodates about fifty children in the charge of two teaching Sisters of the Mercy Order. They gave us a lively account of local activities and policies and their pupils entertained us with happy confidence.

Geoffrey Dutton comments:

There are 280 people in the Aboriginal community at Lake Gregory. Richard Barton, who with his brown felt hat and dark glasses and longish hair did not look at all like a bush character, turned out to be a most admirable and interesting man. He had taken the trouble to come from Billiluna to meet us and he then took us on a boat trip down the flooded river between the trees and across to the island on which the cattle were stranded. The community had tried to keep them alive by ferrying hay across to them but the cost became prohibitive. The poor creatures had not got the message and as we approached they came running and stumbling and lowing down to the water's edge. Behind them near a dead beast was a lone dingo, also marooned, getting fatter every day.

The boat took us back to the community under tall coolabahs where hundreds of darters were nesting, the chicks wobbling in agitation in the shallow nests. The community houses are a mixture of new and traditional: a fine school, new houses, and rough gunyahs. A huge new electricity generating plant had just arrived.

Richard introduced us to some of the community leaders: Rex Johns the manager, son of the Council chairman — 'Can't read or write but a great bloke, no one can put anything over him'; and Jim Bieundurry, a member of the Aboriginal Treaty Council, tall in a purple shirt and with a red-and-yellow band around his curly-brimmed hat. Richard said 'He's very idealistic but not very practical.' Self-taught, he began his working life as a fourteen-year-old drover with Wally Dowling, on eight-month trips with cattle from Hall's Creek to Wiluna. He spoke in a beautiful voice about his disillusion with those whom he called 'manipulators'. The World Council of Churches had sent him to Geneva and London but he came back early in disgust. Now, as a sort of purging, he wanted to go and form a desert community about 200 kilometres north of Lake Gregory. But his wife, a dietician who lives at Mabel Creek, did not want to go and almost no one else wished to accompany him.

We talked for a while about Noonkanbah, where he had been much involved in opposition to mining company schemes. He said that they all now thought the Noonkanbah people had been much too hostile to the companies. They are now co-operating with the oil companies on 'Big explorations out in the desert'.

A number of cheerful women came to talk to us. They get 'plenty bush tucker' for the community, including a lot of fish, berries, nuts, and a plant like asparagus.

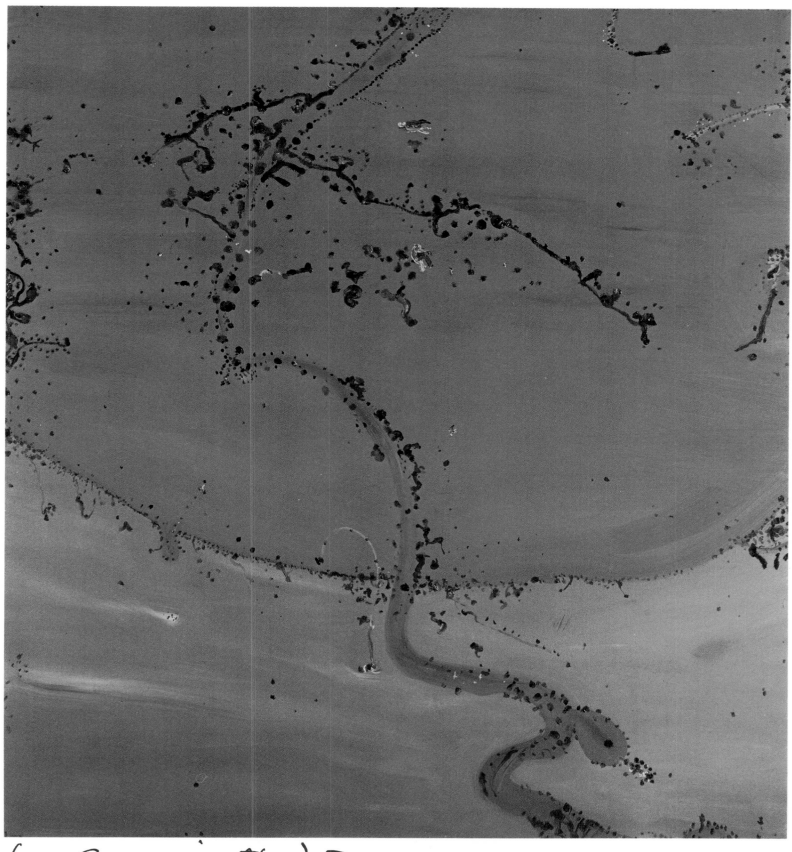

L. Gregory in flood. II

From Lake
Gregory the
travellers flew to
Balgo, of which
Mary Durack
writes:

This outpost station, some 288 kilometres south of Halls Creek, must be one of the most isolated in Australia. It is in the vicinity of what is probably the longest and loneliest stock route in the world, a 1420-kilometre track which Alfred Canning surveyed and equipped with wells between 1906 and 1910. It was planned as a less expensive method of taking Kimberley cattle to market than sending them by sea, but the savings were soon cancelled out by the loss in stock weight and human lives. Only the toughest drovers would undertake the journey and the route was seldom used.

The history of the Balgo settlement goes back to the 1930s, when Father E. A. Worms made contact with the people of the desert tribes during his anthropological studies. He learned the language and laws of the Gogadja, the biggest of the desert groups, and won the respect of their elders who accepted him as one of their own.

It grieved him to find that the establishment of government feeding depots and other amenities were attracting tribal groups into a meaningless existence on the outskirts of towns and settlements. The Pallottine Bishop, Otto Raible, agreed with him on the need for a staging-post on this transition into the white world, and with this in mind a property was leased not far from Halls Creek. Plans for its development as a self-supporting educational and medical centre did not work out. The lease was discontinued after a few years, but the concept was maintained. In 1939 the Bishop obtained the lease of some 445,000 hectares on the tableland adjacent to the Canning Stock Route and about seventeen kilometres south of the Great Salt Lake. This desert outpost would have been hard enough to sustain even without the problems of water shortage and of the obstructive anti-German prejudices which flared on the outbreak of war. Three sites were abandoned before a reliable artesian water supply was found, and the Balgo mission finally settled around good water in 1964.

By that time the desert people had come to regard the mission as a place of friendly contact and help in times of need. Most of them continued to drift between the mission and the bush, sometimes taking their wives and families with them and sometimes leaving the young people to attend school, but the community gradually stabilised. The settlement has now grown to the substantial proportions we saw on our visit, with administrative and living quarters, church, school, hospital, workshops and store.

Here, as elsewhere, the one-time mission is now administered by an Aboriginal Council, but life seems to proceed very much as before. The Aboriginal population fluctuates between 650 and 900 as groups 'go bush' from time to time for ceremonial or ritual gatherings. A number of men are trained and reliable stockmen, in control of a horsebreeding property and an out-camp cattle station, and help to support the community.

These activities are more or less traditional in the North-West Aboriginal communities but I was surprised to learn that the Balgo Council is now handling a very different type of enterprise. This is the Kingfisher Air Transport Service. With headquarters in Alice Springs and a fleet of four aircraft it undertakes charter contracts throughout the Kimberley district. Perhaps it goes without saying that this venture was conceived, and is unobtrusively guided, by people other than the official Councillors.

I was happy to encounter a number of old friends at Balgo, including the St John of God Sisters in charge of the pre-school and hospital, Father Hevern the Project Officer, and Father Anthony Peile who has been at Balgo since 1973. As always, Father Peile was engaged in a research project relating to the desert tribespeople. He had just completed a massive work of medical anthropology and ethno-physiology, involving an Aboriginal concept of anatomy and the medicinal qualities of local flora and fauna. He converses with the people in their own language and knows their country as well as they do.

Vin Serventy was
also acquainted
with Father
Anthony Peile,
whom he met
nearly twenty
years earlier at
Beagle Bay
Mission. He
writes:

In all his years in the North-West he has worked away patiently, grain by grain, collecting a vast store of knowledge about the wildlife and especially the plants. He calls his study ethno-botany.

During his study of Aboriginal languages he discovered a very wide knowledge of the local flora and he asked his teachers a series of questions about each plant: Where is it found? Is it eaten? If so, what part of it? Is it used as medicine? Or for making instruments of some kind? Does it have any other uses? Is it eaten by animals? Are they linked with it in any special way? Is it sacred? And so on.

He recorded many fascinating details. Women who wished to become pregnant wore necklaces strung from a particular type of seed. Young men just circumcised in the initiation ceremony wore a bunch of wattle leaves hanging from a hair belt around their waists. A University botany department examining this particular species of wattle discovered that its leaves have disinfectant properties, possibly valuable in preventing infections which are a problem to newly-circumcised initiates.

Aboriginal child learning to write I

White scientists have also attempted to discover the medical properties of our native flora. Max Bourke, one-time Director of the Australian Heritage Commission, as a young man travelled the country from west to east collecting all kinds of wild tomato, as part of a research programme which hoped to discover a species that would provide a contraceptive. The experiment failed, but one success in such fields of research could justify a thousand disappointments.

I asked Father Anthony how many words he now had in his Gogadja dictionary. He proudly replied 'Fifteen thousand, and the work is not yet finished.'

He is also interested in the medical procedures of the local Aborigines, but when I told him about some Sydney friends who believe we should use tribal doctors for white men's ailments he only laughed. He said 'They don't understand. All the people know of folk medicines, of the plants and animals which can be used for different kinds of sickness, although some women may have more knowledge than others. But a sick person only calls in an elder to cure sickness when the folk medicines have failed. Then he needs a man who can contact the Dreamtime spirits who caused the illness.'

Father Anthony told me about the five seasons of the desert Aborigines. The first is the beginning of the year, a green time when summer monsoon rains fill lakes and waterholes to the brim. Towards the close of this season the termites build their mounds more vigorously and such insects provide food for the people.

Then comes the cooler time, when native animals begin to burrow or shelter in hollow logs. The next season is the time of the gentle winter rains, with cool winds by day and cold ones at night. Plants grow, but only a few provide edible berries and seeding time is yet to come.

The fourth season is the time of abundance, when animals emerge from winter shelter, the bush plants bear fruit and the wattles exude sweet-tasting gum. This gum is dissolved in water to make a pleasant drink or added to bland foods as a sweetener.

In the last season of the year the hot winds blow from the east, although a breeze from the distant sea provides relief in the afternoon.

Ian Crawford wrote of people in his study area, further to the north, who could still boast 'I will never starve. The bush is my home.' They have seven seasons and all are easily recognised. The times are not fixed. If the rains are late or winter prolonged, there may be delays until the plants and animals respond. White men's clocks and calendars are not allowed to time Aboriginal lives.

The best season, the time Aborigines enjoy to the full, is when the south-east winds blow steadily and they burn the long grass to help their hunting. Kangaroos would later gather to eat the green pick that sprouts after the burning and would be easily killed. It is also the time for gathering root crops. We usually call them all 'yams' but Ian Crawford records forty-seven species of roots in the Aboriginal diet and suggests there could be more. The Aborigines collect at least forty-nine species of seeds and fruits. They use twenty-four species to make artefacts and eleven for medicines. Six species are used to stupefy fish in waterholes but do not harm those who eat the fish.

In the season the Aborigines call Yirma they hold many of their ceremonies. The months from September to November are hot and dry and food gathering is difficult, but then come the rains and fruits are plentiful. January–February is a miserable period, with heavy rains swamping the earth and causing rivers to flood. The inland Aborigines often used this time to visit the coastal groups, who still had abundant food especially from the sea.

March is a short season, when leaves fall from the trees but food is still scarce. During April some of the root crops develop to ease the hungry times of the Wet, and by the end of the

1. Gregory in flood III

month the gatherers can unearth more types of roots in a prelude to the 'beginning' of the year when good times come again. Each new season is heralded by signs such as the flowering of the feather flowers and the woolly butt, or the arrival of the bloodsucking marsh flies.

Around our campfires we often compared the lifestyles of the hunter-gatherer with those of agricultural man, and I told the story that Rolf Harris used in Alice Springs: 'Look. All of you are working hard all year, looking forward to those few weeks of holiday. You pack up and go somewhere to swim, lie in the sun, and fish.' A pause. 'The Aborigines do that *all* the time!'

Geoffrey Dutton writes of Balgo:

The Fathers are still there and there are teachers like Leo Lee, a crisp and committed man teaching in the local language. We were particularly impressed with the standard of the art class and the good quality of the Christmas cards they had been producing. With proper marketing they could bring Balgo quite a useful income. These paintings and drawings of the landscape, people, animals and birds were far more integrated with the children's lives than some of the dreadful works we saw at the Christian Brothers college in Broome. There they showed us proudly a selection of paintings on the theme of 'What Death Means to Me'. There were two paintings of white doves with their breasts transfixed by arrows, a couple of bodies being roasted in the flames of hell by devils with pitchforks, and one of bombs falling.

Yet it was at Balgo that the children were being taught, with lots of pictures, about the cathedral towns of France!

The old buildings at Balgo are ranged around a sort of vast quadrangle: a red expanse of original country in the midst of a temporary civilisation. The basketball courts looked quite incongruous. An old lady walked across the quadrangle carrying logs, one could not imagine from how far away, followed by ten dogs with a spindleshanked old crone limping beside them.

The Balgo Council does not allow alcohol in the community, but I remembered Sally in Broome telling us of a recent visit to the Halls Creek races. The 'Balgo Mob' had turned up and, not being used to the drink, had charged into it. In a fight over an educated part-Aboriginal girl, who objected to her arranged marriage with a fifty-year-old layabout, the Balgo men pulled the iron fence-droppers out of the ground between the Members' Stand and the paddock and used them as spears. An off-duty policeman tried to stop them and it was a miracle that no one was killed. The murder case reported in the *Kununurra Echo* also involved Balgo people.

It is undoubtedly a step forward for Aboriginal communities to ban alcohol, or restrict it to a beer ration, but it is obvious that with so much easy transport available the Aborigines can simply drive to the nearest pub.

The incident over the part-Aboriginal girl at Halls Creek makes me think of the doctor at Strelley, who spoke with much indignation of an educated girl from the Strelley Mob who ran away from an arranged marriage with an old man and married a young white man in Broome. The doctor said 'Disgusting — letting the whole community down.'

Australian feminists, who have accomplished so much for their white sisters, might well turn their attention to the problems of black women, in the same way that white Australians go to the bush to protest in favour of Aboriginal Land Rights. Don McLeod might say 'Ah, but that would be interfering with the Blackfellows' Law.' But are the educated Aboriginal and part-Aboriginal girls to be regarded as 'blackfellows'? It is fast becoming a crucial question among the many problems of the Aborigines.

Vin Serventy gives a happy ending to the story of the cattle marooned in Lake Gregory, and comments on the wildlife of the region:

Their Aboriginal owners had attempted to get them to safety by driving them into shallow water, then trying to persuade them to swim across the deeper channels, but they panicked and headed back to the low island on which they were marooned. An expensive attempt was made to carry feed out in small boats but it was too costly to be continued.

The animals on the island were a pathetic sight. They slowly kept pace with our boat, heads low, gaunt bodies showing the weeks of privation, individual animals moaning with hunger. One cow stood unmoving in the water under a sparsely foliaged tree, too weak to break free of the clinging mud.

Months later, we heard that the animals we had thought to be condemned to a slow death from starvation had managed to survive. Grass began to grow on the island and they lived on this until the waters receded.

The unusually heavy rains of that season were a bonanza for the wildlife. Water would have sunk deep into the ground and lain stored in a giant sponge of sand, ready to be tapped by searching tree roots.

The size of our desert trees astonishes people from overseas. When they see such giants they find it hard to believe that the annual rainfall averages only about 100 millimetres. But 'average' may mean that every ten years or so a great downpour floods the country and recharges the underground reservoirs.

Aboriginal child learning to write II

David Carnegie made detailed notes on the inland sea of Lake Gregory and pointed out that it is ten metres deep in the middle, and so able to hold a huge volume of water. Rain that falls 500 kilometres to the north-east flows along Sturt Creek and its tributary Wolf Creek to reach the lake.

We saw many waterbirds around the lake. Dozens of darters, also called needle-beaked shags or snake birds, were nesting. In some of the large nests of sticks we could see the necks of youngsters waving in a continual plea to their parents to fill them with fish.

Nearer the shore a colony of fairy martins had built their neat bottle-shaped mud nests on treetrunks just above water level. Pelicans, silver gulls, gull-billed terns, pink-eared ducks, night herons, coots, darters, and whiskered terns had all found this haven in the desert.

There was an interesting postscript to our Lake Gregory visit after we returned home. Early explorers commented that Sturt Creek and its tributaries disappeared into the sands of the Canning Basin, blocked by an impassable barrier of dunes to the south. A weather satellite photograph has now revealed evidence of a river, said to be 200 million years old, that once continued to the west across the Great Sandy Desert before reaching the sea on the Eighty Mile Beach but is now buried under the desert dunes. It was the blocking of this river that created Gregory's Salt Sea.

the pelicans flew awkwardly away.

Mary Durack adds a nostalgic reflection before the party leaves Kununurra to continue its journey inland:

I should be used by now to looking down from an aircraft onto those irrigated plains, that town between the river and Kelly's Knob, that waterway flowing so confidently at the wrong time of the year for northern rivers to flow.

But it is still quite unreal to me, as though I had come back from another life. It is hard for me to realise that the dome-shaped island in Lake Argyle is really the top of Mount Misery, named by an early survey party which had to camp hereabouts after one of its members broke a leg. The Aborigines called it Bilbilji, after the spirit leader of the locusts which by sheer force of numbers maintained prior rights to the mountain against a multitude of upstart kangaroos.

In years gone by we looked out on this landmark from Argyle homestead and even climbed it occasionally — half-way on horseback, the rest on foot — to enjoy the view and salute the peg left by those first suffering surveyors. Now, the only way to reach the summit of Mount Misery is to start your expedition in a boat.

The diamond-mining area skirting the southern edge of the lake is on what used to be Argyle's neighbouring station, Lissadell: another one-time Durack property. It comprises an impressive spread of buildings, with tracks winding away in all directions over ranges and plains as one would imagine those of the goldseekers of last century.

Aboriginal education

15 | FRUIT BATS AND BEER CANS

HALLS CREEK — FOSSIL DOWNS — GEIKIE GORGE

Mary Durack continues the story:

We drove 300 kilometres from Kununurra to Halls Creek, a town which was moved to its present site from the old one in 1948. It is today a thriving pastoral centre and such a convenient stopping-place for travellers that its hotels are usually booked out. Therefore we decided to camp for the night in a hospitable-looking riverbed, that no doubt accommodated many a gold-hungry prospector in days gone by.

Up with the sun, we drove around the town with its modern facilities and spreading suburbia before taking the thirteen-kilometre track winding through spinifex-studded ranges to the remnants of the original town. When I was here with my father in 1930 the ruins of the old mudbrick post office, the police station and hotel recalled for him the excitement and colourful personalities of the goldrush days. One of his most memorable experiences was an encounter with an urgent procession of travellers on horseback, in wagons, buggies, and spring-carts, and on foot pushing barrows or carrying their swags, on the lonely track between Argyle and the Cambridge Gulf. It was his first sight or knowledge of the goldrush to Halls Creek, which provided the newly-arrived pastoralists with an immediate market for their cattle. In July 1886, on his twenty-first birthday, he was paid £1200 in raw nuggets for a mob of bullocks delivered to the goldfields at £17 a head.

There is a plaque in the old town to the memory of one of the legendary goldrush characters, 'Russian Jack', who is said to have pushed a sick mate in a wheelbarrow along most of the track from Derby to Halls Creek.

The old graveyard is a sad reminder of young men who died of sickness or misadventure. Many were buried in unmarked graves and have long since been forgotten, but one of the stones in the old Halls Creek cemetery recalls the remarkable story of James Darcy. One of a well-known family of local stockmen, he was twenty-nine when he was thrown from his horse in 1917 and seriously injured. His mates took him to Halls Creek in the hope that the postmaster, H. W. Tuckett, who had some first aid training, would be able to help him. Tuckett found Darcy's injuries so serious that he telegraphed to Perth for advice from Dr J. J. Holland, who had instructed him in first aid. Holland replied that he must perform an immediate operation and relayed step-by-step instructions which the postmaster carried out with a sharpened penknife as scalpel. After a second operation, also performed under instructions from Holland, it seemed for a while that Darcy would recover from his injuries. The doctor came north by ship as soon as possible to follow up the case but the patient had died shortly before Holland reached Halls Creek. It was Holland's opinion that the operations had been successful and that Darcy's death had been caused by chronic 'fever', to which so many in the north succumbed in those days.

The Halls Creek incident received Australia-wide publicity, and John Flynn used it as an example of the need for speedy medical assistance for the outback. It helped him to promote the case for the Flying Doctor service which he founded eleven years later.

Next to Darcy's grave is that of his brother Charlie, who was for a number of years a head stockman and station manager for the Durack family company and was well known to all of us. Compared with many of his contemporaries he reached the mature age of fifty-two.

From John Olsen's notebook:

The Aborigines living in the town seemed to be besotted with alcohol. Bottles and cans strewn around on the dusty road, quite a different atmosphere from the missions.

Geoffrey Dutton comments:

There were some signs that all is not always well at Halls Creek, like the three-metre Cyclone fence with a padlocked gate, and outward-sloping barbed wire running along the top, around the fine new Civic Hall. As we approached the town we saw a group of Aboriginal women and girls drinking by a culvert, one of them already passed out in the sun. A utility pulled up and several men jumped out with reinforcements of flagons of port and sweet sherry and joined the women.

The neighbours of 'Young Bill' MacDonald scoffed when he planned a splendid new homestead for Fossil Downs Station in the late 1930s, but the homestead now stands as one of the finest in the North-West

In the evening we saw the opposite picture, one of bounding health and happiness, as long-legged barefoot teenage boys played splendidly dashing football on the lawn of the Memorial to Soldiers and Pioneers, using the flagpoles at each end as goalposts. In the morning young men and their wives wandered round the lawn while their children played on the seesaws and swings.

During the drive from Kununurra to Halls Creek I scored a fortuitous advantage over Vin, who had been anxious to spot one of the scarlet-backed wrens which live hereabouts. Ninette and I had stopped the car to wait for the others to catch up, and I wandered under the trees and in and around the spinifex, which is to be avoided when you are wearing sandals. Suddenly I looked up at a flash of brilliant red in a low tree. It was a scarlet-backed wren, and it waited patiently while I ran back to the car for my camera. I had taken a couple of photos of him when his wife hopped into the frame of the viewfinder and sat on the bough beside him for her picture to be taken too.

From John Olsen's notebook:

Arrived in the afternoon at this beautiful property [Fossil Downs]. Welcomed by the genial Maxine MacDonald. The road from Halls Creek was very dusty but Maxine understandingly had refreshing iced lemon cordial spotted with mint for us. Fossil Downs has elegance and style way and above any property we have seen in the Kimberley. The sheer effort of it — with everything difficult to get. Dinner in the garden, a birthday party for the Toyota dealer at Fitzroy Crossing.

I accidentally trod on a frog. It jumped up crying like a baby in protest — you have ruined my life! It then slumped, extended itself, and died.

One is struck by the tonal harmony of the landscape at this time of year. Soft ochre grass, warm green leaves, blue ochre sky. Corot would love it.

At Fossil Downs when the dotterels and seabirds came in they always closed the [wind] mill down for they knew bad weather was approaching.

Mary Durack describes Fossil Downs Station as 'another place of long association and fond memories'. She writes:

Fossil Downs was taken up by members of the MacDonald family who emigrated from Scotland to Goulburn in New South Wales, where they built up a selection and raised stock in the same district as my Durack forebears. The two families were acquainted from at least the 1850s.

Both of them became interested in the Kimberley district through Forrest's report of 1879, and started cattle on the long drive at much the same time. They met along the way and shared the same hardships but the MacDonalds' drive from Tuena, New South Wales, to the Fitzroy River was considerably the longer of the two. Probably it was the longest cattle drive ever undertaken in this country.

The MacDonalds with their McKenzie cousins took up Fossil Downs in the 1880s. They then went into partnership with Sidney Kidman, whom they bought out in 1931. Eventually a younger son of Donald, the last of the brothers, became the sole leaseholder of the vast and remote Kimberley property. He was William MacDonald, known as 'young Bill', who was brought up on a sheep station in New South Wales. He planned to study architecture but he bought a sombrero and a pair of cowboy breeches and came north to inspect his estate.

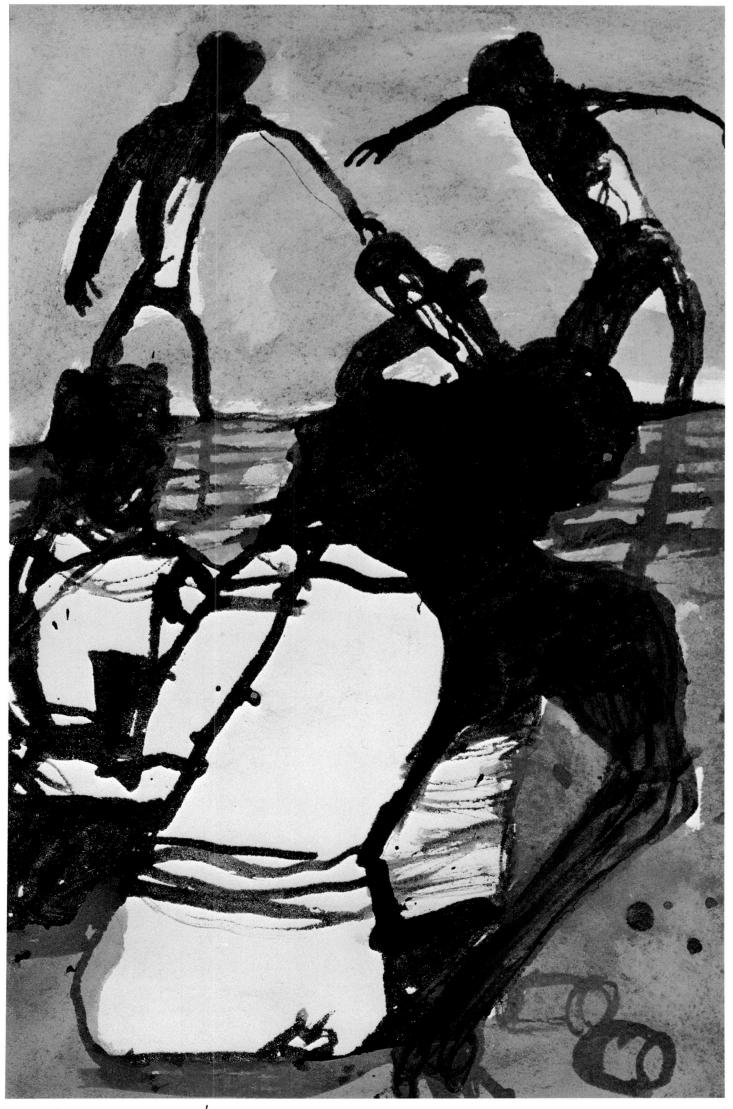

Drinking at Fitzroy Crossing

I remember my father remarking that he was a pleasant well-mannered young man but obviously not cut out for the Kimberley lifestyle. In later life Bill told me he found the old homestead derelict and termite-ridden, but that the bush people laughed when he talked of building a fine new home. Not only was it the depths of the Great Depression but such ideas were considered pretentious and unnecessary. Nevertheless he selected a site where unlimited water was available, pitched a tent in that vicinity, and went about getting to know his property and how to work it.

In 1938 he returned from a holiday in New South Wales with a glamorous bride, Maxine, and plans for a fine residence to be built from local materials. With a team of Aboriginal helpers they began to create a gracious and charming home, but building came to a standstill at the outbreak of war. Bill was appointed local organiser of the Voluntary Defence Corps and Maxine, who refused to be evacuated, took a commando course with the men.

At the end of 1945 they resumed work on construction with renewed enthusiasm. The final result would have been impressive anywhere but it seemed quite incredible in the makeshift Kimberley. French doors opened from wide verandahs onto a hall and staircase of polished bloodwood, a spacious lounge, dining-room and billiard-room. Every building around the homestead, in what amounted to a small village complex, bore the master touch, and before long the surrounding trees and gardens were flourishing.

Local conditions have undergone many changes since I first saw the new homestead in 1947, and a number of once familiar faces are no more to be seen. Bill is no longer with us, but the house he created is as welcoming and elegant as ever. We received a warm reception from Maxine, Annette the younger of her two daughters, her son-in-law John Henwood and members of their staff. The happy Aboriginal families of former days have more or less disappeared, as have those from other station properties, and most of the stockmen and other employees are white, but the traditional community spirit is still strong.

Next morning John Henwood took us to the site of the original homestead, where a commemorative plaque told us that it was here, on 3 June 1885, that the MacDonald brothers halted the first wagon to cross Australia from east to west. A wheel and shaft remaining from the wagon have been set up nearby.

The prime condition of quietly grazing cattle and horses was evidence of good pasture and efficient management. John told us that the property carried about 18 000 cattle and 200 Arab stud horses.

It was tragic to hear, some months after our visit to Fossil Downs, that a freak flood in the Fitzroy area had resulted in a loss of an estimated 12 000 of the station's cattle and 150 of its horses. Much fencing was destroyed and the house, furniture, and outbuildings were damaged.

On the afternoon of their visit to Fossil Downs the party explored Geikie Gorge, still on Fossil territory, cut by the Fitzroy River through an ancient limestone reef of the Oscar Ranges. Mary Durack comments:

The gorge attracts some 3000 tourists a month and has now been declared a National Park and Wildlife Sanctuary, a fact of which the creatures concerned seem well aware. As we cruised between the water-ravaged cliffs, some studded with the fossilised seashells from which Fossil Downs derived its name, we were calmly observed by cormorants, ospreys, egrets, pelicans, and snake-necked shags. Crocodiles glided quietly past and flocks of fruit bats (as I have now learned to name them) flapped lazily among the river trees. Their behaviour reflects considerably better on the white man's influence than does that of the fringe-dwelling Aborigines whom we encountered at Fitzroy Crossing later that afternoon.

Yellow tinted honeyeater.

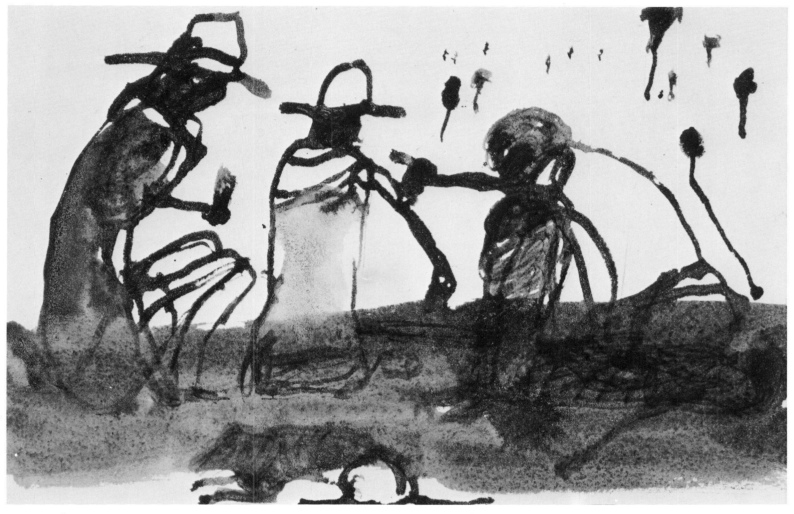

Having a good yarn — Fitzroy Crossing

**Vin Serventy gives
further details of
Geikie Gorge and
some background
on the wildlife of
the region:**

The mighty Fitzroy River drains a catchment area about the size of Victoria and cuts through
the Geikie and Oscar Ranges on its 1000-kilometre passage to the sea. Geikie Gorge, framed
in glittering white walls polished by the flood waters which pour through during the Wet,
is eight kilometres long. In the dry season the drop in water level reveals a wonderland of cliffs
and caverns hollowed out of the limestone walls.

The slowly-flowing water teems with waterlife, including barramundi, archer fish, sharks,
sawfish, and stingrays. The saltwater fish would have swum up the river during the Wet and
then become trapped in the depths of the gorge when the river dropped again.

Freshwater crocodiles lazed on the banks and occasionally dashed in high-gaited style for the
safety of the water when our boat came too close.

Crocodiles, like dingoes, have had a bad press. An adult male freshwater crocodile, two-and-
a-half metres long, looks a formidable creature but freshwater crocodiles have never been known
to attack humans. I have been bitten when handling a baby one though, and the needle-sharp
teeth can draw blood.

The number we saw in Geikie Gorge was a measure of the success of the strict protection
of crocodiles begun in Western Australia in 1970. When Carol and I explored the gorge in 1965
we saw no crocodiles but in 1982 we saw more than a dozen.

To watch one of them hurtling towards the water was a revelation of the speed a coldblooded
creature can reach in a headlong rush. Twenty kilometres an hour has been recorded and
highspeed cameras show that in this kind of dash all four feet sometimes leave the ground, with
the tail giving an extra push.

Crocodiles evolved as a group some 200 million years ago and three families of this ancient
class of reptile still flourish. The Kimberley has freshwater and estuarine or saltwater crocodiles,
and it is the latter that is the feared killer. Records indicate that some individuals may have
reached ten metres long but today a five-metre saltwater crocodile would be regarded as a giant.
The Aborigines have always treated saltwater crocodiles with respect. Baldwin Spencer, writing
during the last century, commented on their method of crossing crocodile-infested waters. The
party moved in single file and '. . . always put an old women in the rear, because, so they
believe, the crocodile always seizes upon the last person, and the loss of an old woman does
not matter much . . .'

Before our journey north I had dinner with Professor Harry Messel, that volcanic physicist
who has played an important part in wildlife conservation. I'll never forget Harry bellowing
at me that he would defeat any attempt to take his beloved animals off the official international
list of endangered species.

His fear for the future of Australian crocodiles was backed by many years of research. He
and Dr Andrew Burbidge published a report on the crocodile populations of the Prince Regent
and Ord river systems, in which only 581 crocodiles were seen including 143 hatchlings. The
report concluded 'The potential for the recovery of the Salt-Water Crocodile population in
Western Australia is not good and culling for the hide should not be allowed.'

Another survey masterminded by Harry revealed that the Northern Territory had a population
of 10 000 crocodiles, Queensland 3000 and the Kimberley 2500. These are not reassuring
numbers for the conservationist.

The lack of large mammals was obvious on our travels through the Kimberley. On my
previous visits I saw agile wallabies in huge numbers along the river flats and a late afternoon
drive would usually put up at least a hundred of them. Early mornings along the riverbanks
were enlivened by wallabies coming to drink and often engaging in friendly bouts of arm
wrestling.

John Henwood told us that the wallabies on Fossil Downs suddenly disappeared earlier in
the year. He had waged war for many years against the marsupials, regarded as a major pest
along the river flats because they compete with cattle for the grass, but some mysterious swing
of nature had achieved what all man's efforts had failed to do. John thought that a disease had
probably swept them away.

The Agriculture Protection Board treated this theory with caution. It said that the wallabies,
once very common along the Fitzroy, may have disappeared because of an epidemic disease but
that a build-up of dingoes could have caused the drop in numbers. The idea has some credibility,
because dingoes do appear to be controlling kangaroo and wallaby numbers in other parts of
Australia. But only a month later, at Kakadu in the Northern Territory, I saw hundreds of agile
wallabies surrounding the creeks of this national park. There were plenty of dingo tracks in the
area, and if there is a 'wallaby disease' it had not reached the Territory.

The bush still has plenty of mysteries and they are likely to occupy we naturalists for a long
time to come.

In the North-West I noticed that the attractive, even if destructive, feral donkeys were also
less common, and we rarely heard their outlandish braying at night. The Agriculture Protection

Pied
stilts

Board told me that donkeys are mainly controlled by shooting, from both ground vehicles and helicopters. The costs work out at about the same, with the extra cost of the choppers being balanced out by their greater effectiveness in flushing out the donkeys.

Geoffrey Dutton continues the story of the journey:

From the Paradiso of Fossil Downs we went to the Inferno of Fitzroy Crossing. The hotel is in an idyllic setting, under huge gum trees above the waters of the Fitzroy River and flanked on the river side by gardens and by plantings of flowering trees and baobabs, but all along the front of the hotel and under the trees across the road were thousands and thousands of beer cans and bottles. You could not walk without treading on them and some of the cans were in heaps a metre high.

Where we stopped, a drunken Aboriginal was hanging onto a tree while he pissed. Another sat in the dust and suddenly plonk spewed out of his mouth across his shirt and out to his trouser legs. Several women lay around like logs, passed out. Two men began to fight, sullenly, heavy thump on thump. A gallery of corellas screeched applause. A man lurched past with his arms full of beer cans, tripped on the root of a tree and fell clanging louder than the corellas. Men came to the car as we got out and patted us on the shoulders or shook hands, mumbling. One more aggressive young man asked for money. It was a relief to get inside the pub.

The publican, Sandy Sandford, is a gentle, quiet man, who seems bemused by what has descended on him. I asked him if he had many visitors to the attractive caravan park by the hotel. 'Plenty of visitors, but not many of them stay. You see them drive in with their vans, look around, do a Uie and drive away as fast as they can.'

He told us that drinkers throw about 16 000 cans a week onto the ground under the trees and in front of the pub. About 10 000 can be taken away in the truck but the rest just lie there.

One cynical man from Broome said to me later 'Fitzroy Crossing! Yeah, they keep it that way on purpose for the tourists. Where else can you see hell on earth?'

We went to an Aboriginal reserve near the bridge to see Bob Hawke's son Stephen, who was much involved with the Noonkanbah confrontation and is now the white adviser to the several Aboriginal communities in and around Fitzroy Crossing. We found him lying on a stretcher under an awning, by a caravan in a garden beyond the workshops. He was a handsome young man with a brown navel, in shorts and barefooted. I said we had mutual friends in Canberra who had suggested we should look him up, and asked whether we could have a few words. He said 'G'day. Now you've had a few words.'

A comely girl with a towel around her came out of the caravan and introduced herself. She was a schoolteacher, Leslie Corbett, and she was more friendly. She asked 'Would you like a cup of tea?'

Hawke said 'Yes, I suppose we can give you a cup of tea.'

Over a barbed-wire hedge of mistrust he continued 'You're in the party of four, Durack and Co., writing a book for the government, aren't you?'

I explained what we were doing. We were joined by a man from the Department of Aboriginal Affairs who seemed friendly enough with Hawke, but Hawke did not say much for a while. Leslie helped, but it was difficult to extract anything from him except a kind of ritual grunt of disgust at the words 'mining company' and 'missionary' and at the names of Chris Saunders and Ian Wilson. The latter was the then Federal Minister for Aboriginal Affairs.

Hawke was totally hostile to both the Federal and State governments and to the 'mishos'. As for the mining exploration parties: 'With any luck they won't find any oil.' But after he accepted another cup of tea and a biscuit from Leslie he suddenly began to string a few words together. He obviously cared genuinely for the plight of a number of groups of Aborigines, about forty or so, who were camped in degrading conditions on stations around Fitzroy Crossing. He said that the children hate being sent away to La Grange School and that the older ones are always running away from Derby Hostel. He thought there should be an Aboriginal school at Fitzroy Crossing.

He seemed to us to be a man luxuriating in the white man's guilt: both fortified by and fuelling Aboriginal hostility for the white man; dissociating himself from white activities with the same kind of apartheid mentality, if not the dignity and force and charisma, as Don McLeod's. 'Oil exploration? Mineral exploration? Hope they don't find anything!' What sort of help can such an attitude be to either black or white Australians?

The Department of Aboriginal Affairs man was easier to talk to but he didn't seem very well-informed. We did not feel much confidence in him when he thought that Nomad (the foundation which supports the Strelley Mob) was 'a Christian show'; and that, when we discussed the fact that everyone had been falling sick at one community until someone discovered that babies' nappies were washed in the drinking water tank, he did not know the meaning of *E. coli*.

Corroboree at Hookers Creek

Brolgas

After all that it was a violent physical, mental and visual shock to go a kilometre from Hawke's stretcher to the Nielsons' garage, house, and shop. He is the Toyota agent and I have never seen such an immaculate workshop. There was a shop alongside, obviously flourishing, full of Aborigines. The stores are in the sheds where the Nielsons lived before they built their very comfortable two-storey house. They created all this in five years after setting up at Fitzroy Crossing.

The Nielsons were immigrants from Denmark and on their first stay in Australia he was a mechanic at Gogo Station. They returned to Denmark, intending to settle down, but they were totally disillusioned by the welfare state conditions. They lost a lot of money over a house they intended to buy because they had to pay tax even though they did not close the sale. They returned to Australia and success at Fitzroy Crossing.

Neat, athletic, friendly, wiry with energy, they had achieved all their success when Australia was supposed to be in an economic slump. But how can one bridge the gap between such people with their love of white Australia and Stephen Hawke's hostility; between their spotless premises and the vomit and urine, blood and beer cans of the Fitzroy Crossing hotel less than a kilometre away? And is racism not a two-edged weapon?

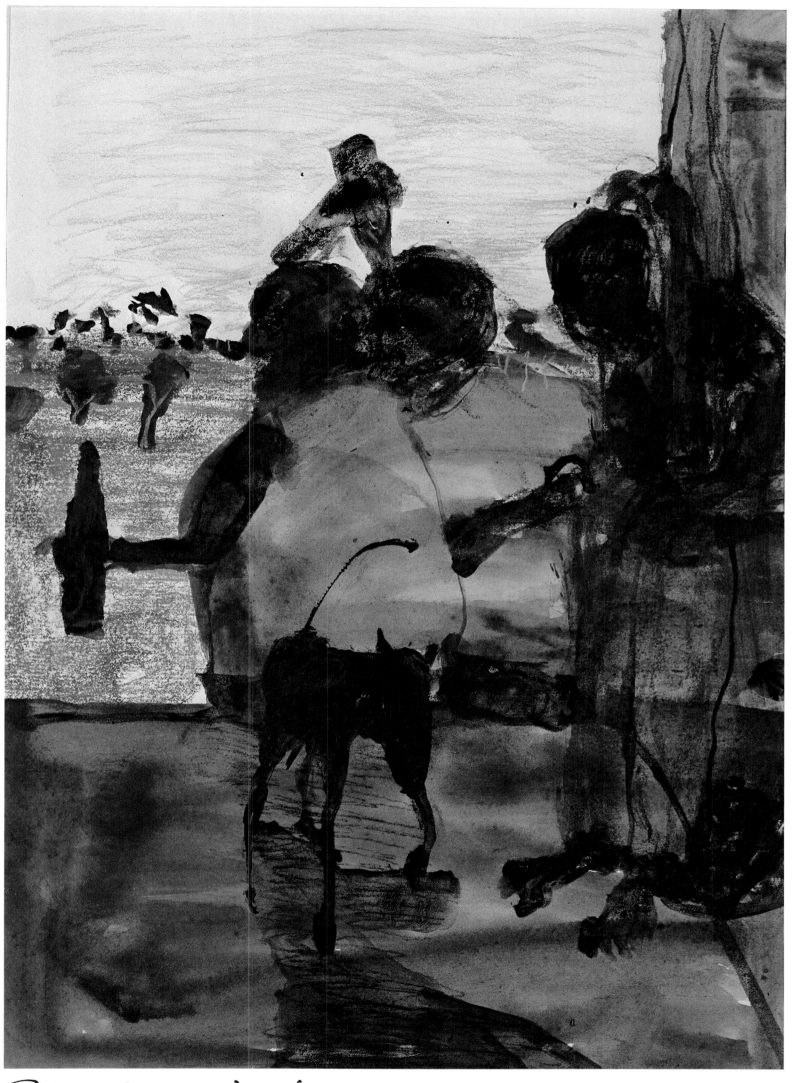

Aboriginals drinking Fitzroy Crossing

16 | SOUTH THROUGH CAMBALLIN

CAMBALLIN — LOOMA ABORIGINAL COMMUNITY — LIVERINGA — BROOME — HOOKER CREEK — CYGNET BAY — ONE ARM POINT — PORT HEDLAND — CARNARVON — GERALDTON

After the visit to Fitzroy Crossing the party drove back to Broome, which would be their base for another trip into the north. On their way to Broome they passed through the deserted settlement of Camballin. Mary Durack writes:

This strange modern ghost town raised many questions in the minds of the other members of the party. Where were the inhabitants of these deserted houses? Who was to use these facilities of a well-planned township — shopping centre, post office, school, sports grounds? What was the purpose of those rows of unused tractors, all that silent machinery?

In one house, a rotating fan gives evidence of occupation. It is an imposing residence with impressive arches and colonnades; looking even more improbable in the Kimberley setting than does the MacDonald homestead at Fossil Downs. No one answered our knock or told us to keep out when we entered through the unlocked doors, but I could claim at least a proprietary interest. The house is the 'Parthenon' built by my brother Kim, and its story, like that of the Camballin settlement, is as fantastic as those of so many places we have visited in recent weeks.

After Kim (Kimberley) Durack warned the people of the Ord River region that they were trying to do too much too quickly he sought ways of pursuing his own developmental ideas. During these investigations he became associated with another enthusiast, Mervyn E. Farley (usually known as Peter) who had big ricegrowing interests and considerable commercial and political influence in New South Wales and Victoria. Farley's search for new ricegrowing areas, and Kim's for new methods of crop growing, led to their founding a company called Northern Developments Pty Ltd in 1950.

Kim, with authority to establish an experimental ricegrowing project, negotiated with the owners of Liveringa Station for the use of a ninety-hectare paddock known as Camballin, on a tributary of the Fitzroy River. The manager and part-owner of Liveringa was Kimberley Rose, a son of another pioneering family. The two Kims had known each other since childhood and so the arrangement, with the help of the Public Works Department, was a happy one for all concerned.

I was a fairly frequent visitor to Liveringa and Camballin in the 1950s and I remember it as a time of co-operation and comradeship. Kim's enthusiasm was infectious and his helpers worked as hard as he did on building fences, levees, and a bridge, installing pumps, levelling the land, sowing and harvesting the crops. In the same period, with the help of a Spanish stonemason, he began to build his 'Parthenon'.

All the difficulties of the ricegrowing project were the subject of lively conversation and no one doubted they would be overcome, although Kim warned that the experimental stage might be longer than some members of Northern Developments anticipated. He said that it was possible to irrigate the ninety hectares of Camballin and control the ravages of native fauna but the situation could be very different on a larger area.

But by 1957, when small quantities of Camballin rice were already being sold in Broome and Derby, Farley and his south-eastern ricegrowing associates thought the time was ripe for more extensive production. Negotiations with the State government and the Liveringa Station partners resulted in Northern Developments' acquisition of the rights to 8000 hectares for rotational cropping of some 2000 hectares a year.

Kim was not in favour of this large-scale venture before a number of questions had been resolved. He saw one of them as the need to experiment with a wider range of rice varieties; another as the solution to the problem of too much or too little water in different seasons. Soon, as on the Ord River, he was seen as being 'obstructionist'.

The other company members outvoted him and so he went along reluctantly with their ambitious plans. But in 1958, when they refused to retrench after floodwaters had destroyed a new twenty-seven-kilometre dam, and the bulk of the following year's crop died from a shortage of water, he resigned from the company. He hoped that he might find government support that would enable him to continue elsewhere at his own pace.

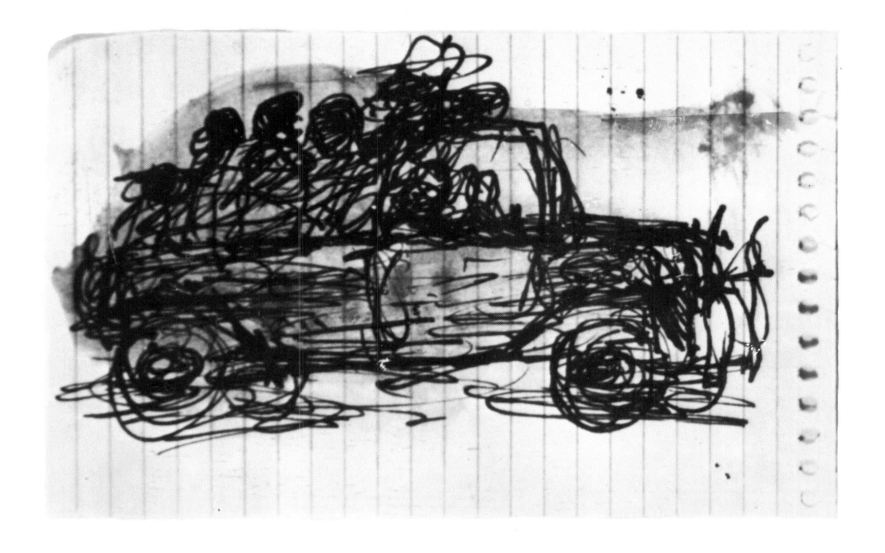

Desert vehicle

He left with a warning that no one was likely to make millions out of Kimberley ricegrowing without a much deeper understanding of the nature of the country and control of its water supply. He had investigated and mapped its river systems and indicated the alternative sites for a dam or dams, including one to harness the most powerful and unpredictable of all, the Fitzroy. He hoped to convince the Federal government of the need to establish what he termed a Rivers Authority, to gain a proper understanding of the major river systems of northern Australia.

As it happened he was never to return to the land with which he was so closely identified. The projects which absorbed him until he died in Canberra in 1968, at the age of fifty-one, are not for this chronicle. The Camballin ricegrowing enterprise that he began with such typically cautious enthusiasm was continued for the next eight years against the ravages of birds, insects and kangaroos, drought and flood, market problems and poor quality crops.

But much had been achieved in co-operation with the State government, including an innovative barrage system to control the Fitzroy at high and low water. This is still operating efficiently, if not adequately, for even more ambitious farming schemes. The government also co-operated in building Camballin township of which the 'Parthenon' and its outbuildings are a part.

Northern Developments Pty Ltd was by that time experimenting with irrigated crops for stock fodder, and soon found that lambing percentages could be substantially improved by pasturing ewes on irrigated fodder crops. The company saw such potential in this procedure that they made a successful bid for Liveringa Station. They continued to grow fodder crops but ricegrowing had faded away and funds were running low.

In 1965 Jack Fletcher, a Texas agricultural consultant of wide experience and reputation, visited Australia and was greatly impressed with the potential of the West Kimberley area. He found that Liveringa alone was a fine pastoral property, and that Northern Developments' resources included the township of Camballin and the availability of about 8000 hectares of freehold land with irrigation facilities.

He opened long negotiations with the State government and Northern Developments, which concluded with his formation of the Australian Land and Cattle Co. Ltd. Financed by American capital, and with headquarters at Camballin, this was the most ambitious agricultural venture ever undertaken in Western Australia or possibly in any other State.

Fletcher's opulent syndicate purchased not only Liveringa but also six other West Kimberley properties including Kimberley, Napier, Louisa, and Bohemia Downs — some two million hectares in all. They began to employ stock improvement techniques used in the United States and anticipated an annual turn-off of over 12 000 prime cattle, the product of upgraded herds raised on open country and fattened for market on enclosed feed lots.

They put a great deal of long-range planning into their project and even contemplated the construction of a dam in the King Leopold Ranges as a sure source of supplementary water. They expected the great quantities of irrigated feed to grow cattle for the Australian market and for the increasing demand in Japan and South-East Asia.

Adverse publicity about 'selling the farm', otherwise much of outback Australia, to United States interests was cheerfully shrugged off. Sorghum planted in 1969 showed encouraging results and a new future not only for the ALCCO properties but for the whole of the Kimberley district seemed virtually assured.

All these euphoric dreams faltered in 1970, when the Wall Street stock market collapsed and ALCCO supporters withdrew an agreed $18 million which would have put the company firmly on its feet. But this setback did not halt company operations or prevent it from buying shares in the Derby and Broome meatworks, where the cattle were processed for export as boneless beef. It had meanwhile decided that sheep breeding, hitherto the mainstay of many West Kimberley stations, was incompatible with cattle raising and phased it out of company planning.

In 1973, just when all seemed plain sailing at long last, the price of export beef dropped by forty per cent and stayed down for the next five years. As in the 1930s depression, cattle were scarcely worth the cost of mustering and transporting to market and ALCCO made a loss of $18 million.

Fletcher, determined to hold on at all costs, embarked on an imaginative promotion campaign which at last resulted in a major US insurance company, Aetna, backing ALCCO to the extent of some $30 million. This injection of new finance gave fresh impetus to the cattle company and by mid-1980 Camballin was the home of 170 vigorous workers and their families and abuzz with new life.

The State government was so impressed that it agreed to build a mammoth covered silo for the storage of up to 16 000 tonnes of sorghum, together with substantial improvements to shipping facilities at Broome. Before long the inhabitants of this port were gazing in wonderment at the unloading of Caterpillar tractors, trucks, road graders, levellers, and other machinery of every shape and size all destined for Camballin.

Pelican & abandoned Camballin

JO.

I met Jack Fletcher at about that time and I was so impressed by his courage, determination, and sustained optimism that I found it hard to imagine, from what he had to say, that anything could go wrong. But who could have foreseen a year's delay in planting 15 000 hectares of grain crops because a shipload of fertiliser was destroyed by fire on its way from Texas? By the time another cargo arrived the company funds were exhausted and Aetna refused to invest further capital. They put the Camballin farming area into receivership on a care and maintenance basis, which explains the state of affairs we encountered on our arrival there.

Apparently the situation between the interests involved is anything but peaceable and it has even reached the stage referred to as a 'range war'. There is a court case pending between the Aetna receivers, who claim the right to confiscate cattle from Camballin and Liveringa feeding plots, and ALCCO. The latter still holds the rights to the properties purchased in 1969 and hopes to raise Saudi Arabian money to finance a new start.

We heard much talk on our travels of where and why the scheme went wrong. Some blamed the impracticable scale of ALCCO activities and the assumption that United States capital and know-how could solve environmental problems which frustrated ignorant Australians. Others criticised ALCCO's refusal to ask or take advice from those with long experience of the Kimberley, while some pointed out, rightly enough, that the project was plagued by sheer bad luck.

Standing in the shade of Kim's 'Parthenon' I seemed to hear his voice echoing down the years, in the words he used for a brochure entitled *A New Deal for Kimberley* published in 1947. He said 'Though in no way poorly endowed with resources Kimberley has, ever since its pioneering days, presented a perplexing problem. We have spoken so long and so loudly about developing our North that the subject bids fair to be seen as an enigma, defying solution. I take heart, however, from a deep conviction based on considerable study and experience, that this land will one day be a powerful productive source . . . At the present time, however, we must realise not only its still untapped potential but its contemporary limitations. We must understand more about the nature of the environment and fluctuating world markets before embarking on large scale projects that may encounter problems we have not reckoned on. The big rivers are the country's life force but will co-operate with man's ambitions only when we learn how they are to be sensibly and adequately controlled . . .'

Those words, written more than thirty years ago, are still very true today.

I felt some sadness as we drove away from Camballin and through Liveringa Station on our way to the Aboriginal village at Looma. I could hardly recognise Liveringa as the place where I have enjoyed the hospitality of the Rose family, who did so much for the development of West Kimberley. A property of 450 000 hectares, taken up in 1881, it was by 1903 running more than 100 000 sheep and some 5800 cattle, a total unsurpassed anywhere in the State before or since. From that time onwards the stock numbers fluctuated according to the markets, the seasons, and the behaviour of the Fitzroy, but Liveringa was always regarded as a 'show place' of the Kimberley and noted for its well-maintained improvements and fine homestead. When we passed through it was obvious that 'receivership' allowed only the most basic upkeep and it was certainly not the lively happy place that I recall.

The Aboriginal stockmen, garden and household helpers, children and old people were all very much at home on Liveringa but there is no sign of them now. I wondered how they had fared under changes which affected their lives as much as the coming of the white men had affected those of their forebears, and hoped to find some answers at Looma.

This Aboriginal community, now the centre for about 350 people, is the outcome of changing policies that began with the introduction of limited cash payment to Aboriginal station workers after the Second World War. Until then they had been paid in kind and kept, together with their extended families, in the basic necessities of life. It was a happy enough mutual arrangement although it would have been difficult to justify the maintenance of a system which looked from the outside somewhat like that of slave labour in the southern States of the USA — with the difference that Aborigines were free to leave the stations whenever they pleased.

In 1968, after the Federal government had ordained that all station employees must receive full award wages, the old pattern of interdependence began to break down. Station owners soon found they could no longer feed and clothe not only necessary helpers but also the extended families, among whom they divided as many minor jobs as possible.

Consequently the once stable and protected communities began to fragment and to drift to camps or reserves on the outskirts of bush towns. A few found jobs but the majority, in receipt of welfare cheques and with nothing better to occupy their time, took to gambling and drinking, These habits led to fighting, of which there had been little in the station environment.

Some blamed this on the granting of Aboriginal drinking rights but this concession had been more or less unavoidable, because increasing numbers of Aborigines claimed the right to drink by reason of their white descent.

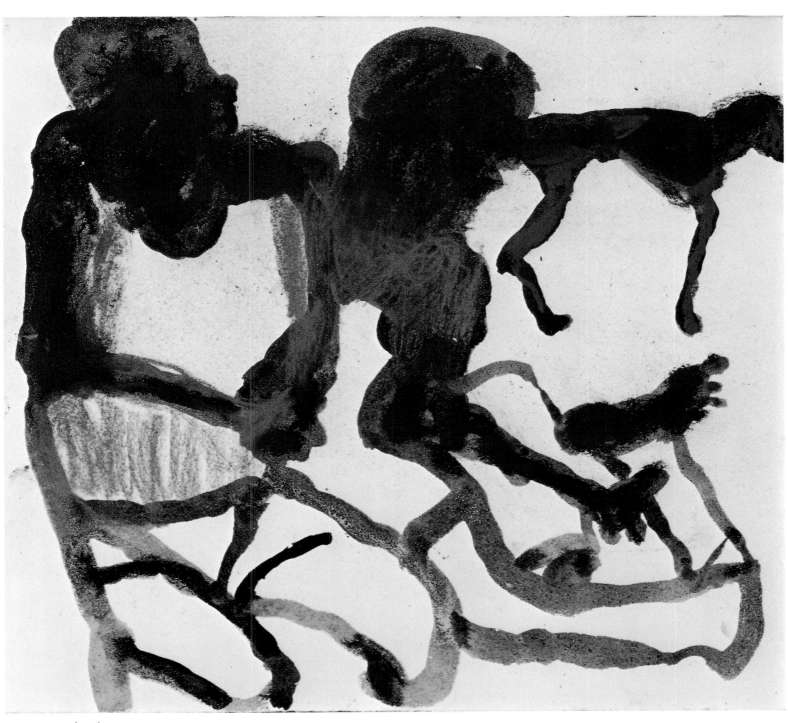

Aboriginal Camp I

The granting of voting rights in 1962, and drinking rights in 1971, decided most of those who had denied their black heritage to become 'reborn' Aborigines, thus creating as dramatic an increase in their population as had the payment of child endowments in 1954.

Many of the problems caused by the breakdown of the station communities might have been avoided if the change had been less precipitate, and the people better prepared for the handling of money and the maintenance of property. As I wrote in 1969 in my book *The Rock and the Sand*, 'Post-war Australian policy, in a precipitate effort to prove its social conscience to the world, had so far done little more for the natives of the north than to deprive them of the few important things that they had clung to in their subjection. They had acquired a sense of importance without incentive or self-respect, freedom with nowhere to go, a living without a way of life.'

Looma, like the other Aboriginal communities, was established in 1972 in accordance with the well-meaning Labor government's ambition of encouraging the Aboriginal people to plan for the future and take responsibility for their own affairs. The hope was that Aboriginal Councils with authority to make decisions might restore to the people the initiative and independence of their tribal past although in a modern setting.

The site of Looma, 7800 hectares excised from Liveringa Station between the Grant Range and the Fitzroy River, was chosen as being a sacred area of the Nygina tribe which those of other groups were welcome to share. The people began to move onto Looma in 1973, and before long a village complex built mainly by Aboriginal labour, with the help of Commonwealth finance and advisers from State Housing and the Department of Aboriginal Affairs, began to take shape. It included living quarters, a school, a general store, and a storehouse for sacred tribal emblems. For some time a few white helpers lived in the village but there are no whites in residence today. The teachers and health advisers commute from outside Looma and the Project Manager and Councillors are all Aborigines.

On our brief visit it was impossible to sum up the success or otherwise of this community, but some of the intelligent and friendly group who welcomed us gave an idea of its complexities. Killer Narga, the genial 'Boss', was formerly a leading stationhand on Liveringa, where he had known the Rose family like his own. His name is said to have been jokingly derived from his having entered the whiteman's world as a small boy, with a group of desert people who had been arrested for cattle spearing. Left with relatives at Noonkanbah Station, he went bush for his tribal initiation and thereafter worked on Liveringa and raised a family.

Killer had no schooling other than in the stock camps and in his tribal culture, but at some stage he came under Christian influence and, like many of his mission-reared countrymen, he sees no contradictions between the Christian precepts of brotherly love and the tribal ethics of his ancestors. His son Gerard had the opportunity of European-style education and he is Looma's Project Officer and Community Manager.

We gathered that opinions voiced by members of the Council often differed as radically as those of our own politicians. It is interesting to speculate on how many parties the Aborigines and the different categories of part-Aboriginals would divide themselves into if they had control of this country today.

When Looma was established it had seemed obvious to Killer that the real power and final decision-making over the Aborigines, once wielded by the white station people and white authorities in the North-West, had simply been transferred to Canberra. It did not lie with the Aborigines themselves as the Federal government wished them to believe. As Killer saw it, the role of the Aboriginal Councillors was to establish a satisfactory reciprocal relationship with the new regime, as they had done with the station bosses, police, and missionaries of former days. He believed that if they did not, then the government could close down their activities at Looma just as the pastoralists had done when Aboriginal labour was found to be uneconomical.

Killer had held that when the village was completed, and no more wages were coming in from State Housing for the Aborigines working on the project, then they would have to prove themselves by raising stock and growing vegetables. But more sophisticated Councillors had a clearer notion of the situation. They said that times had changed: that the Aborigines were no longer seen as a dying race but as an increasing section of the population with the added significance of voting power. Therefore the government must continue to support them whether they worked or not. In any case Looma consists for the most part of flood plains and rocky outcrops and has little economic potential.

Most of the Looma Councillors seemed confident enough that the government will continue to support them, and they see their own responsibilities as those of controlling the human problems and general behaviour of the community and of preserving their Aboriginal identity.

This discussion led us into talking about the aims, objects, and activities of the Aboriginal Cultural Foundation of which they are members. We were soon to catch up with some of the ACF activities at a multi-tribal festival at Hooker Creek.

Aboriginal camp II

Another of the Looma people with whom I shared associations was Nipper Tapadgee, formerly a stockman on Lissadell Station. We exchanged news and memories of mutual friends both black and white, including 'Galloping Paddy' MacNamara who was manager of Lissadell for many years and one of the great characters of the country. He corresponded with me until the time of his death some years ago.

But time was passing and we had to press on, with many of our questions still unanswered about the present and future of the Looma community.

Back in Broome, the party had another opportunity to discuss the Aboriginal situation. Geoffrey Dutton writes:

We talked uninhibitedly with some of the 'bloody mishos': Bishop Jobst, Father Chris Saunders, and Father Michael McMahon. Bishop Jobst was quite open about Father Sanz 'missing the boat' in 1975, when the Minister for Aboriginal Affairs called a meeting to discuss methods of setting up Aboriginal Councils. Father Sanz categorically refused to consider such an eventuality. Kalumburu is now officially run by three directors: John Moraltadji; a representative of the Department of Aboriginal Affairs; and a representative of the Aboriginal Lands Trust. Jobst said flatly 'The Aborigines won't work for love or money.'

Chris Saunders and the radical Father Michael were very frank over lunch. Chris, then a law student at Sydney University, took part in the anti-Vietnam War Moratorium, when Jim Cairns was his hero. Later he became disillusioned with politicians and he once preached a sermon that nothing could be changed through politics, only through prayer.

He was enlightening about election day at Lombadina. He said 'I put the whole show in motion, cast the first vote, and then went fishing for the day so that no one could say I was influencing the vote.' Later he learned that shortly after he left, two Aborigines arrived with 'white advisers' in the background. They mustered the Aborigines and told them how to vote, but ten per cent still voted Liberal and Saunders was later accused of manipulating them.

He was very humble about his future at Kalumburu, not being sure about the situation there or what he could do to influence it. He was emphatic about the linked chain of communications and tactics among the white advisers, especially in the Aboriginal Legal Services and Health: a chain which stretches from the Valley in Brisbane through Redfern in Sydney right around to Perth. He said he had advertised widely for an Aboriginal bookkeeper at Lombadina, at a salary of $17 000 per annum plus house, but had not received a single application although he knew of several well-qualified Aborigines who would be suitable. The implication is that the white advisers do not want anyone to help a 'misho' who may influence an Aboriginal community.

Father Michael was concerned about the lack of job opportunities for Aborigines in Broome, and we asked him why we never saw Aboriginal girls working in the hotels and motels. He said 'Partly because they don't like such jobs, and partly because married white women of around thirty-five to forty get the jobs because their husbands know the proprietors.' He laughed ironically. 'It's the Australian way of life, you see. It demands two incomes.'

He was indignant because there were moves to ease the Aborigines off their reserve between the Mangrove and Roebuck Hotels, which is of course a million-dollar piece of real estate. The conditions on the reserve are disgusting and all the people are jobless, whereas on the other reserve, near the cemetery, the men are all working and the houses are of good quality and well kept. It sounded like yet another vicious circle.

From Broome the travellers flew to Hooker Creek, otherwise Lagamanu, in the semi-desert country of the Northern Territory about 640 kilometres south of Darwin, to attend a dance festival organised by the Aboriginal Cultural Foundation. Mary Durack writes:

The idea for the Aboriginal Cultural Foundation received initial encouragement and financial assistance from the Australian Council for the Arts, of which Dr H. C. ('Nugget') Coombs was then chairman. Dr Coombs was deeply concerned by what he saw as the loss of Aboriginal identity, and he discussed the problem with me in 1969 shortly after Albert Barunga, a leader of the Mowanjum community, had expressed himself in much the same way. Albert had recently returned from New Zealand where he had accompanied a study group as representative of his people. He had been deeply impressed by the way in which the Maoris had maintained their cultural heritage. It had grieved him for some time that the young people of his own race appeared destined to lose their Aboriginal identity and to become 'nothing people', lost in a twilight world of neither black nor white.

Naturally Albert was delighted to hear of Dr Coombs' interest and he became an early and active member of the steering committee of the ACF when it began operations from Darwin in 1970.

With Lance Bennett as executive officer, Barbara Spencer as secretary, and Stefan Haag, who for many years was Director of the Elizabethan Theatre Trust, on the steering committee, the ACF soon began to make its mark. Tribal groups from the north performed in Australian cities and they featured prominently in the first entertainments staged in the Sydney Opera House.

The last dance festival I attended was at Groote Eylandt, off the eastern coast of Arnhem Land, where over 500 people of many different tribes performed in traditional style and regalia

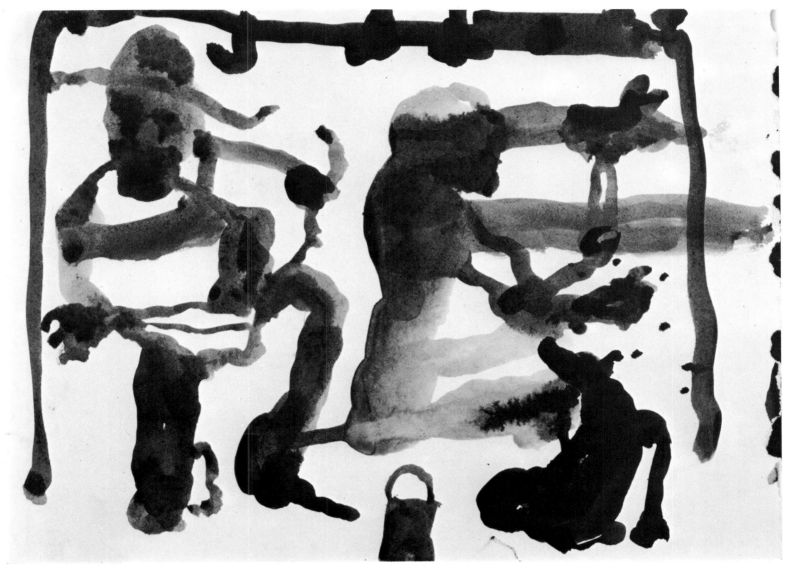

Aboriginal camp. III

and with tireless enthusiasm for the better part of a week. This was at about the time of the confrontation at Noonkanbah Station between mining companies and Aborigines and their white supporters, who felt that sacred sites had not been satisfactorily defined before drilling began. On Groote Eylandt I found the rapport and co-operation between the tribal people and representatives of the BHP, which had contributed generously to the festival, to be a heartening experience.

For the past few years the ACF has been directed by a completely Aboriginal committee, with the experienced assistance of Lance Bennett and Barbara Spencer who met us at Hooker Creek. This place is not a mining site and finance had not been so easy to arrange as for the Groote Eylandt festival. However about the same number of people had arrived and there was an atmosphere of happy expectation and harmony.

Instructions and items of information vibrated over four microphones. The Foundation chairman, Groote Islander Nandjiwarri Amagula M.B.E., who starred in the film *The Last Wave*, was being amplified in English, the common tongue; in his native language; and in that of south-east Arnhem Land. The vice-chairman, Maurice Luther, leader of the Hooker Creek community, was also speaking English as well as his own Walpiri, the language of the largest and culturally most vigorous of the inland tribes. Two other speakers interpreted the proceedings for people from further afield. One announcement in English was to the effect that anyone bringing in grog, resurrecting tribal arguments or making trouble of any kind would find himself kicked out 'harse over 'ead'. No one showed any inclination to disregard this warning as camps were set up and fires lit around the corroboree ground.

Before long each tribal group was painted and arrayed in traditional style. There was a clicking of sticks, a throbbing of didgeriedoos, a rhythmic drone of voices and the show was away.

Between dances I moved around to meet old friends and catch up with the latest developments. Some served on the all-Aboriginal committee of a Benefits Trust, set up to administer mining royalties for the best advantage of their people. They have recently voted that money should be spent on video equipment to record current happenings in dance, song, and ceremony that can be exchanged between the different communities. This move is seen as particularly important, because Aborigines in isolated communities will be able to watch television after 'that there satellite goes up' and this new influence may out-rival the reawakened interest in their own culture.

I talked with Nandjiwarri, Maurice and others about the seemingly improbable outcome of the Groote Eylandt festival. The interest of a visiting American led to an invitation for the ACF to send dancers to the United States, and the twenty-eight members who set off with Lance and Barbara to participate in this adventure created an enormous impact. Enthusiastic audiences saw that they were not portraying a revived or imagined version of an ancient culture but a genuine version of the 'real thing', that had mysteriously survived the passage of time. Equally impressive was the aplomb with which the representatives of a supposedly 'primitive' people conducted themselves and even handled the press in the modern world.

After performing in Los Angeles, Washington, Philadelphia, New York and San Francisco they were urged to go on, but homesickness had got the better of novelty and they were ready to return.

However the rave reviews continued to travel, resulting in an invitation for the ACF to send dancers and artists to the Museum of Modern Art in Paris in 1983. The directors of the ACF would like to demonstrate that their culture is not exclusive to adult males and they were planning to include women and children in this adventure.

When I heard all this exciting news I remembered Albert Barunga, whose passing was a sad loss although his spirit was surely close at hand. I said 'You hear all that, Albert? The children are not growing up to be ''nothing people'' after all. And they have you, as much as anyone, to thank for that.'

From John Olsen's notebook: The 'Grand' Corroboree had taken a lot of organising. Groups came from as far distant as north Queensland (Aurukun), Groote Eylandt, Western Australia (Mowanjum), and the Lajamann desert people of the Northern Territory.

It was a conspicuous affair with a large Aboriginal audience, all sitting squat on the ground as Aborigines do. The dancers had all decorated their bodies according to their tribal tradition. It was spectacular in mood and fantasy. All [the dances] were different, mostly based on animals and the hunt (none were considered to be sacred). Rhythmic and spirited stamping movements raised clouds of dust which added to the atmosphere. It surprised me how short some of the dances were, which had only a duration of a couple of minutes. Some of the Aborigines were outstanding in their group, having a superior style of gesticulation and mime and in some cases not without humour.

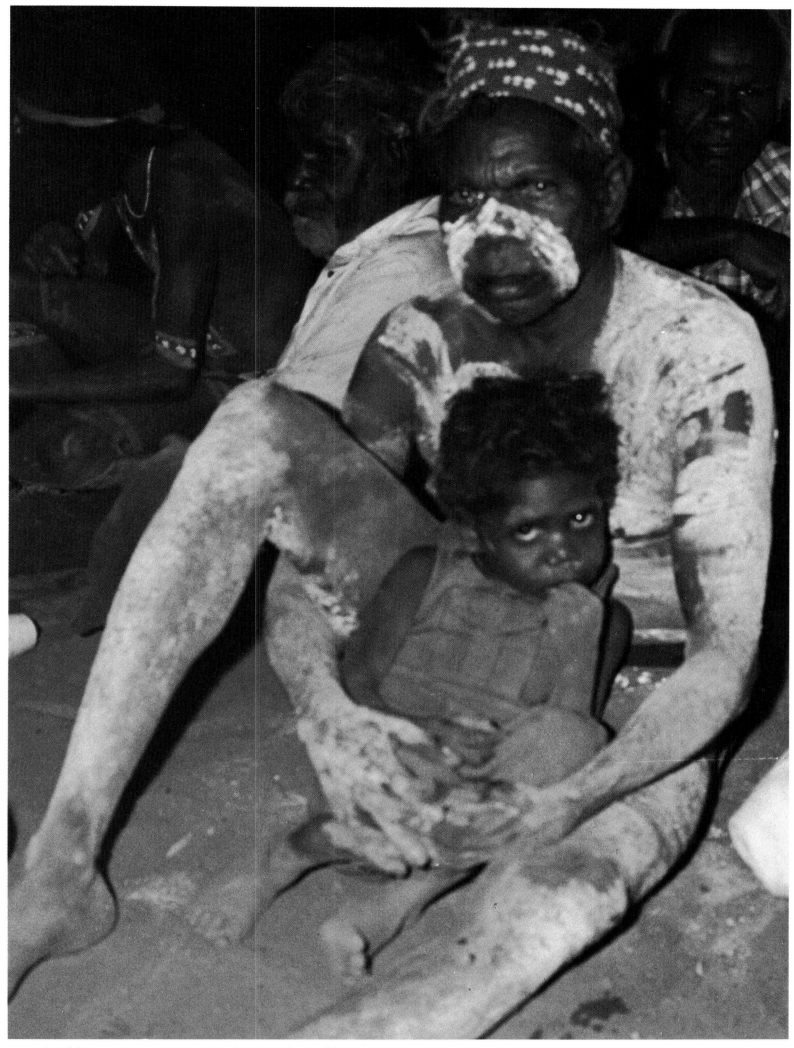

A member of the younger generation, once thought to be in danger of forgetting the ceremonial life of the Aboriginals, is given the opportunity to absorb all the colour and movement of traditional dances in the same way as his forefathers

What do the Aborigines think of this? I think Gawinin Gumana expressed it succinctly when he said 'Culture to me is my foundation — my feet, my flesh. If I had no culture that would mean I am nothing. When I say "culture" I mean my ceremony, my language, my colour.'

ABORIGINAL DANCE, HOOKER CREEK

Dust, red dust, we are a continent of dust
And not until we learn to live with dust
Will our skins be clean.

Feet stamp in the dust at sunset, dust
Shakes from leaf-ringed ankles, dust
Is what the dancers mean.

And the watchers sit cross-legged in the dust,
The children skid lizard-curves in the dust,
And everywhere the sheen

Of dark skin is quite unclouded by dust.
Boomerang-clicks sound clear through the dust,
Rocks might have been

Answering rocks on the far borders of dust,
But here dust replies in soft thuds of dust,
As willy-willies lean

Across the desert dancing in spirals of dust,
Cancelling the signatures of toes in dust.
From somewhere unseen

Raindrops will come dancing in the desert dust,
Then the dust will turn to red mud, for dust
Is the nursery of green.

On the flight back to Broome the party had a stopover at Cygnet Bay, on King Sound near One Arm Point and Cape Leveque, to see the pearl culture operation run by Lyndon and Bruce Brown. Geoffrey Dutton remembers:

Lyndon, stocky and harsh-voiced, wearing dark glasses and a khaki hat, met us at the airstrip and drove us to Cygnet Bay through the thick bush and past some fodder plots they had cleared and sown for their cattle. He told us that Bruce was down in Fremantle to collect their new boat. The wheel has turned full circle in this part of the world. Pearling began from small sailing luggers, ketches, and schooners, then used powered craft, and now the cost of fuel has risen so steeply that Bruce and Lyndon ordered a sailing catamaran.

Lyndon's Japanese wife Shizuko, and Bruce's wife Alison, both remarkable women, welcomed us to the Cygnet Bay oasis of houses and a school. The settlement is an extraordinary achievement to have been created since 1962. The Browns built the houses and school themselves out of bags full of wet concrete, which make an unusual and pleasing texture when they have dried and been painted white. There are actually lawns in the midst of the dry bush! And a fine tennis court, and of course flowers and butterflies.

The raft of the culture pearl operation floats in the bay and we saw Shizuko's brother and another Japanese seed the oysters with quick delicate movements like those of a dentist making a filling. The Brown brothers also seed the oysters. Lyndon was indignant because he is not allowed to employ Aboriginal helpers from the One Arm Point Reserve and has to employ Filipinos instead. He made the good point that the reserves, which are supposed to protect Aborigines from corruption by whites, are in fact more like prisons. The Aborigines are not allowed to invite friends from outside, whether white or black, to their houses.

He took us to a hill above the bay and showed us his father's grave, and told us of a visit from Indonesian pearling pirates. Despite repeated requests to the government and the navy he had not received any protection against them, and so he simply went on board their boat with a shotgun and ordered them off.

His most bitter and certainly justified complaint was that there is no telephone on the whole of the Dampier Archipelago, despite the taxes paid by those who live there, and he followed this up with some strong blasts against the old targets of government handouts to both whites and blacks, and the white bureaucracy that thrives on Aboriginal affairs.

The Browns of Cygnet Bay, the Bradleys of Kununurra and the Nielsons of Fitzroy Crossing are very different types of people but very similar in that they are all extremely capable,

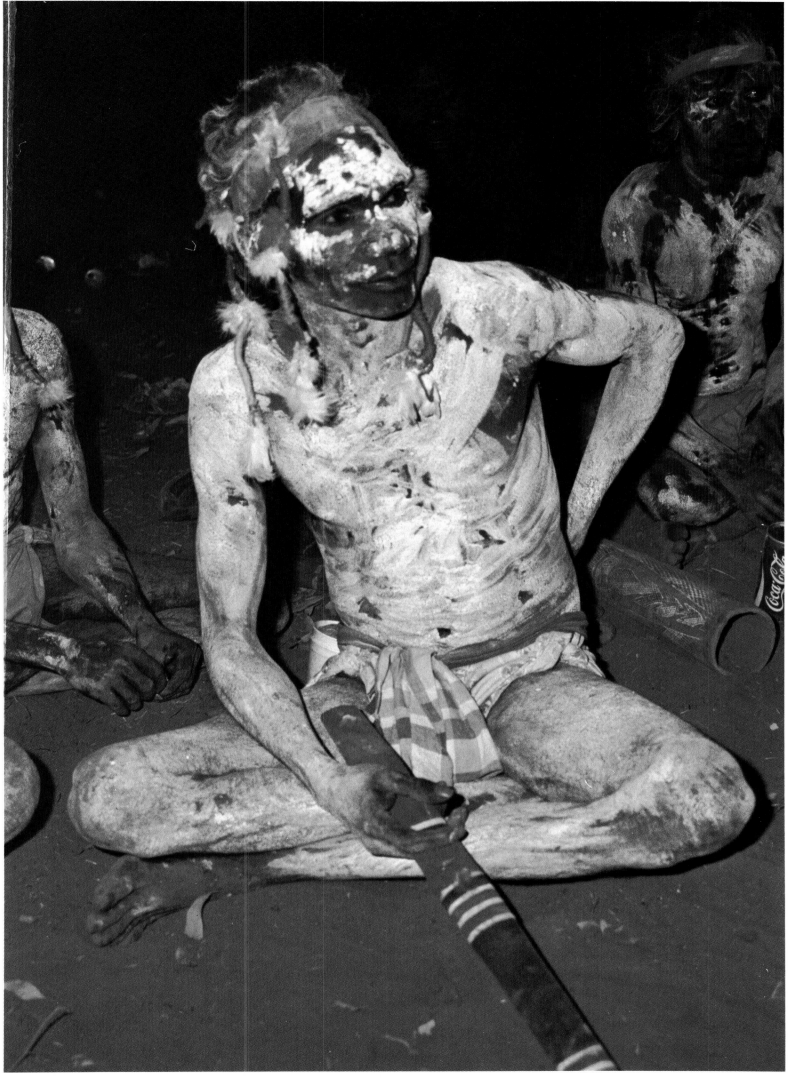

This young Aboriginal is probably familiar with many aspects of western
civilisation and technology, but when he paints himself for dancing he becomes
a living exponent of ceremonies which date back to the dawn of time and existed
long before European civilisation

hardworking and dedicated, and have made brilliant successes of their lives in the tough North-West that is so renowned for failures. It is inevitable, I suppose, that they should all be right-wing, and equally inevitable that there will be more and more conflict between such individualists and the bureaucrats in the south, while millions of Australians either nurse their guilt towards the Aborigines or resent the apparently preferential treatment of Aborigines over whites.

Mary Durack comments on Cygnet Bay:

This peaceful backwater, named after the buccaneer ship careened hereabouts in 1688 in which William Dampier was a crewman, was not always so serene. When I visited the bay for the first time, in 1965, I met an elderly Aboriginal named Monty Iganboor who remembered it as the worst trouble spot on the pearling coast. He had been here with Father Nicholas Emo in 1907 and he cried as he showed me the charred remains of the little house and of the Chapel of Our Lady of the Aborigines which the priest built with his own hands. Monty accompanied him to the Benedictine mission on the Drysdale River and went with him to Lombadina in 1910.

I recorded my next visit to the bay in a diary entry of 15 September 1968: 'This morning from Lombadina to the Brown's camp at Cygnet Bay. Found Dean Brown and son Lyndon hard at work cutting out the cultured pearls from their last harvest — 4000 more shells to come up shortly — each half pearl nets them $3. They seem to have overcome their initial difficulties and are very cheerful and optimistic.'

Dean Brown died in 1980 and he is buried on the hill where they built their first humble living quarters some fifteen years ago.

During lunch, Lyndon casually spilt a handful of cultured pearls onto the table. He told us 'It might be said that these are worth a fortune but taxation doesn't encourage us to sell more than a limited number.' In any case the pearl market is a dicey business and they have now taken on the breeding of stud cattle as a second string to their economic bow.

We admired the delightful little oasis they have created at Cygnet Bay and the lifestyle they have come to love. It was disturbing to read later that the culture pearl industry is no longer flourishing. Pearls Pty Ltd at Kuri Bay, said to have been the richest pearl farm in the world, has been forced to close down because of spiralling costs, recent cyclone damage, a mysterious disease affecting culture pearl oysters, and a 45 per cent drop in world demand for the pearls. This was a sad blow to Broome though it is hoped that smaller culture pearl farms, such as the Browns, can stay in business.

On the return to Broome the party glimpsed some further aspects of the tensions between blacks and whites in the North-West. Geoffrey Dutton writes:

We talked to Hilary Fox, who had been the Celebrant at a marriage at the Mangrove Hotel between a Melbourne schoolteacher and a lovely little girl from Laos. Hilary is a magistrate and that morning she had dealt with fourteen charges of drunkenness against Aboriginal men and women. She fined each of them five dollars but none could pay. They had all received their various welfare cheques on the day before, a Tuesday, and although these were not dated to be cashed until the Thursday the pubs had already 'knocked them down'.

Hilary, like so many of the others we talked to, was enraged by the report of a visiting group from the World Council of Churches who said that we maltreat and discriminate against the Aborigines. In fact the Aborigines receive exactly the same social security benefits as the whites, but they drink the money away while their wives and children go hungry. We remembered the indignation of the Sisters in the Derby Leprosarium about the totally inaccurate reports of the World Council of Churches concerning leprosy among Aborigines.

Hilary Fox has lived in Broome for forty years and she certainly knew what she was talking about. Even for someone as intelligent as she is, the world has changed beyond recall. She was brought up on a station and she told us what we so often heard: that in a well-run station in the old days the Aborigines and their families were happy. 'And there was a future for them. The boys could look forward to becoming stockmen, the girls to jobs working around the house.' Educated young Aborigines would not now think that to be any kind of future — but what is *their* future?

Many people think that only the Aborigines themselves can answer that question. Certainly that is the belief of everyone at Strelley, which we visited again on the way home. This time John Bucknall and his wife Meg were there. A solid man, with a pointed face and a big beard, he is the principal of the five Strelley schools, the administrative adviser, and a qualified aircraft pilot. The Bucknalls gave us drinks in their house and we cheered when we saw a John Olsen painting on the wall. They also had a Drysdale and some bark paintings including a good Elcho.

John is very mindful of his position. An old Aboriginal, Fisher, came in and joined the discussion, and as John talked he frequently interrupted himself and apologised for saying 'We'. He said 'It should be "They" because it's their show.'

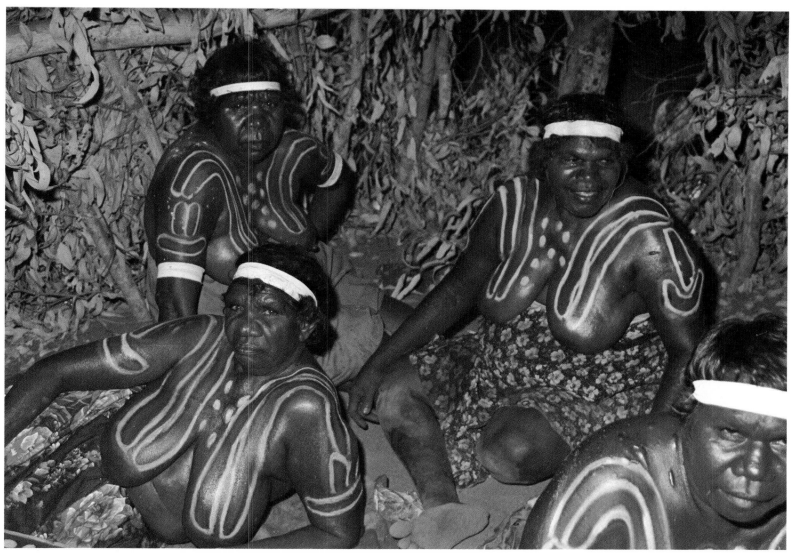

Above: *'Waiting in the wings.' A group of Aboriginal dancers, painted with ceremonial patterns, await their turn to perform at the Hooker Creek dance festival*

Below: *The canine component of one Aboriginal group sleeps or scratches unperturbed while orchestra and chorus provide the accompaniment for one of the dances*

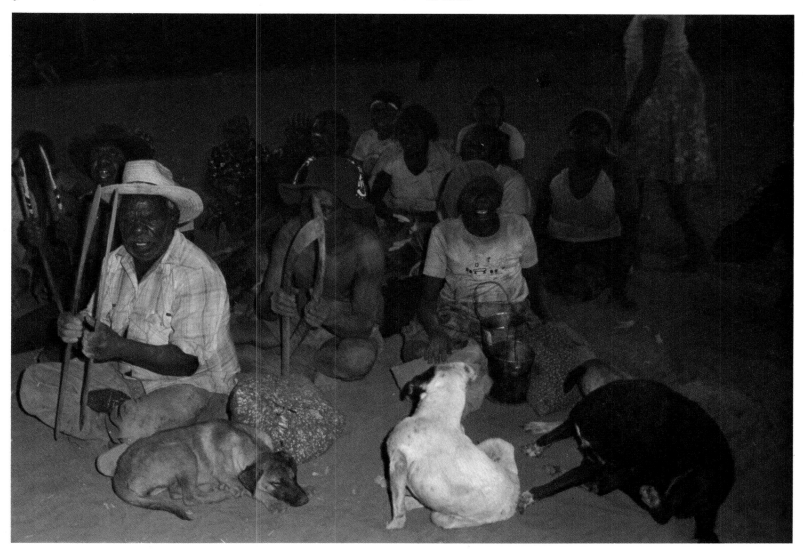

Strelley had refused to take part in the ACF Festival at Hooker Creek because the people thought it was likely to turn into a commercial operation and because it was mixed up with government. I mentioned that a group from Turkey Creek had handed round the hat after their performance, and John commented 'The Aboriginal groups are all different.'

The economics of Strelley are puzzling. John admitted that it carried no livestock although it used to run 15 000 sheep when it was a station. I remembered that our pilot, Ziggy, had told us when we flew over Noonkanbah that it used to carry 20 000 sheep and was once sold for $3 million. There are no sheep there now. John's comment was 'All these stations were appallingly overstocked.' Maybe so, but surely they could carry something like half of what they used to and save the taxpayer a great deal of money in welfare payments?

John and the Council make strenuous efforts to insulate the Strelley Mob from all aspects of white civilisation and to preserve the old ways. While he elaborated on this point I was amused to see Aboriginal children and adults peeping into the video room next door, where they were showing the British film *The Railway Children*. And Strelley is not so insulated from white technology that they do not have tape recorders, a printing press, schools, radios, electric pumps, vehicles, an aircraft, and so on.

After visiting a number of Aboriginal communities, one cannot help fearing that attempts to preserve Aboriginal culture by imposing a form of inverted apartheid is bound to have grave effects on the total Aboriginal community of Australia. We try to encourage immigrants not to lose their ethnic traditions but on the other hand we make it possible for them to integrate with the Australian community, so that they will not form ghettos. But Aboriginal policies are leading towards the formation of rural ghettos in every State where the Aborigines still remain in any quantity.

The basic rules for the Strelley Mob were written on a Strelley school blackboard, clearly by a white hand and clearly in whitefella language:

Aboriginal *Law* is the core of the group's existence.

Aboriginal Law is the starting point for dealing with any matter.

Adjustments are made from this base.

The group is anti-assimilationist.

The economic and social life of the Community operates through the group not through individuals.

The survival of the group is more important than the survival of the individual.

The separateness of Strelley, and what it stands for elsewhere, is becoming a mirror image of the apartheid principles of the Western Australian Natives Act of 1944. In the 1920s and 1930s the Aborigines were not allowed to leave their reserves and there were severe restrictions on Aborigines outside reserves. The city of Perth was declared 'a prohibited area for natives'. Under the Natives Act, an adult Aboriginal might apply, under certain conditions, to a magistrate or government resident for a certificate of citizenship but he had to satisfy the official that he had, for two years immediately preceding his application, 'dissolved all tribal and native associations except with respect to lineal descendants or native relations of the first degree,' and that he had either served in the armed forces or that he was otherwise a 'fit and proper person' to obtain the certificate. Also, the official had to satisfy himself that the applicant could speak and understand English and was not suffering from active leprosy, syphilis, granuloma or yaws.

The whole grim story of white-black relationships until the recent past may be studied in Peter Biskup's book *Not Slaves, Not Citizens*, published in 1973. No thinking person can object to all the attempts to cure the evils of the past, but it is impossible to put the clock back. People of white descent have now been settled in Australia for nearly 200 years, and the vast majority have no other place they can call home. The Aborigines have been here for many times longer than that, and the more white Australians who respect their rights the better. But one might add to the last-quoted of the Strelley maxims that, if the individual is not more important than the group, then the group is not more important than the nation. We cannot have two nations, black and white, in Australia.

After we left Strelley for the second time we drove south to Perth through Port Hedland, Carnarvon, and Geraldton. Day after day on the road gave time for thought, for assessment of all we had seen and heard, and I thought about the richness of white literature on the North-West. The Kimberley has Mary Durack's epic *Kings in Grass Castles* and her novel *Keep Him My Country*, which give the sweep of history and the clash and mingling of the races. Tom Ronan's books, both fact and fiction, give many insights into the lives of men and women on the stations of the North-West. Then, on a lower scale as literature, but important for the feeling of the country and its history that they have given to tens of thousands of Australians, there are the books of Ion L. Idriess including one on Broome.

The most imaginative novel of the Kimberley is Randolph's Stow's novel *To the Islands*. Academics believe that, in Stow's book, the journey of Father Heriot into the interior in search

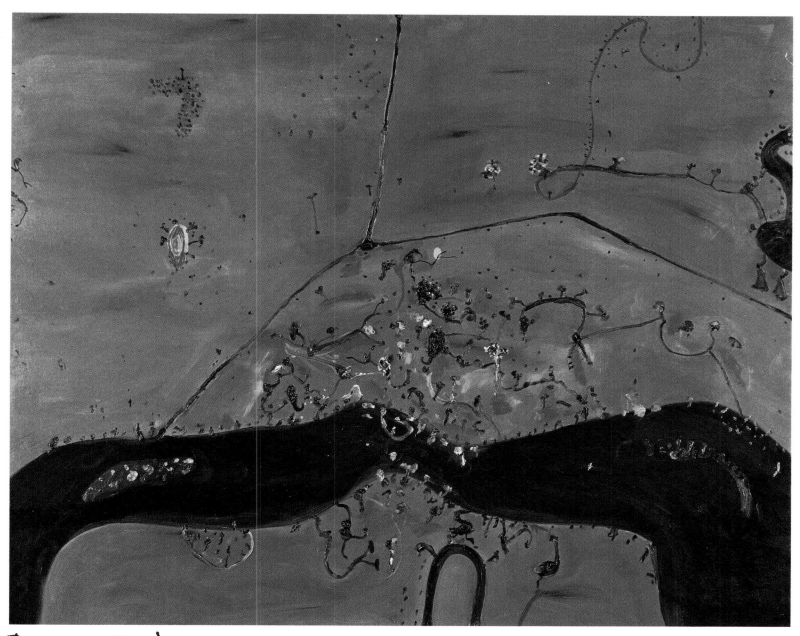

Road & River Carnarvon

of his soul was written as a sort of imitation of Patrick White's *Voss*, a myth perpetuated in the recent *Oxford History of Australian Literature*, especially since Stow's book appeared only a year after *Voss*. But Stow worked on the Forrest River Mission, and gained the mental and spiritual knowledge for his book, long before he read *Voss*. Stow goes deeper than any other Australian novelist, because he has more sympathy with both sides, and looks deeply into the moral conflict of black and white and the relation of both to the land.

Many of Stow's most beautiful poems also stem from his life in the North-West. One is reminded of him all around this coast, and especially in his home town of Geraldton. His *Merry-go-Round in the Sea* should be read in the Geraldton sandhills, in sight of the lighthouse, close to the environment of the boy's longings and despairs.

In 1973, in what would now be an unfashionable confession, he said that he wrote *To the Islands* as a tribute to the missionaries. (Not those of the Gribble type, of course.) But the Tao and Zen, rather than Christianity, are the basis of Stow's understanding of his book and the land. Heriot's last words are 'My soul is a strange country'.

The setting of one of the masterpieces of Australian literature, Katherine Susannah Pritchard's *Coonardoo*, is far out in the Pilbara beyond Paraburdoo, where the whiteman's need of the Aboriginal sense of belonging is deliberately broken by progress and ignorance. Coonardoo herself is one of Australia's few tragic heroines, and all the rarer because she is black.

The most underrated writer of the North-West is Donald Stuart, whose *Yandy* and *Yaralie* in particular are sensitive but not pessimistic studies of black-white relationships. *Yaralie*, set in Port Hedland and out at the 'Eighty Mile', is especially memorable for its part-Aboriginal heroine and her relationship, pure mateship, with her gold-prospector father.

Stuart has a deep knowledge and experience of the Pilbara and the Aborigines and his vision is idealistic, that a 'real people of the North-West' will emerge when the white man's energy is joined to the Aboriginals' 'wise love of the country'.

Grant Watson, the young English scientist who worked with the Aborigines on Bernier and Dorré islands, wrote several novels about them and the near-desert country out towards Meekatharra. His *Where Bonds are Loosed, The Desert Horizon*, and *Daemon* should be in print again because they show an extraordinary penetration into the mystical quality of the landscape and the male-female conflicts in white attempts to settle there. Although they are not strictly tragedies they show a tragic vision of life. In Watson's words: 'What remedy was there for the tragedy of being? None, none whatever possible. In all existence, suffering is the only unquestioned reality.' But to anyone who has lived with the rocks and the distances, the birds and the flowers of the North-West this must seem a restricting view because it limits 'being' to humanity. The Chinese view is better suited to this region than the European.

Fortunately black and white are not the only colours in the North-West. The wildflowers, which alone would have made the whole trip worthwhile, surpassed themselves to welcome us back to 'civilisation' as we drove southwards. From Port Hedland to Perth, and especially where the road and its borders run through the wheat country, there was a delirium of flowers and flowering bushes and trees: flowers simply making their statements of colour, blue with gold hearts, pink, flame, white with black eye and sweet scent, and some as flamboyant as the huge creamy grevilleas waving their arms as though in joy above their skirts of green. Only nature could get away with such audacious mixtures of colour without being vulgar.

At Geraldton there was a chilly sea and a little drizzle. We dug out our sweaters from the bottoms of bags in which they had been buried for many weeks. We were in the south again.

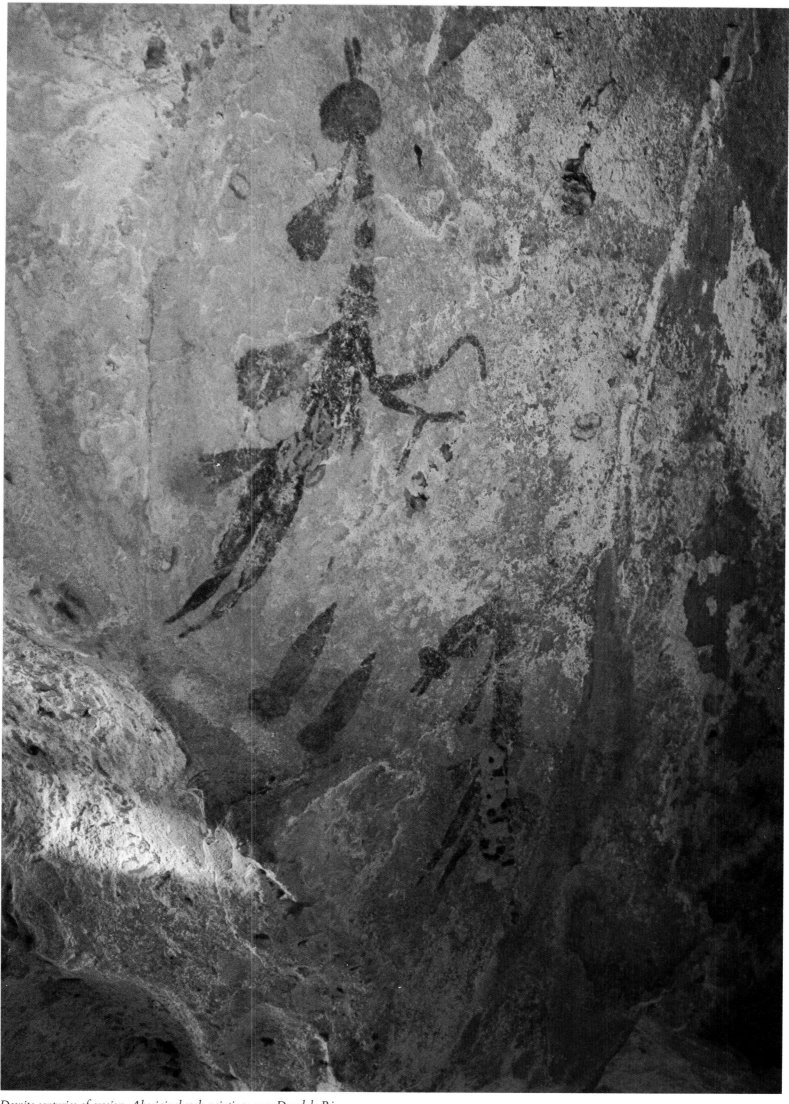

*Despite centuries of erosion, Aboriginal rock paintings near Drysdale River
Station still retain vibrant form and colour. At one time the Aboriginals would
renew the paint during complex rituals each year*

17 | POSTSCRIPT IN BUNGLE BUNGLE

As Vin Serventy comments, 'To travel only during the Dry does not give a complete picture of this country. Pleasant warm weather and easily negotiated bush tracks and river crossings do not tell the whole story.' Consequently the party returned to the North-West towards the end of the wet season, and he continues:

Grasses three metres high grew luxuriantly in a woodland made green by the heavy rains of summer. The skeleton arms of the baobabs were no longer writhing into the sky. Their branches were adorned with green leaves and had lost their strange fascination for us. Some were laden with huge cream tubular flowers, too high to examine easily and puzzling me as to whether they may be pollinated by night rather than by day, perhaps by bats or moths.

Hidden Valley, near Kununurra, which was dry when we saw it first, now echoed with the roar of a small waterfall. On the edge of the waterfall I found a number of long deep grooves in the fine sandstone, where Aborigines once came to grind sharper edges on their stone axes.

We discovered a new world in the time of the Wet. The vivid green of grass and trees was overwhelming, as tender and bright as the fields of Ireland or the meadows of Switzerland. John, who had thought there would be no need for him to take green paint into the North-West, admitted that he was wrong.

At last we were ready for the trip planned into the Bungle Bungle Ranges. The heavy camping gear and food had travelled to Mabel Downs by road, and helicopters lifted us over the mountains into a long-forgotten valley.

This 'postscript' to our expedition had originally been scheduled as a wet season journey out of Broome, but our glimpse of the unique Bungle Bungle Ranges on our earlier flight to Lake Gregory had prompted a change of plans. Alex Bortignon and John Olsen agreed that a trip into the Bungle Bungle would make the ideal conclusion to the expedition, and Alex approached my old friend and student Dr Phil Playford of the Mines Department of Western Australia.

Phil Playford concurred with the idea that it would be a unique experience, never previously documented in the way that we planned. As a part of the Geological Survey of Western Australia organised by the Mines Department, Phil had previously arranged for the geologist Glen Beere to work in the Bungle Bungle and he recommended that Alex should seek all the information he could from Glen.

Alex soon realised that a knowledgeable guide, with the type of experience which Glen possessed, would be essential if our group was to cover the area in a thoroughly professional way. He asked Phil's permission for Glen to accompany us, and there can be no doubt that the success of our Bungle Bungle visit was due to Phil's support and Glen's knowledge and experience, gained during nineteen weeks in the area.

On Glen's previous visit he had gone in the hard way by four-wheel-drive, and spent days battling through the rocky barrier to this wonderland. This time, he and I flew in by helicopter ahead of the others. Our first job was to organise a campsite.

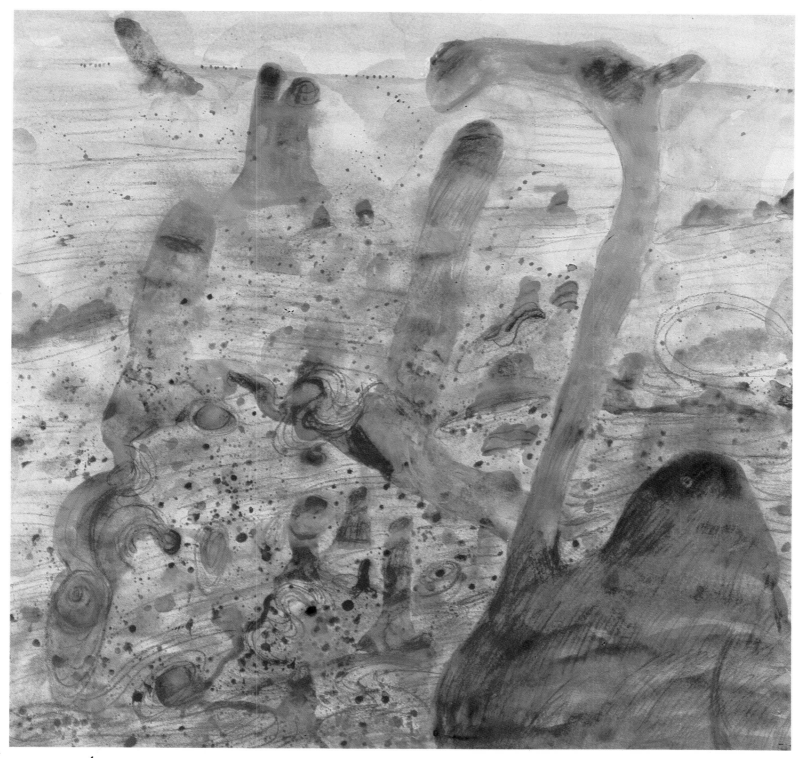

Camels in Bungle Bungle

Mary Durack comments:

Bungle Bungle was not officially named until 1934 but it would seem to have been known as such since the beginning of white settlement. The name may be of Aboriginal origin but it could as aptly be applied to its geological structure and to what little we can learn of its history. The Aborigines claim no sacred sites in the area and no one knows how much they frequented the ranges. Possibly the rugged country was poor hunting territory and unsuitable for a tribal camping ground.

White settlers appear to have regarded the Bungle Bungles as a natural boundary between the adjoining properties: Ord River Station to the south and east, Mabel Downs to the west and Texas Downs to the north. But in the early 1900s a second wave of landseekers, usually known as 'the battlers', began looking around for country left vacant by those who had taken up the better land. Most of these were stockmen who had helped with the overlanding of cattle and remained as station employees. One was Alex Wilson, who took up 32 000 hectares of Bungle Bungle country immediately south of Texas Downs in 1902. Billy Madden and Ted Brennan, two Argyle Station stockmen, took up the remaining 15 600 or so hectares in 1911. Ten years later they took over Alex Wilson's land also, and held the entire 56 000-hectare lease until William Skuthorp bought it in 1934. He held it until 1967, when the Crown resumed the Bungle Bungles to augment the Ord River Catchment Area reserve that included the vast Ord River Station property.

It seems remarkable that the 'battlers' could have maintained a cattle run on this poor grass country among tumbled ranges and winding creeks. A possible clue as to how these runs were stocked and kept up may be found in the unpublished memoirs of Doug Moore, at that time the bookkeeper on Ord River Station. He writes 'What rogues these chaps were. Most of them had something against them in their past but were otherwise nice chaps to meet and carouse with . . . In fact no less than six stations were stocked by shaking Ord River cattle and many employed by us were receiving wages with one hand and robbing us with the other.'

It is easy to understand why an Aboriginal outlaw, Major, who terrorised the East Kimberley district in 1908, chose the Bungle Bungles as a hideout. His story has some resemblance to Pigeon's, although his reign of terror was comparatively brief and he did not have the organised backing of so many of his tribesmen.

Major was reared by Jack Kelly of Texas Downs and acted for some years as his head stockman and special messenger. He accompanied his boss on several trips to the city and Kelly said that he twice saved his life. Occasionally he accompanied police parties in search of Aboriginal miscreants and he tried to dissuade the tribespeople from chasing and spearing stock.

It seems that no one really knows why he suddenly became an outlaw. There are several versions of why he killed Scottie MacDonald, the manager of Growler's Gully which was an outstation of Texas Downs, and made off with weapons and ammunition to join three Aborigines who were wanted for killing a white stockman.

Within the next few months the outlaws held up and robbed a number of travellers, killed two white men on Lissadell Station, and declared their intention to wipe out the white population. The police, helped by Aboriginal trackers and white station workers, sought for them in vain until word spread that they had escaped into the wilds of the Northern Territory to enlist recruits.

Major had left his woman, Biddy, in favour of a girl named Knowla, and the older woman's resentment apparently sharpened her perceptions. She picked up the outlaw's tracks leading into the Bungle Bungles and reported them to the police.

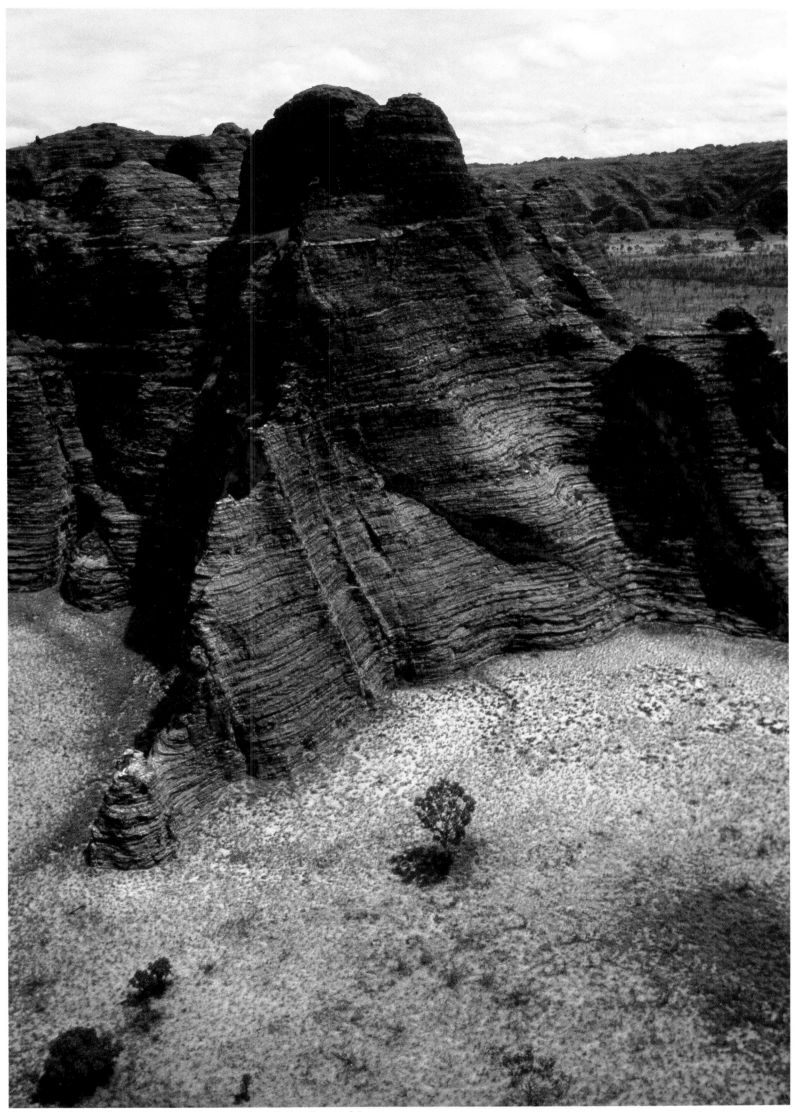

Outcrops of the Bungle Bungle Ranges soar so steeply and abruptly out of the surrounding plains that they almost seem to be works of man rather than nature

There are detailed records of the final tracking-down of Major and his companions in the wild mountainous country south of the Texas Downs border, and of the shoot-out in which Knowla was wounded and all the others killed. Sighs of relief went up all over the countryside when settlers heard the news.

G. W. Broughton, then the bookkeeper on Lissadell Station, later commented in his book *Turn Again Home* 'This bloody episode was just one of many, the outcome of which could often be traced to some form of harsh treatment of the station Aborigines. In general the station owners and managers were benign but firm, but there were some rough men who combined contempt with brutality in their handling of these primitive people. Man's actions can only be judged as in and of their time, and life was new and raw in Kimberley in the period of which I write.'

Vin Serventy continues the story of the party's visit to the Bungle Bungles:

Glen Beere and I knew that the party would be camped for a week in one place and so the right choice was important. On our 'dry' trip into the North-West we had all slept in the open while we camped, but now we needed good clean ground on which to set up our tents. Great cloud masses loomed in the northern sky, the signal that monsoonal showers would drench us after sundown.

We flew along the main valley and found a good site near the deserted Bungle Bungle homestead. The downpour came a little earlier than expected and by the time the rest of the party had flown in and we had settled down in the camp it was in full spate. It was warm rain, not too unpleasant. We ate our dinner huddled around the fire and soon we were snug in our tents — but not for long. The driving rain seeped through tent walls chafed by their long travels in the trucks.

John awoke me to point out that he was very wet. I felt my camera bag, clothes, collecting gear, and the sleeping bag I used as a mattress and found they were all dry, and suggested that he should go to sleep again. He complained that everything he had was wet. I asked him for the time because I imagined it was close to dawn, and feared that the drumming of the rain might herald several days of downpour instead of the usual overnight showers. When he told me it was two o'clock I tried to comfort him with the thought that the weather would clear by morning, and fell asleep again. When I awoke I found myself in a pool of water with all my clothes soaked, but my precious gear still safe and dry.

That was our only bad night. The experience taught me to stow our more precious equipment in the helicopter each night, so that we could lie back and listen to the beating rain without worries.

After breakfast on the first morning we began our study of the Bungle Bungles: a great mass of soft sandstone rocks with occasional layers of conglomerates. These are also called pudding stones: an apt name because the mixture of large boulders, medium-sized pebbles and grains of sand resembles a giant currant pudding.

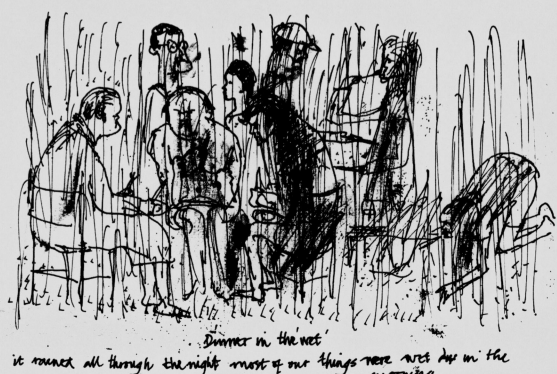

'Dinner in the wet'
it rained all through the night most of our things were wet dry in the morning

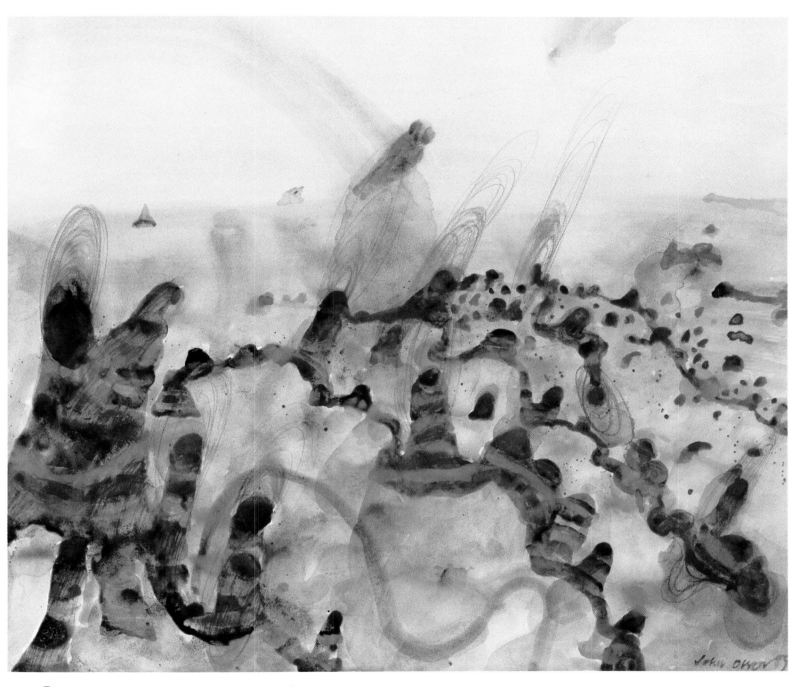

Bird & Bungle Bungles

Glen's explanation of the rocks of the ranges was that they comprised material eroded from more ancient hills to the north, swept south by creeks and rivers into freshwater lakes or rivers where they eventually became beds of sediment. Faster-moving water would occasionally bring down boulders and big pebbles.

All this took place in the Devonian period, some 350 million years ago. In some places sand drifts formed but gradually compressed into rock. Then erosion exposed the ancient sediments while new rivers began to cut the valleys we see today, including the one in which we were camped.

The sandstone was soft, easily eroded by wind and water. All the sediments were horizontal, which explains the regularity of the valley sides. The quivers and paroxysms of nature cause all the earth's rocks to crack into the fissures called joints. Rain trickles down such fissures, steadily reaching the heart of the mountains. Each summer monsoon recharges the water in rocks which act like a giant sponge.

Some of the layers would be less permeable to the water and so it would flow along the more porous layers, seeking a way out until it reached the cliff sides.

All this was happening at every level of the 300-metre-high hills, and so every vertical cliff face had bands of moist and dry sandstone. Algae grew vigorously where the water was present. The outer surfaces of dead algal material were black, but when I broke a chip of rock I saw the deep green of the living plant.

Other simple plants such as lichens grew in some places, while ferns, mosses, and other plants flourished in the more sheltered valleys.

Where the rock was dry the sandstone and conglomerate remained a pale grey, and so the exposed cliff faces were wonderfully marked in shades of light and dark. They reminded me of the cathedral at Siena, where brown and white marbles are set into patterns.

Erosion had worn rocks covering hundreds of square kilometres into pinnacles, cupolas, domes, towering cliffs and vast gorges. From the distance the mass of landforms looked like a long-abandoned city.

To the beauty of the rocks was added the vivid green of fresh grass. It glowed emerald in the early morning and late afternoon and the scene became magically beautiful. A flight up one of the gorges as it zigzagged into the heart of the mountain, the walls steadily closing in until the helicopter had to rise above them to escape, was an experience which revealed the total wonder of the Bungle Bungles.

We returned to our camp on that first afternoon stunned with impressions, perhaps too many for one day. We all agreed it was the greatest Australian landscape that any of us had ever seen. The following days of experience piled on experience confirmed our first impressions.

We saw camels, donkeys, cattle, and a family party of emus, with father streaking ahead of his children as they strove to escape the monster in the sky. The chicks valiantly tried to keep pace as he showed them the way. We saw no kangaroos on the plains and few birds along the valleys. Sandstone weathers to sand and forms an infertile soil, so that wildlife was comparatively scanty, but always in the distances were the walls and pinnacles of Bungle Bungle city arising from the seas of spinifex.

wild donkeys.

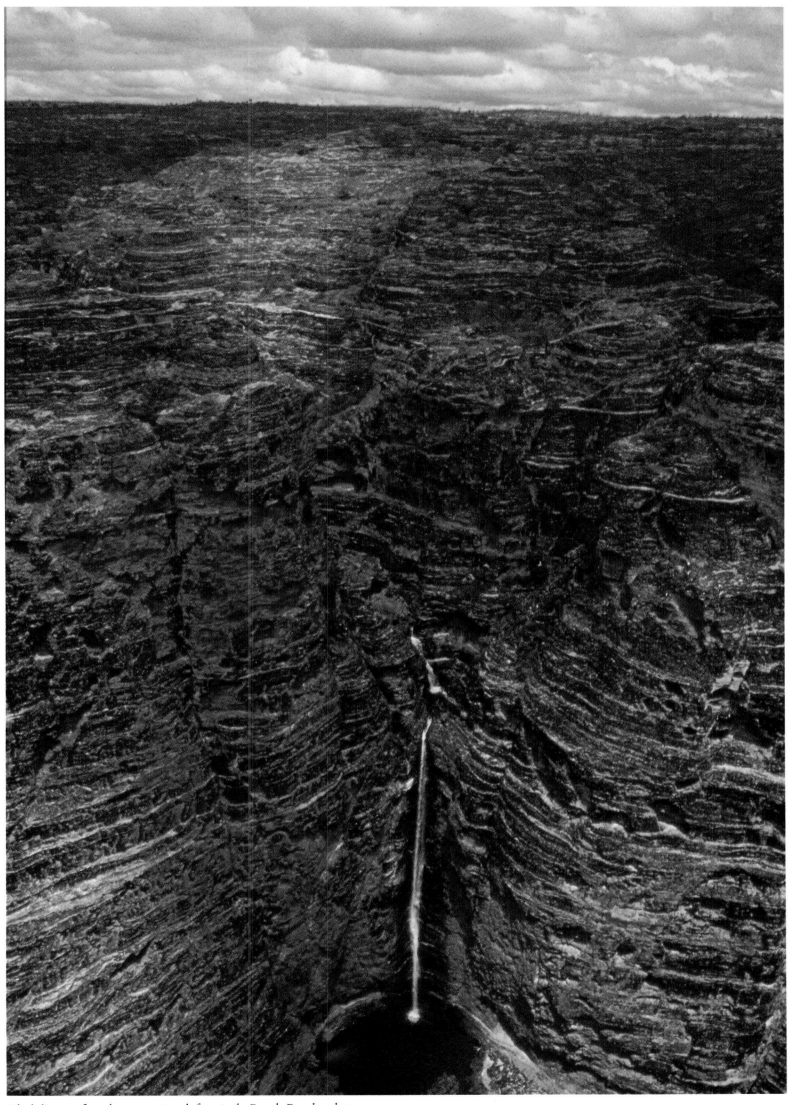

The helicopters flew along gigantic rock faces in the Bungle Bungle, where water finds its way down from the rugged crests and cascades into creeks flowing through deep gorges

There could well be a host of new plants and animals in the deep sheltered gorges, waiting for a team of scientists to work there in the Wet. They might discover a biological treasure house. In 1977 the zoologist Mike Tyler took a group of zoologists to the Kimberley to make the first collections during the Wet and they found six new species of frogs. Since then, triple the number of new kinds of frogs have been found in the region: a sign perhaps that the North-West still has many secrets to reveal to naturalists.

Each night around the campfire we talked about the potential of the enthralling landscape. The State government has reserved the area to protect native plants and is investigating its possibilities as a national park, but this thought made Glen pessimistic. He disliked the idea of the lonely domain being invaded by people, but with good planning the Bungle Bungles will remain undamaged, renewed by the passing of the seasons and able to bring refreshment to the spirit of all those who wander there.

Geoffrey Dutton adds more detail on the venture into the Bungle Bungles:

At the hotel at Kununurra there was no mistaking that it was the Wet. The rooms had that wet towel smell, the rain pounded on the roof, the water on the ground was inching up towards the sliding doors. At the same time it was very hot. Two Alsatian dogs in the back of a Toyota outside the newsagency were loving the deluge. A young man, naked except for shorts and with fat rolls oozing over his belt, got leisurely out of the Toyota and slopped barefooted through the puddles without hurrying. A woman with an umbrella outside the shop, plucking up courage to return to her car, smiled a little nervously and said 'Well, it *is* the Wet, isn't it?'

Our old friends Carl and Doug met us with their red-and-white helicopters and flew us down past Lake Argyle to Mabel Downs, to rendezvous with the truck carrying our camp equipment. From Mabel Downs we took only eleven-and-a-half minutes to fly to the campsite selected by Vin and Glen. The latter told us that when he wrestled a four-wheel-drive through from Mabel Downs to reach the same site he took four-and-a-half days.

Our party was smaller than before: only John, Vin, Alex, Glen, and Rosemary Pratt of the Office of the North-West. We set up our tents in the waist-high spear grass under the shade of coolabahs. There was a great baobab across the brown creek and then a huge red peak going up to the clouds: those clouds which were now always a major presence in the sky. Scarlet and green parrots flew by, lorikeets racketed around in the leaves, the peaceful doves called incessantly and were so tame they often seemed about to hop from a branch onto your shoulder. Their call was soothing after the interrupting song of the friar birds. Rosemary saw a handsome banded tree snake on the tree sheltering our provisions, and Vin caught it. These snakes are harmless.

During the overnight downpour I woke up at about 2 a.m. Feeling thirsty I put my hand down from my stretcher for the water bottle and felt water on the floor, but sleepily did not take much notice. A couple of hours later I woke properly and found the water about ten centimetres deep in my tent. Howls of rage and pain arose from the nearby tent where Vin and John had been sleeping on the ground, because they had not put up their stretchers. Nor had Rosemary in her little tent. We found that our waterproof bags had all leaked and so all our clothes were wet, but fury tipped over into hilarity as it usually does on such occasions and there seemed to be nothing funnier than John squeezing torrents of water out of his rubber mattress. Clothes, books and boots were soon scattered on every tree and bush, drying in the sun which was already fierce by 6 a.m.

In the morning there was a new sound: creek rushing over rapids. When we swam in it we floated downstream, feet brushing the sand, white gums overhead, under an inquisition of friar birds. On my morning toilet walk, four fat brown quail ran along beside me when I reached the open ground beyond the spear grass and then stopped to watch me, unafraid.

WATER — BUNGLE BUNGLE RANGES

It always ends with water, for water puts out the fire,
And it begins with water, rain rinsing the dust from air.

It is The Wet. Birdflowers, sipping the stems, are winged with green,
The tree-frog is a smooth and slippery green, there is the rain-
fresh green of the folded grasshopper, green creepers dangle in the lagoon.
Clouds rush up quickly, in busy combat with the sun.

There are slender waterfalls in the red ranges, diving
White out of a black stream in the plateau, weaving
Lace out of light, till they are slowly lost, waiting
Till the light finds them again, and makes of their mist a rainbow.
For water being colourless holds all the secrets of colour,
Red-mud, sky-blue, sand-green, deep-sea dark roller.

And loving equality, it hints also at tranquillity,
In limpid pools answering that all will end rightly.

Float downstream in the brown creek, toes dragging in the sand,
Drink easy water, see rain far-off, greying the wind.
The water-goanna scouts the bank, only his head
Shows above water, looking. A ripple is where he flowed.
The creek is silent with fish, but listen to the water talking
To the rocks, whispering in little rapids, and a dove calling
Is like drops of water falling, a kind of thanksgiving.
Water-spiders run along the water, stones sink in,
A scarlet dragonfly lands for a moment on a floating leaf,
Ripples flash signals up a tree, it might be for love.

But water is the messenger of grief, tears out of bone.
Go back up the hills all the rivers come from,
Climb the waterfalls, hunt in the web of channels for the source.
The red rock weeps under a black curse,
The cruel logic of having always to find its level,
Bearing the potential of flood, the insidious evil
Of nosing out the weak spot, then drowning stallions
Or babies, indifferent logic, for water will always join
Water, and the creeping flood is the final angle of rain.

Bungle
Bungles
in the
wet

Then came our initiation into the secrets of the ranges, as our helicopters lurched and lifted and swooped off over the trees. The Mahoney Range, as Glen tells us it is about to be called after the geologist who first explored the area, rises inaccessibly from the plain that is red in the dry season and green in the Wet. We flew from our camp towards huge cliffs and gorges and noticed an odd effect. All the gums were blossoming on one side of the escarpment but not on the other.

We lifted higher and landed amidst charred wattle and the brilliant green of young spinifex, on a plateau which had been burnt out by a lightning fire. There, with the new hibiscus beginning to unfold its mauve flowers, rushes sprouting from between the rocks and a butcher bird's liquid call flowing like the little shining stream meandering towards the west, the full weird splendour of the ranges began to unfold.

The hills, as much as 400 metres high, rise out of the plain like striped honeypots, like breasts, like Buddhist temples — one searches for familiar images with which to compare them because they are so extraordinary, so untouched by black or white history, that one longs for a human frame of reference. Even the stripes of red, white, yellow and black strata made me think of Sienese cathedrals. But one soon has to put human references aside and give absolute surrender to forces older than humanity; in the words of the Tao, older than God. The hills which rise so unexpectedly from the plain, so totally unlike the other ranges of the Kimberley which are majestic enough, have the quality of temples reared in honour of the Titans who preceded even the gods of Greek or Norse mythology.

As one attempts to understand the metaphor of the thing, rather than the thing itself, the poets and philosophers always come to the rescue. Swinburne, for instance, in *Hertha*:

> *I am that which began;*
> *Out of me the years roll;*
> *Out of me God and man;*
> *I am equal and whole;*
> *God changes, and man, and the form of them bodily; I am the soul.*
>
> *Before ever land was,*
> *Before ever the sea,*
> *Or soft hair of the grass,*
> *Or fair limbs of the tree.*
> *Or the flesh-coloured fruit of my branches, I was, and*
> *their soul was in me . . .*

In these ranges there is the presence of death as well as of life, what Swinburne calls 'the red fruit of death'; easily plucked by following one of the streams to the edge of the cliff where it falls 240 metres in slow lazy sprays to the bottom of the gorge. But there is no demand for sacrifice, none of prayer or creed; rather a sense of freedom and of a responsibility to life. Walking over the rock exfoliated by fire, with loose flakes showing white under the cinnamon so that one knows fire is altering the texture of the ranges, pessimism evaporates in the clear high air. Pessimism seems like a small-souled human impertinence. Acceptance, unconditional surrender to acceptance, is all that is demanded. And death, too, must be accepted. Fire is the agent of death, yet all around us on the plateau new life was affirming itself in little green leaves emerging from the charred limbs of the wattle; green spinifex and hibiscus on the blackened rock. We walked on the plateau, John the artist, Alex the photographer, and I the poet, with the scientists Vin and Glen busily talking about millions of years, but there was no conflict between our points of view. These ranges are finite and observable, and measurable in scientific terms, and yet they possess a primordial quality which leads beyond matter into infinity.

In the words of Lao Tse, one felt in these ranges a clearing of obstacles; one's spirits were not cramped. And as the waters were being absorbed into the rock, to give life to new growth in places where it seemed nothing might grow, so one could begin to have an understanding of 'What gives life to all creation and is itself inexhaustible — that is Tao.'

The hours and days that followed as we explored the ranges by helicopter left the mind with more than visual images. They created waterfalls of the spirit.

The visual images are of course unforgettable. The ranges lie in many different sections, with the striped domes sometimes following curves like the paws of a crouching lion, sometimes presenting fortress-like bastions, sometimes isolated on the plain. Sometimes the domes give way to sawtoothed erosions, and sometimes they come down over smooth buttresses to tessellated skirts that from a distance seem to have been laid by stonemasons.

As we flew down the deep gorges we were flanked by waterfalls. I liked best the slenderest and most delicate, whose lace would disappear in mid-air but reappear as a rainbow, finally ruffling the dark surface of the pool below. Wet black rockfaces shone in the morning sun; the colours of the rock withdrew into themselves in the evening and then flared up again as

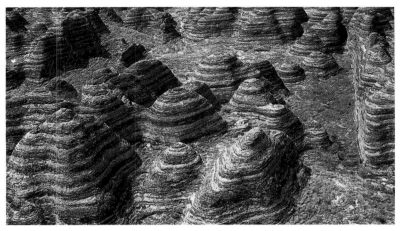

*The travellers found it hard to describe the strange rock formations of the
Bungle Bungle, with layers of different types of rock striping them as regularly
as though they had been painted. The helicopter at mid-right gives some idea
of the size of the formations*

waterfall.

we crossed the western face of the ranges. Occasionally there was a grey termite mound against the stone like a bear climbing the honeypot of rock.

As we swept low around the bend of a river I saw something move and thought it was a kangaroo, but then saw it was a giant goanna, a perentie at least three metres long and thicker than a man's thigh; rushing over the rock in flying curves, something indescribably prehistoric.

We had lunch one day in a lovely enclosed valley, the wild sorghum two metres high with knife-like bladed leaves, amidst the clicking of wild locusts. Yellow cassias were flowering, and hibiscus, and a little blue flower. Amid the great marvels you had to look for little ones too.

In the evenings the pilots joked about the difficulties of flying in such country, relaxed after their conversations with each other in the air. They always kept in touch during flight and told each other about awkward curves or cliffs. 'Coming into the east end of the gorge.'

'I have you visual, mate.'

Up and around an impossible obstacle. 'Piece of cake, mate.'

'Thanks, mate.'

Having some knowledge of flying I asked them about the dangers of winds in such gorges and the effect of heat from the rocks. They told me 'The wind on your right shoulder is the one a helicopter pilot has to watch. It blows against the tail rotor.'

They said that a strong wind can blow into the exhaust of the turbo-jets and blow out the flame when you are trying to start the engine.

Helicopters are appallingly expensive machines because they have so many parts that can only be replaced directly from the manufacturers. The pilots talked about a man who had replaced a rotor bearing with an apparently identical one from a truck, but it burnt out and he was killed. The strip of plastic behind a door costs $1500 and a complete new door costs $10 000.

Such expense requires maximum use and helicopter pilots often fly ten-hour days. Doug flew seventy-five hours in his first week. Some are alone in the bush for months at a time, flying all day every day. All good pilots have an intense, almost personal relationship with their machines. Helicopters, which violate all the old rules of flight, seem particularly to be extensions of the pilots themselves.

We had entertaining yarns around the fire with the two pilots and Jack their young mechanic. Born in The Hague of Dutch parents, he was as Aussie a bloke as you'd wish to meet and already floating down the stream of Australian idiom. John, a fine instructor when needs be, and a professional cook in his own right, was one night giving advice on cooking to Jack and the pilots when Jack commented 'You'd have been a foreman on the Bridge, eh?'

Later, when I made a suggestion about something, he said to me 'Another Bridge man, eh?' It turned out that he had had a mate whose uncle had worked on the Sydney Harbour Bridge.

After a few such comments John asked him 'You'd be a bit of a philosopher, eh, Jack?'

Quick as a flash Jack replied 'I don't know them long words.'

Jack was shaking with fever on our last day, and when we met him again back in Kununurra Vin said 'I hope you haven't got dengue fever.'

'Never heard of it,' said Jack. 'Has it got long ears or short ears?'

Jack and the helicopter pilots returned to Darwin while we waited for the flight to Broome. We had travelled about 20 000 kilometres on our modern exploration, by air, boat, vehicles, and on foot, but the North-West is so vast that we would have needed several more expeditions of the same size and complexity to cover all its deserts, islands, ranges, and rivers, to say nothing of its thousands of kilometres of rugged coastline.

Geographical size and distance are impressive in themselves and they are the great modulators of human affairs, yet like all large and distant things they are composed of innumerable units and links. There is always a close-up, a middle distance; an identifying rock or tree or sandhill or flower. The Aborigines understand how to relate the shapes of the present to the distances of the past, but we have almost forgotten that instinct which evolved over thousands of years. Luckily we can learn a little bit back from them, even without sharing their legends and traditions, and a great many of us are trying to do so. White Australians are gradually attempting to fit themselves into the environment on which they turned their backs for so long, and anyone who has studied our suburban culture for the last thirty years or so will know how profoundly it has been modified by a new knowledge and curiosity about the physical presence of Australia: its birds and mammals, wildflowers, trees, lakes, deserts, and mountains. For a pragmatic people, Australians can be unexpectedly poetical, even mystical in the sense of making room for a mystery. The North-West of Western Australia, which contains some of the wildest regions on earth, is not going to allow easy access to its mysteries, but I cannot think of anywhere in the world where the search is more rewarding.

Bungle Bungle R. (Detail)

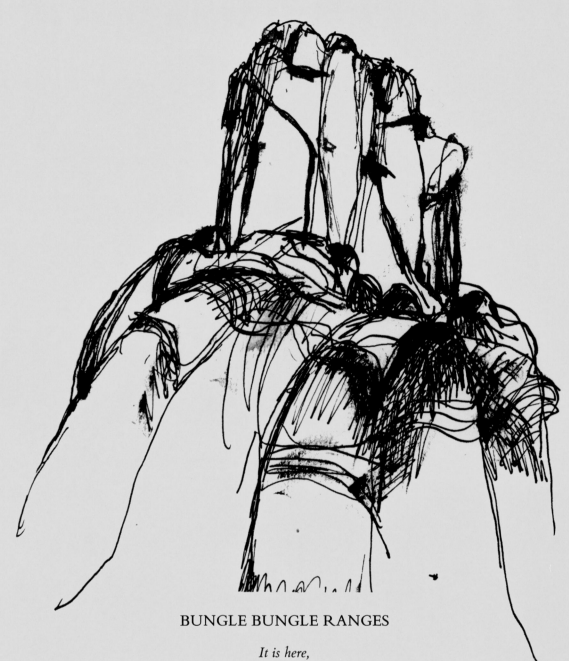

BUNGLE BUNGLE RANGES

It is here,
Nature's architecture
Uninhabited by man
Tessellated domes, layers of colour
Laid cinnamon, black and white up from the high-grass plain.

Buddhist temples
In Cambodia, a mosque in Mashhad,
A striped marble cathedral in Siena,
All built by flood and fire, centuries
Tapping like raindrops, weeping at the release of captive streams.

Now walking here,
Given the freedom of the plateau
By helicopter, while far below
Wild cattle and a wheeling herd of camels stir
The red sand, a kind of worship is building, tier by tier.

Hertha, Rhea,
Cybele, Titans worshipped
Under stone, layer on layer
Of secrets older than Buddha or Christ, script
Of female mysteries, breasts lifting to the sky in prayer.

Turn me away
From noisy toys, bereft
By precipices that take my breath
Away. Across the gorge in the wet cleft
Accept my offering, wash away my death.

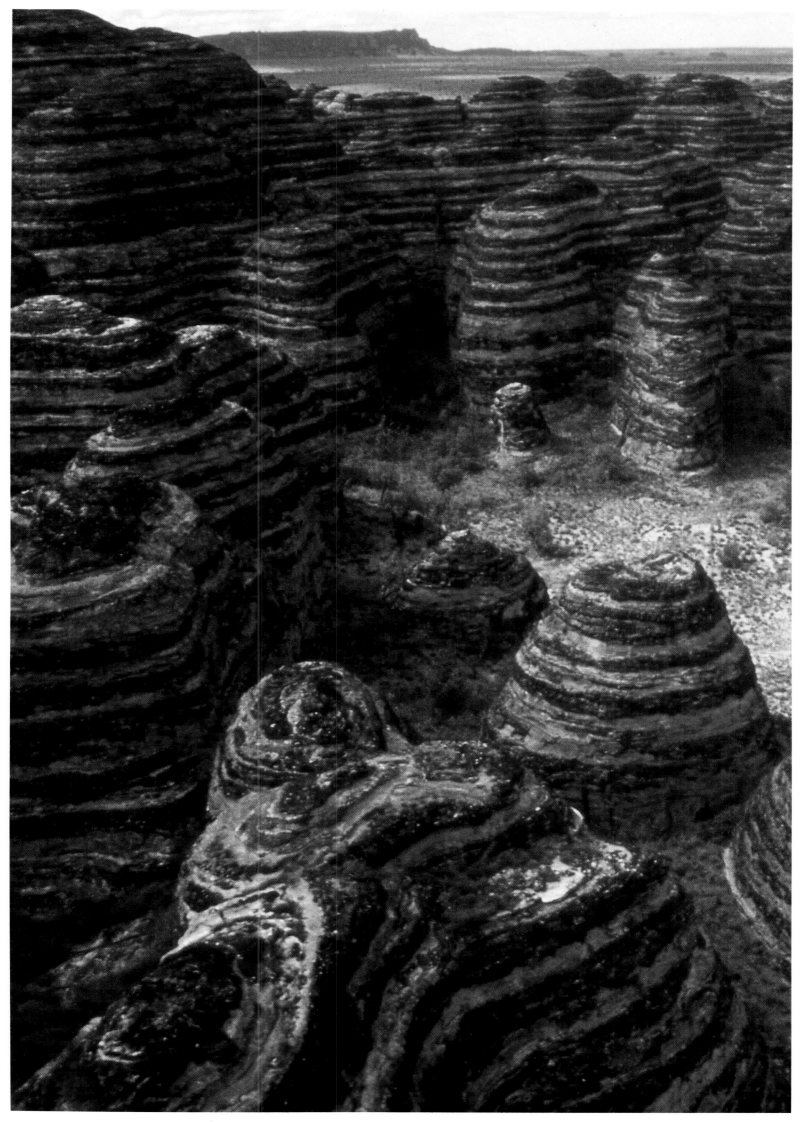

Like a deserted ancient city of strange conical buildings, the Bungle Bungle rock formations rise sharply out of the flat country on which they stand

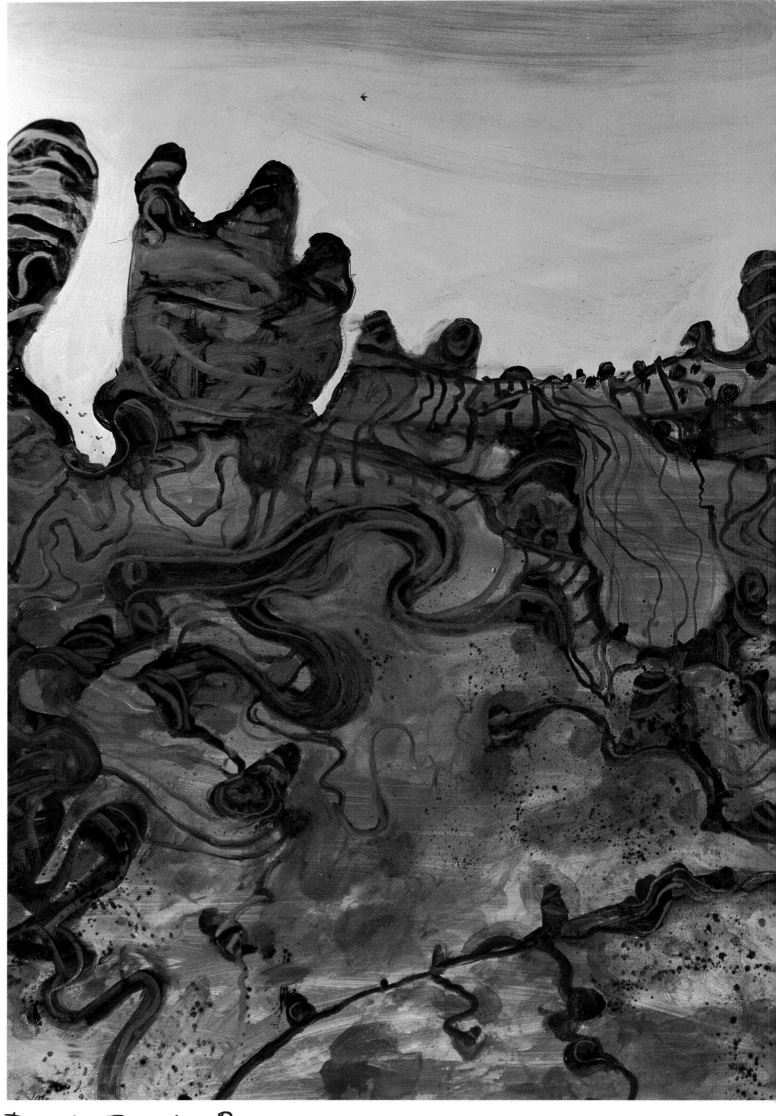

Bungle Bungle R.

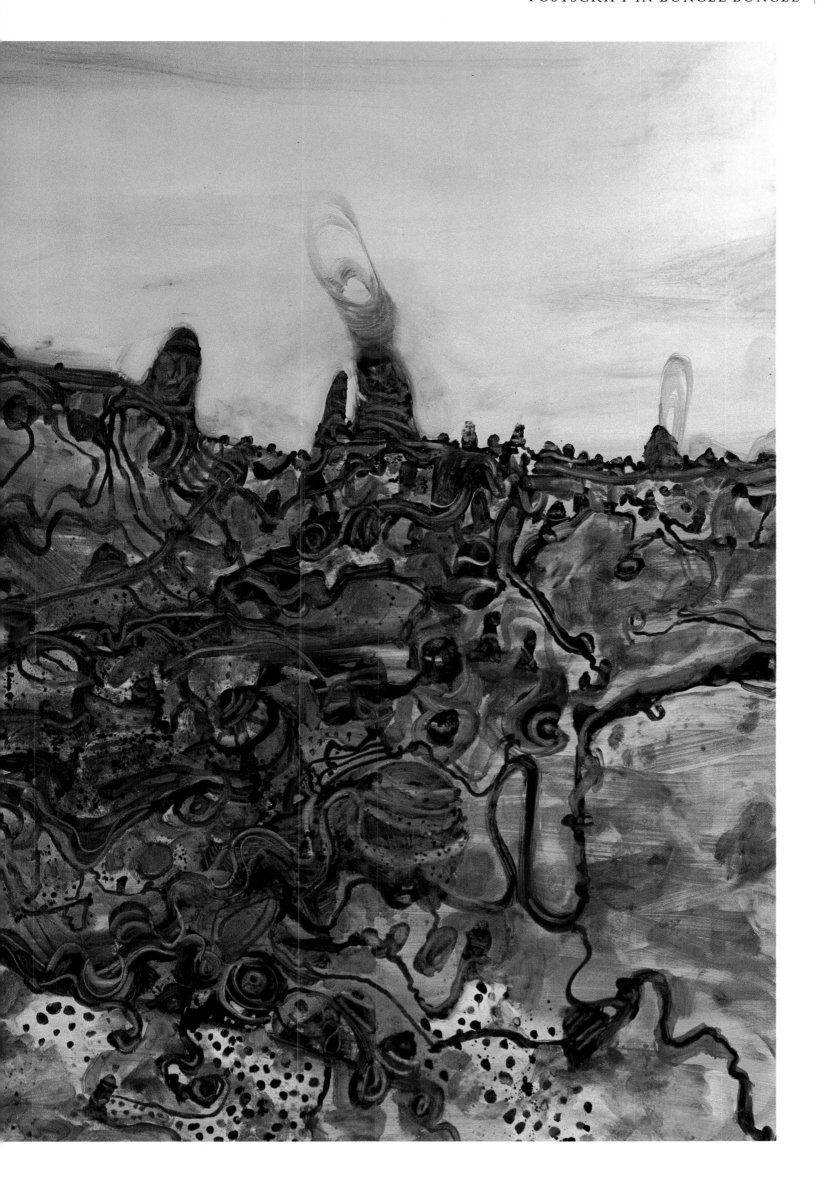

ACKNOWLEDGEMENTS

We wish to acknowledge the support and co-operation of the Office of the North-West of Western Australia, the Mines Department of Western Australia and the Department of Aboriginal Affairs.

We also wish to thank the many missions and Aboriginal communities that we visited, station owners who gave their time to us unstintingly and for the goodwill and help of the many Aboriginal friends of Mary Durack.

CATALOGUE OF WORKS

The works are listed in order of appearance in the book

Jacket Bungle Bungle Range 180 x 240 cm Oil on board
Preface Hamersley Ore Train 180 x 240 cm Oil on board

Chapter 1
Geraldton Sand Plain 153 x 168 cm Oil on canvas

Chapter 3
Two Emus 50 x 37 cm Ink and pastel

Chapter 4
Hamersley Ore Deposits 36 x 54 cm Charcoal
Approaching The Hamersleys 200 x 200 cm Watercolour and pastel
The Old Camel Road, Hamersley Range 27 x 37 cm Watercolour and pastel
Hamersleys I 27 x 35 cm Watercolour and pastel
Hamersleys II 27 x 36 cm Watercolour and pastel
Camels 54 x 35 cm Pastel and charcoal
The Pilbara on Fire 137 x 154 cm Oil on canvas
Desert Children 30 x 32 cm Ink on paper
Aboriginal Mother, Jigalong 37 x 28 cm Watercolour and pastel
Desert Boy, Jigalong 37 x 28 cm Watercolour and pastel
Life at Jigalong Five studies Watercolour and pastel
Tribal Elder, Jigalong 24 x 34 cm Ink and pastel
La Toilette 45 x 22 cm Ink on paper
Soup 40 x 30 cm Ink on paper

Chapter 5
Deserted Homestead, Abydos 36 x 36 cm Ink and watercolour
Aboriginals Drinking, Marble Bar 23 x 19 cm Watercolour and pastel
Feeding the Dog 105 x 78 cm Ink on paper
Aboriginal Woman, Broome 33 x 13 cm Charcoal and pastel
Talking to the Dog 26 x 13 cm Watercolour and pastel
Don McLeod 50 x 37 cm Ink on paper
Emu, Kimberley 50 x 39 cm Ink and pastel
Calling Mum, La Grange 28 x 30 cm Ink on paper
Coming Home From the Mission 37 x 24 cm Ink on paper
Mates, La Grange 36 x 25 cm Ink and watercolour

Chapter 6
The Creation of Broome Cream 40 x 56 cm Ink on paper
Rusted Broome House 28 x 18 cm Ink and watercolour
Old Aboriginal Couple, Broome 51 x 47 cm Watercolour and pastel

Chapter 7
Peter, Tribal Elder, Lombadina 33 x 25 cm Pencil

Chapter 8
Aboriginal Boy Carrying his Brother over Bindieyes 31 x 22 cm Ink and pastel

Chapter 10
Scrub Turkey in the King Leopold Range (Detail) 10 x 21 cm Watercolour and pastel

King Leopold Range (Four studies) 10 x 20 cm Watercolour and pastel
Echidna upside down, Leopold Range 54 x 38 cm Ink and pastel
Honeyeater and Flower 50 x 37 cm Watercolour
Dry Riverbed, Drysdale (Detail) 122 x 133 cm Oil on canvas
Drysdale River 151 x 137 cm Oil on canvas
Ash of Burnt Trees, Drysdale National Park 12 x 27 cm Gouache
Aftermath of Fire 117 x 167 cm Oil on canvas
Prince Regent River 168 x 153 cm Oil on canvas
Three Burnt Trees, Drysdale National Park 35 x 22 cm Oil on canvas
Burning Trees, Drysdale National Park (Four studies each) 50 x 42 cm Oil on canvas
Ebb Tide, Prince Regent River 180 x 240 cm Oil on board

Chapter 12
Two Aboriginals on Horses 24 x 16 cm Watercolour and pastel
The Rider 24 x 16 cm Watercolour and pastel

Chapter 13
Spoonbill and Frog 68 x 45 cm Ink and pastel
Ord River in the Wet 78 x 76 cm Watercolour and pastel
Tree Frog 50 x 37 cm Watercolour and pastel
Frog and Dark Bank 14 x 19 cm Watercolour
Frog and Waterlily 38 x 50 cm Watercolour
Tree Frog Hanging from a Branch 40 x 24 cm Watercolour
Lily Trotters, Ord River 98 x 69 cm Watercolour

Chapter 14
Lake Gregory in Flood I 168 x 153 cm Oil on canvas
Lake Gregory in Flood II 146 x 135 cm Oil on canvas
Aboriginal Child Learning to Write I 22 x 22 cm Watercolour and pastel
Lake Gregory in Flood III 162 x 150 cm Oil on canvas
Aboriginal Child Learning to Write II 52 x 36 cm Ink and pastel
Aboriginal Education I 55 x 58 cm Ink and pastel
Aboriginal Education II 55 x 37 cm Gouache and pastel
Aboriginal Education III 55 x 37 cm Gouache and pastel

Chapter 15
Drinking at Fitzroy Crossing 29 x 18 cm Ink and watercolour
Having a Good Yarn, Fitzroy Crossing 19 x 29 cm Ink on paper
Aboriginals Drinking, Fitzroy Crossing 48 x 28 cm Watercolour and pastel

Chapter 16
Aboriginal Camp I 30 x 33 cm Ink on paper
Aboriginal Camp II 30 x 41 cm Ink on paper
Aboriginal Camp III 30 x 33 cm Ink and pastel
Road and River Carnarvon (Detail) 152 x 182 cm Oil on canvas

Chapter 17
Camel in Bungle Bungle 77 × 77 cm Watercolour and pastel
Bird and Bungle Bungles 70 × 69 cm Watercolour and pastel
Bungle Bungle Range (Detail) Oil on board
Bungle Bungle Range 180 × 240 cm Oil on board

INDEX